D·ANGULO & A·E·PÉREZ SÁNCHEZ

A CORPUS OF SPANISH DRAWINGS

VOLUME TWO:

MADRID 1600~1650

D·ANGULO & A·E·PÉREZ SÁNCHEZ

A CORPUS OF SPANISH DRAWINGS

VOLUME TWO:

MADRID 1600~1650

A CORPUS OF SPANISH DRAWINGS

MADRID
1600~1650

BY DIEGO ANGULO
& ALFONSO E · PÉREZ SÁNCHEZ

 HARVEY MILLER~LONDON

© 1977 D · ANGULO & A · E · PÉREZ SÁNCHEZ

ISBN 0-905203-06-2

A HARVEY & ELLY MILLER PRODUCTION

PRINTED IN GREAT BRITAIN AT THE UNIVERSITY PRESS, OXFORD

BY VIVIAN RIDLER, PRINTER TO THE UNIVERSITY

CONTENTS

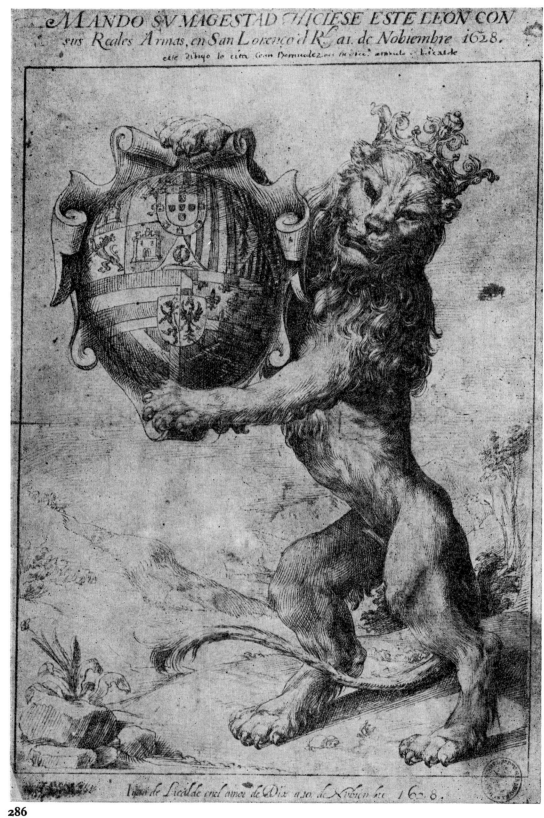

MANDO SU MAGESTAD HICIESE ESTE LEON CON
sus Reales Armas, en San Lorenço el R. a1. de Nobiembre 1628.

INTRODUCTION

THIS SECOND VOLUME of the Corpus of Spanish Drawings presents more than four hundred drawings dating from the first half of the seventeenth century, and which are of the Castilian or, more precisely, of the Madrid School. The artists concerned were active in Madrid between 1600 and 1650, although some of them—as for instance Antonio de Pereda, who was the most long-lived—go beyond this period.

However, the greater part of this volume is made up of the work of Eugenio Cajés (1574–1634) and Vicente Carducho (c. 1576–1638) who, among all the painters of the time, are the most important, the most prolific, and stylistically the most familiar. Cajés, who was born in Madrid, was the son of Patricio Cajés, one of the Tuscan artists who came to the Escorial, and whose work is already recorded in the first volume. Vicente Carducho, the younger brother of Bartolomé, was born in Florence but came to Spain with his brother when nine years old in the retinue of his master, Zuccaro. He considered himself Spanish, and because of his influence on the numerous pupils who were drawn to him on account of his prestige, and his gift for teaching, the later Madrid School can be said to stem from his work.

The existence of many drawings by these artists is known, but only a fraction of them have been studied or reproduced. For instance, in Sánchez Cantón's inventory (1931), only ten drawings by Carducho and nine by Cajés are reproduced, as compared with the one-hundred-and-thirty and ninety respectively, in this volume. This abundant material confirms the dependence of these masters on the Tuscan models brought to Spain through the intermediary of the Escorial.

The stylistic features that characterize the work of these two artists—and, indeed, of almost all those represented in this volume—can be easily related to the influence that Zuccaro and his pupils exercised at the Court of Philip II. Vicente Carducho, in his compositional studies, often uses pen and sepia wash on dark grey-green paper, heightened at times by touches of white lead. This is a customary Mannerist method, but one still not much employed in Italy at that time. Especially when using light buff paper, he also frequently draws in pencil which he subsequently strengthens in sepia wash with the brush. For the still imprecise and fluid outlines of his preliminary sketches, he usually employs a free zigzag stroke with the pen: but for the more detailed and careful studies he prefers thick and smooth black chalk, applied with Tuscan precision and softness. This medium became, in the hands of his pupils, the favourite technique of the Madrid artists of the second half of the century.

In his more worked-out compositions, Eugenio Cajés also tends to use pen and sepia wash over black chalk, and this almost always on white paper, in a search for strong chiaroscuro effects, and with recourse also to very elongated models still largely manneristic in origin. For summary sketches and outlines he prefers sanguine to black chalk or ink, and with this obtains very lively results. In elaborately finished studies he often combines black chalk with sanguine, producing thereby a delicacy of modelling and a mellow softness reminiscent of certain Italian works in the manner of Cavaliere d'Arpino.

Among the pupils of Carducho whose drawings are known to us, Felix Castelo follows closely the methods and techniques of his master. The landscape-painter Collantes, however, has left some sketches that are perhaps nearer to the work of Cajés. In turn, among the latter's pupils there are some outstanding drawings by José Leonardo, who handles sepia wash in strong chiaroscuro, very much in the style of his master. There are also some curious drawings by

Antonio Lanchares in which his use of a nervous, fluid pen stroke links him to the tradition of Zuccaro and his imitators at the Escorial.

The only certain drawings by little-known artists such as Francisco de Rómulo and Andrés Ruiz, also directly recall the work of Zuccaro.

When considering the artists of the younger generation working around 1640, it is worth stressing the technical versatility of the few recorded drawings by Antonio de Pereda. Some of these are executed in a soft and delicate manner, in smooth black chalk or sanguine, emulating the Venetian mellowness of his paintings; others again, in nervous, broken strokes of the pen, suggest cursory forms despite their seeming intricacy. Perhaps his most characteristic traits are sketches lightly traced in pencil or sanguine and then partially worked over with pen and strokes of sepia or red wash, showing a certain amount of volume, but leaving other areas barely indicated.

Diego Polo, Pereda's contemporary, reveals a pictorial quality in his drawings, which has the same Venetian undertones as his paintings: the drawings are always in black, and sometimes heavy chalk.

It is very surprising and most regrettable that no drawings by any of the most important Madrid painters of the period have hitherto been identified, especially those of Juan Bautista Maino. Maino was the most attractive and 'modern' of the painters directly influenced by Caravaggio, and one who also was familiar with the art of the Carracci.

We have also been unable to identify any drawings by Angelo Nardi, despite the fact that in 1800 Ceán Bermúdez knew of some, and was able to comment on Nardi's technique. The example formerly in the Instituto Jovellanos at Gijón, which was destroyed in 1934, is only known to us through a small photograph from which it is impossible to form an opinion.

In view of the close relationship between the technique of these artists and that of their Italian, and especially Tuscan, predecessors, it is not surprising that some Spanish drawings of this period, including some bearing old attributions to their real authors, were regarded as Italian in a number of collections. At the time practically nothing was known about Spanish draughtsmanship. On the other hand, even today it is the evidence of that same relationship with Italian drawing that causes considerable doubt and hesitation regarding the correct attribution of quite a number of the anonymous drawings with a Spanish flavour which we have assembled here. Thus, as explained in the previous volume, it is not impossible that some Italian items may be found among the unattributed drawings; but we have decided to reproduce them here in order to make them known and facilitate their correct classification at a later date.

In a field so little explored, and so lacking in specialist studies as this, the largely provisional nature of our work must always be kept in mind. Indeed, as a result of the publication of the first volume, we have obtained, or been offered, new information about some of the drawings we have reproduced, and new items have been brought to our notice which, as we have already announced, will be incorporated into a supplement in due course.

The system of classification adopted for this catalogue has been organized in the same way as the first volume, as follows: the artists known by name have been listed alphabetically. Under each name are catalogued first those drawings which we consider authentic. These are grouped broadly under subject matter. They are followed by drawings whose attribution is doubtful, and then by a further list of works whose attribution we reject. The group of anonymous drawings which form the second part of the catalogue is divided according to the following iconography—Old Testament, New Testament, and Marian Themes; Saints; Portraits and Miscellaneous Studies.

We should like to thank again all those who have assisted us in the preparation of this second volume, and to all the names mentioned previously we would like to add that of Mrs. McKim Smith, for her valuable help with regard to collections in the United States.

BIBLIOGRAPHY

WORKS QUOTED IN ABBREVIATED FORM

ANGULO: Angulo Iñiguez, Diego, *Cuarenta dibujos españoles*. Madrid, Real Academia de San Fernando, 1966.

ANGULO–PÉREZ SÁNCHEZ: Angulo Iñiguez, Diego and Pérez Sánchez, A. E., *Pintura madrileña del primer tercio del siglo XVII*, C.S.I.C. Madrid, 1969.

BARCIA: Barcia, Angel, *Catálogo de dibujos de la Biblioteca Nacional*. Madrid, 1906.

J. BROWN, 1973: Brown, Jonathan, 'Spanish Baroque Drawings in the Sperling Bequest', *Master Drawings*, 1973, pp. 374–9.

J. BROWN, 1975: Brown, Jonathan, Review of McKim Smith's Catalogue of *Spanish Drawings in North American Collections*, in *Master Drawings*, 1975, pp. 60–3.

CEÁN: Ceán Bermúdez, Juan Agustín, *Diccionario histórico de los más ilustres profesores de las Bellas Artes en España*. Madrid, 1800. Facsimile reprint, Madrid, 1965.

GÓMEZ SICRE: Gómez Sicre, José, *Spanish Drawings* (XV–XIX centuries). Lausanne, 1950.

GRADMANN: Gradmann, Erwin, *Spanische Meisterzeichnungen*. Frankfurt am Main, 1939.

MAYER: Mayer, Augustus L., *Dibujos de Antiguos Maestros Españoles*. Leipzig and New York, 1915–20.

MORENO: Moreno Villa, José, *Dibujos del Instituto de Gijón*. Madrid, 1926.

PÉREZ SÁNCHEZ: Pérez Sánchez, Alfonso E., *Gli Spagnoli dal Greco a Goya. I Disegni dei Maestri*, Vol. IV. Milan, 1970.

PÉREZ SÁNCHEZ, CATÁLOGO FLORENCIA: Pérez Sánchez, Alfonso E., *Disegni Spagnoli, Catálogo della Mostra di disegni Spagnoli*. Gabinetto Disegni e Stampe degli Uffizi. Florence, 1972.

PÉREZ SÁNCHEZ, CATÁLOGO GIJÓN: Pérez Sánchez, Alfonso E., *Catálogo de la Colección de Dibujos del Instituto Jovellanos de Gijón*. Madrid, 1969.

PÉREZ SÁNCHEZ, CATÁLOGO PRADO: Pérez Sánchez, Alfonso E., *Museo del Prado. Catálogo de Dibujos I. Dibujos Españoles. Siglos XV–XVII*. Madrid, 1972.

PÉREZ SÁNCHEZ, CATÁLOGO SAN FERNANDO: Pérez Sánchez, Alfonso E., *Catálogo de los Dibujos, Real Academia de San Fernando*. Madrid, 1967.

SÁNCHEZ CANTÓN: Sánchez Cantón, F. J., *Dibujos españoles*. Madrid, 1970. Five volumes.

SANTARELLI CATALOGUE: *Catálogo della Raccolta di Disegni autografi, antichi e moderni donata dal Professore Emilio Santarelli alla Reale Galleria di Firenze, Florence*, 1870.

TORMO: Tormo, Elias, *La Real Academia de San Fernando. Cartilla Excursionista*. Madrid, 1929.

TRAPIER: Trapier, E. du Gué, Notes on Spanish Drawings, *Notes Hispanic*, Vol. I, 1941, Vol. II, 1942.

VELASCO: Velasco, Miguel, *Catálogo de la Sala de Dibujos de la Real Academia de San Fernando*. Madrid, 1941.

WITT: *Handlist of Drawings in the Witt Collection*. London University, 1956.

JOURNALS

ARCHIVO: Archivo Español de Arte y Arqueología (1925–37) and Archivo Español de Arte (since 1940).

BOLETÍN: Boletín de la Sociedad Española de Excursiones. Madrid 1898–1954.

EXHIBITION CATALOGUES

BORDEAUX 1957: *Bosch, Goya et le Romantique*.

FLORENCE 1972: Gabinetto Disegno e Stampe degli Uffizi, *Disegni Spagnoli* (see Pérez Sánchez).

HAMBURG 1966: Kunsthalle, *Spanische Zeichnungen von El Greco bis Goya*.

LAWRENCE, KANSAS 1974: University of Kansas Museum of Art, *Spanish Baroque Drawings in North American Collections* (see McKim Smith).

MADRID 1892: *Exposición histórico-europea*.

MADRID 1926: Sociedad de Amigos del Arte, *Exposición del antiguo Madrid*.

MADRID 1927: Sociedad de Amigos del Arte, *Exposición franciscana*.

MADRID 1934: Museo de Arte Moderno. *Exposición de Dibujos de Antiguos Maestros Espanoles (Siglos XVI al XIX) del Gabinete de Estampas de la Biblioteca Nacional*.

NEW YORK 1975–6: Metropolitan Museum of Art, Prints and Drawings Gallery, *Drawings Recently Acquired 1972–1975*.

OTHER BOOKS AND ARTICLES

Acebal, R., and Escalera, P., *Bocetos del Instituto Jovellanos*. Gijón, 1878.

Allende Salazar, J., and Sánchez Cantón, F. J., *Retratos del Museo del Prado*. Madrid, 1919.

Angulo Iñiguez, D., 'Dibujos españoles en el Museo de los Uffizi', *Archivo*, 1927–8.

—— 'El pintor pedro Núñez', *Archivo*, 1964.

—— y Pérez Sánchez, A. E., *Pintura Toledana de la Primera mitad del S. XVIII* Madrid, 1973.

Baticle, Janninne, 'Venta de dibujos de la Colección Ceán Bermúdez', *Archivo*, 1962.

—— 'La Fundación de la Orden Trinitaria de Carreño de Miranda', *Goya*, No. 63, 1964.

—— 'Une œuvre retrouvée de Carreño de Miranda: LA FONDATION DE L'ORDRE DES TRINITAIRES', *Revue du Louvre*, 1965.

Benesch, Otto, *Meisterzeichnungen der Albertina*. Vienna and Salzburg, 1964.

Brown, J. M., 'Algunas adiciones a la obra de Blas de Prado', *Archivo*, 1968.

Burger, W., 'École espagnole', *Histoire des Peintres de toutes les écoles*. Paris, 1880.

Camón Aznar, José, *Dominico Greco*. Madrid, 1950. Two volumes.

—— *Velázquez*. Madrid, 1965. Two volumes.

Carducho, Vicencio, *Diálogos de la Pintura*. Madrid, 1633.

Cruzada Villaamil, Gregorio, 'Paginas de la Historia de la pintura en España', *El arte en España*, 1866 and 1867.

—— *Catálogo del Museo Nacional de la Trinidad*. Madrid, 1865.

Cuartero, Baltasar, 'Relación descriptiva de los 56 lienzos pintados por Vicencio Carducho para el claustro grande de la Cartuja del Paular', *Boletín de la Historia*, 1950–1.

Ferri, Pascuale Nerino, *Catálogo riassuntivo . . . della raccolta di disegni . . . degli Uffizi*. Rome, 1890–7.

Gerstenberg, K., 'Zeichnungen von Carducho, Cano und Velázquez', *Pantheon*, 1967.

Gómez Moreno, Manuel, 'El Cristo de San Plácido', *Boletín*, 1916.

Gómez Moreno, María Elena, 'Escultura del siglo XVII', *Ars Hispaniae*, XVI. Madrid, 1965.

Iñiguez Almech, F., *La trazas del Monasterio de San Lorenzo de El Escorial*. Madrid, 1965.

Justi, Karl, *Velázquez y su siglo*. Spanish edition, Madrid, 1953.

Lafuente Ferrari, Enrique, *El realismo en la pintura española del siglo XVII*. Madrid, 1935.

—— *Los retratos de Lope de Vega*. Madrid, 1935.

Lefort, Paul, *Collection de M. Paul Lefort. Dessins anciens principalement de l'école espagnole*. Paris, 1869.

Mâle, Émile, *L'Art religieux après le Concile de Trente*. Paris, 1951.

Mas Kowitz, I., *Great Drawings of All Time*. New York, 1962.

Mayer, Augustus L., *Geschichte der spanischen Malerei*. Leipzig, 1913.

—— 'Die Spanischen Handzeichnungen in der Kunsthalle zu Hamburg', *Zeitschrift für bildende Kunst*, 1918. Spanish translation, *Boletín*, 1920.

—— 'Los dibujos españoles de la Colección Witt en Londres', *Arte Español*, 1926.

—— *Historia de la pintura española*. Madrid, 1947.

McKim Smith, Gridley, *Spanish Baroque Drawings in the North American Collections*. Exhibition Catalogue. University of Kansas Museum of Art, 1974.

Mélida, José Ramón, *Catálogo monumental de Cáceres*. Madrid, 1924. Three volumes.

Méndez Casal, Antonio, 'El Instituto Jovellanos de Gijón. Su colección de dibujos', *Blanco y Negro*, 5 August 1928.

Menéndez Acebal, Jesús, *Catálogo de los bocetos que existen en el Museo del Instituto Jovellanos*. Gijón, 1886.

Mireur, H. *Dictionnaire des ventes d'art faites en France et à l'étranger pendant les XVIIIᵉ et XIXᵉ siècles*. Paris, 1911–12. Seven volumes.

Muller, Priscilla E., *The Drawings of Antonio del Castillo y Saavedra*. Ann Arbor, 1963.

Pacheco, Francisco, *Arte de la pintura*. Seville, 1643. Critical edition by Sánchez Cantón. Madrid, 1956.

Palomino y Velasco, Acisclo Antonio, *Museo Pictórico y escala opticácon el Parnaso Español pintoresco laureado*. Madrid, 1715–24. Issued by Edición Aguilar. Madrid, 1947.

Pantorba, Bernardino de, 'Un nuevo dibujo de Velázquez', *A.B.C.*, 9 May 1968.

Pérez Sánchez, Alfonso E., 'Diego Polo', *Archivo*, 1969.

—— *Gli Spagnoli dal Greco a Goya*. Disegni dei Maestri, Vol. 4. Milan, 1970.

—— 'Sobre dos dibujos de Carducho y Cajés', *Boletín del Seminario de Estudios de Arte y Arqueología de la Universidad de Valladolid*, 1971, pp. 487–90.

—— *Catálogo de Dibujos del Museo del Prado. I. Dibujos españoles de los siglos XV–XVII*. Madrid, 1972.

—— *Disegni Spagnoli, Catálogo della Mostra di Disegni Spagnoli*. Gabinetto Disegni e Stampe degli Uffizi. Florence, 1972.

—— 'Dibujos españoles en los Uffizi florentinos', *Goya*, no. 111, 1972, pp. 146–57.

Ponz, Antonio, *Viaje de España*. Madrid, 1772–94. Eighteen volumes. New edition Aguilar. Madrid, 1947.

Popham, A. E., and Fenwick, K. M., *National Gallery of Canada. Catalogue of European Drawings*. Toronto, 1965.

Réau, Louis, *Iconographie de l'art chrétien*. Paris, 1955–9. Six volumes.

Rosell y Torres, J., 'Dibujos de Vicente Carducho para la decoración del lamado Salón de Reinos del antiguo Palacio del Buen Retiro', *Museo español de antigüedades*, Vol. X, 1880.

San Román, Francisco de Borja. Noticias Nuevas para la Biografía de Luis Tristán. *Boletín de la Real Academia de Bellas Artes y Ciencias Históricas de Toledo*, 1924, pp. 113 ff.

Sánchez Cantón, F. J., *Nacimiento e infancia de Cristo*. Madrid, 1948.

—— *Cristo en el Evangelio*. Madrid, 1950.

—— *Catálogo de las pinturas del Museo del Prado*. Madrid, 1963.

—— *Spanish Drawings from the 10th to the 19th Century*. London and New York, 1964.

—— *Dibujos españoles*. Madrid, 1969.

Sanz Pastor y Fernandez de Pierola, Consuelo, *Museo Cerralbo. Catálogo de Dibujos*. Madrid, 1976.

Sciolla, Gianni Carlo, *I Disegni di Maestri Stranieri della Biblioteca Reale di Torino*. Turin, 1974.

Sentenach, Narciso, 'Dibujos originales de antiguos maestros españoles', *Historia y Arte*, Vol. II, 1896.

Soria, M. S., and Kubler, G., *Art and Architecture in Spain and Portugal and their American Dominions 1500–1800*. Pelican History of Art, 1959.

Standish, *Catalogue des tableaux, dessins et gravures de la Collection Standish légués au Roi*. Paris, 1842.

Stein, Adolphe, *Master Drawings*. London, 1973.

Stirling, William, *Annals of the artists of Spain*. London, 1848. Three volumes.

Taylor, Mary Cazort, *European Drawings from the Sonnenschein Collection and Related Drawings in the Collection of the University of Michigan Museum of Art*. Ann Arbor, 1975.

Tormo, Elias, *Las viejas series icónicas de los reyes de España*. Madrid, 1917.

—— *Las iglesias del antiguo Madrid*. Madrid, 1927.

Trapier, E. du Gué, 'Notes on Spanish Drawings', *Notes Hispanic*, 1941.

Valverde Madrid, José, 'El pintor Antonio del Castillo', *Boletín de la Real Academia de Córdoba*, 1961, pp. 163–271.

Vey, Horst, and de Salas, Xavier (Editors), *German and Spanish Art to 1900*. New York, 1965.

Wethey, Harold E., 'Alonso Cano's Drawings', *Art Bulletin*, 1952.

Wormser, S. O., 'Tableaux espagnols à Paris au XIX^e siècle' (University of Paris Doctoral Thesis), unpublished.

The manuscript for this work was delivered in Spanish
and has been translated by Nicholas Wyndham
Later material was translated by Theodore Crombie

CATALOGUE

SEVENTEENTH CENTURY
ARTISTS KNOWN BY NAME

LORENZO ALVAREZ

A non-existent artist accidentally created by the historian Ceán Bermúdez, who made a mistake regarding the identity of Lorenzo Suárez.

STANDING KNIGHT. London, Jennings-Brown. See Anonymous Artists, No. 418.

IGNACIO ARIAS

An artist, evidently from Madrid, who is known solely from the signature on a still-life with fish, dated 1652 and in a Madrid private collection. The testament of his widow, dated 1690, has recently come to light, confirming that he was active in the second half of the century. He was possibly related to Antonio Arias (1614–84), a well-known painter represented in the Prado Museum. The attribution is not acceptable.

ST. JOHN THE BAPTIST. Lawrence, University of Kansas, Museum of Art

358×171 mm. Pen and sepia wash. Cream laid paper.

Inscribed in ink *YgO Arias*, in a seventeenth-century hand.

Treating the inscription as a signature, Mrs. McKim Smith, 1974, No. 1, catalogued this drawing as by Arias, though acknowledging the very strong influence of Luca Cambiaso. J. Brown, 1975, p. 62, has more prudently pointed out that it should be attributed to an Italian follower of Cambiaso, and that the inscription should be interpreted as an owner's mark rather than as a signature.

EUGENIO CAJÉS

Madrid 1574–1634.
Son of Patricio, the painter from Arezzo who was one of the artists working at El Escorial, and of a Spanish mother, Cajés was brought up in Madrid and travelled in Italy. On his return to the court, he was appointed Royal Painter in 1612 and, as well as his undertakings for the palace, concurrently produced a considerable body of work for churches and convents. He was a colleague and friend of Vicente Carducho, and the two of them collaborated on several major projects (Chapel of the Virgin of the 'Sagrario', Toledo, 1618; Guadalupe altar-piece, 1619) both in oils and fresco.
Formed by the mannerism of the turn of the century, he belonged to the generation who, in the school of Madrid, gave rise to baroque naturalism. His style is distinctly personal and displays a certain preoccupation with chiaroscuro and a very individual softness of modelling.

Gospel Subjects

1 GOD THE FATHER. Madrid, National Library

194×127 mm. Red chalk. Buff paper. A large section of paper has been cut away from the bottom right-hand corner. *Plate III*

Barcia assumed, probably correctly, that this must be a study for an Annunciation, as the presence of a desk—more probably a prie-dieu—suggests.
Possibly a study for the same painting as the drawing of the *Virgin kneeling* which is also in the National Library. See No. 7.

Barcia, No. 54.

2 ANNUNCIATION WITH A PRELATE SAINT PRAYING AS A DONOR. Florence, Uffizi

143×115 mm. Blacklead and brown watercolour. Buff paper. Squared. *Plate II*

Listed under anonymous artists in the Santarelli Collection. The technique and figures are characteristic of Cajés.

Provenance: Santarelli Collection.

Santarelli Catalogue, p. 710, No. 34 (Inventory 10364).

3 ANNUNCIATION WITH A KNEELING MONASTIC SAINT. Florence, Uffizi

155×128 mm. Prepared with blacklead. Pen and ink, and sepia wash. Buff laid paper. *Plate II*

Inscribed in ink, in an early hand: *1 Rs.*

In the Santarelli Collection the drawing was attributed to Domenica Cresti de Passignano, but it is clearly by the same hand and for the same composition as the preceding drawing, a characteristic work by Cajés.

Provenance: Santarelli Collection.

Santarelli Catalogue, p. 190, No. 12 (Inventory 2586).

4 ANNUNCIATION. Formerly Gijón, Instituto Jovellanos. Destroyed in 1936

190×120 mm. Ink and red wash. Thin paper. Squared in red chalk. *Plate II*

An old attribution: *Eugenio Caxés.*

Related in certain respects to the picture, signed and dated 1619, in the altar-piece of the Madrilenian township of Algete (Angulo–Pérez Sánchez, Pl. 176).

Moreno Villa, p. 38, No. 360; Pérez Sánchez, *Catálogo Gijón*, 1969, p. 46, Pl. 94.

5 ANNUNCIATION. Madrid, Prado Museum. Inventory No. F.A. 18

220×185 mm. Blacklead and red chalk. Buff, squared paper. A large ink blot. *Plate II*

Study for the painting, dated 1620, in Santo Domingo el Antiguo, Toledo, with some minor variants (Angulo–Pérez Sánchez, Pl. 178).

Provenance: Royal Collection.

Pérez Sánchez, *Catálogo Prado*, 1972, p. 37.

6 ANNUNCIATION. Philadelphia, Museum of Art

276×149 mm. Pen and sepia wash over preparatory drawing in black chalk. Buff laid paper. *Plate I*

Attributed by McKim Smith to Cajés, this drawing is clearly a companion to the *Presentation in the Temple* (No. 17) and would therefore appear to be by the same hand as others long attributed to the artist. It does not correspond to any other recorded Annunciation by him.

CHRIST AT THE COLUMN is mounted on the verso.

Exh. Lawrence, Kansas, 1974, No. 13; McKim Smith, 1974, No. 14; J. Brown, 1975, p. 61.

7 VIRGIN KNEELING. Madrid, National Library

190×70 mm. Red chalk. Buff paper. *Plate III*

In modern pencil: *80.*

This could be a study for an Annunciate Virgin, perhaps related to the drawing of God the Father, catalogued above (see No. 1). It could also be a saint, although this seems less likely.
Barcia attributes it to Cajés, although he considers the attribution doubtful. The drawing is probably autograph.

Provenance: Madrazo Collection.

Barcia, No. 71; Exh. Madrid, 1934, No. 18.

8 ADORATION OF THE SHEPHERDS. Madrid, National Library

209×205 mm. Blacklead and sepia wash. Buff paper. Squared. *Plate III*

Barcia attributed this drawing to Cajés. The attribution is tentative but probably correct.

Provenance: Madrazo Collection.

Barcia, No. 73.

9 ADORATION OF THE MAGI. Formerly Gijón, Instituto Jovellanos. Destroyed in 1936

220×380 mm. Sepia watercolour with touches of red. Buff paper. *Plate IV*

In ink in a seventeenth-century hand: *de Eugenio Cajes.* Further to the right: *Solis.* This is the signature of the seventeenth-century painter-collector to whom the drawing belonged. The preceding attribution is probably also his handwriting. In ink: *6*

This drawing does not correspond to Cajés' painted version of this subject in the Budapest Museum (Angulo–Pérez Sánchez, Pl. 190).

Moreno Villa, p. 39, No. 364; Sánchez Cantón, II, 178; *id., Nacimiento e infancia de Cristo*, 1948, p. 190, Pl. 221; Pérez Sánchez, *Catálogo Gijón*, 1969, p. 47, Pl. 98.

10 ADORATION OF THE MAGI. Formerly Gijón, Instituto Jovellanos. Destroyed in 1936

280×190 mm. Ink and wash. Buff paper with a watermark of a hand with letters. Squared. *Plate V*

In ink in the handwriting of the seventeenth-century painter-collector: *Solis, 3 Rs.* (3 *reales*).

This was attributed to Solis on the strength of the inscription, but Moreno Villa pointed out its closeness to Cajés' style. From the point of view of technique, figures, and proportions, the composition is unquestionably by Cajés. It was used by José Leonardo, with minor variants, as a basis for the painted altar-piece at Cebreros (Ávila), which was signed in 1625, and which therefore gives us a *terminus ante quem* for Cajés' composition. The Cebreros altar-piece is the first known work by Leonardo, who was then still Cajés' pupil and strongly influenced by his choice of figure types.
It is not impossible that the drawing is by Leonardo himself. As will be seen (Nos. 282–5), the surviving drawings by Leonardo which are similar to this in technique and figure types are few and far between.

Moreno Villa, 43, No. 404; Pérez Sánchez, *Catálogo Gijón*, 1969, p. 49, Pl. 103.

11 ADORATION OF THE MAGI. Madrid, Prado Museum

176×215 mm. Blacklead and red chalk. Buff laid paper. Squared. *Plate IV*

In ink: *4 Rs.*

Has close affinities with the painting in the Budapest Museum (Angulo–Pérez Sánchez, Pl. 190), although it cannot be considered an exact preparatory study for it.

Provenance: Fernández Durán Bequest, 1930, No. 1403.

Pérez Sanchez, *Catálogo Prado*, 1972, p. 38.

12 ADORATION OF THE KINGS. Madrid, Prado Museum. Inventory No. F.A. 755

210×145 mm. Red chalk with red and sepia washes. Buff laid paper. Squared in red chalk. Torn and restored at the edges. *Plate V*

A very typical drawing by Cajés and probably from his last period, to judge from the stiff upright figures and the angels, which are very similar to those in his paintings of St. Isabel and St. Engracia in the church of San Antonio de los Portugueses at Madrid (Angulo–Pérez Sánchez, Pls. 186 and 187), dated 1631.

Provenance: Pedro Beroqui Collection. Bequeathed to the Museum in 1958.

Pérez Sánchez, *Catálogo Prado*, 1972, p. 38.

13 ADORATION OF THE MAGI. Madrid, National Library

177×226 mm. Red chalk and dark sepia wash. Buff paper. *Plate V*

In ink the valuation: *22 rs.*

The composition is closely related to Cajés' painting of the *Adoration* in the Budapest Museum (Angulo–Pérez Sánchez, Pl. 190), but has been reversed.

Provenance: Castellanos Collection.

Barcia, No. 6856.

14 CIRCUMCISION AND TWO STANDING SAINTS Madrid, Academia de San Fernando

87×50 mm.; 90×82 mm.; 92×55 mm. Preliminary drawing in blacklead. Violet and sepia wash. Buff paper. *Plate VI*

The three compositions are framed by borders as for the panels of a mural decoration. The standing figures on the two smaller panels appear to be monastic saints, possibly Dominicans according to Tormo. The central panel depicts the Circumcision. Its composition resembles the fresco by Cajés in the antesacrarium of Toledo Cathedral, a work of 1615–16 (Angulo–Pérez Sánchez, Pl. 163). Tormo thought it was 'a Dominican saint's profession of faith', and Velasco conjectured that the two saints were St. Dominic and St. Albert the Great. The attribution to Cajés was first suggested by Pérez Sánchez.

Tormo, No. 31, p. 66; Velasco, No. 2; Pérez Sánchez, *Catálogo San Fernando*, 1967, p. 71.

15 PURIFICATION OF THE VIRGIN. Madrid, Prado Museum

153×255 mm. Pencil and sepia wash. Buff paper. Squared in pencil. *Plate VI*

On the mount, in ink in a nineteenth-century hand: *Eugenio Cajés.*

A few barely visible pencil lines indicate that the composition was intended to be framed by a depressed arch. Closely related to a painting in the reserves of the Prado Museum which is unattributed but at least from the workshop of Cajés.

Provenance: Fernández Durán Bequest, 1930, No. 1749.

Sánchez Cantón, II, 179; Pérez Sánchez, *Catálogo Prado*, 1972, pp. 38–9.

16 PURIFICATION OF THE VIRGIN. Madrid, National Library

136×108 mm. Blacklead and red ochre. Buff squared paper. *Plate VI*

In ink in an early hand: *4, 1 R y mº* (1½ *reales*).

The numbers are written in the same hand as on the *St. Peter receiving the keys* (No. 29) which used to be attributed to Carducho. Perhaps they both formed part of the same group.
The composition is related to the Algete altar-piece of 1619 (Angulo–Pérez Sánchez, Pl. 177), although the variations in the painted version are numerous.

Provenance: Carderera Collection.

Barcia, No. 56.

17 THE PRESENTATION IN THE TEMPLE. Philadelphia, Museum of Art

282×139 mm. Pen and sepia wash over preparatory drawing in black chalk. Cream laid paper. *Plate VI*

A companion drawing to No. 6 (*The Annunciation*) and, like it, published by Mrs. McKim Smith but entitled *The Circumcision*. In its general composition it effectively recalls *The Circumcision* by Cajés in the retable of the Church of Algete (Madrid) which is dated 1619 (Angulo–Pérez Sánchez, 1969, Pl. 177).

Exh. Lawrence, Kansas, 1974, No. 14; McKim Smith, 1974, No. 14; J. Brown, 1975, p. 61.

18 VIRGIN AND CHILD. Formerly Gijón, Instituto Jovellanos. Destroyed in 1936

180×130 mm. Watercolour and white chalk. Buff paper. Squared in pencil. *Plate VII*

In ink in an eighteenth-century hand: *E ó P. Caxessi* (E. or P. Cajés).

Attributed to Eugenio Cajés by Moreno Villa and Sánchez Cantón. The drawing, however, shows many features characteristic of V. Carducho.

Moreno Villa No. 362; Sánchez Cantón, II, 185; *id., Nacimiento e infancia de Cristo*, 1948, p. 173, Pl. 287; Trapier, 1941, p. 33; Pérez Sánchez, *Catálogo Gijón*, 1969, p. 47, Pl. 96.

19 VIRGIN ADORING THE SLEEPING CHILD. London, Courtauld Institute

149×119 mm. Red chalk and blacklead. Buff laid paper. *Plate VII*

Study for the painting in the Prado Museum which was for a long time kept in the Museum at Gerona (Angulo–Pérez Sánchez, Pl. 173).

Provenance: Collection of R. P. Roupell. Collection of J. P. Heseltine. Witt Collection.

Witt, No. 3824.

20 VIRGIN WITH THE SLEEPING CHILD. Madrid, Prado Museum. Inventory No. F.A. 19

170×145 mm. Red chalk and red wash. Dark-coloured, glueless paper. *Plate VII*

In pencil: *Legajo 43 nº 18* (Bundle 43 No. 18).

The relaxed pose of the Child, fast asleep, is reminiscent of the painting by Cajés in the Prado Museum (Angulo–Pérez Sánchez, Pl. 173). This could be a rough preliminary draught for that composition.

Provenance: Royal Collection.

Pérez Sánchez, *Catálogo Prado*, 1972, p. 39.

21 VIRGIN AND CHILD. Madrid, National Library

210×134 mm. Pencil, pen and ink, and reddish sepia wash. Buff paper. Squared in pencil. *Plate VII*

In the left-hand margin, where the paper has been considerably trimmed, in ink in handwriting that is probably early, the end of a name: . . . *io*. On the mount in ink in a modern hand: *Eug° Caxes* (?).

The subject is probably the Virgin resting on the flight into Egypt. There was a painting of this subject, catalogued as being from the 'school of Eugenio Cajés', in the Palace of Buen Retiro in the eighteenth century, but it has not survived (Angulo–Pérez Sánchez, p. 240). Trapier thought this drawing was a study for the painting mentioned by Stirling (*Annals*, I, 196), but Stirling was probably referring to the one now in the Prado (Angulo–Pérez Sánchez, Pl. 173), which is not related to this drawing.

Provenance: Carderera Collection.

Barcia, No. 58; Trapier, 1941, pp. 27 and 33.

22 VIRGIN AND CHILD WITH ANGELS. Madrid, National Library

197 × 84 mm. Blacklead and red ochre. Buff laid paper. Squared. *Plate VIII*

The figure of the Virgin is no more than suggested. The angels are more finished.

Provenance: Madrazo Collection.

Barcia, No. 64.

23 KNEELING FIGURE AND SOME CALCULATIONS Pen and ink and sepia wash. Verso of No. 22. *Plate VIII*

24 HOLY FAMILY. Madrid, National Library

114 × 135 mm. Blacklead. Buff paper. *Plate VIII*

Barcia lists this with anonymous works, but it is characteristic of Cajés' style. It may perhaps also be related to a *Rest on the flight into Egypt*, like No. 21.

Provenance: Madrazo Collection.

Barcia, No. 540.

REST ON THE FLIGHT INTO EGYPT. Formerly Gijón, Instituto Jovellanos
See No. 95, GROUP OF FIGURES.

25 HOLY FAMILY ON A JOURNEY. Madrid, Prado Museum. Inventory No. F.A. 21.

162 × 111 mm. Preparatory drawing in pencil. Crimsonish watercolour. Buff paper. Squared in red chalk. *Plate IX*

In pencil in a modern hand: *Legajo 43* (Bundle 43), *n° 10, Claudio*.

The attribution to Claudio Coello seems unacceptable. The proportions and figure types are closer to Cajés.

Provenance: Royal Collection.

Pérez Sánchez, *Catálogo Prado*, 1972, pp. 39–40.

26 THE HOLY FAMILY AS THE HOLY TRINITY ON EARTH. Madrid, Prado Museum, Inventory No. F.A. 20

173 × 120 mm. Preparatory drawing in pencil. Pen and ink and sepia wash. Buff paper. *Plate IX*

In pencil in a modern hand: *Legajo 43* (Bundle 43), *Camilo, n° 13*.

This was a fairly common iconographic theme in the seventeenth century, when it was promoted by the Counter Reformation (Mâle, *L'Art réligieux après le Concile de Trento*, Paris, 1951, p. 312).
It is a study for the signed painting in the church of Santo Domingo el Real in Madrid (Angulo–Pérez Sánchez, Pl. 192). It was probably executed before the other drawing of the same subject which is listed next.
Sánchez Cantón thought the former was by Pereda. Pérez Sánchez made the attribution to Cajés after comparing it with the drawing at the Academia de San Fernando. The inscribed attribution to Camilo is unacceptable.

Provenance: Royal Collection.

Sánchez Cantón, III, 241; Pérez Sánchez, *Catálogo San Fernando*, 1967, p. 69; Pérez Sánchez, *Catálogo Prado*, 1972, p. 39.

27 THE HOLY FAMILY AS THE HOLY TRINITY ON EARTH. Madrid, Academia de San Fernando

172 × 130 mm. Preparatory drawing in pencil. Pen and ink and sepia wash. Buff laid paper. Squared in ink. *Plate IX*

A more fully worked-out version of the preceding drawing, closer to the final painting.
Whereas Tormo, who was probably familiar with the painting, thought that this was by Cajés, Velasco, on seeing the attribution on the drawing in the Prado, thought that it must be by Pereda. Angulo was the first, followed by Pérez Sánchez, to re-attribute it to its author.

Tormo, No. 52, p. 68; Velasco, No. 17; Angulo, p. 9, Pl. 5; Pérez Sánchez, *Catálogo San Fernando*, 1967, p. 69.

28 BAPTISM OF CHRIST. Formerly Gijón, Instituto Jovellanos. Destroyed in 1936

320 × 230 mm. Coarse paper. Wax crayon. Squared. *Plate VIII*

In ink in a seventeenth-century hand, probably that of Solís: *Eugenio Cajes*.

The only reference to a painting of this subject by Cajés, or by his circle, is Ponz's mention of a work in the church of the Buen Suceso in Madrid (Angulo–Pérez Sánchez, p. 241), which has not survived. Although it is a little different from Cajés' usual style, the drawing could be by him.

Moreno Villa, p. 39, No. 368; Sánchez Cantón, II, 182; *id.*, *Christo en el Evangelio*, 1950, p. 20, Pl. 33; Pérez Sánchez, *Catálogo Gijón*, 1969, p. 48, Pl. 100.

29 ST. PETER RECEIVING THE KEYS. Madrid, National Library

125 × 90 mm. Blacklead and sepia wash. Buff paper. Squared. *Plate IX*

In ink: *4. Possibly an early numbering of a series.*

On the sheet of paper to which it has been pasted, at least since the time of Carderera, to whom it belonged: *Carducho.* It looks more like a Cajés, and the numbering in ink at the top right-hand corner is identical to that on the *Purification of the Virgin* (No. 16), which is certainly by this artist.

Barcia, No. 14.

30 LAST SUPPER. Madrid, National Library

175 × 131 mm. Red ochre on an area of light sepia wash. Dark buff paper. Part of the right-hand corner is missing. *Plate X*

Barcia lists it among anonymous works, but it is probably by Cajés or by a close follower, perhaps José Leonardo, since it is reminiscent of his *Last Supper* on the Cebreros Altar-piece (1625). It shares certain motifs with Cajés' *Last Supper* of 1609, now at Obrzycko in Poland (Angulo–Pérez Sánchez, Pl. 158).

Provenance: Madrazo Collection.

Barcia, No. 122.

31 CHRIST PRAYING IN THE GARDEN OF GETHSEMANE. Madrid, Academia de San Fernando

163 × 125 mm. Blacklead and red chalk. Light buff paper. *Plate X*

In ink in a seventeenth-century hand: *Ujenio Cajes.*

We are not sure whether the subject has been correctly identified.

Provenance: Royal Collection, Palace of Pardo, where it is described as *Christ kneeling.*

Tormo, No. 102, p. 74; Velasco, No. 94; Pérez Sánchez, *Catálogo San Fernando,* 1967, p. 70.

32 THE FLAGELLATION. Madrid, National Library

268 × 98 mm. Red chalk. Dark buff paper. Squared. *Plate XI*

The technique is reminiscent of other drawings by Cajés, especially No. 36.

Provenance: Carderera Collection.

Barcia, No. 55; Exh., Madrid 1934, No. 16.

33 CHRIST AT THE COLUMN. Philadelphia, Museum of Art. Inventory No. P.A.F.A. 269 (together with Nos. 6 and 17)

250 × 149 mm. Sepia wash over preparatory drawing in black chalk. Cream laid paper. Upper corners cut. *Plate XI*

In pencil, in a nineteenth-century hand: *Patricio Caxes.* On the verso, in sepia ink in a seventeenth-century hand which is certainly autograph: *28 lune___ os___ +/ 29 martes c___ +/ 30 miercoles___ +/ 1 juebes___ +/ 2 viernes___ +/3 sabado___ +/4 domingo___ +/ 5 lunes___ +/ 6 martes___ +/ 7 miercoles___ +/ 8 juebes___ +/ 9 viernes___ +/ 10 sabado___ +/ 11 domingo___ +/ 12 lunes___ +/.*

There are also various mathematical calculations, additions, and multiplications and the repetition of some letters, either the initials of a signature or more likely, simply strokes of the pen to make the ink flow.

Despite the attribution to Patricio Cajés, this drawing has been convincingly ascribed to Eugenio by Mrs. McKim Smith, although her interpretation of the pen strokes as a signature is less acceptable.
In technique and style this drawing and Nos. 6 and 17 are typical of Cajés and perhaps fairly early in date.

Exh. Lawrence, Kansas, 1974, No. 15; McKim Smith, 1974, No. 15; J. Brown, 1975, p. 61.

34 CHRIST SEATED ON CALVARY. Florence, Uffizi

270 × 150 mm. Blacklead. Buff laid paper. Squared in red chalk. *Plate XI*

Inscribed in ink, in the artist's hand, as on his other drawings: *uxenio.* Later inscription in ink: *18 Rs.,* crossed out; *4 Rls.* and *10 Rls.* Also inscribed in pencil, in a modern hand: *Cristofano Allori.*
In the Santarelli Collection the drawing was attributed to Cristofano Allori, but it is a very characteristic work by Cajés, related to the paintings of the same subject in the University of Barcelona and in the Mercedarian Convent of Don Juan de Alarcón in Madrid (Angulo–Pérez Sánchez, Pls. 176 and 193) and to the drawings catalogued here (Nos. 35 and 36).

Provenance: Santarelli Collection.

Santarelli Catalogue, p. 116, No. 1 (Inventory 1500); Pérez Sánchez, *Catálogo Florencia,* 1972, no. 50, fig. 39.

35 CHRIST AND THE VIRGIN MARY ON CALVARY PRIOR TO THE CRUCIFIXION. Gijón, Instituto Jovellanos. Destroyed in 1936

260 × 200 mm. Ink and carmine and sepia washes. Dark-coloured paper. Squared. *Plate X*

In ink in a modern hand: *Cano.*

On the back: a head.

Moreno Villa catalogued this among the drawings of Alonso Cano with the title *Christ appearing to a saint in the form of an Ecce Homo,* and praised it. Pérez Sánchez pointed out that it is indisputably by Eugenio Cajés, since it is related to a devotional composition of which he did at least two versions, one, signed in 1619, at the Mercedarian Convent of Don Juan de Alarcón, and another for the Colegio de Doña María de Aragón, which is now at Barcelona University, on loan from the Prado (Angulo–Pérez Sánchez, Pls. 176 and 193).
The figure of Christ in the drawing matches that in the Barcelona painting almost exactly, but the figure of the Virgin, being nearer to Christ and consequently larger in scale, relates more closely to the painting in the Convent of Don Juan de Alarcón in Madrid. One should also consider the possible existence of a lost third version. The attribution to Cano, untenable on a stylistic basis, is explained by the unusual iconography that the Granada artist used in his painting in the Capilla del Cristo de San Ginés in Madrid, which may perhaps have been inspired by precisely these paintings by Cajés.
This is a drawing of great quality and remarkable intensity of expression.

Moreno Villa, p. 29, No. 235; Pérez Sánchez, *Catálogo Gijón,* 1969, p. 46, Pl. 93.

36 CHRIST SITTING ON CALVARY. Madrid, Academia de San Fernando

250×170 mm. Blacklead and red chalk stump. Buff paper. *Plate XI*

In ink in a seventeenth-century hand: *uxenio*. In very faded red ochre in a later hand: *Caxés*. In pencil in a modern hand, no longer visible: *20, Caxes*.

Drawing for the figure of Christ in the painting of *Christ with the Virgin Mary and St. John on Calvary before the Crucifixion*, executed in 1619, in the Mercedarian Convent of Don Juan de Alarcón, Madrid (Angulo–Pérez Sánchez, Pl. 176).
The drawing was for a long time considered a study for a Flagellation, until Angulo identified the subject correctly.

Provenance: Royal Collection.

Tormo, p. 74, No. 104: Sánchez Cantón, 11, 183; Velasco, No. 97; Angulo, p. 9, Pl. 4; Pérez Sánchez, *Catálogo San Fernando*, 1967, p. 68; Exh. Hamburg, 1966, No. 87, Pl. 8.

37 SUPPER AT EMMAUS. Formerly Gijón, Instituto Jovellanos. Destroyed in 1936

120×140 mm. Ink and carmine wash. *Plate X*

Listed as anonymous in the Gijón collection. Moreno Villa thought it was Valencian, of the late sixteenth century. Pérez Sánchez noted the closeness of its figures and technique to other drawings by Cajés, to whom he attributes it, but with reservations.

Moreno Villa, p. 77, No. 639; Pérez Sánchez, *Catálogo Gijón*, 1969, p. 49, Pl. 104.

38 CHRIST WOUNDED. Madrid, Prado Museum. Inventory No. F.A. 22

171×114 mm. Preparatory drawing in blacklead. Pen strokes and strokes of red chalk. Buff laid paper. *Plate XI*

In pencil in a nineteenth-century hand (part of the writing has been trimmed away): *Legajo 43* (Bundle 43) *nº 9* and *Cano*.

Judging by the pose, this is most probably a study for an *Incredulity of St. Thomas*. Sánchez Cantón considered it School of Madrid, *c.* 1650.

Provenance: Royal Collection.

Sánchez Cantón, V, 373; Pérez Sánchez, *Catálogo Prado*, 1972, p. 40, pl. 80.

39 THE PRODIGAL SON. Madrid, Condes de Alcubierre

295×210 mm. Blacklead and sepia wash. Buff paper. *Plate XII*

In ink in an early, probably eighteenth-century hand: *Caxete Ma . .* The two letters following the name could be an abbreviation of Madrid.

Marian Themes

40 IMMACULATE CONCEPTION. Florence, Uffizi

210×90 mm. Trimmed to an irregular shape. Blacklead and red chalk. Buff laid paper. Squared. *Plate XII*

Listed as an anonymous work in the collection, it is to a certain extent related to the *Immaculate Virgin* in the Augustinian Convent at Salamanca, dated 1628 (Angulo–Pérez Sánchez, Pl. 175), and yet more closely to another *Immaculate Virgin*, known only through a copy in the church of St. John, Castrogeriz (Burgos).

Provenance: Santarelli Collection.

Santarelli Catalogue, p. 715, No. 136 (Inventory 10466); Pérez Sánchez, *Boletín Valladolid*, 1971, p. 489, pl. III.

41 IMMACULATE CONCEPTION. Madrid, Prado Museum. Inventory No. F.A. 17

230×160 mm. Blacklead and sepia wash, picked out in white lead. Buff paper. Squared in blacklead. *Plate XIII*

In ink in handwriting probably of the seventeenth century: *de Eujenio*. The following line has been trimmed away. In pencil: *Nº 16*.
On the back, in ink in a seventeenth-century hand: *dibuxo de Ugenio* (drawing by Eugenio).

Although there are many variations, it is related to the painting, dated 1628, in the Augustinian Convent of Monterrey at Salamanca (Angulo–Pérez Sánchez, Pl. 175).

Provenance: Royal Collection.

Pérez Sánchez, *Catálogo Prado*, 1972, p. 37.

42 THE ASSUMPTION OF THE VIRGIN. Florence, Uffizi

145×260 mm., rounded above and certainly cut at top and sides. Pen and ink, and sepia wash. Touches of white lead. Buff laid paper. Squared in blacklead. *Plate XII*

Inscribed in ink, in eighteenth-century handwriting: *8 Rs* and *18 Rls*, and in pencil, in a modern hand: *Passignano*.

In the Santarelli Collection, the drawing was attributed to Passignano. It is, however, a preparatory drawing for a canvas in the Prado Museum by Cajés or by one of his immediate pupils, such as Lanchares, who remained faithful to his technique and his figure types (Angulo–Pérez Sánchez, p. 243, No. 154A).

Provenance: Santarelli Collection.

Santarelli Catalogue, p. 191, No. 25 (Inventory 2599).

43 THE VIRGIN OF THE 'SAGRARIO'. Madrid, National Library

280×189 mm. Red ochre stump. Buff paper. *Plate XIV*

In ink in an eighteenth-century hand: *Eugenio Caxes*.

The Virgin, standing on a cloud, places the statue of the Virgin of the 'Sagrario' on her altar in Toledo Cathedral. Accompanying her in a blaze of glory are three martyr saints with palm fronds. On the left there are two priests kneeling on the ground, another standing with the Cross, and two angels. On the other side, the archbishop's throne, empty, and a woman with a candle.
The obscure iconography must relate to the Toledan legend of the Virgin of the 'Sagrario'.

Barcia considers this to be a study for one of the pictures which Cajés painted for the chapel of the high altar at Toledo Cathedral. This is possible, but the painting is no longer there and one cannot see any recess that might have taken it. (See Angulo–Pérez Sánchez, pp. 145 and 233.)

Barcia, No. 57.

44 HEAD OF A WOMAN. Madrid, Academia de San Fernando

190×145 mm. Blacklead and red chalk. Greyish paper. Very faded squaring in blacklead. *Plate XII*

In pencil in a modern hand: *Caxés.*

According to Pérez Sánchez, this is closely related to the Virgin in the Museo Cerralbo's *Assumption*, which Cajés is thought to have painted as a young man (Angulo–Pérez Sánchez, Pl. 194).
According to Tormo, the drawing is by Carreño or Cerezo.

Provenance: Royal Collection at the Palace of El Pardo.

Tormo, p. 74; Velasco, No. 96; Pérez Sánchez, *Catálogo San Fernando*, 1967, p. 70.

Saints and Angels

45 ST. ANN WITH THE VIRGIN AND CHILD (?) Formerly Gijón, Instituto Jovellanos. Destroyed in 1936

190×120 mm. Ink and red wash. Thin paper.
Plate XIV

In ink in a seventeenth-century hand, perhaps that of the painter-collector Solís: *eujenio Casses*, and a price: *4 Rls.*

Moreno Villa notes the peculiarity of the iconography. The figure presumed to be that of the Virgin with the Child in her arms is on a smaller scale and raised on a pedestal as if it were a statue, and the larger figure holds the supposed Virgin's arm. The scene could be the caretaker of a sanctuary arranging a statue. The proportions of the figures, which are extremely elongated in a typically mannerist way, are characteristic of Cajés' style, and the drawing is undoubtedly by him.

Moreno Villa, p. 38, No. 361; Pérez Sánchez, *Catálogo Gijón*, 1969, p. 47, Pl. 95.

46 MARTYRDOM OF ST. CATHERINE. Florence, Uffizi

270×160 mm. Blacklead and sepia wash. Laid paper.
Plate XIV

In ink in an early seventeenth-century hand: *eugenio cajes, 6 Rs.* In another hand: *42 Rs.*

Three studies of a saint tied to a tree-trunk with her hands behind her back. In the first one can see the wheel which identifies the subject.
In the collection it is attributed to an unknown Giovanni Francisco Collado, but is more typical of Cajés' style, although no painting by him of this subject is known.

Provenance: Santarelli Collection.

Santarelli Catalogue, p. 694, No. 1 (Inventory 10146), Pérez Sánchez, *Catálogo Florencia*, 1972, no. 51.

47 THE MYSTIC MARRIAGE OF ST. CATHERINE Madrid, National Library

279×188 mm. Blacklead and reddish sepia. Buff laid paper. Squared in pencil. *Plate XIV*

In ink in an eighteenth-century hand: *Rl 8* and *4 R.*

To some extent related to the painting of an analogous subject in an Austrian private collection (Angulo–Pérez Sánchez, Pl. 196).

Provenance: Castellanos Collection.

Barcia, No. 62.

48 ST. FRANCIS. Madrid, National Library

154×111 mm. Red ochre. Buff paper. *Plate XV*

Behind the saint, on a smaller scale, a roughly sketched figure, possibly a statue.

On the back, in ink, the incomplete text of a letter:

Con deseo estoy de saber de la salud de V.m |
eujenio Caxes a quien suplicome manden . . . |
bien que lo ar(e) de muy buena gana anto(ni) lo q . . . | su . . .
plico a entramos a dos me escriban dos letras |
que lo estimaré en mucho. Y como ha de cosa . . . |
blanqueado y la cal se está pudriendo m . . . |
xas muy grandes el Sr. Luis Tristan les . . . | mu . . .
chas beces y que si le manda V. sus al . . . |
ver a todos . . . |

(I am desirous of knowing of your health
Eugenio Cajés, to whom I beg to be sent . . .
although I will do it with pleasure . . . which . . .
I beg both of them to write me two letters
for I shall value it highly. And since . . .
whitewashed and the lime is rotting . . .
very big, Sr. Luis Tristán . . .
Often, and (that) if you send him your/his . . .
to see everyone . . .)

On the back, in blacklead, a sketch of a head, probably a portrait. The mention of Tristán in the text of the letter dates the drawing almost certainly before 1624, the year of his death.

Provenance: Carderera Collection.

Barcia, No. 63.

49 ST. FRANCIS. Madrid, Academia de San Fernando

186×137 mm. Blacklead, sepia wash. Buff paper.
Plate XV

In pencil in a modern hand: *Caxés.* On the back, now hidden by the mount: *Caxes* in ink, in an apparently seventeenth-century hand.

Provenance: Royal Collection at the Palace of El Pardo.

Tormo, No. 99, p. 74; Velasco, No. 93; Pérez Sánchez, *Catálogo San Fernando*, 1967, p. 70.

50 ST. FRANCIS. Whereabouts unknown

Sepia and white.

Provenance: Paris, Mariette sale, 1775. Sold for 51 francs.

Mireur, II, 123.

51 NICHOLAS IV AND THE BODY OF ST. FRANCIS
Vienna, Albertina

300×172 mm. Blacklead and pen and ink and sepia wash with white lead. Brown-coloured paper. Squared in pencil. *Plate XV*

The body of the saint stands upright on his tomb, and Nicholas IV, on his knees, lifts the hem of the habit and reveals the saint's wounded foot. To the right, a cardinal with a large torch, and two other figures. This subject is frequently depicted in baroque art.
Preliminary design for the painting in the cloisters of San Francisco el Grande in Madrid, which was praised by Pacheco, who apparently saw it in 1625 (*Arte de la Pintura*, 1956 ed., II, 347), but which is now lost (Angulo–Pérez Sánchez, p. 247).
The canvas must have been painted before 1613, when Cajés undertook to make a copy for Pedro Reus.
When he published it in 1915, Mayer thought the drawing depicted a 'miracle of St. Bruno'. Sánchez Cantón identified its true subject, but it is still called St. Bruno by Gómez Sicre.

Exh. Madrid, 1892, Room 1, No. 531; Mayer, Pl. 75: Sánchez Cantón, II, 184; J. Gómez Sicre, *Les dessins Espagnols*, 1950, p. 28; Pérez Sánchez, *Gli Spagnoli dal Greco a Goya*, 1970, p. 81, pl. V.

52 ST. ILDEFONSUS AND KING RECESVINTH AT THE TOMB OF ST. LEOCADIA. Madrid, Prado Museum. Inventory No. F.A. 23

156×246 mm. Pencil outlines reworked in ink, with touches of brown wash. *Plate XVIII*

Pasted onto another sheet. Inscribed in pencil in a nineteenth-century hand: *legajo 43 nº 26.*

The subject represents the miraculous apparition of St. Leocadia at her tomb, and the moment at which the Archbishop St. Ildefonsus cuts a piece from the Saint's tunic with the knife of King Recesvinth.
The drawing is close to Cajés in style, technique, and the scale of the figures, though it is probably the work of an artist in his immediate circle. Cajés himself painted an entirely different version of this subject for the Chapel of the Virgin of the 'Sagrario', Toledo (Angulo–Pérez Sánchez, Pl. 161).

Provenance: Royal Collection.

Pérez Sánchez, *Catálogo Prado*, 1972, p. 40.

53 ST. ISABEL OF PORTUGAL. Formerly Gijón, Institute Jovellanos. Destroyed in 1936

350×240 mm. Brush and sepia and black watercolour. Dark-coloured paper. *Plate XV*

In ink in an eighteenth-century hand: *Eugenio Caxes.*

At the foot of the sheet: *El quadro esta en la Iglesia de Sⁿ Antº de los Portugueses en Madrid* (The painting is in the church of San Antonio de los Portugueses in Madrid).

A study for the painting in the Madrilenian church of San Antonio de los Portugueses, signed in 1631 (Angulo–Pérez Sánchez, Pl. 187), but with numerous differences. It belonged to Ceán Bermúdez, who mentions it in his *Diccionario*: *Conservo algunos (dibujos) de su mano y el que hizo para el cuadro de Santa Isabel reina de Portugal que está en la iglesia de San Antonio de los Portugueses*

(I have several [drawings] by him, including the one he did for the painting of St. Isabel, queen of Portugal, which is in the church of San Antonio de los Portugueses). It has been noted that there is another drawing for the same composition which was sold with the Lefort Collection in 1869 (see No. 54). Lefort identified it as that described by Ceán, and since he acquired a lot from the historian's collection (see J. Baticle in *Archivo*, 1962, p. 73), the doubt as to which of the two actually belonged to the famous historian remains.

Ceán, I, 303; Mayer, No. 76; Moreno Villa, p. 39, No. 363; Trapier, 1941, p. 32; Pérez Sánchez, *Catálogo Gijón*, 1969, p. 47, Pl. 97.

54 ST. ISABEL OF PORTUGAL. Whereabouts unknown

260×150 mm. Pencil and sepia wash. Squared.

According to the catalogue of the Lefort sale of 1869 (No. 65), this is a study for the painting in San Antonio de los Portugueses.
See the preceding drawing.

Provenance: Ceán Collection (?) Paris, Lefort.

Ceán, II, 303.

55 ST. JOSEPH THE CARPENTER. Formerly Gijón, Instituto Jovellanos. Destroyed in 1936 with no surviving pictorial record

180×120 mm. Ink, watercolour and white chalk.

On the back, an illegible text.

In the Gijón collection, it was regarded as an anonymous work, but Moreno Villa thought that it was in the style of Cajés.

Moreno Villa, p. 77, No. 647; Pérez Sánchez, *Catálogo Gijón*, 1969, p. 50.

56 ST. JOHN THE BAPTIST. Madrid, Academia de San Fernando

216×176 mm. Blacklead and red chalk stump. Buff paper. Squared in blacklead. *Plate XVI*

In a modern hand in blacklead: *Caxes, 49*; in red ochre: *Caxes*. On the back, in ink, an illegible text.

Provenance: Royal Collection, Palace of El Pardo.

Tormo, No. 103, p. 74; Velasco, No. 98; Pérez Sánchez, *Catálogo San Fernando*, 1967, p. 69.

57 ST. JOHN THE BAPTIST. Madrid, National Library

260×190 mm. Red chalk and carmine watercolour. Buff paper. Squared in pencil. *Plate XVI*

In the lower left corner in ink: *D* (?).

Attributed by Barcia to Bartolomé Carducho, this is more reminiscent of Eugenio Cajés, and may be presumed to come from his immediate circle.

Provenance: Carderera Collection.

Barcia, No. 7275.

58 ST. JOHN THE EVANGELIST. Madrid, National Library

197×103 mm. Blacklead and red ochre. Buff paper. Squared. *Plate XVI*

There is a record of a St. John the Evangelist by Cajés, but the work has not survived (Angulo–Pérez Sánchez, p. 249).

Barcia, No. 59.

59 ST. JOHN AND ST. MATTHEW. Whereabouts unknown

110×107 mm. Reddish sepia watercolour.

Probably a companion piece to No. 63, although the Standish catalogue considers one to be by Cajés and the other of 'his school'.

Provenance: Paris, Standish Collection.

Standish, *Catalogue*, 1842, No. 373.

60 FLAGELLATION OF ST. LEOCADIA. Madrid, National Library

221×175 mm. Blacklead and sepia wash. Buff paper. Squared. *Plate XVIII*

An old ink inscription: *8r.* In pencil in a modern hand: *V. Carducho.*

Study for the corresponding painting in the chapel of the high altar in Toledo Cathedral, a work of 1615–16 (Angulo–Pérez Sánchez, Pl. 162).
Barcia attributes the drawing to Vicente Carducho, calling it *Martyrdom of a saint*—it has often been exhibited under this attribution, which is also accepted by J. Brown.

Provenance: Carderera Collection.

Barcia, No. 32; Exh. Madrid, 1934, No. 14; Exh. Hamburg, 1966, No. 62; J. Brown, 1973, p. 378.

61 MARY MAGDALENE. Madrid, National Library

198×140 mm. Trimmed to an oval shape. Red ochre and sepia wash. Buff laid paper. *Plate XVIII*

A *Mary Magdalene* by Cajés was mentioned in Cuzco in the seventeenth century, but it has not survived (Angulo–Pérez Sánchez, Pl. 250).

Provenance: Madrazo Collection.

Barcia, No. 60.

62 MARY MAGDALENE AT THE FOOT OF THE CROSS Madrid, Zobel Collection

97×135 mm. Red chalk. Buff laid paper. *Plate XIX*

A characteristic work by Cajés, although it does not correspond exactly to any of his known compositions.

Provenance: Collection of the Marqués de Zenete.

63 ST. MATTHEW AND ST. LUKE. Whereabouts unknown

117×110 mm. Ink and sepia wash.

Companion piece to No. 59, although the catalogue considers it 'school of Cajés'.

Provenance: Paris, Standish Collection.

Standish, *Catalogue*, 1842, No. 374.

64 recto ST. MATTHEW. Madrid, Rodríguez Moñino

Blacklead. Buff laid paper. Squared. *Plate XVII*

In ink: *2 R.*

64 verso Roughly sketched figure of a kneeling monk.
Plate XVII

65 recto AN APOSTLE ON A JOURNEY. Madrid, Prado Museum. Inventory No. F.A. 24a

180×150 mm. Red chalk. Buff laid paper. *Plate XVII*

In pencil, in a modern hand: *Legajo 43, No. 20* (Bundle 43, No. 20).

On the same sheet, a study of a man's head in profile, and a left hand, both in blacklead and perhaps for the same figure.

Pérez Sánchez, *Catálogo Prado*, 1972, p. 42.

65 verso ST. JAMES THE APOSTLE. Inventory No. F.A. 24

144×144 mm. Red chalk. Squared in red chalk. Pasted onto back of 65 recto. *Plate XVII*

In pencil in a nineteenth-century hand, crossed out: *Legajo 43* (Bundle 43) and *21.*

Study for the corresponding figure in the *Assumption of the Virgin*, dated 1629, at Torrelaguna (Angulo–Pérez Sánchez, Pl. 182).

Provenance: Royal Collection.

Angulo–Pérez Sánchez, 1969, p. 231; Pérez Sánchez, *Catálogo Prado*, 1972, p. 41.

66 ST. SEBASTIAN. Madrid, Prado Museum. Inventory No. F.A. 25

184×78 mm. Preparatory drawing in pencil. Pen and ink and sepia wash. Buff laid paper. Squared in pencil. *Plate XVIII*

In pencil in a nineteenth-century hand: *nº 18, Legajo 43* (Bundle 43), *Cano.*

This is very reminiscent of Cajés' style. Perhaps it is by him, or by a pupil.

Provenance: Royal Collection.

Pérez Sánchez, *Catálogo Prado*, 1972, p. 41.

67 THE INCREDULITY OF ST. THOMAS. Florence, Uffizi

105×90 mm. Red chalk, pen and ink, and sepia wash. Dark buff laid paper. *Plate XIX*

In the Santarelli Collection the drawing was attributed to Passignano.

Provenance: Santarelli Collection.

Santarelli Catalogue, p. 190, No. 15 (Inventory 2589).

68 SAINT KNEELING. Florence, Uffizi

250×170 mm. Red chalk and red wash. White laid paper. *Plate XIX*

The pilgrim's cloak may perhaps suggest St. James, and the pose suggests a study for an Assumption or an Ascension.
It is catalogued among anonymous drawings, but it is characteristic of Cajés.

Provenance: Santarelli Collection.

Santarelli Catalogue, p. 708, No. 2 (Inventory 10332); Pérez Sánchez, *Catálogo Florencia*, 1972, no. 52.

69 SAINT KNEELING. Florence, Uffizi

290×200 mm. Blacklead. Dark buff laid paper. *Plate XIX*

Catalogued as an anonymous work, it appears to be very close to Cajés.

Provenance: Santarelli Collection.

Santarelli Catalogue, p. 711, No. 64 (Inventory 10394).

70 RELIGIOUS AROUND A TOMB. Florence, Uffizi

88×105 mm. Pen and ink and sepia wash. Buff paper. *Plate XX*

In ink: *4 R.*

Listed as an anonymous work in the Santarelli Collection. Its proportions and technique bring it close to Cajés, to whom it can be attributed with reservations.

Provenance: Santarelli Collection.

Santarelli Catalogue, p. 710, No. 38 (Inventory 10368).

71 STANDING SAINT. Florence, Uffizi

115×50 mm. Ink and sepia wash. White laid paper. *Plate XX*

Two positions for the head. If one can identify the object in his right hand as a knife, the figure is probably St. Bartholomew.
Catalogued as an anonymous work, it seems typical of Cajés.

Provenance: Santarelli Collection.

Santarelli Catalogue, p. 711, No. 50 (Inventory 10380).

72 TWO OLD MEN IN AN ATTITUDE OF ADORATION Madrid, National Library

184×159 mm. Red ochre. Dark buff paper. *Plate XX*

The slightly stooping figure on the left seems to be

carrying a roughly sketched vessel in his hands. Could be studies for an Adoration of the Magi.
As indicated by Barcia, this is a companion piece to the next drawing. He thought they both formed part of a single sheet and catalogued them both under the same number.

Provenance: Carderera Collection.

Barcia, No. 68.

73 OLD MAN IN AN ATTITUDE OF ADORATION Madrid, National Library

184×143 mm. Red ochre. Dark buff paper. *Plate XX*

Could be a study for one of the Magi. See the preceding drawing.

Provenance: Carderera Collection.

Barcia, No. 68.

74 TWO KNEELING APOSTLES. Madrid, Prado Museum. Inventory No. F.A. 26

253×185 mm. Blacklead, with red ochre on the heads. Buff paper. *Plate XXI*

A section of the paper in the bottom right-hand corner is missing and has been restored.

In pencil in a nineteenth-century hand: *Legajo 43* (Bundle 43), *nº 7* and *cano.*

As argued by Sánchez Cantón, this is probably a study for an Ascension, or, more likely, an Assumption. He considers it an anonymous work of *c.* 1650, but it seems close in style to Cajés and resembles the corresponding figures in the *Assumption* of the Guadalupe altar-piece of 1618 (Angulo–Pérez Sánchez, Pl. 175).

Provenance: Royal Collection.

Sánchez Cantón, V, 372; Pérez Sánchez, *Catálogo Prado*, 1972, p. 41.

75 TWO STANDING APOSTLES. Whereabouts unknown

200×190 mm. Brush and sepia wash.

Provenance: Lefort Collection. Sold for five francs.

Lefort, *Collection*, 1869, No. 66.

76 SAINTS AND A GLORY OF ANGELS. Formerly Gijón, Instituto Jovellanos. Destroyed in 1936 with no surviving pictorial record

220×160 mm. Ink and wash. The lower half squared.

On the verso a cherub's head in pencil.

Labelled: *Caxes.*

Moreno Villa, p. 39, No. 370; Pérez Sánchez, *Catálogo Gijón*, 1969, p. 49.

77 ANGEL. Formerly Gijón, Instituto Jovellanos. Destroyed in 1936, with no surviving pictorial record

160×130 mm. Blacklead and red chalk. Paper with a watermark of a heart with a cross.

Attributions: *De mano de Eugenio Caxes* (From the hand of Eugenio Cajés), *Eugenio Caxes*.

Provenance: Jovellanos Collection.

Moreno Villa, No. 366, p. 39; Pérez Sánchez, *Catálogo Gijón*, 1969, p. 48.

78 SCENE WITH AN ANGEL. Formerly Gijón, Instituto Jovellanos. Destroyed in 1936 with no surviving pictorial record

120×80 mm. Blacklead. Squared.

Attribution: *Cases*, and on the verso the numbers of a calculation.

It used to be assumed that this represented St. Peter freed by the angel. Moreno Villa identified it as an Annunciation.

Provenance: Jovellanos Collection.

Moreno Villa, No. 367, p. 39; Pérez Sánchez, *Catálogo Gijón*, 1969, p. 48.

79 ANGEL. Formerly Gijón, Instituto Jovellanos. Destroyed in 1936

150×120 mm. Red chalk. Dark-coloured paper.
Plate XX

In a seventeenth-century hand: *R, Caje . . . Euxenio.*

The correct attribution to Cajés was first made by Moreno Villa. It is unquestionably his work, and is to some extent related to the women tending the mother-to-be in the fresco of the *Nativity of the Virgin* in the chapel of the Virgin of the 'Sagrario', Toledo—documented in the year 1616 (Angulo–Pérez Sánchez, Pl. 163). Pérez Sánchez noted this similarity and thought the drawing represented the figure of a woman, but the wings are clearly visible.

Moreno Villa, p. 73, No. 609; Pérez Sánchez, *Catálogo Gijón*, 1969, p. 49, Pl. 102.

80 SEATED ANGEL. Madrid, Prado Museum. Inventory No. F.A. 27

152×110 mm. Blacklead and red chalk. Buff paper.
Plate XXII

In ink, crossed out: *3 Rs.* In pencil in a modern hand: *Legajo 43 nº 21* (Bundle 43, No. 21).

Sánchez Cantón listed this as an anonymous Madrilenian work of *c.* 1650. However, the technique and figure type are characteristic of Cajés.

Sánchez Cantón, V, 371; Pérez Sánchez, *Catálogo Prado*, 1972, p. 42.

81 CHILD-ANGEL MUSICIANS. Madrid, Prado Museum. Inventory No. F.A. 28

200×125 mm. Black and red chalk. Buff wire-marked paper.
Plate XXII

Two pieces of different paper pasted together on another sheet. In pencil: *Nº 12* and *Legajo 43*.

Provenance: Royal Collection.

Pérez Sánchez, *Catálogo Prado*, 1972, p. 42.

Allegories and Secular Subjects

STUDIES FOR THE CATAFALQUE OF PHILIP III
Florence, Uffizi

The five drawings that follow (Nos. 82–86) are probably preparatory studies for the catafalque constructed for the funeral of a Spanish sovereign. Sánchez Cantón suggested that the structure was intended for the obsequies of Ann of Austria (d. 1580) or Philip II (d. 1598), believing as he did that the drawings dated from the end of the sixteenth century and were of unknown authorship.
Recently, F. Iñiguez Almech thought he recognized the hand of the architect Juan de Herrera in some of the texts inscribed on the drawings, and suggested that the artist could be Pantoja.
The style of the drawings argues for an attribution to Eugenio Cajés, and as there is documentary evidence that he worked on Philip III's catafalque in San Jerónimo el Real (Angulo–Pérez Sánchez, p. 259), it is reasonable to think that the drawings relate to this.

82 FOUR WORKS OF MERCY. Florence, Uffizi

565×410 mm. Pencil, pen and ink and sepia wash. White paper.
Plate XXIV

In ink in a hand which is probably that of the artist: *Dibuxos de los ocho arcos del cuerpo ochavado de debaxo de la media naranja en que se an de pintar en los siete de ellos las siete obras de misericordia corporales y en la otava un bersso latino a la vida de su mag^d. que las cumplio en bida y muerte, nº 1 Bisitar los enfermos, nº 2 Dar de comer al ambriento, nº 3 Dar de beber al sediento, nº 4 Bestir al desnudo* (Drawings of the eight arches of the octagonal structure beneath the cupola, on which are to be painted, on seven of them the seven works of corporal mercy, and on the eighth, a Latin verse on the life of His Majesty, who performed them in life and death. No. 1, Visiting the sick; No. 2, Giving food to the hungry; No. 3, Giving drink to the thirsty; No. 4, Clothing the naked).
In the middle, a scale from right to left: *1, 2, 3, 4, 5, 6, 7, 8, 9, 10.*
Also in ink: *6 R^s.* In pencil in a nineteenth-century hand: *Gº F. Collado.*
We have no record of any artist of this period called Collado or Fernández Collado; perhaps this is a collector's name.

Provenance: Santarelli Collection.

Santarelli Catalogue, p. 694, No. 5 (Inventory 10150); Sánchez Cantón, II, 141; F. Iñiguez Almech, *Las trazas del Monasterio de San Lorenzo de El Escorial*, 1965, p. 84; Pérez Sánchez, *Catálogo Florencia*, 1970, no. 53, fig. 41.

83 THREE WORKS OF MERCY AND A CARTOUCHE. Florence, Uffizi

565×410 mm. Pencil, pen and ink and wash. White paper.
Plate XXIV

In ink in a hand which is probably that of the artist: *nº 5 Dar posada al peregrino, nº 6 Redemir al cautivo.*

nº 7 Enterrar los muertos, nº 8 Discripcion (No. 5, Giving shelter to the pilgrim; No. 6, Ransoming the captive; No. 7, Burying the dead; No. 8, Description).
Also in ink: *6 Rs.*
In the middle, from left to right: *1, 2, 3, 4, 5, 6, 7, 8, 9, 10 pies* (feet).

In pencil in a modern hand: *G. F. Collado.*
See notes on the preceding drawing.

Provenance: Santarelli Collection.

Santarelli Catalogue, p. 695, No. 6 (Inventory 10151); Sánchez Cantón, II, 142; F. Iñiguez Almech, *op. cit.*, p. 84; Pérez Sánchez, *op. cit.*, no. 54.

84 FAITH AND PRUDENCE. Florence, Uffizi

252×405 mm. Pen and ink, pencil, and wash. White laid paper. *Plate XXIV*

In ink in a hand which is probably that of the artist: *La fé* (Faith), *FIDES, La Prudencia PRUDENCIA.* Also in ink: *3 Rs.*

This and the following drawings must correspond to the top of the same funeral monument as the preceding drawings. It should be noted that drawings of only three pediments survive. See Nos. 82 and 83.

Provenance: Santarelli Collection.

Santarelli Catalogue, p. 694, No. 3 (Inventory 10148); Sánchez Cantón, II, 138; F. Iñiguez Almech, *op. cit.*, p. 84; Pérez Sánchez, *op. cit.*, no. 56, fig. 42.

85 GENEROSITY AND RELIGION. Florence, Uffizi

270×405 mm. Pen and ink, pencil, and wash. White paper. *Plate XXIV*

In ink in a hand that is probably that of the artist: *La liberalidad, LIBERALITAS SACRA, La religión, RELIGIO.* Also in ink: *8 Rs.*

Provenance: Santarelli Collection.

Santarelli Catalogue, No. 4, p. 694 (Inventory 10149); Sánchez Cantón, II, 139; F. Iñiguez Almech, *op. cit.*, p. 84; Pérez Sánchez, *op. cit.*, no. 56.

86 CONTINENCE AND MEEKNESS. Florence, Uffizi

275×410 mm. Pen and ink, pencil, and wash. White paper. *Plate XXIV*

In ink in a hand which is probably that of the artist: *La continencia, CONTINENCIA, La Mansedumbre* (Meekness), *MANSUETUDO.*
Probably from another hand: *Pintese par del niño un corderillo que con* (deleted) *pone las manecillas* (deleted: *se pone*) *encima del braço de la mansedumbre* (Corresponding to the child, there should be painted a little lamb, which with . . . places its little hands . . . upon the arm of Meekness). Also in ink: *3 Rs.*

Provenance; Santarelli Collection.

Santarelli Catalogue, p. 694, No. 2 (Inventory 10147); Sánchez Cantón, II, 140; F. Iñiguez Almech, *op. cit.*, p. 84; Pérez Sánchez, *op. cit.*, no. 55, fig. 43.

87 A SIBYL (?) Florence, Uffizi. Inventory No. F. 14405

145×204 mm. Prepared with lead. Sepia wash. Buff laid paper. *Plate XXIII*

Inscribed in ink: *3 Rs.*

Rounded above, as if for a lunette.
Similar to the allegorical figures in the drawings for the funeral of Philip III catalogued above (nos. 82–6). It may be a companion to the following drawing, which is also related in style to V. Carducho. As has been mentioned, the two artists often worked together.

Provenance: Medici Collection.

Pérez Sánchez, *op. cit.*, p. 61.

88 A PROPHET OR PATRIARCH. Florence, Uffizi. Inventory No. F. 14404

127×197 mm. Prepared with lead. Sepia wash. Buff laid paper. *Plate XXIII*

Numbered *45* and *7* as if forming part of a series.

Rounded above, as if for a lunette.

The figure may be Moses. Something in the style is reminiscent of V. Carducho, but we are inclined to give the drawing to Cajés.

Provenance: Medici Collection.

Pérez Sánchez, *op. cit.*, p. 61.

89 THE DEATH OF ADONIS (?) Madrid, Prado Museum. Inventory No. F.A. 29

153×202 mm. Red chalk, slightly heightened with ink. Buff wire-marked paper. Squared in pencil. A large tear in the right bottom corner, roughly restored.
 Plate XXII

The subject, certainly mythological, is obscure, but could represent Venus lamenting over the dead Adonis. The style is clearly that of Cajés who is recorded as having copied the mythological compositions of Correggio.

Provenance: Royal Collection.

Pérez Sánchez, *Catálogo Prado*, 1972, p. 42.

90 A WOUNDED WARRIOR BEING TENDED (?) Madrid, National Library

280×188 mm. Red ochre, with a blotch of indian ink. Buff paper. Squared in ink. *Plate XXIII*

The squaring is numbered in ink from 1 to 7 and from 1 to 9.

The subject has not been identified. In view of the large number of figures, it does not look as if this represents St. Sebastian, even though one figure seems to be tending the wounded man, or pulling an arrow from his thigh. The scene appears to be taking place in a military tent and could be a theme from antiquity or literature, such as the Healing of Aeneas or of Philoctetes. It may be remembered that Cajés painted at least one scene from classical history—the picture of Agamemnon painted for the Alcázar in 1626 (Angulo–Pérez Sánchez, p. 252).

Provenance: Castellanos Collection.

Barcia, No. 65.

91 SCENE FROM CLASSICAL HISTORY. Florence, Uffizi

145×135 mm. Ink and blue washes. Laid paper.
Plate XXV

In ink in a seventeenth-century hand: *Eujenio Casesi.*

Listed as an anonymous work in the collection. The attribution to Cajés does not seem to tally with the style of the drawing, but has been accepted with reservations in view of its early date.

Provenance: Santarelli Collection.

Santarelli Catalogue, No. 58, p. 711 (Inventory 10388).

92 BATTLE BETWEEN SPANIARDS AND FLEMINGS Whereabouts unknown

170×280 mm.

Provenance: Paris, Standish Collection.

Standish, *Catalogue*, 1842, No. 372.

93 PORTRAIT OF A MAN. Madrid, Prado Museum. Inventory No. F.A. 31

287×216 mm. Black and red chalk heightened with white. Thick buff paper. *Plate XXVI*

Inscribed in ink in an old hand: *nᵒ 152.*

On the verso, in black chalk, the figure of a woman with a child in her arms. *Plate XXV*

This is a very fine drawing of uncertain attribution. Sánchez Cantón first published it as anonymous and then accepted the attribution to Antonio del Castillo in the 1789 manuscript inventory of the Museum, although it cannot be related to him either in technique or style. The figure on the verso is very typical of Cajés, and the male figure close to those that appear in his history paintings. It is certainly by him or by an artist in his immediate circle.

Provenance: Royal Collection.

Sánchez Cantón, III, 250; *id., Spanish Drawings*, 1965, Plate 54, p. 86; Pérez Sánchez, *Catálogo Prado*, 1972, p. 43, Plate 9.

94 STANDING KNIGHT. Switzerland, Private Collection

290×200 mm. Blacklead. Buff paper. *Plate XXV*

In ink in a hand that is probably eighteenth-century: *Trazo Bela*... very faint, and *Belazquez* (i.e. Velázquez's design). Likewise in ink in a hand that may also be eighteenth-century: *dibujo por detrás* (drawing on the back).

Bernadino de Pantorba published this as a work by Velázquez, pointing out that it could relate to *The expulsion of the Moriscos* painted by the great Sevillian master in 1627. It seems more likely to be a preliminary sketch for the figure of General Don Juan de Haro in Cajés painting of the *Recovery of Puerto Rico* in the Prado Museum (Angulo–Pérez Sánchez, Pls. 188 and 189). Drawing and painting match exactly in the costume and the position of the right arm. The only differences are that in the picture the left arm is lower, possibly for compositional reasons, and that the hat is turned more into a silhouette.

Bernardino de Pantorba, 'Un nuevo dibujo de Velázquez', *A.B.C.* (9 May 1968).

95 GROUP OF FIGURES. Formerly Gijón, Instituto Jovellanos. Destroyed in 1936

170×160 mm. Blacklead and red chalk. Dark-coloured paper. *Plate XXV*

In ink in the handwriting of the painter-collector Solís: *de Eugenio Cajes.*

Moreno Villa has already remarked on the unusual composition of the group. The drawing is clearly a detail from a larger composition. On the other hand, the attribution is correct. Pérez Sánchez compares it with the group in the background in José Leonardo's *St. John the Baptist* in the Los Angeles County Museum of Art, where the man's position is repeated virtually point for point, revealing behind him one figure viewed full-face and another in profile. This is not the only occasion on which a drawing by Cajés is copied, with a greater or lesser number of variants, by Leonardo. See No. 10.
The drawing was thought to be a *Rest on the flight into Egypt*, but the presence of more than three figures precludes such an identification.

Moreno Villa, p. 39, No. 365; Pérez Sánchez, *Catálogo Gijón*, 1969, p. 48, Pl. 99.

96 GROUP OF FOUR MEN. Madrid, National Library

112×74 mm. Blacklead and red ochre, and pen and ink. Buff paper. *Plate XXVII*

The four men are looking intently at something strange which is to be imagined on the right. The vertical line bounding the group on the left clearly indicates that the figures belong at one edge of a narrative composition.

Provenance: Carderera Collection.

Barcia, No. 28.

97 BOY WITH A CELLO. Madrid, National Library

123×123 mm. Red ochre stump. Buff paper, trapezoidal with a curved left-hand edge. Squared in pencil.
Plate XXVIII

Foreshortened from a very low viewpoint. The position of the figure, adapted to the trapezoidal format, and the shape of the paper itself, with its curved edge, suggest that this could be a study for a decorative figure in a lunette or similar area in a mural painting.

Provenance: Carderera Collection.

Barcia, No. 66; Exh. Madrid, 1934, No. 17.

98 A KING. Madrid, National Library

164×118 mm. Blacklead and sepia wash. Squared in pencil. Buff paper. *Plate XXVII*

In the background, a study for another, apparently

seated, figure. On the left, where the paper has been considerably trimmed, part of a sum and some letters. Barcia, although he lists it among Cajés' drawings, considers the attribution doubtful, but it seems typical of Cajés. It could be one of the Magi for an Epiphany, or possibly a study of the figure of the King of Portugal for the background of the painting of *St. Isabel of Portugal* in the church of San Antonio de los Portugueses, Madrid (Angulo–Pérez Sánchez, Pl. 187), to which it bears some resemblance.

Barcia, No. 69.

99 MAN SEEN IN PROFILE. Madrid, National Library

180×85 mm. Red ochre. Dark buff paper.
Plate XXVII
In ink in an early hand: *2*.

Seems to be numbered in the same way as drawings Nos. 16 and 29, and as if it once formed part of the same group.

Provenance: Carderera Collection.

Barcia, No. 70.

100 MAN SITTING ON THE GROUND. Madrid, National Library

193×144 mm. Red ochre and blacklead. Buff paper.
Plate XXVIII
Provenance: Carderera Collection.

Barcia, No. 67.

101 SOLDIER LEANING AGAINST A CHIMNEY-PIECE Formerly Gijón, Instituto Jovellanos. Destroyed in 1936

210×170 mm. In ink in handwriting probably of the seventeenth century: *Eugenio Cajesi, 6 Rs.*
Plate XXVII
For a painting of a scene from contemporary history. The drawing's technique is identical to that of the *King* listed above (No. 98).

Moreno Villa, No. 371, p. 39; Pérez Sánchez, *Catálogo Gijón*, 1969, p. 49, Pl. 102.

102 BOY DRINKING. Madrid, National Library

170×116 mm. Blacklead. Buff paper. Squared in pencil.
Plate XXIX
Barcia finds this reminiscent of Cajés' style, but lists it among anonymous works. One can accept an attribution to Cajés, but with some reservations. It could be a preparatory drawing for a painting of Moses and the water from the rock, although there is no proof that he ever painted this subject, or it could simply be a study of a beggar.

Provenance: Madrazo Collection.

Barcia, No. 681.

103 KNEELING SHEPHERD. Madrid, Prado Museum. Inventory No. F.A. 108

236×145 mm. Red chalk. Buff laid paper. *Plate XXIX*

Inscribed in red chalk in an eighteenth-century hand: *Castillo*.

The attribution to Castillo which was noted by Sánchez Cantón and accepted by Valverde, cannot be upheld, as P. Müller has already pointed out. Judging by the human model and the handling, it is close to the drawing style of Cajés and can be given to him with certain reservations.

Provenance: Royal Collection.

Sánchez Cantón, V, 372; Valverde Madrid, *El Pintor Antonio del Castillo*, 1961, p. 28; P. Müller, *The Drawings of Antonio del Castillo y Saavedra*, 1963, p. 221, no. 6; Pérez Sánchez, *Catálogo Prado*, 1972, pp. 165–6.

104 FALLING MALE NUDE. Formerly Gijón, Instituto Jovellanos. Destroyed in 1936

200×340 mm. Red ochre stump. Coarse paper.
Plate XXVIII
In ink in a seventeenth-century hand: *Cajes*. Also in ink: *8 Rs.*

A faint sketch of a leg in the background.
The head is bent back, and the limbs are spread like those of a figure falling in space, rather than lying on the ground. It may possibly be a study for a devil vanquished by St. Michael. There is a painting of this subject, dated 1605, in Copenhagen Museum (Angulo–Pérez Sánchez, Pl. 156). Pérez Sánchez thought it could also be a study for a painting of the metal serpent. Sánchez Cantón thought it an academy figure or a study for a St. Sebastian.

Moreno Villa, p. 39, No. 369; Sánchez Cantón, II, 180; Pérez Sánchez, *Catálogo Gijón*, 1969, Pl. 10.

105 PAGE WITH A TRAY. Florence, Uffizi

180×105 mm. Blacklead with a trace of red chalk. Buff paper. *Plate XXIX*

In ink in a seventeenth-century hand: *de eugenio Cajes*. Also in ink: *8 Rs, 1 Rl.*

A figure with its back turned, very roughly sketched, and above the tray, the outline of another figure is easily distinguishable.

Provenance: Santarelli Collection.

Santarelli Catalogue, p. 699, No. 1 (Inventory 10226); Pérez Sánchez, *Catálogo Florencia*, 1972, p. 61.

106 BOY GRASPING A JAR. Madrid, Prado Museum. Inventory No. F.A. 30

226×131 mm. Blacklead and red chalk. Buff paper.
Plate XXIX

In pencil, a nineteenth-century inscription: *Legajo 43* (Bundle 43), *n⁰ 11* and *Cano*. In ink *2 rˢ*.

On the verso, the signature *fraᶜᵒ bergel*, a name that does not belong to any known artist. A large blotch of ink. Definitely a study for a Marriage at Cana, although there is no proof that Cajés painted this subject. Sánchez Cantón and Wethey attributed it to Carreño.

Provenance: Royal Collection.

Sánchez Cantón, V, 387. Wethey, 'Alonso Cano's drawings', *Art Bulletin*, 1952, p. 234; Pérez Sánchez, *Catálogo Prado*, 1972, p. 43.

107 PROJECT FOR THE DECORATION OF A VAULT
Madrid, Archivo Histórico Nacional

180×380 mm. Pen and thin sepia wash. Buff laid paper.
Plate XXV

Inscribed in the central compartment: *conzezion* (Immaculate Conception) and *Nazimiento de nuestra señora* (Nativity of Our Lady). On the back, in ink: *en madrid a beinteyuno de mayo de mil y seisçientos y beinteyuno* (at Madrid on 21 May 1621), *Fray Alonso González* (?) and *Eugenio Caxes.*

The first inscription and signature are probably in the hand of the Prior of the monastery for which the work was commissioned. In 1621 Cajés was working for the Convento de la Merced Calzada in Madrid (Angulo–Pérez Sánchez, pp. 224, 229), where he painted the principal altar-piece together with Alonso de Carbonel. It may be assumed that the drawing records some project for the decoration of the vault of the presbytery which was to contain a painting of the Virgin and the Mysteries of the Redemption.

Provenance: Sanjurjo Collection.

Doubtful Attribution

108 REST ON THE FLIGHT INTO EGYPT. Madrid, National Library

97×117 mm. Blacklead and sepia wash. Buff paper. Squared in pencil. *Plate XXVIII*

Barcia lists this with anonymous works. It looks like the work of a pupil or imitator of Cajés.

Provenance: Castellanos Collection.

Barcia, No. 514.

Attributions not accepted

ADORATION OF THE KINGS. Turin, Royal Library. Inventory No. 16226
Attributed to Cajés by Gianni Carlo Sciolla (*I Disegni di Maestri Stranieri della Biblioteca Reale di Torino.* Turin, 1974, No. 316). It is not Spanish.

ASSUMPTION OF THE VIRGIN. Madrid, Cerralbo Museum
Attributed to Cajés by C. Sanz Pastor (*Museo Cerralbo. Catálogo de Dibujos*, Madrid, 1976, No. 24); it is not by him.

MIRACLE OF ST. ANTHONY. Madrid, Academia de San Fernando
This is by Vicente Carducho. See No. 144.

MARY MAGDALENE. Madrid, National Library
Anonymous, Madrilenian, *c.* 1660.

Barcia No. 61.

A FRIAR SAINT. Madrid, Academia de San Fernando
Attributed to Cajés by Sentenach. It is by Pacheco.

Pérez Sánchez, *Catálogo San Fernando*, 1967, No. 13.

ACHILLES AND BRISEIS. Madrid, Academia de San Fernando
This is by Vicente Carducho. See No. 232.

MAN WITH A HOE. Madrid, Academia de San Fernando
By Vicente Carducho. See No. 146.

HEAD OF A MAN. London, Courtauld Institute
See under Anonymous Drawings, No. 438.

FOOT. London, Courtauld Institute
See under Anonymous Drawings, No. 442.

ALONSO CARBONEL

A Madrilenian architect whose activities are documented between 1620 and 1660. He was an important figure during the reign of Philip IV, and a protégé of the Conde Duque de Olivares, for whom he created the Palace of Buen Retiro in Madrid (1631–3), and built the Convent of Loeches (1635–8). He also designed altar-pieces in a style that still owes much to the tradition of El Escorial.

109 DESIGN FOR AN ALTAR. Florence. Uffizi

264×155 mm. Pen and ink and carmine wash. Buff wire-marked paper. *Plate XXX*

Marked with a price, very worn, in ink: *1 Rls* or *4 Rs.*

This design is very typical of Madrid architecture during the first two decades of the seventeenth century, a date which the costume of the donors also confirms. Its close relationship to the signed drawing by Alonso Carbonel (No. 110), which even repeats the theme of the brackets supported by children, justifies an attribution to this artist. However, our ignorance of the drawing style of other designers of altars at this period, demands the addition of a query mark.
Described as by 'an anonymous Tuscan artist' when in the Santarelli Collection.

Provenance: Santarelli Collection.

Santarelli Catalogue, p. 782, No. 40 (Inventory 11526); Pérez Sánchez, *Catálogo Florencia*, 1972, no. 35.

110 ALTAR-PIECE. Madrid, National Library

614×365 mm. In ink and sepia wash with touches of carmine on the sculptures and paintings. Buff laid paper.
Plate XXX

Signed by the artist: *Alonso Carbonell.*

The design presents two alternative solutions for the side panels. On the socle, to the left, the royal arms of the Spanish Austrias, which must be those of Philip III, and, on the right, another royal blazon with the arms of Austria in chief, which would represent Margaret of Austria, his wife. The heraldry suggests that this was a design for the altar-piece of some church or chapel of royal foundation.

Provenance: Carderera Collection.

Barcia, No. 11.

VICENTE CARDUCHO

Florence 1576–Madrid 1638.

Vicente Carducho was born in Florence but came to Spain as a child with his brother Bartolomé, who was his master, and considered himself a Madrilenian. He was the best known and most respected painter in Madrid during the reigns of Philip III and Philip IV, until the arrival and triumph of Velázquez. The most important work in his prolific output is the cycle of pictures of Carthusian monks painted between 1626 and 1632 for the Charterhouse of El Paular, and now dispersed. A

theorist and man of letters, he wrote some *Diálogos de la Pintura*, which were published in 1633. His style, Tuscan in origin, shows the shift from Florentine academicism to the naturalistic realism inspired by Venetian painting. He had considerable influence, and many of the Madrilenian artists of the first fully baroque generation were his pupils.

Biblical Subjects

111 TRIUMPH OF DAVID. Madrid, Academia de San Fernando

253×412 mm. Blacklead, light sepia wash, and touches of white body-colour. Dark buff paper. Squared.
Plate XXX

In the middle of the inner border: *C*.
A large grease spot.

We think it very likely that this represents the *Triumph of David*, because a drawing by Carducho with this title figures in the manuscript inventory of the collection at the Palace of El Pardo, from which this work comes. The subject is at all events a biblical or historical scene, planned for some suite of decorations.
Velasco thought the principal figure was a woman.

Provenance: Palace of El Pardo.

Velasco, No. 48: Pérez Sánchez, *Catálogo San Fernando*, 1967, p. 47.

112 CORONATION OF ESTHER. New York, Metropolitan Museum, Sperling Bequest

190×208 mm. Preparatory drawing in pencil. Ink and sepia wash. Laid paper. Squared in pencil; the grid is numbered from 1 to 16 and from 1 to 14.
Plate XXXI

In ink '*24 Rs.*'. At the back: *Bartolome Carducho. Costa 8 Rls. 1 Rl.*

Usually thought to be by Bartolomé Carducho. It is a typical work of Vicente as pointed out by J. Brown who considers it to be from the late 1620s or early 1630s.

The episode depicted is probably the crowning of Esther (Esther 2: 17).

No painting by V. Carducho of this subject survives.

J. Brown, 1973, p. 375, pl. 28; Exh. New York, 1975–6, No. 72.

113 TRIUMPH OF MORDECAI. Madrid, Academia de San Fernando

144×185 mm. Pen and ink with sepia wash. Buff paper. Squared in blacklead.
Plate XXXI

In ink in a seventeenth-century hand: *De Bicençio Carducho* and, also in ink: *4 Rs.*

Attributed to Carducho in the collection at the Palace of El Pardo, from which it comes.

Tormo entitles it *Triumph of David and Saul*, but Velasco's identification of the scene as coming from the story of Mordecai is more plausible—with Haman leading the white horse by the bridle (Esther 6: 11). It may have formed part of the same series as the preceding drawing.

Provenance: Palace of El Pardo.

Tormo, No. 61, p. 69; Velasco, No. 39; Pérez Sánchez, *Catálogo San Fernando*, 1967, p. 67.

114 THE MEETING AT THE GOLDEN GATE. Vienna, Albertina. Inventory 25428

391×251 mm. Pencil and sepia wash, highlighted with white. Buff paper. Squared in pencil. *Plate XXXII*

Along the bottom, in ink in a seventeenth-century hand: *Vicenço Carduch. . . .* In front of this, another almost totally illegible inscription: *fr . . .(?).*
The edges are stained.

This drawing is considered to be a Visitation by the Albertina. It is characteristic of Carducho's style, although the elongated proportions and the figure types perhaps compel one to regard it as early in date. It does not tally with the only surviving work by Carducho on this subject—that in the Royal Palace, Madrid, originally in the Convent of the Encarnación (Angulo–Pérez Sánchez, Pl. 65B).

Purchased in 1927.

O. Benesch, *Meisterzeichnungen der Albertina*, 1964, No. 228, p. 374.

115 recto THE MEETING AT THE GOLDEN GATE Vienna, Albertina. Inventory 25917 recto

227×165 mm. Preparatory drawing in pencil. Pen and brush, picked out in white. Squared in blacklead. Dark-coloured paper.
Plate XXXII

In ink in an early hand: *Vº Carduchi.* In ink: *8 R.*

This does not tally with the only surviving painting of this subject executed by Carducho (Angulo–Pérez Sánchez, Pl. 65B).

Donated anonymously in 1930.

115 verso THE MEETING AT THE GOLDEN GATE Vienna, Albertina. Inventory 25917 verso
Blacklead.

Although the iconography and composition are similar to the drawing overleaf, the differences in conception are evident.
The ink from the drawing overleaf has soaked through the paper extensively.

116 BIRTH OF THE VIRGIN. Madrid, National Library

342×232 mm. Blacklead, with touches of white lead. Buff paper.
Plate XXXII

In ink in a contemporary hand: *bicenço carduchi.* A price: *4 Rs.*

No painting of this subject by Carducho survives, although he must have painted one, since the drawing, which is highly finished, is squared for scaling up onto canvas.

Provenance: Carderera Collection.

Barcia, No. 13; Exh. Madrid, 1934, No. 13.

117 STUDIES FOR AN ANNUNCIATION. Florence. Uffizi

170×205 mm. Pen and ink. Buff wire-marked paper.
Plate XXXIII

In black chalk, in a nineteenth-century hand: *Scuola di Guido.*

Attributed in the Santarelli Collection to Francesco Vanni, this is an important drawing by Vicente Carducho,

directly related to the picture in the Valladolid Museum (Angulo–Pérez Sánchez, Pl. 39) which is signed and dated 1606 and is one of the first documented works by the artist. Of the different studies for poses of the Virgin and the Angel, the central one corresponds to the Valladolid painting and the others were used by Carducho at various times during his career. The Angel in the upper right corner and the Virgin in the lower appear in a very similar form, but reversed, in the picture of 1616 in the Convent of the Encarnación at Madrid, and in its replica of 1624 in the Convent of the Descalzas Reales, also at Madrid (Angulo–Pérez Sánchez, Pls. 56 and 66). The Angel in the lower part occurs again with slight changes in the painting in the Guadalupe retable of 1618 (Angulo–Pérez Sánchez, Pl. 59), and the one on the left, with hands crossed on its breast, is found in a painting in the Parish Church of Villa del Prado (Madrid), which is a copy of a lost original.

Provenance: Santarelli Collection.

Santarelli Catalogue, p. 342, No. 112 (Inventory 4809 S); Pérez Sánchez, *Boletín Seminario de Estudios de Arte de Valladolid*, 1971, p. 488, Pl. II; Pérez Sánchez, *Catálogo Florencia*, 1972, p. 51, No. 36, Fig. 28.

118 ANNUNCIATION. Madrid, National Library

350×230 mm. Blacklead, with sepia and black washes, picked out in white. Buff paper. *Plate XXXIII*

Barcia suggested this might be a study for the painting over the high altar in the Convent of the Encarnación although its composition is totally different (Angulo–Pérez Sánchez Pl. 56).
The figure of the angel Gabriel and the entire upper portion of the drawing are closely related to those in the painting now kept at Covadonga (Angulo–Pérez Sánchez, Pl. 128A).

Provenance: Carderera Collection.

Barcia, No. 12.

119 ADORATION OF THE SHEPHERDS. Whereabouts unknown.

214×159 mm. Sepia wash with touches of white.

Provenance: Paris, Standish Collection.

Standish, *Catalogue*, 1842, No. 258.

120 ADORATION OF THE MAGI. Whereabouts unknown

133×100 mm. Wash.

Provenance: Paris, Standish Collection.

Standish, *Catalogue*, 1842, No. 257.

121 HOLY FAMILY WITH SAINTS. Madrid, Prado Museum

208×190 mm. Blacklead and sepia wash, with touches of white lead. Squared paper. *Plate XXXIV*

In ink in a hand later than the drawing, possibly eighteenth-century: *Vicº Carducho.*

In the painting corresponding to this drawing, now in a private collection in London, the design is unchanged, except that a basket of fruit has been added in the lower left-hand corner and the infant St. John's cross is brought more into line with the overall movement of the composition (Angulo–Pérez Sánchez, Pl. 127).

Provenance: Ceán Bermúdez Collection. Lefort Collection. Came to the Prado with the Fernández Durán Bequest (1931), No. 146.

Lefort, *Collection*, Paris, 1869, No. 46; Sánchez Cantón, II, 168; Angulo–Pérez Sánchez, 1969, p. 155; Pérez Sánchez, *Catálogo Prado*, 1972, p. 65, pl. 20.

122 HOLY FAMILY WITH SAINTS. Madrid, National Library

247×190 mm. Preparatory drawing in pencil. Pen and ink wash with touches of white. Dark buff paper. Squared. Heavily restored. *Plate XXXIII*

In ink: *2 Rls.*

Barcia, who was uncertain to which of the Carduchos the drawing belonged, catalogued it with those by Bartolomé, pointing out that it is a very weak piece of work. In fact, it is simply an old copy of the preceding drawing.

Provenance: Madrazo Collection.

Barcia, No. 7273.

123 VIRGIN AND CHILD. Formerly Gijón, Instituto Jovellanos. Destroyed in 1936

120×110 mm. Watercolour and white chalk. Blue-tinted paper. *Plate XXXIII*

In ink in handwriting which is probably seventeenth-century: *Carduch.* In another hand, possibly eighteenth-century: *Carducho.*

Not directly related to any surviving painting.

Provenance: Jovellanos Collection.

Moreno Villa, p. 37, No. 351; Sánchez Cantón, II, 174; Pérez Sánchez, *Catálogo Gijón*, 1969, p. 38, Pl. 70.

124 RESURRECTION OF LAZARUS. Madrid, National Library

156×160 mm. Pencil and sepia wash, picked out in white. Dark buff paper. Squared. *Plate XXXVI*

A price: *4 Rs.*

No painting of this subject by Carducho has survived, although the squaring would seem to indicate that the design was intended to be transferred to canvas.

Provenance: Carderera Collection.

Barcia, No. 15.

125 TRANSFIGURATION. Budapest, Museum of Fine Arts. Inventory K 57-5

303×208 mm. Preparatory drawing in pencil. Ink and sepia wash with touches of white lead. Dark-coloured laid paper. *Plate XXXV*

In ink in an eighteenth-century hand: *V. Carducho.*

This is closely related to the painting in the Masaveu

Collection in Oviedo, which Angulo–Pérez Sánchez (Pl. 17) thought was by Bartolomé Carducho—although they mentioned the possibility that it could be by Vicente in a style close to his brother's. The drawing, which is obviously by Vicente, would incline one to attribute the painting to him. Alternatively, given the differences between the two works and the greater animation of the drawing's composition, the latter might be a later interpretation of Bartolomé's painting by Vicente.

126 CHRIST STUMBLING ON THE ASCENT TO CALVARY. London, Courtauld Institute

285×211 mm. Sepia wash with touches of white. Buff paper. Squared. *Plate XXXVI*

Signed: *Biçencio Carducho*.

The composition draws its inspiration from Raphael's *Lo Spasimo di Sicilia*.

Provenance: Collection of Sir John Stirling Maxwell.

Mayer, *Arte Español*, 1926, p. 2; Witt, p. 159, No. 37.

127 CHRIST ON THE CROSS. Formerly Gijón, Instituto Jovellanos. Destroyed in 1936

400×260 mm. Blacklead. Coarse paper. Squared.
 Plate XXXVI

From Christ's waist down, the drawing is mounted on to another piece of paper.

In ink in a seventeenth-century hand: *Carduchi*. In an eighteenth-century hand: *V^{te}. Carducho*.

Gómez Moreno felt this was different in technique from Carducho's best-known work, and he pointed out the comparative similarity of the iconography to that of Crucifixions by Pacheco and Velázquez: the legs are uncrossed and there are four nails. Nevertheless, it seems certain that this is by Vicente Carducho.

Gómez Moreno, *Boletín*, 1916, p. 187; Moreno Villa, p. 37, No. 347; Pérez Sánchez, *Catálogo Gijón*, 1969, p. 37, Pl. 68.

CHRIST ON THE CROSS. London, Lord Northwick Sale (1920)

Present whereabouts unknown. Sold at Sotheby's with an attribution to Carducho, on 1 November 1920, together with other Spanish drawings.

128 CRUCIFIXION WITH ST. JOHN AND THE VIRGIN Madrid, National Library

201×121 mm. Pen and ink and carmine-coloured wash. Laid paper. Squared. Partly damaged. *Plate XXXVI*

Inscribed *Solis* and *2 Rls.* in the handwriting of the painter-collector F. de Solis.

According to Barcia, who praises its 'feeling and mastery', this is the work of 'one of the skilled masters of the sixteenth century'. It probably comes from Carducho's close circle, and may even be by him, in view of this Christ's similarity to that by Carducho in Cuenca Cathedral (Angulo–Pérez Sánchez, Pl. 63).

Provenance: Madrazo Collection.

Barcia, No. 123.

129 MATER DOLOROSA. Madrid, National Library

168×194 mm. Blacklead, touches of white. Dark buff paper. *Plate XXXVII*

In ink in a contemporary hand, probably, as Barcia believes, that of the artist: *Viçencio Carduchi*.

Barcia thinks the drawing depicts a saint and suggests she might be the Blessed Mariana of Jesus, but such an identification is impossible, because we know the latter's features well from a quite different-looking portrait by Carducho himself (Angulo–Pérez Sánchez, Pl. 133). It seems more reasonable to regard the subject as Mary sorrowing at the foot of the Cross.

Provenance: Carderera Collection.

Barcia, No. 41.

130 PENTECOST. Madrid, National Library

187×152 mm. Blacklead picked out with white. Buff paper. Squared. *Plate XXXVII*

In the top right-hand corner, 2, written by the artist. Further in on the right, a valuation: *4 Rs*.

This is not directly related to any surviving picture, but the subject is one that Carducho painted many times (Angulo–Pérez Sánchez, pp. 160–1).

Provenance: Carderera Collection.

Barcia, No. 16.

131 CORONATION OF THE VIRGIN. Formerly Gijón, Instituto Jovellanos. Destroyed in 1936

270×180 mm. Sepia wash. Buff paper. Squared.
 Plate XXXVII

In an eighteenth-century hand: *Del Card . . .*

Through a misreading of the inscribed attribution which must surely have read *Del Carducho* but which was understood as *Del Cardi*, this drawing was attributed to the Tuscan painter Lodovico Cardi da Cigoli (1559–1613). Pérez Sánchez was the first to point out its similarity to Vicente Carducho's drawings, although he kept the attribution to Cigoli. A closer examination of the surviving photograph argues for an attribution to Carducho, and it is clearly related to the painting in the Palace of La Granja (Angulo–Pérez Sánchez, Pl. 128).

Moreno Villa, p. 5, No. 37; Pérez Sánchez, *Catálogo Gijón*, 1969, p. 36, Pl. 67.

132 CORONATION OF THE VIRGIN. Whereabouts unknown

Sepia wash picked out with white.

Provenance: Paris, Mariette Sale, 1775.

Sold at 24 francs.
Mireur, II, 69.

133 ADORATION OF THE HOLY SACRAMENT. Madrid, National Library

282×161 mm. Blacklead and sepia wash, picked out with white lead. Dark buff paper. Squared.
 Plate XXXVII

The iconography of this theme was used widely in Spain about the middle of the century, by Zurbarán, for example (Murcia Town Hall), and by Espinosa (Valencia Museum).

Provenance: Madrazo Collection.

Barcia, No. 17.

134 TRIUMPH OF THE EUCHARIST. Madrid, National Library (kept at the Municipal Museum)

363×360 mm. Preparatory drawing in pencil. Pen and ink and sepia, red, violet, and blue washes, with touches of white lead and gold. Coarse buff laid paper.
Plate XXXVIII

In the central, octagonal compartment, an altar with the Holy Sacrament surrounded by saints and above, the Saviour with the Virgin Mary, and St. John the Baptist and angels. In the four rectangular side compartments, very lightly sketched in pencil: Moses and the Water from the Rock; the Gathering of Manna; Adam and Eve kneeling in front of an altar; and a sacrificial scene, perhaps the sacrifice of Abel.
In the four large lunettes, on both sides of the recesses, are seated figures with cartouches, who must be the Four Fathers of the Latin Church and the Four Fathers of the Greek Church. In the oval panels above the four recesses are seated figures, possibly of the four Evangelists. In addition, there are standing figures of prophets, and angels supporting cartouches and seated on *trompe-l'oeil* pediments.
This is a highly finished drawing. No doubt, as Barcia thinks, it is part of the plans submitted for approval for the ceiling of the chapel in the Palace of El Pardo, which is now destroyed, but which we know very well from the description Carducho himself gives in his *Diálogos* (f. 109; Angulo–Pérez Sánchez, pp. 185–6). The description tallies with the general outlines of the arrangement and to a great extent with the individual subjects.
The ceiling was painted between 1611 and 1612, and the valuation of it, together with the other paintings in the palace, gave rise to a prolonged lawsuit.

Provenance: Carderera Collection.

Barcia, No. 52; Exh. Madrid, 1926, p. 287, No. 277.

135 ARCHANGEL JEUDIEL. Florence, Uffizi

354×203 mm. Blacklead and sepia wash with touches of white lead. Dark buff paper. Squared in pencil.
Plate XXXVIII

A price: *2 Rls.*

Study for a painting in a private collection in Madrid, in which the archangel's name appears in the brilliant aureole encircling his head: *IHEUDIEL REMUNERA-TOR* (Angulo–Pérez Sánchez, Pl. 40)—a characteristic work by Vicente.
Attributed to Bartolomé in the Uffizi.

Provenance: Santarelli Collection.

Santarelli Catalogue, p. 168, No. 11 (Inventory 2289); Angulo–Pérez Sánchez, 1969, p. 176; Pérez Sánchez, *Catálogo de Florencia*, 1972, p. 55, no. 41, fig. 34.

136 GROUP OF ANGELS. Florence, Uffizi

186×150 mm. Pen and ink. Pea-green paper.
Plate XXXVIII

An early inscription: *Carducho*, and an illegible price in *reales*.

This is probably for a eucharistic subject, since one of the angels appears to be supporting a host.
It is attributed to Bartolomé in the collection, but it is typical of Vicente.

Provenance: Santarelli Collection.

Santarelli Catalogue, p. 167, No. 9 (Inventory 2287).

137 ANGEL WITH A CARTOUCHE. Madrid, National Library

137×108 mm. Irregularly trimmed. Pen and ink and red wash. Dark buff paper. *Plate XXXVIII*

In ink in a seventeenth-century hand: . . . *cencio.* In a later hand: *5 Rls.*

Barcia classifies it with anonymous seventeenth-century drawings. As a possible interpretation of the name, he suggests Pedro Núñez de Villavicencio (1644–1700) but admits that the style rules the Sevillian artist out of consideration. The inscription should in fact read *Vicencio*, and the style is obviously Carducho's. The drawing is probably a design for the top of an altar-piece. The moulding of the uppermost tier is clearly visible, and the spring of the semicircular curve of the canopy is indicated.
Companion piece to the following drawing.

Provenance: Madrazo Collection.

Barcia, No. 559.

138 ANGEL WITH A CARTOUCHE. Madrid, National Library

107×100 mm. Irregularly trimmed. Pen and ink and sepia wash. Dark buff laid paper. *Plate XXXIX*

Companion piece to the preceding drawing.

Provenance: Madrazo Collection.

Barcia, No. 560.

Saints

139 ST. AUGUSTINE BETWEEN CHRIST AND THE VIRGIN MARY. Madrid, National Library

292×258 mm. Blacklead, sepia wash, touches of white lead. Dark buff paper. *Plate XXXIX*

The subject comes from the vision described in the early lives of the saint, which was depicted by Rubens (Academia de San Fernando) and Murillo (Prado Museum) among others.

Provenance: Carderera Collection.

Barcia, No. 20.

140 BISHOP SAINT (St. Augustine or St. Ambrose) Madrid, Prado Museum. Inventory No. F.A. 65.

251×103 mm. Blacklead, sepia wash, touches of white lead. Dark buff paper. Squared. *Plate XXXIX*

The technique looks characteristic of Vicente Carducho, and the figure is very close to his *St. Blasius* in Seville Cathedral (Angulo–Pérez Sánchez, Pl. 130). Sánchez Cantón thought the drawing was by Romulo Cincinnato.

Companion piece of Nos. 141 and 182, from a series of Fathers of the Church.

Provenance: Royal Collection.

Sánchez Cantón, II, 119; Pérez Sánchez, *Catálogo Prado*, 1972, p. 65, pl. 21a.

141 A FATHER OF THE CHURCH (St. Ambrose or St. Augustine). Madrid, Prado Museum. Inventory No. F.A. 66

250×105 mm. Blacklead, sepia wash picked out with white lead. Buff paper pasted on to cloth. Squared.
Plate XXXIX

Companion piece of the preceding drawing and of the *St. Gregory* (No. 182).
Sánchez Cantón reproduced this as an anonymous work of the late sixteenth century.

Sánchez Cantón, II, 150; Pérez Sánchez, *op. cit.*, p. 66, pl. 21b.

142 THE MIRACLE OF ST. ANTHONY AND THE MULE Florence, Uffizi

215×178 mm. Blacklead, sepia wash, touches of white lead. Buff paper. *Plate XLI*

This drawing is not related to the analogous subject painted on the altar-piece of the church of San Antonio de los Portugueses (Angulo–Pérez Sánchez, Pl. 68). Attributed to Bartolomé, this seems to be, nevertheless, the work of Vicente.

Provenance: Santarelli Collection.

Santarelli Catalogue, p. 168, No. 19 (Inventory 2297).

143 MIRACLE OF ST. ANTHONY. Madrid, Prado Museum

167×277 mm. Pencil and sepia wash picked out in white. Greyish paper. *Plate XL*

A valuation in ink: *120 Rs*.

The scene depicted is the miraculous cure of the son who became lame after kicking his mother. See the following drawing.
This is a study for the painting on the socle of the principal altar-piece in the church of San Antonio de los Portugueses, a work dating from 1631–3 and now dismantled (Angulo–Pérez Sánchez, Pl. 68 and p. 111).

Provenance: Fernández Durán Bequest (1931), No. I.192.

Angulo–Pérez Sánchez, p. 112; Pérez Sánchez, *Catálogo San Fernando*, 1967, p. 146; id., *Catálogo Prado*, 1972, p. 65.

144 MIRACLE OF ST. ANTHONY. Madrid, Academia de San Fernando

205×258 mm. Blacklead and sepia wash. Dark buff paper. *Plate XL*

In modern red pencil: *V. Carduci*. In ink, an early valuation: *6 Rs*.

See the preceding drawing.
A large section of the paper is missing from the right-hand side, where the brother and the knight accompanying the saint would have been.
Tormo, probably because he thought the paintings in San Antonio de los Portugueses were by Cajés, also attributed the drawing to him, as did Velasco. Pérez Sánchez catalogued it as by Carducho.

Tormo, No. 64, p. 69; Velasco, No. 45; Pérez Sánchez, *Catálogo San Fernando*, 1967, p. 45.

145 ST. BERNARD. Madrid, National Library

212×130 mm. Blacklead and sepia wash picked out in white. Buff paper. *Plate XLI*

The figure of the saint is similar to the *St. Bernard* in the church at Telde (Angulo–Pérez Sánchez, Pl. 132), but the composition is different.

Provenance: Carderera Collection.

Barcia, No. 23; Exh. Madrid, 1934, No. 13.

STORIES OF ST. BRUNO AND VENERABLE CARTHUSIANS

The following twenty-two drawings (Nos. 146–167) constitute a series of studies for the paintings which Vicente Carducho executed between 1626 and 1632 for the main cloisters at the Charterhouse of El Paular in the province of Madrid. According to the contract, the artist had to present the drawings to the prior of the Charterhouse for his approval, and there are comments written on some of them which must come from the prior's hand. They can be divided into two distinct groups. On the one hand, there are the drawings which are complete, worked-out compositions, almost in the manner of *modellini* in the Tuscan tradition. On the other, partial studies of isolated figures, animals, limbs, or drapery, which were probably drawn from life.
In the inventory of Carducho's belongings which was written after his death (published by Mª Luisa Caturla, *Arte Español* 1968–69, pp. 145–221, particularly p. 183) a book with seventy-seven drawings of the history of St. Bruno for the Paular cycle is mentioned—'assi de historias principales como de figuras sueltas' (with complete compositions as well as isolated figures). Only the twenty-two drawings reproduced here have hitherto been identified.
The series of paintings is discussed and reproduced almost in its entirety in Angulo–Pérez Sánchez, *Pintura madrileña del siglo XVII*, Madrid, 1969. The drawings are here arranged in the same order as the paintings in that work.

146 MAN WITH A HOE ON HIS SHOULDER. Madrid, Academia de San Fernando

165×168 mm. Blacklead. Buff laid paper. *Plate XLI*

In ink in an early hand: *Cajes, E, 9, 44, no n.* In pencil: *80.* The top has been restored.

As Trapier noted, this is a study for a figure in the background of the painting of the *Miracle of the fountain* from the Charterhouse series, which is now in the Prado (No. 639A). The different position of the right hand is the only variant in the drawing (Angulo–Pérez Sánchez, Pl. 77).
Owing no doubt to the early attribution to Cajés inscribed in ink (the *E* following *Cajes* would be the initial for Eugenio) Sánchez Cantón and Velasco considered it his work.

Sánchez Cantón, II, 181; Velasco, No. 97 ff.; Trapier, 1941, p. 33, Fig. 24; Pérez Sánchez, *Catálogo San Fernando*, 1967, p. 45.

147 ST. BRUNO PRAYING IN RETREAT AT LA TORRE London, British Museum

311×270 mm. Blacklead and touches of white. Buff paper. Squared in pencil. *Plate XLII*

Towards the bottom a virtually illegible inscription.

Study for the painting of the same subject now housed in Cordova Cathedral (Angulo–Pérez Sánchez, Pl. 84).

Mayer, No. 73; Trapier, 1941, p. 33.

148 ST. BRUNO APPEARS TO ROGER GUISCARD II, DUKE OF APULIA AND CALABRIA. Madrid, National Library

350×255 mm. Blacklead, sepia wash and a touch of white. Dark buff paper. The top is semicircular. The drawing is dirty and discoloured by damp.
 Plate XLII

At the top of the sheet, in an early hand which Barcia suggests could be Carducho's own: . . . *se allaron a los traydores y los siguieron y cojieron y en recompēsa dest hico a los car(tujos donaci)ones y gracias* (the traitors were located, and they followed and took them, and in recompense for this he granted the Carthusians donations and favours).

The drawing depicts the moment when the saint appears to Roger of Calabria to warn him that he is threatened by a conspiracy.
This is a study for the painting which is now in the Archbishop's Palace in Valladolid (Angulo–Pérez Sanchez, Pl. 100) and of which there is a sketch in the Contini Collection in Florence.
There is a copy of the painting in Castellón Museum with a long explanatory note on the subject.

Provenance: Carderera Collection.

Barcia, No. 25.

149 DEATH OF THE VENERABLE LANDUINO IN PRISON. Florence, Uffizi

325×275 mm. Blacklead and sepia wash picked out with white lead. Buff paper. *Plate XLII*

A preparatory drawing, with a number of variants, for the painting now in Poblet Monastery (Angulo–Pérez Sánchez, Pl. 85). The most striking differences appear in the figure types and the poses of the people tending the dying man, and also in the presence in the painting of a remarkable still life on the stool to the right, which does not exist in the drawing.

Provenance: Santarelli Collection—where it was attributed to Bartolomé Carducho.

Santarelli Catalogue, p. 167, No. 7 (Inventory 2285); Pérez Sánchez, *Catálogo Florencia*, 1972, pl 53, no. 38, fig. 33.

150 APPARITION OF THE VIRGIN TO A CARTHUSIAN BROTHER. Madrid, National Library

295×255 mm. Blacklead and touches of white. Greyish-green paper. Squared. The top is semicircular.
 Plate XLIII

In what Barcia also considers to be Carducho's own handwriting: *un religioso fraile estando acostado ve entrar en el aposento muchos demonios en figuras de perros feisimos y fieros y en medio un demonio mas grande como gigante que echa fuego por las narices y ojos y con un garabato grande y . . . santo y como apareciese mª sª con una varilla muy gloriosa y los echa de alli* (A religious brother lying in bed sees many demons shaped like hideous, fierce dogs enter the room, and in their midst a bigger demon, like a giant, who spews fire from his nostrils and eyes, with a big hook, and . . . holy and how Our Lady Mary appears with a most glorious wand and drives them out).
At the top, in the same hand: *. . . mas pequeña con . . . figura . . . la cama no haya lienzo sino la almohada* (. . . smaller with . . . figure . . . the bed should have no linen apart from the pillow).

A study, with very minor variants in detail, for the painting signed in 1632, now in the Charterhouse of Miraflores, Burgos. There is a copy of this painting in the Castellón Museum, with a long, early inscription textually similar to that on the drawing (Angulo–Pérez Sánchez, Pl. 100). As Barcia remarked, the man in the drawing cannot be Fray Juan Fort, with whom Cruzada identified him (*Catálogo del Museo Nacional*, 1865, No. 42), because since he is called a religious brother, he cannot be a monk, but must be a lay brother or *conversus*. The monstrous head of the demon with a human body is directly inspired by that of the devil in Albrecht Dürer's woodcut of *Christ in Limbo*, engraved in 1510.

Provenance: Carderera Collection.

Barcia, No. 27; Exh. Hamburg, 1966, No. 60, Pl. 17.

151 DEMON. Madrid, National Library

407×262 mm. Blacklead, touches of white. Greenish-grey paper. *Plate XLIII*

The same figure as in the preceding drawing on a larger scale.

The drawing was followed exactly in the painting, except that the head was lowered slightly, to intensify the demon's terror in the presence of the Virgin, and the position of the left hand is somewhat changed. As in the preceding drawing, the head is directly inspired by Dürer's woodcut.
See the preceding drawing.

Provenance: Carderera Collection.

Exh. Bordeaux, 1957, No. 37, Pl. 31; Exh. Hamburg, 1966, No. 61, Pl. 16; Barcia, No. 28; Pérez Sánchez, *Gli Spagnoli dal Greco a Goya*, 1970, p. 81, pl. III.

152 THE VENERABLE BERNARDO, BISHOP OF DIA, IN PRAYER. Madrid, National Library

312×263 mm. Blacklead, with a touch of white which has turned black. Squared. *Plate XLII*

The Venerable Bernardo, wearing a bishop's cape, in prayer before the altar. In the background, a chapel with a funeral urn—clearly his own—and invalids and cripples. B. Cuartero first identified the subject (*Boletín de la Real Academia de la Historia*, 1950, p. 198). According to Cruzada (*Catálogo del Museo Nacional*, 1868, No. 12), the figure depicted in the painting must be St. Bruno, a proposal that Barcia rejects on the grounds that

St. Bruno was not a bishop. Barcia thinks this subject could be St. Hugh of Lincoln.

The Venerable Father Bernardo was the founder and first prior of the Charterhouse of Las Puertas and Bishop of Dia.

This is a study for the painting signed in 1632 and now in the Archbishop's Palace in Valladolid (Angulo–Pérez Sánchez, Pl. 95). The main difference between the drawing and the painting is that the urn in the painting is half hidden by hangings.

Provenance: Carderera Collection.

Barcia, No. 24.

153 BEGGAR. Madrid, National Library

240 × 119 mm. Blacklead. Buff paper. *Plate XLIV*

In a seventeenth-century hand: *Carducho* and a price: *1 Rl.*

Study for one of the figures praying at the tomb in drawing No. 147. In the painting, this figure is followed more closely than the one in the above drawing.

Provenance: Carderera Collection.

Barcia, No. 42; Angulo–Pérez Sánchez, p. 135.

154 APPARITION OF FATHER BASILE OF BURGUNDY TO ST. HUGH OF LINCOLN. Madrid, National Library

305 × 265 mm. Blacklead and white. Greenish-grey paper. *Plate XLIII*

The squaring is numbered along the top, bottom, and the sides. In ink in handwriting which in Barcia's view dates from the end of the seventeenth century: *Martínez fᵗ.* Large inkblots.

Father Basile, eighth General of the Order, appears to his pupil Hugh, later Bishop of Lincoln, to kindle in his heart the fire of divine love.
Study for the painting signed in 1632 (Angulo–Pérez Sánchez, Pl. 86) and now in the Prado Museum (No. 2501). The figures of the demons are very different in the painting where the first demon has the legs of a male goat and his hands are joined in front of his face and the second has been replaced by a succubus who rides through the air on a male goat and holds a scorpion in her right hand. The position of her head relates her to the woman sketched in pencil in the drawing.
Cruzada (*Catálogo del Museo Nacional*, 1868, No. 37), Barcia, and the *Catálogo del Museo del Prado* (1963 edn.) consider the subject depicted the *Apparition of St. Bruno to a Carthusian monk*. Baltasar Cuartero is responsible for the correct identification.
Without explaining the reason for the signature *Martínez* Barcia attributes the drawing to Carducho, although he recalls that Antonio Martínez, the son and pupil of Jusepe, was a Carthusian. One might perhaps consider the drawing a faithful copy from Martínez's hand.

Provenance: Carderera Collection.

Barcia, No. 26.

155 DEVIL FLEEING. Madrid, Prado Museum. Inventory No. F.A. 70

243 × 180 mm. Blacklead. Buff paper. *Plate XLIII*

Squared in blacklead. In ink: *1½ rˢ* and another price, deleted. In pencil: *Nº 47.*

A study of the fleeing devil in the painting mentioned in the notes on the preceding drawing (Prado No. 2501; Angulo–Pérez Sánchez, Pl. 86).

Provenance: probably the Royal Collection.

Angulo–Pérez Sánchez, p. 135; Pérez Sánchez, *Catálogo Prado*, 1972, p. 69, pl. 22.

156 DEATH OF THE VENERABLE FATHER ODO OF NOVARA. Madrid, Rodríguez Moñino

275 × 223 mm. Pen and ink and sepia wash. Greenish-grey paper. Squared. The top is semicircular.
Plate XLIV

The squaring is numbered at the bottom from 1 to 14. Also at the bottom, in the same hand as the preceding: *S. Odon de Novara.*
In handwriting that is definitely Carducho's own: *Un religioso de edad de cien anos questa a la muerte en una camilla . . . descubre debajo de las mantas algunos sarmientos y sin . . .* (A one hundred year-old religious, who is lying dying on a couch . . . discovers some vine shoots underneath some blankets and . . .).
In a different, later hand: *Carducho.*

Study for the painting signed in 1632 (Angulo–Pérez Sánchez, Pl. 90) and now in the Prado Museum (No. 639).
Three religious brothers, one kneeling and two standing, who appear on the canvas are missing from the drawing, as are the small table and the staff in the foreground. The two brothers kneeling on the left of the drawing match the first and third in the corresponding group in the painting. The first is bald in the painting, but not in the drawing. Palomino (1947 edn., p. 852) records the tradition handed down in the Charterhouse that Carducho portrayed himself in the painting 'near the bedhead of the servant of God', a story that Céan repeats (I, 248). In fact, the figure most resembling trustworthy portraits of Carducho is the priest kneeling by the feet, biretta in hand, as has already been pointed out by Cruzada (*Arte in España*, IV, 1866, 111). The monk who has come to be regarded as a portrait of Lope de Vega does not appear in the drawing.

157 ST. ANTHELM CONSECRATED BISHOP OF BELLEY BY ALEXANDER III. Madrid, National Library

370 × 263 mm. Preparatory drawing in pencil. Pen and ink and sepia wash. Buff paper. *Plate XLIV*

Above, in ink in an early hand which, despite Barcia's view, is not that of the artist: *S. Anselmo despues de aber Reusado ser Obispo Belizense, el papa alexᵒ 3ᵒ le hace lo admita y por su persona misma le consagra* (After St. Anthelm has refused to be Bishop of Belley [i.e has withdrawn from his see], Pope Alexander III makes him bishop [again], and admits him and personally consecrates him). In ink, a price: *1 r.*

Design for the signed picture now in Cordova Cathedral (Angulo–Pérez Sánchez, Pl. 97), with which it tallies except in minor details, such as the number of dishes on the credence and the placing of the candlesticks, details which Cruzada (No. 10) thinks were painted by pupils. While he regards the drawing's composition as the work of Carducho, Barcia doubts whether this was executed

by him and argues that it could have been done by a pupil. It is true that the drawing falls below the series' average in boldness and quality.

Provenance: Madrazo Collection.

Barcia, No. 29.

158 THE VENERABLE DENYS VAN RIJKEL (DIONYSIUS THE CARTHUSIAN) WRITING. Madrid, Academia de San Fernando

308 × 254 mm. Blacklead and light sepia wash picked out in white. Blue-tinted paper. *Plate XLIV*

In pencil in a modern hand: *S. Dionisio.*

A study for the painting housed in the School of Fine Arts, Corunna (Angulo–Pérez Sánchez, Pl. 92).
Tormo, who mentions the painting as being kept at the Archbishop's Palace in Valladolid, lists the drawing as *St. Bruno.* Ceán recalls that there is an engraving by Palomino, which omits the halo and some other detail.

Provenance: Purchased from Vicente Camarón in 1864.

Tormo, No. 58, p. 68; Velasco, No. 41; Angulo, p. 15, Pl. 12: Pérez Sánchez, *Catálogo San Fernando*, 1967, p. 15, Pl. 13.

159 MARTYRDOM OF MONKS AND LAY BROTHERS OF THE LONDON CHARTERHOUSE. Madrid, Rodríguez Moñino

340 × 280 mm. Preparatory drawing in pencil. Ink and sepia wash with touches of white lead. Buff paper. Squared. Torn in several places. *Plate XLV*

For the painting signed in 1632 and now in the Archbishop's Palace, Valladolid (Angulo–Pérez Sánchez, Pl. 93), from which it does not differ radically, except that the lamp is missing, the large central column has become a tree, and the monk on the right is in a more frontal position.
The early copy of the painting which is in Castellón Museum (Inventory No. 50) bears the following inscription: *En la persecución de Enrique 8 de Inglaterra murieron en la cárcel de maltratamiento los padres de D Ricardo Befrez, D. Tomaz Louson, D . . . Gronez sacerdotes y don Juan Darmo, diacono y frai Guillermo Grenobade y frai Tomas Binomen, frai Robert Salte, frai Uval, pere Berton frai Tomas Veding año de 1537 y frai Guillermo Bone, su compañero abiendo padecido 4 años despues, le descuartizaron a 4 de Noviembre de 1544. Todos hijos de la Cartuja de Londres* (In the persecution of Henry VIII of England there died of maltreatment in prison the fathers Dom Richard Beer, Dom Thomas Johnson, Dom (Thomas) Green, priests, and Dom John Davy, deacon, and Brother William Greenwood and Brother Thomas Scriven, Brother Robert Salt, Brother Uval (?), Father Pierson, (and) Brother Thomas Reding in the year 1537; and Brother William Horn their companion, after suffering four years longer, was quartered on the fourth of November, 1544. All sons of the London Charterhouse).
In effect, both in the painting and in the drawing there are ten religious in chains, and in the background a quartering is taking place. Although all this corroborates the identification of the scene, the presence in England of the figure with a turban as witness of the action in the background is nonetheless strange, and rather suggests

a story about the martyrdom of Carthusians in a land bordering on Mohammedan territory, such as Hungary.

160 MARTYRDOM OF MONKS AND LAY BROTHERS OF THE LONDON CHARTERHOUSE. Florence, Uffizi

335 × 295 mm. Blacklead and sepia wash, picked out in white lead. Greenish paper. Squared. *Plate XLV*

Another version of the preceding drawing with scarcely any variants. Attributed to Bartolomé Carducho in the collection.

Provenance: Santarelli Collection.

Santarelli Catalogue, p. 167, No. 6 (Inventory 2284).

161 THE VENERABLE FATHER JUAN FORT. Madrid, National Library

298 × 197 mm. Blacklead, Buff paper, squared.
Plate XLVI

A study for the painting of the *Apparition of the Virgin to the Venerable Juan Fort*, signed in 1632 and now in Cordova Cathedral, of which there are copies in the Charterhouse at Granada and in Castellón Museum (Angulo–Pérez Sánchez, Pl. 94).
Father Fort was a monk at the Charterhouse of Scala Dei in Valencia, and, according to the old inscription on the Castellón copy, he was *tan faboreçido de la Virgen como un hijo de su madre, reçando el oficio, al tiempo de tomar benia le dava besar la mano y açiendo reverençia a un Crucifijo de piedra, la cruz se le inclino y se quedo assi hasta oi dia* (as favoured of the Virgin as a son of his mother. When he was saying mass, at the time of the granting of forgiveness, she gave him her hand to kiss, and when he made obeisance to a stone crucifix, the cross bowed to him and has remained thus to this day).
Barcia did not identify the subject, although he thought it was for one of the paintings at El Paular.

Provenance: Madrazo Collection.

Barcia, No. 40.

162 MARTYRDOM OF FOUR CARTHUSIANS. Florence, Uffizi

335 × 265 mm. Preparatory drawing in pencil. Pen and ink and sepia wash with touches of white. Buff paper. squared. *Plate XLV*

In ink, an early numbering: *33.*

A study for the painting signed in 1632, now at Seville University (Angulo–Pérez Sánchez, Pl. 101). There is a rough sketch for the painting in the Contini Bonaccossi Collection in Florence and an engraving by Palomino (Cruzada, 1866, p. 113) with a few variants.
Although the four groups and the general lines of the architectural background in the painting tally with those of the drawing, the drawing omits the dog in the foreground and two figures in the background, and only very slight traces of the wall in the background are hinted at on the left and nothing can be seen of it on the right. The balustrade enclosing the arch on the left is also missing, and the ecclesiastical habit in the foreground does not cover part of the soldier's leg.
According to Baltasar Cuartero (*Boletín de la Real Academia de la Historia*, 1950–1, No. 51), the scene depicted is the martyrdom of the Venerable fathers, Dom

Jean Monthot and Dom Jean Avril, and of the lay brothers, Benoît l'Evesque and Thibaud Tonnelier, a teacher at the Charterhouse of Fontaine-le-Vièrge at Boura-Fontaine, in the diocese of Soissons. In Cruzada's view (p. 113), the religious in the foreground is Dionysius the Carthusian.
The drawing was catalogued in the Santarelli Collection with anonymous works, but Angulo identified it as by Carducho in 1927.

Provenance: Santarelli Collection.

Santarelli Catalogue, p. 717, No. 163 (Inventory 10493); Angulo, *Archivo*, 1927, p. 95; Angulo–Pérez Sánchez, p. 141; Péres Sánchez, *Catálogo Florencia*, 1972, p. 54, no. 39.

163 STUDY OF A CARTHUSIAN FRIAR. Madrid, Casa de la Moneda (Royal Mint).

223×152 mm. Black and white chalk on dark laid paper.
Plate XLVI

In pencil, in a seventeenth-century and certainly autograph hand: *de la cintura arriba es mucho*.
Squared in black chalk. Attached to a sheet with inscriptions in ink in an eighteenth-century hand: *Rey* and *Carducho*.

A preparatory study for one of the principal figures in the painting 'The Martyrdom of Nothingam and Auxialme, the Carthusian Priors of London', one of the series from the Charterhouse of El Paular, now in the School of Fine Arts at Corunna (Angulo–Pérez Sánchez, 1969, Pl. 96).

Provenance: Collection of Tomás Francisco Prieto, 1772.

164 MARTYRDOM OF THE MONKS FROM THE CHARTERHOUSE OF RUREMOND. Budapest, Museum of Fine Arts. Inventory No. 1932.2345.

260×224 mm. Blacklead and sepia wash with touches of white lead. Buff laid paper. *Plate XLV*

In ink in an eighteenth-century hand: *Carducho*. At the bottom, the remains of an inscription that has been trimmed off: *Bi . . .*

The glory of angels has been pasted on another sheet of paper. On the back, in blacklead, a nude study for one of the executioners.
Preparatory drawing for a painting of the same subject and title, signed in 1632 and now preserved, in very bad condition, at the Prado (Angulo–Pérez Sánchez, p. 141, No. 169).

K. Gerstenberg, 'Zeichnungen von Carducho, Cano und Velazquez', *Pantheon*, 1967, pp. 191 ff.

165 CONTRITE CARTHUSIAN. Madrid, Prado Museum

164×258 mm. Blacklead with traces of white chalk. Greyish paper. Squared. *Plate XLVII*

In ink in a seventeenth-century hand: *Biçençio Carducho*. As Sánchez Cantón observed, this must be a study for the series of paintings at El Paular, although it cannot be related to any of those that have survived.

Provenance: Fernández Durán Bequest, 1930, No. 362.

Sánchez Cantón, II, 172; Exh. Hamburg, 1966, No. 56; Pérez Sánchez, *Catálogo Prado*, 1972, p. 69.

166 MAN EXPRESSING HORROR. Madrid, National Library

300×233 mm. Blacklead. Buff paper. Squared.
Plate XLVI

Barcia thinks the man is a monk. Behind his left hand and partly behind his head there is a pencil sketch, apparently of a crowned head. We have been unable to link this with any of Carducho's known paintings, but it is very close in character and technique to the preparatory studies for the El Paular series, catalogued above.

Provenance: Madrazo Collection.

Barcia, No. 37.

167 MONK LYING WITH HIS FEET IN THE STOCKS. Formerly Gijón, Instituto Jovellanos. Destroyed in 1936 with no pictorial record surviving

250×210 mm. Blacklead. Dark-coloured paper.

In the background, a niche with a scarcely visible statue of the Virgin. An illegible inscription: *Vicenti . . .*
An attribution: *Biçencio Carducho*.

This must surely be a study for one of the El Paular paintings, in several of which there are scenes with martyrs being put to death in the stocks. See for instance the *Martyrdom of monks and lay brothers of the London Charterhouse*, which is now in the Archbishop's Palace in Valladolid (Angulo–Pérez Sánchez, Pl. 93) and is discussed here under No. 159.

Moreno Villa, p. 37, No. 353; Pérez Sánchez, *Catálogo Gijón*, 1969, p. 38.

168 MIRACLE OF A CARTHUSIAN. Whereabouts unknown

160×260 mm. Ink and wash picked out in white.

'Très beau dessin.' According to Lefort, the painting of this was executed, which may suggest that he was familiar with it.

Provenance: Paris, Lefort Collection.

Lefort, *Collection*, 1869, No. 49.

169 ST. CHRISTOPHER. Madrid, National Library

234×165 mm. Blacklead and white chalk. Dark buff paper. *Plate XLVII*

Barcia, who catalogued this among anonymous drawings saw in it something of the style of Carreño. In fact, it is fairly characteristic of Carducho, and very closely related to the corresponding saint in the painting of the *Attendant saints* in the church of Santo Domingo de Benfica in Lisbon (Angulo–Pérez Sánchez, Pl. 138).

Provenance: Madrazo Collection.

Barcia, No. 573.

170 ST. CHRISTOPHER. Whereabouts unknown

155×108 mm. Watercolour picked out in white.

Provenance: Paris, Standish Collection.

Standish, *Catalogue*, 1842, No. 260.

171 SCENES FROM THE LIFE OF ST. DIEGO DE ALCALÁ. Florence Uffizi. Inventory No. 6110F

210×289 mm. Pen and ink and sepia wash over black chalk, heightened with white. Buff wire-marked paper.
Plate XLVIII

Numbered in the upper right-hand corner: 2.
Various inscriptions in ink in a contemporary hand: *acese ermitaño*; *açotase el Sº delante de una cruz*; and *Açota los conejos porque comen la verdura de la guerta.*
A companion drawing to the two following drawings and with them forming part of a doubtless longer series narrating the life of St. Diego de Alcalá (canonized in 1588, and much revered in seventeenth-century Spain), and probably designed for a Franciscan convent. The style and models are closely related to those of Vicente Carducho and must be regarded as by him, or by one of his nearest collaborators with no determinate style of his own. Similarities of style, models, and design have been suggested to some of the drawings and paintings in the series at the Charterhouse of El Paular, and it is thought they may have been executed around 1626–32.
Attributed in the Uffizi to a certain 'Gaspar de la Huerta' doubtless the Valencian Gaspar de la Huerta y Romaguera (1645?–1714) with whose known style they have absolutely no connection.

Provenance: Medici Collections (?).

Pérez Sánchez, *Catálogo Florencia*, 1972, No. 46, fig. 36; *id.*, *Goya*, No. 111, 1972, pp. 148 and 151.

172 ST. DIEGO TAKING THE HABIT. Florence. Uffizi Inventory No. 6109F

204×383 mm. Pen and ink and sepia wash over black chalk, heightened with white. Buff wire-marked paper.
Plate XLVIII

With various inscriptions relating to the subjects and details: *Recibe el abito de Nº Pº S. Francº*; *Pedrica (predica) en las Canarias*; *este templo seria . . .* ; *Passa a la Gran Canaria.*

Companion drawing to the preceding and following items.
The inscriptions point to the identity of the saint as St. Diego de Alcalá, the only Spanish Franciscan saint who preached in the Canaries.

Provenance: Medici Collections (?).

Ferri, 1890, p. 360; Pérez Sánchez, *Catálogo Florencia*, 1972, No. 47, fig. 37; *id.*, *Goya*, No. 111, 1972, p. 148.

173 THE DEATH OF ST. DIEGO. Florence, Uffizi. Inventory No. 6111F

210×282 mm. Pen and ink and sepia wash on a black chalk ground, with touches of white lead, on buff wire-marked paper.
Plate XLVII

Numbered in the right-hand upper corner: 6.
Inscribed in ink in a contemporary hand: *ojo.*

Companion drawing to the two preceding.

Provenance: Medici Collections (?).

Pérez Sánchez, *Catálogo Florencia*, 1972, No. 48.

174 THE STONING OF ST. STEPHEN. Formerly Gijón, Instituto Jovellanos. Destroyed in 1936 with no surviving pictorial record

370×250 mm. Sepia wash and white chalk. Greenish paper.

With other episodes: *San Esteban ante las autoridades* (St. Stephen before the authorities), and *Quema del cadaver de San Esteban* (Burning of St. Stephen's corpse). Moreno Villa pointed out that, while it was catalogued among anonymous drawings, it was identical in technique to No. 349 of the same collection, which was a work by Carducho.

Moreno Villa, p. 78, No. 657; Pérez Sánchez, *Catálogo Gijón*, 1969, p. 38.

175 BEHEADING OF ST. EULOGIUS. Oxford, Ashmolean Museum

273×387 mm. Preparatory drawing in pencil. Pen and sepia wash. Buff laid paper. Squared in pencil.
Plate XLIX

In ink in a seventeenth-century hand: *Vicençio Carducho in. f.* A valuation in ink: *7 Rˢ*.

Study for the scene in the background of the painting of *St. Eulogius* in Cordova Cathedral (Angulo–Pérez Sánchez, Pl. 132).
In the Colnaghi sale catalogue of 1951, this (No. 80) is presumed to be a study of one of the paintings in the Charterhouse at El Paular.

176 CRUCIFIXION OF ST. PHILIP. Florence, Uffizi

330×225 mm. Blacklead and sepia wash with touches of white lead. Greenish-grey paper with a white wash. Squared in blacklead.
Plate XLIX

In ink: *3 Rls* and *V.*

The Santarelli Catalogue, which attributes this to Bartolomé Carducho, identifies the saint as St. Andrew, but the shape of the cross obliges one to think him St. Philip, even if this does not tally with Vicente Carducho's known version of the subject (Angulo–Pérez Sánchez, Pl. 57).

Provenance: Santarelli Collection.

Santarelli Catalogue, p. 167, No. 8 (Inventory 2286).

177 ST. FRANCIS. Madrid, National Library

260×144 mm. Pen and sepia wash picked out with white. Buff paper. Squared.
Plate L

In ink in an early hand: *Carduch.* Numerations: *33, 34.* A valuation: *1 Rl.* In pencil: *8.*

Shown in the Franciscan Exhibition in Madrid in 1927.

Provenance: Carderera Collection.

Barcia, No. 30; Exh. Madrid, 1927, No. 78.

178 ST. FRANCIS AND ST. BONAVENTURE. Whereabouts unknown

259×345 mm. Blacklead and white.

According to the catalogue, an 'Allegory of the Holy Cross'.

Provenance: Paris, Standish Collection.

Standish, *Catalogue*, 1842, No. 259.

179 GLORIFICATION OF ST. GILES ABBOT. Madrid, National Library

384×255 mm. Blacklead and sepia wash, picked out in white—with a blotch of sepia and white in the wash. Buff paper. *Plate L*

A valuation in ink, deleted: *3 R.*

The hunting of the hind depicted in the lower half reminds us that the hermit saint was wounded by king Wamba when the king pursued the tame hind whose milk served as food for the saint (Reau, *Iconographie de l'art chrétien*, II 2ª, p. 593).
Undoubtedly a preparatory study for the central canvas of the retable dedicated to the saint in the Convent of St. Giles at Madrid. This is lost but is known from the literature, and was probably painted in 1631, the date which appears on the other existing retables.

Provenance: Carderera Collection.

Barcia, No. 6855; Angulo–Pérez Sánchez, 1969, pp. 117–18.

180 ST. GILES. Florence, Uffizi

338×232 mm. Black chalk and sepia wash with touches of oxidized white lead. Buff wire-marked paper.
Plate L

On the verso, in old ink: *9 Rls.*

Though attributed in the Uffizi to Antonio Tempesta, this drawing is undoubtedly by Vicente Carducho.

The episode represented in the drawing is that referred to in the previous item. It is probably a preparatory study for one of the paintings in the retable of St. Giles already mentioned. (Angulo–Pérez Sánchez, p. 117.)

Provenance: Santarelli Collection.

Santarelli Catalogue, p. 685, No. 9 (Inventory 10037S).

181 ST. GREGORY THE GREAT. Florence, Uffizi

240×117 mm. Blacklead and white chalk. Pea-green paper. *Plate L*

An early inscription: *Vᵉ Carducho.*

Despite the old attribution, which is credible on stylistic grounds, the drawing is attributed to Bartolomé in the Uffizi.

Provenance: Santarelli Collection.

Santarelli Catalogue, p. 168, No. 13 (Inventory 2291).

182 ST. GREGORY THE GREAT. Madrid, Prado Museum. Inventory No. F.A. 67

250×112 mm. Blacklead and sepia wash picked out with white lead. Buff paper pasted on to cloth. Squared.
Plate LI

Sánchez Cantón published this as an anonymous work of the late sixteenth century.
A companion piece to Nos. 140 and 141, it was probably for a series of Fathers of the Church. See also the following two drawings.

Provenance: Royal Collection.

Sánchez Cantón, II, 149; Pérez Sánchez, *Catálogo Prado*, 1972, p. 66.

183 ST. GREGORY THE GREAT. Madrid, National Library

245×110 mm. Pen and brush and ink, and sepia wash picked out in white. Buff paper. Squared. Part of the bottom left corner is missing and has been repaired, probably by Carderera. The left and right sides trimmed. It is possible that the trimming was done in order to alter the fall of the cope. *Plate LI*

In ink in an early hand: *Cardu..* Numbered, probably at a later date: *44.* A valuation: *1 Rl.*

Another version of the preceding composition. Probably a studio copy.

Provenance: Carderera Collection.

Barcia, No. 21.

184 ST. GREGORY THE GREAT. Madrid, National Library

195×123 mm. Pen and ink and sepia wash. Dark buff paper. Part of the top right-hand corner is missing.
Plate LI

Another version of the two preceding drawings, except that the Holy Spirit has been omitted. The hem of the cope is different on the left.
This is the weakest of the three drawings and seems to be a copy by a pupil.

Provenance: Madrazo Collection.

Barcia, No. 22.

185 ST. GREGORY THE GREAT WRITING. Madrid, Prado Museum

310×206 mm. Blacklead and sepia wash picked out with white lead. Bluish-grey paper. Squared. *Plate LI*

In ink in two, probably eighteenth-century, hands: *Vincᵒ Carducho.* This is probably the 'St. Leo', also a pope, which Mayer mentioned (*Historia*, 1924, p. 413) as being in the Prado.

Provenance: Ceán Bermúdez Collection. Lefort Collection; in the sale of this collection in 1869 it reached 19 francs. Fernández Durán Bequest (1930), No. 1735.

Lefort, *Collection*, Paris, 1869, No. 47; Sánchez Cantón, II, 17; Pérez Sánchez, *Catálogo Prado*, 1972, p. 67.

186 MARTYRDOM OF A SAINT (ST. JAMES THE LESS?) Chicago, Art Institute

340×233 mm. Black chalk with sepia, grey, and red

washes, heightened with white. Squared in black chalk, with black ink border. *Plate XLIX*

In ink in a seventeenth-century hand: *biçençio Carducho*.

The squaring-up points to this drawing being a preparatory study for an unknown painting. The similarity to the drawings for the El Paular series and the close resemblance of some of the figures to those in the martyrdom scenes of the same series, suggests a date very close to the latter, i.e. between 1626 and 1632, as proposed by Mrs. McKim Smith.

The presence in the centre of the composition of a heavy club as an instrument of martyrdom, supports the suggestion that the saint represented is St. James the Less, who is usually portrayed with this attribute.

The inscription is the same as that on the drawing in the Biblioteca Nacional (Barcia No. 38, here No. 241) and on that in the Prado (F.D. 362, here No. 165) which indicates that it comes from the same collection.

Provenance: Lord G. McCartney (stamp on the verso: George Lord McCartney, Albums of Drawings, Puttick and Simpson Sale, 14 March 1913, Lot No. 114): W. F. E. Gurley (Lugt Supplement No. 1230b).

Exh. Lawrence, Kansas, 1974, No. 5; McKim Smith, 1974, No. 5; J. Brown, 1975, p. 61.

187 PENITENT ST. JEROME. Florence, Uffizi

265 × 160 mm. Blacklead and sepia wash with touches of white. Dark-coloured paper. *Plate LII*

On the left, the remains of an inscription: . . . *ucho* and *Rs.*

It is attributed to Bartolomé in the collection, but it must be by Vicente.

Provenance: Santarelli Collection.

Santarelli Catalogue, p. 167, No. 2 (Inventory 2280).

188 ST. JEROME. Formerly Gijón, Instituto Jovellanos. Destroyed in 1936 with no surviving pictorial record

400 × 270 mm. The top cut to a semicircle. Aquatint and white chalk retouched with pencil. Very dirty. Squared.

On the back, unconnected inscriptions, among them: *Santos del ciclo de Ma . . .* (saints from the cycle of Ma . . .) and some ornamental sketches which seemed to Moreno Villa to come from another hand.

Moreno Villa, p. 37, No. 348; Pérez Sánchez, *Catálogo Gijón*, 1969, p. 37.

189 ST. JEROME. Madrid, National Library

126 × 133 mm. Pen and ink and wash on a sepia base. Buff paper. *Plate LII*

In ink in an early hand: *Carducho.*

Probably a study for a painting on the socle or between the mouldings of the second tier of an altar-piece.
The technique is reminiscent of works from the Escorial derived from Cambiaso, like those of Ribalta.

Provenance: Carderera Collection.

Barcia, No. 31.

190 PENITENT ST. JEROME. Vienna, Anton Schmid

Preparatory drawing in pencil. Sepia wash with touches of white lead. Dark-coloured paper. Squared.

Plate LII

In a seventeenth-century hand: *de Bicencio Carducho, 20 Rls.*, and, crossed out, *20 Rs.*

Seal of Luigi Grassi Collection.

191 BEHEADING OF ST. JOHN THE BAPTIST. Florence, Uffizi

245 × 185 mm. Blacklead and sepia wash with touches of white lead. Greyish paper. Squared in blacklead.

Plate LIII

Preparatory drawing with slight variants for the painting which was originally in the lay brother's choir at El Paular and is now in the Museum of Fine Arts, Cáceres (Angulo–Pérez Sánchez, Pl. 69). The figure of the executioner is very similar to the one in the *Beheading of St. Eulogius* (No. 175), who appears in the background of the picture in Cordova Cathedral. Both paintings are therefore of about the same date, perhaps between 1626 and 1632, when Carducho was working for El Paular.
There is an obvious recollection of the *Beheading of St. James* by Navarrete el Mudo in El Escorial.
The Santarelli Catalogue calls the drawing *Flagellation of Christ* and attributes it to Bartolomé.

Provenance: Santarelli Collection.

Santarelli Catalogue, p. 167, No. 1 (Inventory 2279); Pérez Sánchez, *Catálogo Florencia*, 1972, p. 54, no. 40, fig. 35.

192 MARTYRDOM OF ST. LAWRENCE. Florence, Uffizi

255 × 260 mm. Blacklead and sepia wash with touches of white lead. Buff paper. *Plate LIII*

Listed as anonymous in the Santarelli Collection, the execution and figure types, suggest it is a work by Vicente Carducho. It may be remembered that the attic storey of the altar-piece of St. Philip in the Convent of the Encarnación, Madrid, once contained a Martyrdom of St. Lawrence, which was probably roughly square in shape but has not survived. See Angulo–Pérez Sánchez, pp. 116 ff.

Provenance: Santarelli Collection.

Santarelli Catalogue, p. 709, No. 27 (Inventory 10357).

193 ST. LAWRENCE. Madrid, Prado Museum

180 × 116 mm. Blacklead. Buff paper. Squared.

Plate LIV

In ink in an early hand: *Vizº Carducho.* Valuations: *1 Rl, 2¼, 1.* In pencil: *17.*
Badly torn and stained.

This is very much in El Escorial tradition, but nevertheless does not seem uncharacteristic of Vicente Carducho. According to Father Zarco (see Sánchez Cantón), this seems to be a study for the painting in the porter's lodge of the Escorial, although 'in the latter his eyes are downcast'. We have not been able to identify the canvas in question.

Sánchez Cantón, II, 177; Pérez Sándrez, *Catálogo Prado*, 1972, p. 67.

194 ST. LUKE PORTRAYING THE VIRGIN. Madrid, Instituto de Valencia de Don Juan

245 × 200 mm. Blacklead and sepia wash and touches of white. Squared. *Plate LII*

In ink in handwriting which may be eighteenth century: *Carducho.*

Characteristic of Carducho's style. No painting by him of this subject survives.

J. Brown, 1973, p. 378.

195 ST. MICHAEL. Madrid, National Library

324×200 mm. Blacklead, sepia wash picked out with white. Dark buff paper. Squared. *Plate LIV*

A small section is missing from the bottom of the sheet. No painting by Carducho of this subject is known.

Provenance: Madrazo Collection.

Barcia, No. 18.

196 ST. NICHOLAS. Madrid, Prado Museum. Inventory No. F.A. 814

252×141 mm. Heavy sepia wash over pencil outlines heightened with white. Buff wire-marked paper. Squared in pencil. *Plate LIV*

Torn and stained. Modern pencil inscription: *Cº Coello.*
Very close in style to Nos. 140, 141 and 143.
There is no record of a painting corresponding to this subject.

Entered the Museum in 1971.

Pérez Sánchez, *Catálogo Prado*, 1972, p. 68.

197 MARTYRDOM OF ST. PELAGIUS. Madrid, Academia de San Fernando

210×198 mm. Pencil, pen and ink and sepia wash. White paper. Squared. *Plate LIII*

In pencil in a modern hand, now scarcely visible: *7 Carducho.*

On a piece of paper which was once pasted to the drawing could be read: *n dio más a de aver treinta reales que me dio a 16 deste mes y bimos cuenta a catorçe de abril en bispera de Pascua yo y el señor biçencio y me alcanço en treinta y nuebe reales y me içio merd de darme cuarenta y nuebe en año de 1618* (This paragraph is crossed out.) *y beinte y seis de junio y bimos cuenta y se me bino alcançar en 77 reales desquitando los setenta y nuebe de arriba*
(In another contemporary hand:) *Digo yo Feliz Castelo que recevi de anton de Salas Vº de la Villa de Torregon de Belasco . . .* (deleted), *quinientos y sesenta reales del principal que debia a mi tio Francº Serrano que los a de aber de la parte del año de 24 en binos de Cubas del año pasado de 1.619 y ansi mesmo recibo cuarenta reales de los que uve del trueco de la mitad que abia de ser en plata y* (tear) *mas a cumplimiento de lo* (. . . gave more . . . there must be thirty *reales* which he gave me on the sixteenth of this month; and we reviewed accounts on the fourteenth of April on Easter Saturday, Señor Vicente and I, and he found me indebted for the sum of thirty-nine *reales* and did me the favour of giving me forty-nine. In the year of 1618. .·. and the twenty-sixth of June and we reviewed accounts and my debt stood at seventy-seven *reales*, recouping the

seventy-nine above. I, Félix Castelo, testify that I have received from Antonio de Salas, native of the village of Torrejón de Velasco, five hundred and sixty *reales* of the principal which he owed my uncle Francisco Serrano, who must have them by the year 1624 in Cubas wines of last year, 1619, and I also receiving forty *reales* of those which I acquired by exchanging the half that had to be in silver and . . . but in fulfilment of . . .)

The first part of the writing is a settling of accounts of 1618 between Vicente Carducho and the writer. Since the second part is a reckoning in Félix Castelo's hand, one might think, but for the difference in the hand-writing, that the first half was written by Castelo as well, as he is known to have been a pupil of Carducho. The second part refers to payments which he receives, as the nephew of Francisco Serrano.
This is probably the scene in which the child Pelagius is quartered for not complying with the lewd desires of the Caliph of Cordova.
The attribution is due to Menéndez Pidal and Velasco. The drawing's style is reason enough to consider Carducho, but since Castelo is his pupil and the copied text refers to Castelo it is very possible that the drawing is by him—his style of drawing is not yet thoroughly known.

Provenance: probably the Royal Collection at the Palace of El Pardo.

Tormo, p. 69, No. 62; Velasco, No. 10; Angulo, p. 15, Pl. 13; Pérez Sánchez, *Catálogo San Fernando*, 1967, p. 44.

198 THE ARCHANGEL RAPHAEL AND TOBIAS Madrid, Prado Museum. Inventory No. F.A. 815

303×200 mm. Pen and brush over pencil, heightened with white on dark wire-marked paper. Squared in pencil. *Plate LIV*

An inscription in ink, cut, in the lower part. In pencil, in a modern hand: *C. Coello.*

No corresponding painting is known.

Entered the Museum in 1971.

Pérez Sánchez, *Catálogo Prado*, 1972, p. 68.

199 THE VIRGIN RECEIVING ST. TERESA AND ST. MARY-MAGDALENE DEI PAZZI. Florence, Uffizi

237×185 mm. Blacklead and sepia wash with touches of white. Buff paper. Squared in blacklead. *Plate LV*

The Virgin stands in the middle dressed in a Carmelite habit. On her right stands St. Teresa, writing at the dictate of the Holy Spirit. On her left, is St. Mary-Magdalene with the Child Jesus in her heart.
The catalogue of the Santarelli Collection mistakes the Virgin for Christ and attributes the drawing to Bartolomé.

Provenance: Santarelli Collection.

Santarelli Catalogue, p. 168, No. 20 (Inventory 2298).

200 ST. TERESA AND ST. JOHN OF THE CROSS Madrid, Private Collection

157×246 mm. Pen and sepia wash heightened with white. Buff paper. *Plate LVI*

Inscribed in ink in a seventeenth-century hand: *Vicencio carducho.*

The drawing shows three different scenes in one compartment. In the centre foreground, St. Teresa kneels before St. John of the Cross in the habit of the Order. At the sides, in the right background, the Virgin and St. Joseph invest the Saint with the collar and robe, and in the left background she receives her nuns at the gate of the convent.

The style confirms the old attribution to Carducho.

201 ST. PAUL AND THE ANGEL. Whereabouts unknown

Sepia wash picked out in white.

Provenance: Paris, Mariette Sale, 1775. Sold for 48 francs.

Mireur, II, 69.

202 A FATHER OF THE CHURCH. Florence, Uffizi

195×140 mm. Lightly sketched in pencil. Sepia wash and touches of white lead. Buff paper. *Plate LV*

In an early hand: *10 Rs.*, deleted.

A composition for a lunette of the same kind as those in the chapel of the Virgin of the 'Sagrario', Toledo Cathedral (Angulo–Pérez Sánchez, Pls. 50, 51, and 168–9). In the Uffizi it is listed as anonymous, but its style is very close to that of Carducho.

Provenance: Santarelli Collection.

Santarelli Catalogue, p. 718, No. 187 (Inventory 10517).

203 A MONK SAINT WASHING CHRIST'S FEET. Madrid, Castromonte

290×220 mm. Pencil and sepia wash, lightly picked out in white. Buff paper. Squared. *Plate LVII*

In ink: *8 R.*

Iconographically, the theme might lead one to think of St. Augustine (canvases by Strozzi, Murillo, etc.), but the habit is not that of his order.

Judging by the measurements and the subject, this must be the presumed *St. Bruno washing Christ's feet* from the Lefort sale.

Lefort, *Collection*, Paris, 1869, No. 48.

204 KNEELING SAINT. Madrid, National Library

265×229 mm. Blacklead picked out in white. Buff paper.
 Plate LV

In ink that has almost faded away, on the left-hand inside corner: *Carducho.* Numbered: *40.*

The saint is dressed in a tunic with a girdle and appears to be wearing a scapular or apron in front.

Study for a complex composition.

An excellent drawing, close in its vigour and the simplicity of its technique to the best in the El Paular series.

Provenance: Carderera Collection.

Barcia, No. 39.

205 A SAINT KNEELING AND CROWNED WITH THORNS BY TWO ANGELS. Florence, Uffizi

185×175 mm. Blacklead and sepia wash with touches of white lead. Pea-green paper. *Plate LV*

Attributed to Bartolomé in the collection.

Provenance: Santarelli Collection.

Santarelli Catalogue, p. 168, No. 12 (Inventory 2290).

206 A MONK BEING DRAGGED TO HIS EXECUTION Madrid, National Library

135×270 mm. Pencil, sepia wash and touches of white lead. Greenish-grey paper. Squared. *Plate LVI*

Valuations in ink: *8 Rs, 6 Rs.* In the top right corner: *3.*

Judging by the habit, the figure could be a Benedictine or Cistercian monk. It is perhaps appropriate to relate this to the paintings on the socle of the altar-piece of St. Bernard of Madrid (Angulo–Pérez Sánchez, p. 113, nos. 19–21); their subject is not specified but it is reasonable to think that they were scenes involving his order (Angulo–Pérez Sánchez, p. 113).

Provenance: Carderera Collection.

Barcia, No. 34.

207 COMMUNION OF A NUN SAINT. Madrid, Prado Museum. Inventory No. F.A. 69

235×177 mm. Pen and sepia wash over pencil heightened with white. Buff wire-marked paper, glued to another sheet. Squared in pencil. *Plate LVII*

Sánchez Cantón reproduced this drawing with an attribution to Cajés which he himself questioned. It seems in fact much closer to V. Carducho, with a technique and models very similar to other known drawings by his hand.

Provenance: Royal Collection.

Sánchez Cantón, II, 186; Pérez Sánchez, *Catálogo Prado*, 1972, p. 68.

208 A MONK BEING DRIVEN IN A CART. London, Courtauld Institute

179×258 mm. Pencil and sepia wash. Blue-grey paper. Squared in pencil. *Plate LVI*

Attributed to Bartolomé in the handlist of the Witt collection, where it is called *Auto da fé*, this is evidently from the same hand as the preceding drawing.

Witt, p. 159, No. 3778.

Allegorical and Secular Subjects

209 CHARITY. Madrid, National Library

167×130 mm. On an octagonal piece of paper. Blacklead, watercolour, and touches of white. Dark buff paper. Squared. *Plate LVII*

Provenance: Carderera Collection.

Barcia, No. 36.

210 THE CHURCH. Paris, Louvre. Inventory 18417

360×257 mm. Blacklead and sepia wash. Buff paper.

Plate LVI

In ink in a seventeenth-century hand: *Carducho.*

Provenance: Gouvernet Collection.

J. Brown, 1973, p. 378.

211 ALLEGORICAL FEMALE FIGURE. Florence, Uffizi

260×165 mm. Blacklead, and sepia wash picked out with white. Buff paper. Squared in pencil. *Plate LVII*

Various prices: *3 Rls.* and *14 Rls.* crossed out.

The figure, in a flying pose, with a branch of laurel in her right hand and the chalice in her left, her eyes lifted up towards the Holy Spirit, who is flying above her, could perhaps represent the Church.

The Santarelli Catalogue calls her 'the Angel of Peace' and attributes the drawing to Bartolomé.

Provenance: Santarelli Collection.

Santarelli Catalogue, p. 167, No. 4 (Inventory 2282).

THE KINGDOMS OF THE SPANISH MONARCHY

The following thirteen drawings (Nos. 212–24) are studies for a series, whose purpose is unknown, of allegorical figures of the kingdoms comprising the Spanish realm. Rosell thought those in the National Library were studies for decorations for the Hall of Kingdoms at Buen Retiro. Tormo rejected this argument. Barcia thought he could read on one of the drawings: *del Salón de Burgos*, an unverifiable identification. J. Brown thought that for stylistic reasons they could be dated about 1634 and could perhaps be related to a project for the decoration of the Hall of Kingdoms at Buen Retiro, which was then rejected.

Six of them (Nos. 212, 213, 216, 217, 218, 219) are semi-circular at the top. Seven (Nos. 214, 215, 220, 221, 222, 223, 224) are rectangular. Some are squared.

The attribution of the four now kept in Florence to Juan Fernández could suggest that they were acquired by El Escorial. That belonging to Mr. Sperling, which appeared only recently, suggests that several more of the same series may have survived.

The eight in the National Library have inscriptions underneath indicating the kingdoms and a numeration which went up to 16. Those in Florence and New York have been trimmed. The dimensions of the Madrid drawings are therefore somewhat larger (385×125 mm. on average) than the others (336×130 mm.).

All the drawings are sketched in pencil and heightened with pen and ink and sepia wash. Buff laid paper.

Rosell, *Museo Español de Antigüedades*, X, 1880; Tormo, *Boletín*, 1911, p. 24; Angulo, *Archivo*, 1927, p. 346; Sánchez Cantón, II, 169.

212 ARAGON. Madrid, National Library

385×120 mm. *Plate LVIII*

At the bottom, in a contemporary hand: *Aragón nº 3.*
On the bends of the shields: *Colorado, oro* (Red, gold).

Barcia, No. 44.

213 LÉON. Madrid, National Library

383×120 mm. *Plate LVIII*

The shield is crossed out. A preliminary sketch of the

smaller shield, in pencil. Lower down, in ink, a smaller shield bearing a cross between four heads, the arms of Aragon.

Deleted: *Leon, 2* and in ink: *no a de tener margeles de purpura en campo blanco* (is not to have purple margins on a white field).

Barcia, No. 45.

214 GALICIA. Madrid, National Library

385×120 mm. *Plate LVIII*

At the bottom: *Galicia 9.* On the shield: *azul, oro* (blue, gold).

Barcia, No. 46.

215 SEVILLE. Madrid, National Library

185×120 mm. *Plate LVIII*

At the bottom: *Sevilla.* On the shield: *blanco* (white), *gris* (grey), *oro, oro* (gold), *colorado* (red).
In a later hand: *70 rs.*

The arms are in fact those of Sicily and not Seville, and as will be seen, they occur repeatedly throughout the series.

The pose is the same as that in No. 223, although the figure there is young and here old.

Barcia, No. 47.

216 CASTILE. Madrid, National Library

183×119 mm. *Plate LVIII*

On the shield: *Oro, Colorado* (gold, red).
At the bottom: *Castilla No. 1.*

Barcia, No. 48.

217 PORTUGAL. Madrid, National Library

385×119 mm. *Plate LVIII*

On the shield: *colorado* (red), *plata* (silver), *azul* (blue), *oro* (gold).
At the bottom: *Portugal* (deleted) *16.* In a later hand: *7 rˢ.*

Barcia, No. 49.

218 JERUSALEM. Madrid, National Library

383×120 mm. *Plate LIX*

On the shield: *colorado* (red), *oro* (gold), *blanco* (white).
At the bottom: *Jerusalem 6, no a de tener más q la+en el pen . . .* (is not to have more than the cross in the . . .).

Barcia, No. 50.

219 SICILY. Madrid, National Library

381×121 mm. *Plate LIX*

On the shield: *oro* (gold), *colorado* (red), *oro, color* (red), *oro, colorado, oro, co oro* (with gold).
At the bottom: *Cicilia 4.*
Part of the paper is missing from the lower right-hand corner.
On the added piece of paper: *7 rˢ.*

Barcia, No. 51.

220 NAVARRE. Florence, Uffizi. Inventory No. 14393

335 × 135 mm. *Plate LIX*

On the shield in the artist's hand: *Campo colorado* (Red field), *esmeralda* (emerald), *cadenas d'oro* (chains of gold).

Attributed to Juan Fernández.

Pérez Sánchez, *Catálogo Florencia*, 1972, p. 56, no. 42.

221 ARAGON. Florence, Uffizi. Inventory No. 14394

337 × 135 mm. *Plate LIX*

On the shield: *plata* (silver), deleted, and *azul* (blue).

Attributed to Juan Fernández.

The arms depicted are those of the old countship of Aragon, which are now kept by the town of Jaca.

Pérez Sánchez, *op. cit.*, p. 56, no. 43, fig. 30.

222 GRANADA. Florence, Uffizi. Inventory No. 14395

336 × 133 mm. *Plate LIX*

On the shield: *una granada de su color en campo de plata* (a pomegranate proper on a field argent).

Attributed to Juan Fernández.

Pérez Sánchez, *op. cit.*, p. 57, no. 44, fig. 31.

223 VALENCIA. Florence, Uffizi. Inventory No. 14396

337 × 135 mm. *Plate LIX*

On the shield: *colorados* (red), *oros* (gold).

Attributed to Juan Fernández.

Angulo, *Archivo*, 1927, p. 346, fig. 5; Pérez Sánchez, *op. cit.*, p. 57, no. 45, fig. 32.

224 THE ARMS OF ARAGON. New York, Metropolitan Museum, Sperling Bequest

330 × 130 mm. Pencil and sepia wash. Laid paper.

 Plate LX

On the shield, notes on colouring: *doradas laqueadas* (lacquered gilding), *la cruz/de jerusalen/* (the cross of Jerusalem), *las armas de aragon* (the arms of Aragon), *colorado–oro* (red–gold), *plata–oro* (silver–gold).

In its subject-matter and layout, it is a companion piece to the kings in the Uffizi and the National Library, but it is somewhat smaller. Perhaps the bottom of it has been trimmed.

J. Brown, 1973, p. 375, pl. 29.

Exh. New York, 1975–76, no. 71.

225 ATAULF. Madrid, Academia de San Fernando

394 × 217 mm. Blacklead. Paper tinted dark grey-blue. Squared. *Plate LX*

In ink in the artist's hand: *ATHAULPHUS-GOT-REX-ISP.* (Ataulf the Goth, king of Spain.)

For the series of pictures of Gothic kings in the Palace of Buen Retiro, painted around 1635 by various Madrilenian artists. That of Ataulf is now in the Army Museum in Madrid (Angulo–Pérez Sánchez, Pl. 121). The main difference is that in the painting the king faces and looks at the spectator.

Although the drawing was attributed to Carducho by Tormo, who connected it with the corresponding painting, Sánchez Cantón and Velasco thought it was by Pereda, but at a later date Sánchez Cantón reattributed it to its author.

Provenance: Royal Collection at the Palace of El Pardo.

Tormo, *Las viejas series icónicas de los reyes de España*, 1917, pp. 118 and 128; Tormo, p. 68, No. 57; Sánchez Cantón, III, 240; Velasco, No. 43; Sánchez Cantón, *Spanish Drawings*, 1964, p. 72, Pl. 40; Angulo, p. 14, Pl. 11; Exh. Hamburg, 1966, p. 57, Pl. 18; Pérez Sánchez, *Catálogo San Fernando*, 1967, p. 43; Pérez Sánchez, *Gli Spagnoli dal Greco a Goya*, 1970, p. 88, fig. 5.

226 THE STORMING OF RHEINFELDEN. London, British Museum

305 × 410 mm. Preparatory drawing in pencil. Pen and ink and indigo wash. Buff laid paper. *Plate LXI*

At the top in ink in the artist's own hand: *Brisac, Basilea* (Basle), *Reinfeld*.

A study for the canvas painted in 1634 for the Hall of Kingdoms at Buen Retiro and now in the Prado (Angulo–Pérez Sánchez, Pl. 118). The drawing shows the composition already completely worked out and differs from the painting only in minor details, mostly of dress. The event depicted happened in 1633, and the general is Don Gómez Suárez de Figueroa, Duke of Feria.

Mayer, Pl. 72; Sánchez Cantón, II, 176; *id., Catálogo del Prado*, 1963, p. 119; Pérez Sánchez, *Gli Spagnoli dal Greco a Goya*, 1970, p. 81, pl. IV.

227 TWO HORSEMEN. Florence, Uffizi

395 × 267 mm. (measurements of the cut-out figures), 415 × 272 mm. (measurements of the sheet on which they are pasted). Charcoal, brown, and sepia washes. Buff wire-marked paper. Squared in red chalk. *Plate LXI*

Attributed in the Uffizi to Antonio Tempesta. Pérez Sánchez has pointed out that this drawing is in fact a preparatory study for the painting by Carducho of the *Battle of Fleurus*, executed in 1634 for the Salón de Reinos of the Buen Retiro Palace. (Angulo–Pérez Sánchez, Pl. 119.) In the finished picture the attitudes and profiles of the two figures are retained but they are converted into true portraits: the principal one is the general Don Gonzalo de Córdoba (1585–1631), the son of the Duke of Sessa. Although the technique is very different, the drawing is thus contemporary with No. 226; No. 262 by Felix Castelo; No. 94 by Cajés, and No. 285 by José Leonardo, all of which are preparatory studies for pictures in the same series.

Provenance: Santarelli Collection.

Santarelli Catalogue, p. 685, No. 9 (Inventory 10038S); Pérez Sánchez, *Catálogo Florencia*, 1972, p. 52, No. 37, fig. 38; *id., Goya*, 1972, No. 111, pp. 149 and 151.

228 PHILIP II RECEIVING SUPPLIANTS. Madrid National Library

289 × 245 mm. Pen and ink and sepia wash. Buff paper.

 Plate LXIV

In ink in a hand of the period: *15 pies y ¼ . . .* (15¼ feet) and *3 Rs.*

The king and queen are seated on the throne, and behind the king stands a prince. On his right, there are courtiers, and on his left, a prelate is blessing three people supplicating the monarch on their knees. A number of courtiers in the background.

Below, a trifoliate arch which could be that of the door over which the painting was to hang.

The period of the king's and queen's costume and the presence of the prince bear out Barcia's plausible suggestion that the characters depicted are Philip II, his wife, and the prince Don Carlos.

Judging perhaps by their long hair, Barcia thinks the suppliants are foreigners and suggests that they could be Irish and that this could be a study for a painting for the Irish college at Valladolid.

Although the overall composition falls completely within Carducho's style, the way in which the figures are drawn differs from the majority of those of his drawings which use a similar technique.

Provenance: Carderera Collection.

Barcia, No. 43.

229 EXPULSION OF THE MORISCOS. Madrid, Prado Museum. Inventory No. F.A. 716

308 × 503 mm. Preparatory drawing in pencil, pen, and blue wash. Buff laid paper. *Plate LXII*

Probably a study for the canvas Carducho painted in 1627 in competition with Nardi and the young Velázquez who produced paintings on the same subject. Velázquez won, as Pacheco and Palomino relate.

Camón Aznar thought the drawing was by Velázquez, but its style, with so many reminiscences of mannerism, is clearly Carduchesque.

Acquired in 1931.

Sánchez Cantón, II, 175; id., *Spanish Drawings*, 1964, p. 38, Pl. 6; Trapier, 1941, p. 33; Camón Aznar, *Velázquez*, 1965, p. 328; Angulo–Pérez Sánchez, p. 88; Pérez Sánchez, *Catálogo Prado*, 1972, p. 70.

230 A HISTORICAL SUBJECT (COLUMBUS AT LA RÁBIDA?). Formerly Gijón, Instituto Jovellanos. Destroyed in 1936 with no surviving pictorial record

250 × 230 mm. Semicircular. Watercolour and white chalk. Dark-coloured thin paper. A watermark of a cross within a heart.

In one corner, a heraldic shield.
Attribution: *Vicente Carducho.*
The title *Columbus at La Rábida* given by Moreno Villa seems very unlikely for Carducho's period.

Moreno Villa, 37, No. 349; Pérez Sánchez, *Catálogo Gijón*, 1969, p. 37.

231 ACHILLES IN THE HARBOUR AT AULIS. Madrid, Condes de Alcubierre

195 × 250 mm. Blacklead and wash. Buff paper.
 Plate LXII

In ink in a seventeenth-century hand, maybe that of the artist: *Llega Aquilles al puerto de Aulis dondestavan los Reies y toda l'armada de los griegos se detiene | mucho tiempo por falta de viento declara Chalcos el adivino que lo causava Diana por averle muerto Aqu . . . | en el bosque de diana una cierva sagrada y que no cesaria la ira si primero Agamenon no sacrificava | a Diana a su ija Iphigenia doncella ermossisima que quedava en argos envio por ella . . . | siendo que la queria cassar con Achilles* (Achilles arrives at the harbour at Aulis where the kings are and the entire Greek fleet is being held up for lack of a (fair) wind. Calchas the soothsayer declares that Diana has brought this about because Achilles killed . . . a sacred hind in Diana's grove, and that her anger will not cease unless Agamemnon first sacrifices to Diana his daughter Iphigenia, a most beautiful maiden, who is staying in Argos. He sends for her . . . for he wanted to marry her to Achilles).

Another, later inscription: *Julio Romano fec.*

The attribution to Giulio Romano is without foundation. The drawing is characteristic of Carducho and can be related to the stories of Achilles which he painted from 1608 on in the Palace of El Pardo (Angulo–Pérez Sánchez, p. 188).

Definitely a companion piece to No. 232.

232 ACHILLES AND BRISEIS. Madrid, Academia de San Fernando

116 × 232 mm. Blacklead and brown wash. Buff paper. Squared. *Plate LXIII*

The scene is framed by a semicircle.

The fact that Carducho was painting the frescoes of the stories of Achilles in the Palace of El Pardo in 1608, and the stylistic kinship of this with the preceding drawing suggest that the subject depicted is the parting of Achilles and Briseis, as Pérez Sánchez hazarded. Tormo entitled it *Hector's farewell*, and *Dido and Aeneas* has also been suggested.

Velasco thought it was by Cajés, but the style, as Pérez Sánchez pointed out, is Carducho's.

Provenance: Royal Collection at the Palace of El Pardo.

Tormo, p. 77, No. 155; Velasco, No. 95; Pérez Sánchez, *Catálogo San Fernando*, 1967, p. 47.

233 A CAPTAIN FROM ANTIQUITY SEATED ON A THRONE. Madrid, National Library

212 × 170 mm. Blacklead and watercolour with touches of white lead. Dark buff paper. *Plate LXIV*

In ink in handwriting which may be nineteenth century: *de Bartolome Carducho.*

Barcia was the first to point out that it seems to be by Vicente. It may perhaps be a drawing for one of the episodes in the stories of Achilles for the Pardo Palace.

Barcia, No. 7278.

234 COMBAT OF CAVALRY AND INFANTRY. Madrid, Academia de San Fernando

266 × 405 mm. Blacklead and red ochre, sepia wash, and touches of white. Dark-coloured paper. Squared in red chalk. *Plate LXIII*

On the back, an early handwritten attribution to Carducho, now no longer visible.

Tormo thought the drawing was Italian. Soria mentions it in connection with the battles of Esteban March and, attributing it to Carducho, stresses the subtler, more balanced and more Italian character of its composition.

Tormo, No. 65, p. 69; Velasco, No. 47; M. S. Soria, *Art Bulletin*, 1945, p. 111, note 18; Pérez Sánchez, *Catálogo San Fernando*, 1967, p. 48.

235 A KING. Madrid, Prado Museum

163×70 mm. Preparatory drawing in pencil. Pen and ink and sepia wash, picked out in white lead. Squared.
Plate LX

In a surround with slightly bevelled corners.
In ink in the top right-hand corner: *G*, in the bottom right: *20 Rs.*

Attributed to Zurbarán in the Fernández Durán Collection, it is possibly a study for the series of Gothic kings discussed under No. 224, or for another similar series.

Provenance: Fernández Durán Bequest, 1930, No. 1392.

Pérez Sánchez, *Catálogo Prado*, 1972, p. 69.

236 A DEVOTEE OF SAINTS COSMAS AND DAMIAN Madrid, National Library

151×139 mm. Brush and sepia wash with touches of white. Dark greenish-grey paper. Squared. *Plate LXIV*

In ink in an eighteenth-century hand: *Carducho.*

The 'devotee' is as Barcia describes him, a half-length figure of an ecclesiastic with his hands joined in prayer in front of an altar on which are the statues of Saints Cosmas and Damian.
Probably for a painting on the socle of an altar-piece.

Provenance: Carderera Collection.

Barcia, No. 35.

Miscellaneous Figure Studies

237 MONK SEATED IN ECSTASY. Formerly Gijón, Instituto Jovellanos. Destroyed in 1936 with no pictorial record surviving

250×210 mm. Inside a depressed arch. Blacklead. Dark-coloured paper. Squared.

An attribution: *Vicente Carducho.*

Moreno Villa, p. 37, No. 352; Pérez Sánchez, *Catálogo Gijón*, 1969, p. 38.

238 SEATED MALE FIGURE. Formerly Gijón, Instituto Jovellanos. Destroyed in 1936

250×230 mm. Blacklead. Coarse paper. *Plate LXV*

The paper is very badly preserved: the top left-hand corner has been bevelled off, and the bottom is very stained.
In ink in a later hand, possibly eighteenth-century: *Vº Carducho.*

On the verso: a rearing horse, poorly drawn in Moreno Villa's view. According to Sánchez Cantón, the figure is a drapery study for a Dream of St. Joseph. Moreno Villa entitles it *Seated Apostle.*

Moreno Villa, p. 36, No. 350; Sánchez Cantón, II, 173; Pérez Sánchez, *Catálogo Gijón*, 1969, p. 38, Pl. 69.

239 SEATED MALE FIGURE. Madrid, Prado Museum Inventory No. F.A. 71

215×152 mm. Slightly bevelled corners. Blacklead. Greenish paper. *Plate LXV*

In pencil in a modern hand: *Legajo 43 nº 1* (Bundle 43, No. 1).

The figure is a copy, reversed like an engraving, of the preceding drawing, in a similar but simpler technique. It could have been done from No. 238, either by Carducho himself or by a pupil in his shop.

Provenance: Royal Collection.

Pérez Sánchez, *Catálogo Prado*, 1972, p. 70.

240 MALE FIGURE. Florence, Uffizi

240×200 mm. Blacklead with touches of white lead and white chalk. Dark-coloured laid paper. *Plate LXV*

In ink in handwriting which is perhaps seventeenth-century: *Carducho.*

Study for an elaborate composition. Although attributed to Bartolomé in the collection, it is more likely to be by Vicente and related to some of the drawings for El Paular.

Provenance: Santarelli Collection.

Santarelli Catalogue, p. 167, No. 5 (Inventory 2283).

241 KNEELING MAN. Madrid, National Library

250×313 mm. Blacklead. Buff paper. *Plate LXIV*

A piece of paper has been added at the bottom, left of the middle.
In ink in a seventeenth-century hand which may be that of the artist: *Vicencio Carduchi.* The handwriting is the same as on the *Mater dolorosa* (No. 129). Also in ink: *2 Rs.*

Two lighter sketches on a smaller scale, in front of and behind the principal study.

Provenance: Carderera Collection.

Barcia, No. 38; Mayer, Pl. 72.

242 A KING IN PRAYER. Madrid, National Library

90×44 mm. The figure has been cut out, making the paper an irregular shape. Blacklead and sepia wash picked out in white. Dark buff paper. *Plate LXV*

Study for a narrative painting.
Barcia catalogues this among anonymous works but rightly remarks that it is reminiscent of the drawings of Carducho, to whom it may in fact be attributed.

Provenance: Madrazo Collection.

Barcia, No. 607.

243 THREE SEPARATE PORTRAITS. Whereabouts unknown

Paris, Kaileman sale, 1858. Sold for 39 francs.

Mireur, II, 69.

244 PORTRAIT OF A MAN. Whereabouts unknown

Marking stone heightened with red.

Provenance: Paris, Kaileman sale, 1858. Sold for 62 francs.

Mireur, II, 70.

Doubtful attributions

245 CIRCUMCISION. London, British Museum
Inventory 1938—12–10–4

250×171 mm. Pencil, pen and ink and sepia wash.
White laid paper. *Plate LXVI*

Mounted at the Museum with an attribution to Mateo
Gilarte. Its style is very close to Carducho's, and if it is
not by him, it must be by one of his pupils.

246 FLAGELLATION. Paris, Louvre. Inventory 18416

147×346 mm. Pencil, pen and ink and sepia wash.
White paper. *Plate LXVI*

Its elongated proportions suggest that it is a drawing for
the socle of an altar-piece.
Attributed to Bartolomé Carducho in the museum, it is
more probably by Vicente or one of his followers.

247 ASSUMPTION. Madrid, Academia de San Fernando

390×250 mm. Greenish-grey paper. Pen and brush and
ink, and brown wash heightened with white.
Plate LXVIII

In modern pencil: *Carduchi*. A valuation: *12 R.*

At the top, the mouldings of a semicircular frame. On
a piece of paper pasted on the verso, a silhouette of a
woman in ink, from another hand completely uncon-
nected with Carducho—probably a copy of a Venetian
engraving.

Provenance: Royal Collection at the Palace of El Pardo.

Velasco, No. 44.

248 THE VIRGIN OF ALL SAINTS. Madrid, Private
Collection

210×200 mm. Preparatory drawing in red chalk. Pen
and ink and wash picked out in white. Buff paper.
Plate LXVI

In ink in an early hand: *V° Carducho.*

The Virgin, drawn from a foreshortening viewpoint,
protects several saints beneath her mantle, among whom
one can identify St. Thomas Aquinas on the left with
the monstrance, and St. Peter Martyr on the right with
the palm of martyrdom and the three crowns. All are
standing on a platform of clouds. Below, on a slightly
smaller scale and spread out in a semicircle, a number of
prelates and religious presided over by a pontiff.
The identification of the two Dominican saints does not
necessarily prove that this is a painting with special
connections with the Dominican order. The clothing of
the saint who is writing in a book in the foreground on
the right, drawn in darker ink, may possibly be intended
to indicate a cardinal's cape, in which case the figure is
probably St. Bonaventure.
Though the style is not irreconcilable with Vicente
Carducho's, it does not seem characteristically his.
This work is directly related to a drawing in the National
Library (Barcia No. 219) which is attributed to Alonso
Cano but is probably Madrilenian, and which has a simi-
lar layout, with groups of angels added and a more in-
tense treatment of the shadows.

249 ST. GREGORY THE GREAT. Boston, Museum of Fine
Arts. Inventory No. 481102

222×190 mm. Coarse pen and sepia wash over pre-
paratory drawing in pencil. Coarse yellowish (chick-pea)
coloured paper. *Plate LXVII*

Collector's Mark of Peter Silvestre.

Though attributed in the collection to Murillo, this
drawing is a work of the Madrid School and close to
V. Carducho, to whom it is firmly attributed by J. Brown.

J. Brown in *Master Drawings*, 1975, p. 61.

250 ST. JEROME SCOURGED BY THE ANGELS. Madrid,
National Library

394×272 mm. Ink and brush. Buff paper. The edges
damaged. *Plate LXVIII*

In ink in an eighteenth-century hand: *3 Rls.*

Catalogued as an anonymous work in the National
Library. Probably from the school of Vicente Carducho.

Provenance: Madrazo Collection.

Barcia, No. 581.

251 BEHEADING OF ST. JOHN THE BAPTIST. Florence,
Uffizi

195×285 mm. Light wash and touches of white lead.
Buff paper *Plate LXVII*

Attributed in the Santarelli Collection to Bartolomé, it
could be by him or, more probably, by Vicente.

Provenance: Santarelli Collection.

Santarelli Catalogue, p. 168, No. 15 (Inventory 2293).

252 ST. LUKE PAINTING THE VIRGIN WITH ANGELS
Formerly Gijón, Instituto Jovellanos. Destroyed in 1936,
with no surviving pictorial record

310×240 mm. Sepia wash. Squared.

In Moreno Villa's view, this is the work of a pupil who
imitated Vicente Carducho's drawings.

Moreno Villa, p. 82, No. 701; Pérez Sánchez, *Catálogo
Gijón*, 1969, p. 39.

253 BEHEADING OF ST. JAMES. Florence, Uffizi

280×195 mm. Blacklead, sepia wash, and touches of
white lead. Buff paper. Squared in blacklead.
Plate LXVII

Listed as anonymous Spanish in the Santarelli Collec-
tion.
This is a Madrilenian work from the first third of the
century, very close to Carducho, and perhaps by him.

Provenance: Santarelli Collection.

Santarelli Catalogue, p. 714, No. 11 (Inventory 10441).

254 ST. SEBASTIAN. Madrid, Academia de San Fernando

178×114 mm. Pen and ink and sepia wash. Buff laid
paper. *Plate LXVIII*

Luis Menéndez Pidal first attributed this, in his manu-
script notes, to Carducho, and Tormo thought it was

similar to his style, while comparing the pose with 'a' St. Sebastian by El Greco. Camón notes, it relates to the *St. Sebastian* in Palencia Cathedral. The pose is known to derive from Tintoretto or Michelangelo.

Sánchez Cantón attributes it with reservations to Herrera the Elder, Velasco, with a query, to Pereda. Pérez Sánchez catalogued it as by Carducho.

Provenance: Palace of El Pardo.

Tormo, No. 56, p. 68; Velasco, No. 15; Sánchez Cantón, III, 212; Camón Aznar, *Dominico Greco*, 1950, pp. 393 and 397; Pérez Sánchez, *Catálogo San Fernando*, 1967, 46.

255 SEATED SAINT. Hamburg, Kunsthalle. Inventory 38504

330×228 mm. Blacklead and wash heightened with white lead. Blue paper. *Plate LXVII*

In ink in a, possibly, seventeenth-century hand: *Bizencio Carduche fecit*. The writing is not the artist's, so this is not a signature.

Probably a study for a scene involving a number of figures. Mayer thought it was a drapery study for the figure of an apostle and accepted the attribution to Carducho, which seems a little doubtful.

Mayer, *Boletín*, 1920, p. 130.

256 MARTYRDOM OF MONKS ABOARD A SHIP Florence, Uffizi

295×415 mm. Ink and sepia wash. Buff laid paper.
Plate LXVI

A number of monks are seen to be crucified on the ship's masts.
Attributed to Bartolomé in the collection, it looks more like a work by Vicente, or from his circle.

Provenance: Santarelli Collection.

Santarelli Catalogue, p. 167, No. 10 (Inventory 2288).

257 ATTACK ON A BERBER STRONGHOLD. Madrid, Academia de San Fernando

224×156 mm. Pen and ink and sepia wash. Buff paper.
Plate LXVIII

Attributed to Carducho by Tormo and Velasco. Pérez Sánchez doubts the attribution and thinks the drawing may be Italian.

Tormo, p. 66, No. 20; Velasco, No. 46; Pérez Sánchez, *Catálogo San Fernando*, 1967, p. 48.

Attributions not accepted

JOSEPH STORING GRAIN DURING THE SEVEN YEARS OF PLENTY. New York, Metropolitan Museum, Sperling Bequest
Attributed to Vicente Carducho by J. Brown, it is in fact by Patricio Cajés. See Volume I, No. 117.

MOSES AND THE MIRACLE OF THE ROCK. London, Courtauld Institute
Black chalk and pale sepia wash, heightened with white (lead?).

In pencil, in a nineteenth-century hand: *Herrera el mozo*, with another very old inscription, crossed out.

Attributed by the Courtauld Institute to Herrera the Younger, R. Buendia has ascribed this drawing to Juan Antonio Escalante, relating it to the painting in the Prado Museum which is signed and dated 1668, though he points out that apart from their proportions, the figures are only remotely connected. J. Brown attributes it to V. Carducho. Some of the figures, especially those in the background, recall Carducho's style and models, but the general composition and the foreground figures seem later and more advanced in their interpretation.

Witt, 1956, No. 49; J. R. Buendia, 1970, p. 43, Pl. VIII; J. Brown, 1973, p. 378.

MARRIAGE OF THE VIRGIN. Madrid, National Library
See Anonymous Drawings No. 354.
Barcia, No. 53.

ST. JEROME IN THE DESERT. New York, Metropolitan Museum, Sperling Bequest
Attributed to Vicente by J. Brown (1973, p. 275, Pl. 26), it is actually a work of Bartolomé. See Volume I, No. 95A.

ST. PETER RECEIVING THE KEYS. Madrid, National Library
This is by Cajés. See No. 29.
Barcia, No. 14.

MARTYRDOM OF A SAINT. Madrid, National Library
This is by Cajés. See No. 60 FLAGELLATION OF ST. LEOCADIA.
Barcia, No. 32.

ST. JOHN THE BAPTIST. Madrid, National Library
See under Anonymous Drawings, No. 391.
Barcia, No. 19.

KNEELING FRIAR. Madrid, National Library
See under Anonymous Drawings, No. 430.
Barcia, No. 504.

FIGURE KNEELING BEFORE A POPE (?) Madrid, National Library

266×254 mm. Blacklead with touches of white. Dark greenish-grey paper.

This is not by Carducho, and it is probably not Spanish either.

Provenance: Madrazo Collection.

Barcia, No. 33.

A KING OF SPAIN. Madrid, National Library

220×190 mm. Black chalk. Grey-green paper. Squared in pencil.

Though hitherto attributed to Alonso Cano and closely related to the painting in the Prado Museum (No. 632), Kurt Gerstenberg believes this drawing to be by Carducho. He also considers it to be Carducho's model for one of the series in the Salón de Comedias in the Alcázar, though he ignores the fact, which is well documented, that Carducho submitted as model not a drawing but a painting with two figures (Angulo–Pérez-Sánchez, 1968, p. 182, No. 474). Moreover it is very different in style from the work of Carducho.

Barcia, No. 232. Martinez Chumillas, 1949, p. 90. K. Gerstenberg, 1967, p. 191.

STUDY OF A NUMBER OF FIGURES. Toronto, National Gallery of Canada. Inventory 6893

209×284 mm. Blacklead and sepia wash. Buff paper.

Attributed by the Gallery to Carducho in view of certain similarities with drawing No. 175, in the Ashmolean at Oxford. The presence of a monk led to the idea that it might be a drawing for the El Paular series. McKim Smith and J. Brown agree with this opinion. The attribution is not acceptable, and the drawing is probably not Spanish.

Acquired in London (Colnaghi) in 1957.

A. E. Popham and K. M. Fenwick, *Catalogue of European Drawings*, 1965, p. 205, No. 302; McKim Smith, 1974, No. 6; J. Brown, 1975, p. 61.

FÉLIX CASTELO

Madrid, 1595–1651.
A Madrilenian painter, son of one of the Italian painters who came to work at the Escorial, and a pupil of Vicente Carducho, whose style he imitates faithfully and in whose shop he must for many years have been the most outstanding journeyman.

258 THE BUILDING OF SOLOMON'S TEMPLE. Florence, Uffizi. Inventory No. 13980F

Pen and sepia wash. Buff wire-marked paper. Squared in pencil. *Plate LXIX*

Inscribed in ink: *13 Rls.*

Unattributed in the Uffizi, this drawing is of the Madrid School and close to Félix Castelo, though it cannot with certainty be given to the latter.

Provenance: Medici–Lorraine Collections (?)

259 SAMSON FINDS THE HONEY IN THE ENTRAILS OF THE LION. Florence, Uffizi

197×142 mm. Pen and sepia wash. Buff wire-marked paper. Squared in pencil. *Plate LXIX*

Attributed to Tempesta in the Santarelli Collection, this drawing is clearly a work of the Madrid School, in the circle of Vicente Carducho, and very similar to certain drawings of Félix Castelo, to whom it may be given with reservations.
The subject portrayed (Judges 14: 8–9) has always been thought to anticipate the Eucharist, and it should be recalled that in 1641 Castelo painted the vault of the antechamber of the Sacrarium in the Royal Chapel in the Alcázar at Madrid (Viñaza, 1889, II, p. 332).
The subject is especially suited to this location, and though there is no description of the themes actually depicted, it can be plausibly suggested that this was one of them.

Provenance: Santarelli Collection.

Santarelli Catalogue, p. 685, No. 7 (Inventory 10036S).

260 HOLY FAMILY IN THE CARPENTER'S WORKSHOP Florence, Uffizi

213×184 mm. Pen and ink and blue wash with touches of white. Greenish-grey paper. *Plate LXIX*

Listed in the Santarelli Collection as the work of an anonymous Spaniard.

This is the work of a follower of Vicente Carducho, and must be by Félix Castelo. It is very close to the latter's *Holy Family* in the church of Santa Isabel, Toledo (Angulo–Pérez Sánchez, Pl. 148).

Provenance: Santarelli Collection.

Santarelli Catalogue, p. 714, No. 102 (Inventory 10442); Pérez Sánchez, *Catálogo Florencia*, 1972, p. 60.

261 PARABLE OF THE GUEST AT THE KING'S WEDDING. Madrid, National Library

276×485 mm. Blacklead with touches of white lead. Dark buff paper. Squared in pencil. *Plate LXIX*

Barcia thought this was by Bartolomé Román (1596–1647) and linked it with the canvas by that artist in the sacristy of the Convent of the Encarnación in Madrid, and this attribution has been accepted until recently. In fact, it is the work of Castelo and relates directly to the picture painted for the Segovian Capuchins in 1641 and now kept in the Ceballos Collection in Madrid (Angulo–Pérez Sánchez, Pl. 147). It differs from the painting only in details and in the central group with the expelled guest.

Provenance: Carderera Collection.

Barcia, No. 470; Mayer, No. 78; Sánchez Cantón, II, 191; Exh. Hamburg, 1966, No. 190, Pl. 19; Angulo–Pérez, Sánchez, p. 199.

262 THE RECAPTURE OF THE ISLAND OF SAN CRISTOBAL BY DON FADRIQUE DE TOLEDO. Florence, Uffizi

190×225 mm. Black chalk, pen and sepia wash. Whitish buff paper. Squared in black chalk. *Plate LXIX*

On the verso, in ink, the price *2Rls* and in pencil, in a nineteenth-century hand: *Tempesti*.

Attributed in the Uffizi to Antonio Tempesta, Pérez Sánchez has pointed out that this drawing is a preliminary study for the painting signed by Félix Castelo (Prado No. 654) which forms part of the series of battles painted in 1634 (Angulo–Pérez Sánchez, Pls. 143–4) for the Buen Retiro Palace, and in which other Madrid artists collaborated (see Nos. 226 and 227).
The subject portrayed is the recapture by Spanish troops of the Island of San Cristobal (today St. Christopher or St. Kitts) in the West Indies.
It has been suggested that this is the same drawing as the *March of Soldiers* which was in the Kaileman Sale in Paris in 1858 (see the following item).

Provenance: Santarelli Collection.

Santarelli Catalogue, p. 685, No. 19; Pérez Sánchez, *Catálogo Florencia*, 1972, p. 59, No. 49, fig. 40.

263 SOLDIERS ON THE MARCH. Whereabouts unknown

Pen and ink and wash.
See the preceding entry for notes.

Provenance: Paris, Kaileman sale (1858). Sold for 20 francs.

Mireur, II, p. 113.

FRANCISCO RÓMULO CINCINNATO

Born in Madrid, *c.* 1579, the son of Rómulo Cincinnato and the younger brother of Diego. On the death of their father, both brothers studied at Madrid and later at Rome. In 1599 he is documented as living in Madrid and already married. On the death of Diego in 1625, Philip IV arranged that the membership of the Order of Christ bestowed upon him by the Pope, should pass to his younger brother Francisco, who was 'of equal merit and skill as a painter'. There is no record of his works in Madrid or in Rome, where, according to Palomino, he apparently died in 1635.

264 THE ENTRY OF CHRIST INTO JERUSALEM. Ann Arbor, University of Michigan, Museum of Art. Inventory, 1970, 2.27

203 × 307 mm. Pen and sepia wash. Cream laid paper.
Plate LXX

Signed in ink: *Fco. Romulo, en 21 Julio 1629.* In ink in the lower right corner, the number: *2.*

On the verso in ink ..*Romulo Cincinato* and a long inscription which identifies the painter with the son of the Italian Rómulo Cincinnato who worked in Madrid.

The signature adds special interest to this drawing as hitherto nothing has been known of the work of this distinguished artist who on many occasions was praised by his contemporaries.
It is a unique example of his style, which in its attitudes and figures still echoes the mannerist tradition of his father Rómulo and Zuccaro.

Provenance: M. Rosenheim Collection (Sale E. Parson and Sons, n.d.). Bequest of E. Sonnenschein.

Exh. Lawrence, Kansas, 1974, No. 17; M. Cazort Taylor, *European Drawings*, 1974, p. 8, No. 16; McKim Smith, 1974, No. 17; J. Brown, 1975, p. 61.

265 THE DREAM OF ST. JOSEPH. London Art Dealer (A. Stein)

195 × 140 mm. Pen and sepia wash. Cream laid paper.

In ink, in an old hand: *Cano.* In another hand *190 rls,* and another crossed-out inscription *No. 192*(?).

Although it has been called 'The Angel appearing to Christ', this drawing probably represents the Dream of St. Joseph.
Traditionally attributed to Alonso Cano, it has been ascribed to F. Rómulo by M. Cazort Taylor. Although there is clearly a close stylistic relationship, the attribution must be considered provisional, as there is only one known work by Francisco Rómulo which can serve as a basis of comparison, and the style of other draughtsmen with a similar background is equally unknown.

Provenance: De Pass Collection, 1928; No. 313; Truro, Royal Institute of Cornwall.

Catalogue, Christie's Sale, 30 November 1965, No. 137; Stein, 1973, No. 4; Cazort Taylor, 1974, p. 8; McKim Smith, 1974, p. 40.

GIAN FRANCESCO COLLADO

Several drawings by Eugenio Cajés in the Uffizi are ascribed to this name, which belongs to no artist we know of. See Nos. 46, 82–86.

FRANCISCO COLLANTES

Madrid 1599–1656.
Francisco Collantes was apparently a pupil of Vicente Carducho. He began to specialize early in landscapes enlivened with tiny figures, taken from the Bible or mythology, and is perhaps the only Spanish landscape painter with a distinctive personality. In his rare paintings with large figures, he displays a powerful naturalism, akin to that of Ribera.
We know virtually nothing about his activities as a draughtsman, except that Pedro Perret engraved a *Boar-hunt* from a drawing of his, which appeared in Juan Mateos's *Origen y dignidad de la caza* (Madrid, 1634). Ceán Bermúdez (I, 348) praised his drawings in red ink, none of which we have been able to locate.

266 THE VIRGIN AND CHILD ADORED BY ANGELS Whereabouts unknown

220 × 300 mm. Pen and ink with red wash.

No painting of this subject by Collantes is known.

Provenance: Paris, Lefort Collection.

Lefort Collection, 1869, No. 73. Sold at 16 francs.

267 FORESHORTENED CRUCIFIX. Besançon, Musée des Beaux Arts. Inventory D2316

322 × 222 mm. Blacklead. White laid paper.
Plate LXX

In ink, an abbreviated name which it is difficult to decipher: *fco Rz* (?).

Attributed to Collantes in the collection. If the signature represented *Francisco Rodríguez* or *Ruiz*, this would suggest a collector, because we know of no contemporary painter of those names.
The attribution to Collantes is doubtful.

Provenance: Jean Gigoux Collection.

268 ST. JEROME (OR AN EVANGELIST). Formerly Gijón, Instituto Jovellanos. Destroyed in 1936

140 × 250 mm. Blacklead. Dark-coloured paper.
Plate LXXI

Signed at the top: *Francisco Collantes* in his characteristic handwriting. An attribution in another hand: *Francisco Collantes f.*

On the back, according to Moreno Villa in Collantes's handwriting, fragmentary reflections on the confessions. The work is interesting for it is one of his rare figure drawings.

Moreno Villa, p. 40, No. 379; Pérez Sánchez, *Catálogo Gijón*, 1969, p. 53, Pl. III.

269 LANDSCAPE. Formerly Gijón, Instituto Jovellanos. Destroyed in 1936 with no surviving pictorial record

100 × 120 mm. Ink.

The name has been defaced. It apparently read: *L. M. Collan.*

It was catalogued as French, under the name of a non-existent Collat, when Moreno Villa attributed it to Collantes.

Moreno Villa, p. 53, No. 466; Pérez Sánchez, *Catálogo Gijón*, 1969, p. 53.

270 HEAD OF A MAN. Besançon, Musée des Beaux Arts. Inventory D 2250

224 × 205 mm. Blacklead. Blue-tinted laid paper.
Plate LXXI

The attribution to Collantes appears uncertain.

Provenance: John Gigoux Collection. Mentioned in his sale of 1882. (Wormser, unpublished thesis.)

271 STUDIES OF FEET. Madrid, National Library

277 × 222 mm. Red chalk. Two pieces of buff laid paper placed next to one another and pasted on a larger sheet.
Plate LXXI

The upper drawing is signed in ink: *Fran^co Collantes.* Also in ink but deleted: *2 R^s* and *m^o.*

Provenance: Madrazo Collection.

Barcia, No. 332; Mayer, 97; Exh. Madrid, 1934, No. 62.

PEDRO FREILA (or FREILE) DE GUEVARA

Cordovan architect and sculptor. He and his brother Juan worked during the first few years of the seventeenth century in Granada and Cordova and, judging by the following drawing, in Guadalupe as well.

272, 273 PRESBYTERY OF GUADALUPE CHURCH Madrid, National Library

Two sheets 480 × 319 mm. and 485 × 321 mm. Pen and ink with brown washes. Buff paper. *Plate LXXII*

One of the sheets is badly damaged.

On the first drawing, the measurements in ink. On the door: *474.* One is signed: *P^o freila de guevara.* On the other, a note in the hand of the architect Juan Gómez de Mora, badly defaced by a tear: *Su magt^d á bisto esta . . . / señora de guadalupe / qe el campo de los escudos y . . . / marmol blanco . . . señalado letras . . . los escudos sean de m^o reliebe con las colores que le pertenecen y que los compartimientos de dentro de los nichos de las figuras que fueran de colores; que estas rafajadas sean tan solam^te en campo pardo de marmol negro de granada y todo lo demás sea de Sant pablo; y que se aga asi. fha en Ma^d a 15 de Junio de 1606. Juan Gomez de Mora* (His Majesty has seen this . . . Lady of Guadalupe / that the field of the shields and . . . white marble . . . indicated letters . . . the shields should be in half relief with the appropriate colours and the compartments inside the niches with figures should be coloured. These embrasures (?) should alone be on a brown field in black Granada marble and all the rest in San Pablo (stone). Let it thus be executed. Dated in Madrid on the 15 June 1606. Juan Gómez de Mora). On each sheet there is also a note by a notary: *escritura en favor del monasterio de Guadalupe en 28 de Julio de 1606* (instrument on behalf of Guadalupe Monastery on 28 July 1606).

The two drawings show, in a form that agrees with the way they were eventually built, the side walls of the presbytery of Guadalupe Monastery, with the funeral monuments of Henry IV of Castile and his mother Doña María. It has come to be believed that the archi-

tectural design of the whole is by Gómez de Mora and the sculptures by Giraldo de Merlo. The Valencian Bartolomé Abril, the Genoese Juan Bautista Semería, and one Miguel Sánchez were also involved, as workers in marble.

In view of the signature on this drawing, one must assume that Freila de Guevara supervised the work. The architectural *œuvre* of Guadalupe is described and studied in Mélida, *Catálogo monumental de Cáceres*, II, pp. 150 ff.

Provenance: Royal Collection of the Palace of El Pardo.

Barcia, Nos. 359 and 360.

JUAN GÓMEZ DE MORA

Madrid c. 1586–1648.
An architect and decorator, the culminating figure of the first stage of Madrilenian baroque. Whilst still inspired by Juan de Herrera's severely classical forms, his style nevertheless moved towards continually more animated compositions. He was the favourite architect of both Philip III and Philip IV in the first years of his reign, and built the Monastery of the Encarnación, the Plaza Mayor and the City Hall in Madrid, and the Clerecía at Salamanca and many other monuments.

274 DESIGN FOR THE MAIN ALTAR-PIECE AT GUADALUPE. Madrid, National Library

635 × 336 mm. Pen and ink, and sepia and red wash. Buff laid paper. *Plate LXXII*

In the top left-hand corner, trimmed away: *. . . mas / estro.* On the two panels: *historias de nra. sra. de pintura* (stories of Our Lady of Painting) and *San geronimo* (St. Jerome). Underneath, a long inscription, in the architect's own hand:
Conforme a esta traça m.^da su mag.^d que se haga el Retablo del altar mayor del monasterio de nra. s.^a de guadalupe; todas quatro hordenes de colunas an de ser corintias, que son dedicadas a la Virgen: todos los frisos desta obra an de ser entallados al Romano, y las cornisas y alquitabes an de tener su talla, como son quentas obalos y carteles en las cornisas: las colunas todas estriadas de alto abajo y no entorchadas; los pedestales é asientos del Retablo y puertas, lo que alcança de la A a la B. a der ser de jaspe y marmol muy Ricamente labrado y conpartido, sin mas labores de las que aqui los çocolos señalados C. sobre que cargan las colunas pueden ser de diferencia de jaspe si pareçiere no hacerse de madera; y assi mando su mag.^d que no se altere nada de lo que aqui ba, sin particular orden suya; y que pinten el dho Retablo Vicencio Carducho y Ugenio Caxesi, sus pintores, y que la arquitetura talla y escoltura podrá el conbento elejir los mejores maestros que puedan acer esta obra con mucha perfeçion; que esta fue siempre la boluntad del Rey su padre, que aya gloria; y en quanto á la madera, si a de ser de borne o pino, que escoja la que mas convenga; y siempre de lo que se yçiere y dudare manda su mag.^d le bayan dando quenta. en Madrid a veynte de diciembre de mil seiscientos y catorce años. Para lo qual me mando firmar y entregar la dicha traça: esto es lo que mando Su mag.^d que se cumpla no ostante otros qualesquier conciertos y escripturas que el conbento tenga echas. Joan Gomez de mora.
(His Majesty commands that the altar-piece of the high altar of the Monastery of Our Lady of Guadalupe be made in conformity with this design. All four orders of

columns must be Corinthian, for they are dedicated to the Virgin. All the friezes of this work must be sculpted in the Roman manner, and the cornices and architraves are to have their carvings, as for example egg and dart and cartouches on the cornices. All the columns fluted from top to bottom and not twisted. The pedestals and lower parts of the altar-piece and the doors, everything between A and B must be jasper and marble, very richly worked in panels, but worked no more than those drawn here. The socles marked C on which the columns rest can be of a different jasper if it is thought better not to make them of wood. His Majesty therefore commands that nothing herein be altered without his personal sanction. And let Vicente Carducho and Eugenio Cajés, his painters, paint the said altar-piece. And for the architectural masonry, carving and sculpture the Convent may select the best masters to execute this work most perfectly, for such was always the will of the King its progenitor to whom be glory. And as for the wood, whether it is to be pine or laburnum, let that be chosen which is most suitable. And His Majesty commands that he be continually given account of what is done and of any problems. In Madrid on the 20 December 1614. Wherefore he commands me to sign and hand over the said design. This is His Majesty's command; let it be carried out, any other agreements and instruments which the Convent may have had drafted notwithstanding. Juan Gómez de Mora.)

On the pediment, Faith and Charity. To either side of Christ, the Virgin and St. John. In the side attics, St. Peter and St. Paul. In the four upper compartments, prophets. In those of the middle tier, the Fathers of the Church, St. Jerome, St. Ambrose, St. Augustine, St. Gregory. In the compartments of the lowest tier, the Evangelists, St. Luke, St. Mark, St. John, and St. Matthew.

The figures of saints and prophets, touched in in red watercolour with remarkable mastery, seem to be the work of Vicente Carducho and Eugenio Cajés.

As Sánchez Cantón observes, although Ceán says the altar-piece was constructed according to a design by Vergara, this plan by Gómez de Mora was in fact followed with considerable fidelity, except that St. Jerome was not depicted in the central painting.

For the paintings of the altar-piece and its history, see Angulo–Pérez Sánchez, p. 111 and Pls. 59, 60, 174, and 175.

Barcia, No. 365; Mayer, 71; Sánchez Cantón, II, 155; Pérez Sánchez, *Gli Spagnoli dal Greco a Goya*, 1970, p. 81, pl. VI.

ANTONIO LANCHARES

Madrid *c.* 1590–Madrid 1630.
A Madrilenian painter, pupil of Eugenio Cajés, highly praised in his day. In the few of his works which have survived he shows himself a faithful follower of his master's style.

275 ABRAHAM CASTS FORTH HAGAR AND ISHMAEL Madrid, National Library

117 × 183 mm. Pen and ink and sepia wash. Buff paper.
Plate LXXIII

Listed as anonymous in Barcia's catalogue. Judging by the following items, which have early attributions, it seems possible to attribute this to Lanchares.

Provenance: Madrazo Collection.

Barcia, No. 507.

276 LOT FLEEING WITH HIS DAUGHTERS. Florence, Uffizi

180 × 186 mm. Pen and ink and sepia wash over preparatory drawing in blacklead. Buff laid paper.
Plate LXXIII

In ink in a seventeenth-century hand: *Lanchares.*

Provenance: Santarelli Collection.

Santarelli Catalogue, p. 688, No. 1 (Inventory 10074).

277 MATER DOLOROSA. Madrid, Condes de Alcubierre.

70 × 68 mm. Pen and ink. Laid paper. *Plate LXXI*

In the margin of the drawing, in ink in an eighteenth-century hand: *Lanchares.*

The drawing is of a different kind from the others attributed to him, but the facial type is not far removed from those in his paintings.

278 ST. LUKE, ST. MARK, AND ANOTHER SAINT Florence, Uffizi

160 × 223 mm. Pen and ink and sepia wash. White laid paper. *Plate LXXIII*

The style here is a little different from that of the other drawings attributed to him at the Uffizi.

Provenance: Santarelli Collection.

Santarelli Catalogue, p. 688, No. 3 (Inventory 10076).

279 TWO STANDING APOSTLE FIGURES. Florence, Uffizi

174 × 145 mm. Blacklead, pen and ink and sepia wash. Buff laid paper. One of the figures squared in pencil.
Plate LXXIII

If the subject were St. John the Evangelist, this could be a preparatory drawing for a Calvary, or possibly for an Assumption or Ascension.

Provenance: Santarelli Collection.

Santarelli Catalogue, p. 688, No. 2 (Inventory 10075).

280 MONK SITTING AND WRITING. Formerly Gijón, Instituto Jovellanos. Destroyed in 1936

160 × 120 mm. Reddish wash. *Plate LXXI*

Inscribed (or signed?): *Lanchares.*

This drawing belonged to Ceán Bermúdez who mentions it in his *Diccionario: Conservo un dibujo original de su mano, que figura un obispo sentado, hecho con aguada roxa, con mucha valentía y magisterio* (I have in my keeping an original drawing from his hand, which depicts a seated bishop, done in red wash with great dash and mastery). It is easy to see Lanchares' dependence on Cajés' figure

types and technique. This is the only drawing of this kind known and attributed to Lanchares, but the fact that the technique is that used by his master and that the attribution is an old one, which Ceán may merely be repeating, suggests that the drawing could be by him.

Ceán, III, p. 3; Moreno Villa, p. 41, No. 384; Pérez Sánchez, *Catálogo Gijón*, 1969, p. 81, Pl. 159.

281 A WOMAN SUCKLING A CHILD, AND OTHER FIGURES. Florence, Uffizi

160×225 mm. Pen and ink and sepia wash. Buff laid paper. *Plate LXXIII*

Provenance: Santarelli Collection.

Santarelli Catalogue, p. 688, No. 4 (Inventory 10077).

ANDRÉS LASCHETA

The catalogue of the Santarelli Collection attributes a number of drawings to an artist of this name, who is unknown to us. The name, which is written on one drawing in an eighteenth-century hand, could be that of a collector. (See Nos. 346, 400, 412 and 413.)

JOSÉ LEONARDO

Catalayud 1602–Zaragoza 1656.
He trained in Madrid with Eugenio Cajés, and was later influenced by Velázquez. He is one of the most interesting personalities in Madrilenian painting. Unfortunately, in 1648, he went mad. His battle paintings for the Hall of Kingdoms at Buen Retiro are possibly the most beautiful next to Velázquez's *Las Lanzas*, in their stylishness, lightness of touch and exceptional handling of colour.

282 THE PURIFICATION OF THE VIRGIN. Madrid, National Library

441×380 mm. Blacklead and sepia wash. Buff laid paper. *Plate LXXIV*

In ink in a seventeenth-century hand which may be that of the artist: *Joseph leonardo*. Also in ink: *5 Rls*. At the top: *4*.
Leonardo's affinity with his master Cajés shows clearly in the figure types and technique.

Provenance: Carderera Collection.

Barcia, No. 420; Mayer, 91; *id.*, *Historia*, 1947, p. 453.

283 THE PRESENTATION OF THE VIRGIN IN THE TEMPLE. Madrid, Biblioteca de Palacio Real

205×195 mm. Sepia wash over preparatory drawing in black chalk. Cream laid paper. Squared in pencil.
Plate LXXV

In ink in a seventeenth-century hand: *Joseph Leonardo*. In another later hand: *2 rls*.

This drawing was published by Mazón de la Torre with the title of *Christ disputing with the Doctors*, the inscrip-

tion being regarded as a signature. Although the squaring suggests that a painting was executed, this cannot be traced today.

Mazón, 1975, p. 266, fig. 5.

284 ST. ISIDORE PLOUGHING. Madrid, Prado Museum. Inventory No. F.A. 84

220×150 mm. Blacklead, and reddish sepia wash. Buff laid paper. *Plate LXXV*

The lower right-hand corner is damaged.
In ink in a seventeenth-century hand: *Leon . . .* Also in ink: *6 Rs*.

Sánchez Cantón reproduces this as an anonymous work of *c.* 1660–70. But its relation to Cajés' idiosyncratic mannerism is evident and the damaged inscription no doubt refers to Leonardo.

Provenance: Royal Collection.

Sánchez Cantón, V, 253; Pérez Sánchez, *Catálogo Prado*, 1972, p. 100.

285 THE SURRENDER OF JÜLICH. Madrid, Prado Museum

260×390 mm. Preparatory drawing in blacklead. Pen and ink and sepia wash. Buff laid paper. Squared in pencil. *Plate LXXV*

In ink in a seventeenth-century hand: *Joseph leonardo en el Retiro* (José Leonardo at Buen Retiro).

Preparatory drawing for the main group on the canvas painted in 1634 for the Hall of Kingdoms at Buen Retiro and now in the Prado Museum (No. 858). The two generals on horseback are Ambrogio di Spinola and Don Felipe Messia de Guzmán, Marquis of Leganés. The presence of Spinola has on occasion caused the painting and the drawing to be interpreted as representing his capture of Breda.

Provenance: Fernández Durán Bequest, 1930, No. 331.

Trapier, 1941, p. 33; Sánchez Cantón, II, 224; *id.*, *Spanish Drawings*, 1964, Pl. 39; *id.*, 1966, Pl. 71; Exh. Hamburg, 1966, No. 147, Pl. 36; Sánchez Cantón, *Dibujos españoles*, 1969, p. 71; Pérez Sánchez, *Gli Spagnoli dal Greco a Goya*, 1970, p. 90, fig. 16; *id.*, *Catálogo Prado*, 1972, p. 100, pl. 44.

Attribution not accepted

ADORATION OF THE ANGELS. Madrid, Academia de San Fernando

See under Anonymous Drawings, No. 355.

JUAN DE LICALDE

A Madrilenian painter, pupil of Pedro de las Cuevas, who was active about 1628, and who, according to his biographer, died young leaving few works.

286 LION WITH THE ROYAL ARMS. Madrid, National Library

330×228 mm. Pen and ink. Buff laid paper.

Page 6

An inscription in the artist's hand: *MANDO SU MAGESTAD HICIESE ESTE LEON CON | sus Reales Armas en San Lorenzo el Rl a I de Nobiembre 1628* (His Majesty commanded that I should make this lion with his royal arms at San Lorenzo el Real on the I November 1628), and a signature: *Juan de Licalde en el amor de Dios a 10 de Nobiembre 1628* (Juan de Licalde in the love of God on the 10 November 1628).
In ink in the hand of the collector Carderera: *este dibujo lo cita Ceán Bermúdez en su dicco articulo Liclade* (Ceán Bermúdez mentions this drawing in his *Diccionario* in the article on Licalde).

Ceán Bermúdez gives a detailed description of this drawing—at that time it belonged to the engraver Pedro González de Sepúlveda.
It is the artist's only known work.

Provenance: González de Sepúlveda Collections. Carderera Collection.

Barcia, No. 85; Ceán, III, 37; Mayer, 77; *id.*, *Historia*, 1947, p. 417.

JUAN BAUTISTA MAINO

Pastrana 1578–Madrid 1641.
A Spanish painter whose father was Italian. He was probably trained in Italy, for he was one of the first to introduce Caravaggio's style into Spain. His personal interpretation of this style favoured clear colours in the manner of Gentileschi while retaining the classical figure types characteristic of the Carracci's circle. In 1611 he professed as a Dominican friar, and in his mature years in Madrid he was Philip IV's drawing master and perhaps royal mentor in artistic matters. He painted the main altar-piece in the Convent of San Pedro Mártir in Toledo, whose parts are now dispersed, and he collaborated on the Hall of Kingdoms at Buen Retiro in 1634, with his masterly *Recovery of Bahia*, now in the Prado.

Attribution not accepted

ONE OF THE MAGI KNEELING. London, Courtauld Institute

240×327 mm. Charcoal and chalk. Greenish-blue paper.

On the verso: a study of a male nude, and in pencil in a modern hand: *Parte del cuadro de la toma de posesion del Brasil por Dn Fadrique de Toledo en el Retiro* (Part of the picture of the taking possession of Brazil by Don Fadrique of Toledo at Buen Retiro).

Two figures are lightly sketched in the middle distance.

Mayer interpreted the inscription literally and noticing that the figure did not appear in the painting which is now in the Prado, came to doubt whether the latter was really the painting from the Buen Retiro series.
The shaven or almost shaven head, with a topknot or pigtail at the back, suggests that this is one of the Three Kings, and not a defeated king in a historical painting.

Although we possess no other drawing by him the attribution to Maino seems unacceptable, and the Cortonesque character of the linework suggests this may be Italian, from the second half of the seventeenth century.

Provenance: Collection of Sir John Stirling Maxwell. Witt Collection.

Mayer, *Arte Español*, 1926, p. 3; Witt, p. 161, No. 38.

SANTIAGO MORÁN (the Elder)

A Madrilenian painter—apparently a pupil or friend of Juan Pantoja de la Cruz—who died *c.* 1626. He is recorded above all as a portraitist, although no authenticated portrait has come down to us. His compositions echo Pantoja's style. He is sometimes confused with his son who had the same name.

287 THE MEETING AT THE GOLDEN GATE. Florence, Uffizi. Inventory No. 6112F

370×240 mm. Pen and ink and sepia wash. Buff laid paper.

Plate LXXVI

In ink in a hand of the period: *de Santiago moran pintor del Rey* (by Santiago Morán, the King's painter).

The style is fairly typical of El Escorial, with a pronounced Venetian influence.

Ferri, *Catálogo riassuntivo*, 1890-7, p. 361.

288 HEAD OF A YOUNG WOMAN. Whereabouts unknown

260×190 mm. Blacklead lightly picked out with white chalk.

Whether it is by the father or the son is not specified.

Provenance: Paris, Lefort Collection.

Lefort, *Collection*, 1869, No. 151.

Attribution not accepted

TITLE PAGE FOR A BOOK. Florence, Uffizi
By Santiago Morán the Younger. See No. 289.

SANTIAGO MORÁN (the Younger)

Madrilenian painter, son of the above, whose activities are documented from 1634 to 1663, when he died in Valladolid. Several competent religious paintings are known by him, and from his drawings the engravings were made which illustrate the *Nueve Musas*, poems by Quevedo.

289 TITLE PAGE FOR A BOOK. Florence, Uffizi

278×200 mm. Pen and ink and brown wash. Buff paper.

Page 62

Signed in ink: *Santiago moran fe.*

Catalogued as anonymous in the Santarelli Collection.

It was considered by Sánchez Cantón to be the work of Morán the Elder, but the more advanced style, and the known activity of the son as a book illustrator, encourage an attribution to him.

Provenance: Santarelli Collection.

Santarelli Catalogue, p. 716, No. 149 (Inventory 10479); Sánchez Cantón, II, 189.

ANGELO NARDI

Razzo (Tuscany) 1584–Madrid 1664.
He was trained in Italy, came to Spain in 1607, and settled in Madrid, working for the Court and attaining the post of Royal Painter, unpaid in 1625 and salaried in 1631. His style, which is a little archaic for its date, is full of reminiscences of Tuscan and Venetian painting, and his output is of a consistently high quality. His most important works are preserved at Alcalá de Henares, Jaén, and La Guardia (Toledo).

290 THE PLACING OF THE CHASUBLE ON ST. ILDE-FONSUS. Formerly Gijón, Instituto Jovellanos. Destroyed in 1936

380×270 mm. Carmine watercolour. Coarse paper.
Plate LXXVI

On the back, some geometrical axioms and the signature: *Miguel Ballesteros* and *don. . Carrisco*.

This could be one of the drawings 'in red wash' by Nardi that Ceán Bermúdez once owned and that he mentions in his *Diccionario* (II, 223).
The attribution recorded by Moreno Villa must have been based on a label. We do not know of any other drawings by Nardi which could confirm or refute the attribution to him of this work, which is certainly Castilian from the first half of the seventeenth century.

Moreno Villa, p. 7, No. 57; Pérez Sánchez, *Catálogo Gijón*, 1969, p. 64, Pl. 187.

291 ADORATION OF THE SHEPHERDS. Whereabouts unknown

200×142 mm. Ink and wash.

'Study of the original painting from the Count of Aguilar's collection, now in the Louvre', according to the catalogue of the Standish Collection, 1842.
The painting alluded to must be that from the Luis Felipe Collection, now in the National Gallery in London (Neil MacLaren, *The Spanish School*, 1952, p. 60, No. 232) that belonged to the Count of Aguila (not Aguilar). It is thought to be of the Sevillian School, but it was no doubt once considered a work by Nardi.

Provenance: Paris, Standish Collection.

Standish, *Collection*, 1842, No. 451.

292 ADORATION OF THE SHEPHERDS. Whereabouts unknown

173×129 mm. Ink and wash.

'Preparatory drawing with variants, for the painting from the Count of Aguilar's collection, now in the Louvre', according to the catalogue of the collection, 1842.
This drawing probably relates to the same painting as No. 291.

Provenance: Paris, Standish Collection.

Standish, *Collection*, 1842, No. 452.

293 ANGELS PLAYING MUSICAL INSTRUMENTS
Whereabouts unknown

180×240 mm. Red wash, picked out in white.

Signed: *Angelo Nardi*.

Provenance: Ceán Bermúdez Collection. Paris, Lefort Collection.

Ceán, III, p. 223; Lefort, *Collection*, No. 320 (sold for 5 francs).

PEDRO NÚÑEZ

Madrid *c.* 1590–1649.
A Madrilenian painter who was trained in Italy, where he rose to become a member of the Accademia di S. Luca in Rome. A scant few works by him have survived, impressive in their quality, the summation of mixed influences from Bolognese classicism to incipient tenebrism.

Attribution not accepted

ABRAHAM AND THE THREE ANGELS. Vienna, Albertina

301×410 mm. Blacklead and red chalk; pen and sepia wash with touches of white lead. Yellowish paper. Squared in pencil.

In ink in capital letters, perhaps eighteenth century: *PEDRO NUNES*, superimposed on other writing which is not easy to read.

The enormous difference in style from the few paintings known to be by Núñez precludes the acceptance of this attribution. It is even very likely that the drawing is Italian.

Exposición historico-europea, Madrid, 1892–3, Room I, No. 553; Mayer, No. 98; *id.*, *Historia*, 1947, p. 461.

PEDRO DE OBREGÓN

Madrid *c.* 1597–1657.
A pupil of Vicente Carducho, his few authenticated works reveal him as a copyist and imitator of his master. He was also an engraver, and some of his engravings after compositions by Alonso Cano have survived.

294 PIETÀ WITH ANGELS. Madrid, Prado Museum. Inventory No. F.A. 88

156×190 mm. Oval. Preparatory drawing in pencil. Pen and brush with ink and sepia wash. Buff laid paper.
Plate LXXVI

In pencil in a modern hand: *Legajo 43* (Bundle 43), *nº 24* and *Pedro de Obregón*.

In spite of the fact that the attribution is a recent one, it is so definite that whoever made it may have had some corroborative information regarding the origin of the drawing. The style of the only known paintings by this artist does not appear to conflict with that of the drawing.

Provenance: Royal Collection at the Palace of El Pardo.

Pérez Sánchez, *Catálogo Prado*, 1972, p. 107.

FRANCISCO DE PALACIOS

Madrid 1640–76.
An artist with very few authenticated works, he was a pupil of Velázquez, and was admired for his portraits and *bodegones*.

295 ANNUNCIATION. Madrid, Prado Museum
Inventory No. F.A. 89

160×160 mm. Preparatory drawing in pencil. Ink and sepia wash, with touches (or blotches) of green watercolour. Buff paper. Squared in pencil. *Plate LXXVII*

In ink in a seventeenth-century hand (?): *Palacios*.

Since we do not know any of Palacios' paintings apart from the *bodegones* in the Harrach Gallery, Vienna, we have no criteria by which to confirm or refute the old attribution. The style is similar to that of the drawings by Cajés and his circle.

Provenance: Royal Collection.

Pérez Sánchez, *Catálogo Prado*, 1972, p. 109.

ANTONIO DE PEREDA

Valladolid 1611–Madrid 1678.
Although he was born in Valladolid, his training and style are entirely Madrilenian. He studied as a protégé of the Italian Giovanni Battista Crescenzi, Marqués de la Torre, who involved him in the decoration of the Hall of Kingdoms at Buen Retiro. On the death of his protector in 1635, he did not return to work for the Palace but dedicated himself wholly to religious painting and collectors' pieces. His style blends Venetian and Flemish characteristics with a highly personal attitude to naturalism.
His *bodegones* and *Vanitates* are key works of their kind, and his religious compositions, while sometimes awkward, always attain a high standard in their technique and use of colour.

296 THE HEALING OF TOBIAS. Madrid, Casa de la Moneda (Royal Mint). Inventory No. 149

190×154 mm. Pen and sepia wash over preparatory drawing in red chalk, heightened with white. Cream laid paper. *Plate LXXVII*

In ink: *M.S* interlaced, the monogram of Mariano González de Sepúlveda, who bequeathed his collection of drawings to the Casa de la Moneda. In blue pencil *149*.

A preparatory study with very slight variations for the painting, signed and dated 1652, in the Bowes Museum, Barnard Castle. (E. Young, 1970, p. 59, No. 34.)

Provenance: González de Sepúlveda, 1812.

297 GOD THE FATHER. Paris, Jacques Petit Horry

Preparatory drawing in pencil. Ink and sepia wash, with touches of white lead. Bluish-grey paper. *Plate LXXX*

The attribution to Pereda in the collection, is probably correct, judging by the very close similarities of the face and of the drapery folds to those of the St. Paul on one of the side altars in the church of the Carmelites at Toledo—a work which probably belongs to 1645, the date of the canvas on the high altar. Apart from its excellent quality, the drawing is important because it is the only one we know of that uses this exceptionally light technique.

Provenance: Paris, Ruby Collection.

298 THE IMMACULATE CONCEPTION. Florence, Uffizi

335×240 mm. Prepared with blacklead and red chalk. Touches of red wash. Buff laid paper. *Plate LXXVII*

Composition and movement are reminiscent of the *Immaculate Conception* painted in 1657 in the Hospital of the Tertiary Order in Madrid and so far unpublished. In the Santarelli Collection the drawing was attributed to Murillo.

Provenance: Santarelli Collection.

Santarelli Catalogue, 1870, p. 692, No. 10 (Inventory 10130); Pérez Sánchez, *Catálogo Florencia*, 1972, p. 72, no. 73, fig. 54; *id.*, 'Dibujos españoles en los Uffizi florentinos', *Goya*, 111, 1972, pp. 151 and 154.

299 THE IMMACULATE CONCEPTION. Florence, Uffizi

415×290 mm. Prepared with blacklead and red chalk. Crimson wash. Buff laid paper. *Plate LXXVII*

Torn and repaired, especially at the right, where a large piece of paper is missing and has been clumsily replaced. In the posture and in the groups of angels the drawing is related to the large picture of the *Immaculate Conception* in the Museo de Arte at Ponce, Puerto Rico (*Catalogue*, 1965, p. 130), which is believed to have been painted in 1635. In the Santarelli Collection attributed to Murillo.

Provenance: Santarelli Collection.

Santarelli Catalogue, 1870, p. 692, No. 11 (Inventory 10131); Pérez Sánchez, *Catálogo Florencia*, 1972, p. 73.

300 VISITATION. Florence, Uffizi

185×235 mm. Preparatory drawing in pencil. Pen and brown wash with touches of white lead. Greenish paper. *Plate LXXVII*

Listed as an anonymous work in the Santarelli Collection. The figure types, and the character of the drawing, are reminiscent of Pereda's paintings, and the drawing is in

fact a study for the canvas in the Museo Lázaro Galdiano, which has evidently been trimmed down either side and has therefore sometimes been understood as the *Return of the young Jesus*, or as *St. Joachim and St. Anne receiving the Virgin*, because the figure of St. Joseph with the donkey, which enables one to recognize the *Visitation*, has disappeared with the cutting.

Provenance: Santarelli Collection.

Santarelli Catalogue, p. 708, No. 7 (Inventory 10337). Pérez Sánchez, 'Dibujos españoles en los Uffizi florentinos', *Goya*, III, 1972, pp. 152 and 154; *id., Catálogo Florencia*, 1972, p. 72, no. 72, fig. 55.

301 THE AGONY IN THE GARDEN. Madrid, Prado Museum

296 × 245 mm. Red wash over black chalk. Buff paper.
Plate LXXVII

The figure of the Apostle in the foreground directly recalls the technique and model of No. 307. The angel is also related to other drawings of Pereda (*The Immaculate Conception* in the Uffizi, No. 299), and justifies an attribution to him.

Provenance: Fernández Durán Bequest, 1930, No. F.D. 1624.

Pérez Sánchez, *Catálogo Prado*, 1972, p. 112.

302 CHRIST ON THE CROSS. Madrid, Prado Museum

185 × 130 mm. Pen and ink. Buff laid paper.
Plate LXXVIII

In ink, probably in the artist's hand: *1648.*

This was attributed to Tristán in the Lefort Collection, but the date precludes an attribution to that artist, who died in 1624. The figure type and the technique suggest Pereda.

Provenance: Paris, Lefort Collection. Fernández Durán Bequest No. 1408.

Lefort, *Collection*, 1869, No. 193; W. Burger, *Histoire des Peintres*, Paris, 1880; Pérez Sánchez, *Catálogo Prado*, 1972, p. 113.

303 PIETÀ. Madrid, Academia de San Fernando

173 × 171 mm. Pen and ink, over a previous attempt in red chalk. Buff laid paper. *Plate LXXVIII*

A study, with variants, for the painting now kept in the Marseilles Museum and thought to date from the artist's mature years (1650–60).

Provenance: Royal Collection at the Palace of El Pardo, where it was already attributed to Pereda.

Tormo, p. 90; Velasco, No. 4; Angulo, p. 32, Pl. 34; Pérez Sánchez, *Catálogo San Fernando*, 1967, p. 117; *id., Gli Spagnoli dal Greco a Goya*, 1970, p. 90, fig. 18.

304 APPEARANCE OF THE CHILD JESUS TO ST. ANTHONY. Whereabouts unknown

290 × 210 mm. Oval. Pen and ink with sepia wash and touches of white lead.

Provenance: Lefort Collection.

Lefort, *Collection*, 1869, No. 169.

305 recto ST. DOMINIC IN SORIANO. Madrid, Biblioteca Nacional

265 × 227 mm. Red chalk. Yellowish (chick-pea) coloured paper. *Plate LXXVIII*

This drawing was regarded by Barcia as a doubtful work by José del Castillo, the eighteenth-century painter, but Sinués y Urbida, at the suggestion of Gómez Moreno, has related it to the painting by Pereda, now in the Cerralbo Museum, Madrid, dated *c.* 1655 (Tormo, 1916, p. 86). Although the technique is somewhat different to that of other autograph drawings in the same medium, the variants *vis-à-vis* the painting are sufficiently marked to make it acceptable as a preparatory study. Of special significance is the kneeling figure who is receiving the picture with the miraculous effigy of the Saint: in the drawing this is a peasant, and in the finished composition he is a Dominican friar, in accordance with the legend.

Provenance: Madrazo Collection.

Barcia, No. 936; Sinués y Urbida, 1917, pp. 22–4; A. Mortimer, 1933, p. 131. Dep.

305 verso A study of a female figure for one of the Saints, and a nude child, a study for one of the angels. *Plate LXXVIII*

306 THE PLACING OF THE CHASUBLE UPON ST. ILDEFONSUS. London, British Museum

322 × 310 mm. Red chalk and wash. White laid paper.
Plate LXXIX

In ink in a seventeenth-century hand: *Pereda.*

This should be the drawing that Mayer considers a study for the *St. Dominic at Soriano* in the Museo Cerralbo.

Mayer, *Historia*, 1974, p. 459.

307 recto ST. JEROME. London, British Museum

252 × 215 mm. Blacklead and red ochre. Buff laid paper.
Plate LXXX

In pencil in a modern hand: *Pereda.*

Provenance: Madrazo Collection. Malcolm Collection.

Mayer, Nos. 93 and 94; *id., Historia*, 1947, p. 459; Sánchez Cantón, *Spanish Drawings*, 1964, Pl. 34; *id.,* Spanish ed., 1969, p. 65; Pérez Sánchez, *Gli Spagnoli dal Greco a Goya*, 1970, p. 84, pl. XIX.

307 verso

Studies of hands, arms and legs and *Col. Madrazo, J.C.R. 1863. Madrid.* *Plate LXXXI*

308 NUDE OLD MAN (St. Jerome?). Madrid, Academia de San Fernando

307 × 250 mm. Red chalk with touches of white chalk. Dark-coloured paper. *Plate LXXX*

In pencil in a modern hand: *Pereda.*

The attribution, which is not definitive, was made by Tormo because of a certain similarity to the figure types in Pereda's paintings.

Tormo, No. 144, p. 77; Velasco, No. 108; Pérez Sánchez, *Catálogo San Fernando*, 1967, p. 117.

309 THE ASCENSION OF THE MAGDALENE. Whereabouts unknown

Pen and wash. Wire-marked paper. Very stained.

Plate LXXIX

Known only from an old photograph in the files of the Prado Museum, it would appear to be a typical work in the style of Pereda.

310 ST. PAUL. Madrid, Prado Museum. Inventory No. F.A. 724

185 × 144 mm. Blacklead. Buff, glueless paper.

Plate LXXX

In ink in handwriting which may be seventeenth-century: *Pereda*. Also in early handwriting, other superimposed inscriptions which are illegible.

The figure type and the soft, sensual technique are characteristic of Pereda. Given the character and the proportions of the drawing, one might think it was a first idea for the *St. Paul* that crowns one of the side altars in the church of the Carmelites, Toledo—a work of 1645 (see the note on No. 297).

Provenance: Allende–Salazar Bequest (1939).

Pérez Sánchez, *Catálogo Prado*, 1972, p. 113.

311 TRANSFIXION OF A MONK SAINT. Florence, Uffizi

175 × 265 mm. Preparatory drawing in blacklead. Pen and ink. Buff laid paper. *Plate LXXVIII*

In ink the price: *8 Rls.* and a numeration: *58.66.*

It is considered anonymous in the collection, but its style is so close to Pereda's as to suggest that it is by him.

Provenance: Santarelli Collection.

Santarelli Catalogue, p. 717, No. 166 (Inventory 10496).

312 MONK SAINT ADORING A STATUE OF THE VIRGIN Bayonne, Musée Bonnat. Inventory N.I. 1346, N.I. 1402

217 × 305 mm. Preparatory drawing in pencil. Pen and ink and sepia wash. Buff laid paper. *Plate LXXIX*

In ink in an eighteenth-century hand: *Pereda*.

The old attribution can be accepted with certain reservations.

313 AN INFANT ANGEL. Formerly Gijón, Instituto Jovellanos. Destroyed in 1936

100 × 80 mm. Charcoal. *Plate LXXXI*

In ink in a seventeenth-century hand: *Pereda*.

Ceán, to whom this drawing must have belonged, says in his *Diccionario* (IV, p. 67): *Conservo algunos dibuxos suyos executados con carbón y llenos de gracia, fecundidad*

e inteligencia (I have in my keeping some drawings by him done in charcoal, full of grace, invention, and wit.)

Moreno Villa, p. 42, No. 390; Sánchez Cantón, III, 238; Pérez Sánchez, *Catálogo Gijón*, 1969, p. 101, Pl. 203.

314 TWO HEADS. Formerly Gijón, Instituto Jovellanos. Destroyed in 1936

140 × 140 mm. Blacklead. *Plate LXXXI*

In ink in a seventeenth-century hand: *Pereda*.

In Mayer's view, possible studies for apostles in an Ascension or Assumption.

Acebal y Escalera, *Bocetos del Instituto Jovellanos*, 1878, Pl. 10; Mayer, No. 95; Sánchez Cantón, II, 238; Gómez Sicre, p. 57; Moreno Villa, p. 42, No. 391; Méndez Casal, *Blanco y Negro* (5, VIII, 1928); Pérez Sánchez, *Catálogo Gijón*, 1969, p. 101, Pl. 204.

315 HEAD OF AN OLD MAN. Madrid, Zobel Collection

85 × 56 mm. Blacklead. Buff laid paper. *Plate LXXXI*

On the back some late attributions: *Spanish, Francisco Herrera or Antonio de Pereda*.

Related to the preceding drawing and therefore probably attributable to Pereda.

316 ANGELS FOR AN IMMACULATE VIRGIN. Madrid, Prado Museum

360 × 252 mm. Pen and ink and light wash. Yellowish laid paper. *Plate LXXXII*

Preparatory drawing in pencil.

Graticulated, with an attribution in ink in an eighteenth-century hand (?): *de Pereda*.

Provenance: Fernández Durán Bequest, 1930, No. 1657.

Sánchez Cantón, III, 239; Pérez Sánchez, *Catálogo Prado*, 1972, p. 113.

317 CHILD ANGELS. Madrid, Prado Museum Inventory No. F.A. 822

243 × 180 mm. Black and red chalk, pen and sepia wash heightened with white. Buff wire-marked paper.

Plate LXXXII

On the verso, indecipherable outlines in red chalk.

Rather than a preparatory study for an individual painting, this drawing would appear to be a study of various poses for reference purposes.

Entered the Museum in 1971.

Pérez Sánchez, *Catálogo Prado*, 1972, p. 114.

318 DEATH OF A RIGHTEOUS MAN. London, Courtauld Institute

185 × 148 mm. Pen and ink and blue-grey and sepia washes. Buff laid paper. *Plate LXXXII*

In pencil, a nineteenth-century attribution: *Vélazquez*.

In the Stirling-Maxwell and Witt collections, this was thought to be by Zurbarán—an attribution completely

untenable. The character of the figures, especially of the angel accompanying the dying man, and the method of hatching, allow it to be included with Pereda's known work with certain reservations.

Provenance: Collection of Sir John Stirling Maxwell. Witt Collection.

Witt, No. 43, p. 163.

319 DEATH OF A RIGHTEOUS MAN. Norfolk (Virginia), Chrysler Museum

185×152 mm. Preparatory drawing in pencil. Pen and ink. Yellowish paper. *Plate LXXXII*

This drawing, attributed to Valdés Leal and thought to be of the death of a Franciscan saint, possibly St. Diego of Alcalá, looks, technically and in its human types, to be very close to Pereda and may be attributed to him, with certain reservations.
As far as the subject is concerned, the identification suggested does not seem definite.

Sánchez Cantón, *Spanish Drawings*, 1964, Pl. 49; *id.*, *Dibujos españoles*, 1969, p. 81; J. Brown, 1975, p. 61.

320 THE DEATH OF THE JUST MAN. London, Colnaghi

192×163 mm. Pen and sepia wash over preparatory outlines in black chalk. Cream laid paper.
 Plate LXXXIII

On the frame of the picture which the angel is showing to the dying man are the words *EXPEXO DE BUENA MUERTE* and another inscription: *IN | EST | FIDAS DE..(?)*

At one time attributed to Alonso Cano, Wethey (1952, p. 234) was the first to suggest the name of Pereda and that of Valdés. Leal has also been suggested here as well as for what is clearly the pendant drawing at Norfolk (No. 319). McKim Smith rejects the attribution to Pereda, but as J. Brown has pointed out the reasons are insufficient and it can be accepted. As Brown has indicated, this and the pendant at Norfolk must belong to a series illustrating the preparation for death of the Christian soul. To this same series also belonged No. 321 whose whereabouts are now unknown, and probably No. 318, which is almost identical in format and style.

Provenance: D. Farr Collection, London.

Exh. Colnaghi & Co., *Exhibition of Old Master Drawings*, June 25–July 12, 1974, No. 5; Wethey, 1952, p. 234; McKim Smith, 1974, p. 58; J. Brown, 1975, pp. 61–2.

321 THE DREAM OF LIFE. Whereabouts unknown

Pen and ink. *Plate LXXXIII*

Known only through a photograph. Sánchez Cantón connects it with the painting by Pereda in the Academia de San Fernando and regards the attribution as certain. It is at least close to his style. (See No. 320.)

Sánchez Cantón, III, 242.

322 DEATH OF A MONK SAINT. Madrid, Rodríguez Moñino

205×162 mm. Pen and ink and light sepia wash. Buff paper. *Plate LXXXIII*

In ink in an eighteenth-century hand: *Pereda*.

The style is close to work that is demonstrably by Pereda, and the attribution may be provisionally accepted.

323 ST. FRANCIS RECEIVING THE STIGMATA. New York, Metropolitan Museum. Inventory C. Vanderbilt 80.3.493

238×174 mm. Pen and ink and blue-grey wash over preparatory drawing in red chalk. Cream laid paper. Ink border. *Plate LXXXIII*

For long considered an anonymous Spanish work and entitled *Death of a Saint*, the identification of the subject and the attribution to Pereda are due to Mrs. McKim Smith. J. Brown would appear to agree. Although not entirely convincing, it is provisionally recorded here.

Provenance: C. Vanderbilt Collection.

Exh. Lawrence, Kansas, 1974, No. 33; McKim Smith, 1974, No. 33; J. Brown, 1975, p. 61.

324 SEATED MALE NUDE. Florence, Uffizi

273×220 mm. Blacklead and red chalk. Buff laid paper. Restored. *Plate LXXXI*

In ink in an eighteenth-century hand: *Pereda*. Also in ink, half crossed out: *2 Rls*.

Attributed to Blas de Prado in the Santarelli Collection, it was re-attributed to Pereda by Sánchez Cantón. It is noticeably rather academic.

Provenance: Santarelli Collection.

Santarelli Catalogue, p. 698, No. 21 (Inventory 10203); Sánchez Cantón, III, 237; Pérez Sánchez, *Catálogo Florencia*, 1972, p. 73, no. 74.

Attributions not accepted

LOT FLEEING FROM SODOM. Gijón, Instituto Jovellanos
Possibly the work of Pedro Orrente.

ATAULF. Madrid, Academia de San Fernando
This is by Vicente Carducho. See No. 225.

HOLY FAMILY. Madrid, Prado Museum
This is by Eugenio Cajés. See No. 26.

HOLY FAMILY. Madrid, Academia de San Fernando
This is by Eugenio Cajés. See No. 27.

MATER DOLOROSA. London, British Museum
See under Anonymous Drawings, No. 375.

VIRGIN AND CHILD. Hamburg, Kunsthalle, No. 5489
See under Anonymous Drawings, No. 359.

VIRGIN AND CHILD. Hamburg, Kunsthalle, No. 5488
See under Anonymous Drawings, No. 360.

CARAVAN. Vienna, Albertina. Inventory 13082
Preparatory drawing in pencil. Pen and ink.
In ink in handwriting which is perhaps nineteenth century: *Pereda*.

The draughtsmanship is somewhat reminiscent of Antonio del Castillo. But it is more likely that the drawing is not Spanish but French, in the manner of Callot.

MANUEL PEREIRA

Oporto 1588–Madrid 1683.
A Portuguese sculptor resident in Madrid from at least 1624, he was a figure of major importance in his time in the field of Castilian religious sculpture. He worked in both wood and stone and was the creator of some of the most expressive, sober, and lifelike devotional images in the whole of Madrilenian art.

325 ST. BRUNO. Paris, Dutch Institute

251×132 mm. Semicircular at the top. Blacklead. Greyish paper. *Plate LXXXIV*

On the mount, in an eighteenth-century hand: *Manuel Pereira*.

Closely related to the statue of St. Bruno from the hospice at El Paular, Madrid, which is now in the Academia de San Fernando, and which probably dates from around 1635–40, according to Kubler (*Art and Architecture in Spain and Portugal*, 1959, Pl. 79), or else from the 1650s, according to María Elena Gómez Moreno (*Ars Hispaniae*, XVI, p. 113).

Provenance: Collection of Sir W. Stirling-Maxwell; Sold at Sotheby's on 21 October 1963, No. 26; Lugt Collection.

326 MONK SAINT. Whereabouts unknown

270×170 mm. Blacklead. Bluish-grey paper. *Plate LXXXIV*

In ink in an eighteenth-century hand: *Pereyra*.

On the verso: a head in profile, looking down, and a half figure in profile, all in pencil.

We owe the photograph of this drawing and details of it to D. Manuel Gómez Moreno.
It is impossible to confirm or refute the attribution. The drawing is certainly sculptural in character.

DIEGO POLO (the Younger)

Burgos *c.* 1610–Madrid *c.* 1655.
Nephew of a painter of Burgos with the same name who is called the Elder for the sake of distinction. He was a pupil of Antonio Lanchares and worked as a painter for the churches of Madrid and for the Alcázar in 1639. His *œuvre*, which is of noteworthy quality, has only come to be known in recent years. He excelled above all in his exceptional gifts as an imitator of Titian.

327 MAN KNEELING. Florence, Uffizi

179×255 mm. Blacklead. Buff laid paper. Squared in pencil. *Plate LXXXIV*

In ink: *De mano de Diego Belazq . . .* (From the hand of Diego Velázquez), in an eighteenth-century hand, on top of some virtually illegible writing in pencil: *Diego Po . . .*
Although it is attributed to Velázquez in the Santarelli Collection, the half-effaced writing corroborates the attribution to Polo of this drawing as well as of the large painting of the *Gathering of Manna* which belonged to the collection of the Infante Don Sebastián Gabriel de Borbón (1811–75) and now in the art-market in Madrid, still attributed to Diego Polo. The drawing is no less than a preparatory study for the figure in the foreground of this painting, which was cited by Palomino in 1724 as one of this ill-fated artist's masterpieces. Palomino added that the painting was highly praised by Velázquez, to whose style it bears obvious affinities.

Provenance: Santarelli Collection.

Santarelli Catalogue, p. 689, No. 5 (Inventory 10086); Pérez Sánchez, *Archivo*, 1969, p. 47, pl. 2.

328 MAN STOOPING TO PICK UP STONES. Florence, Uffizi

170×165 mm. Blacklead. Buff laid paper. *Plate LXXXV*

In ink in an eighteenth-century hand: *dibujos de diego polo* (drawings by Diego Polo).

This drawing is attributed in the Santarelli Collection to an unidentified Pedro Pablo, but tallies with what we know of Diego Polo. It is in a graphic style to some extent related to that of Cajés and foreshadows that of Carreño.
It is most probably a study for a *Stoning of St. Stephen*, as the Santarelli Catalogue indicates.

Provenance: Santarelli Collection.

Santarelli Catalogue, p. 694, No. 2 (Inventory 10043); Pérez Sánchez, *Archivo*, 1969, pp. 47 and 50, pl. 50.

329 MAN THROWING STONES. Florence, Uffizi

205×123 mm. Blacklead. Buff laid paper. *Plate LXXXIV*

A companion piece to the preceding work. The face is clearly derived from the types of Cajés and Lanchares. The drawing is very probably for the same composition as No. 328, the *Stoning of St. Stephen*.
Also attributed to 'Pedro Pablo'.

Provenance: Santarelli Collection.

Santarelli Catalogue, p. 694, No. 3 (Inventory 10144); Pérez Sánchez, *Archivo*, 1969, p. 50.

330 SEATED WOMAN. Formerly Gijón, Instituto Jovellanos. Destroyed in 1936

240×190 mm. Blacklead. Coarse paper. *Plate LXXXIV*

In ink in a seventeenth-century hand: *diego Polo* and, in another hand, of the eighteenth century: *Diego Polo f.*

The old cataloguing of Menéndez Acebal (1886) listed this as being by Diego Polo the Elder, but Moreno Villa promptly attributed it to the Younger, an attribution that seems self-evident because of its kinship with the

preceding drawings and because of its entirely Seicento character.

Moreno Villa, p. 42, No. 392; Pérez Sánchez, *Catálogo Gijón*, 1969, p. 105, Pl. 210; *id., Archivo*, 1969, pp. 47 and 50, pl. 5.

331 SEATED MALE NUDE. Barcelona, Private Collection

Blacklead. Buff laid paper. *Plate LXXXIV*

In ink in a seventeenth-century hand: *Diego Polo* and a price *2 Rls.*

In the same technique as the preceding drawings.
For our knowledge of this work and the photograph reproduced here we are indebted to D. Manuel Gómez Moreno.

Pérez Sánchez, *Archivo*, 1969, pp. 47 and 50, pl. 5.

FELIPE RAMIREZ

A painter who was definitely Castilian and perhaps Toledan, and worked during the first third of the seventeenth century. A Still Life in the style of Sánchez Cotán, signed in 1628, and a few drawings are known to be by him. Ceán Bermúdez thought he was Sevillian.

332 MARTYRDOM OF ST. STEPHEN. Formerly Gijón, Instituto Jovellanos. Destroyed in 1936

330×260 mm. Watercolour with touches of white lead. Coarse greenish paper. Squared. *Plate LXXXV*

In a seventeenth-century hand: *Philipe Ramirez.*

Ceán describes it: *Tengo un diseño también firmado de su mano de más de tercia de largo y una cuarta de ancho, en papel verdoso, con tinta parda, realzados los claros con albayalde y tocado con mucha inteligencia del desnudo, que figura el matirio de San Esteban* (I have a drawing, likewise signed by his hand, more than a foot long and a span wide, on greenish paper, in brown ink with the highlights on the nude picked out in white lead most skilfully applied, which depicts the martyrdom of St. Stephen).
The fact that the inscription comes from the same hand as that on the following drawing, which cannot be a signature, makes it difficult to accept that the inscription on this is autographic. The drawing in fact copies, though with some variants, the engraving which C. Cortes made from M. Venusti's composition dated 1576.
The Prado Catalogue (1963) assumes, obviously by mistake, that the drawing mentioned by Ceán entered the Museum with the Fernández Durán Bequest. There was no drawing by Ramirez in the Bequest.

Ceán, IV, 146; Sánchez Cantón, II, 187; *id., Catálogo del Prado*, 530; Moreno Villa, p. 34, No. 326; Pérez Sánchez, *Catálogo Gijón*, 1969, p. 109, Pl. 215; Angulo–Pérez Sánchez, *Pintura Toledana*, 1973, p. 107.

333 ST. JOSEPH. Madrid, National Library

225×155 mm. Blacklead and red chalk. Buff laid paper. *Plate LXXXV*

In ink in a seventeenth-century hand: *de Philipe Ramirez.* Badly stained.

Provenance: Madrazo Collection.

Barcia, No. 452; Angulo–Pérez Sánchez, *Pintura Toledana*, 1973, p. 107.

334 STUDY FOR ST. ISIDORE THE FARM-SERVANT Formerly Gijón, Instituto Jovellanos. Destroyed in 1936 with no surviving pictorial record

240×170 mm. Ink.

Attribution: *Phelipe Ramirez.*

Moreno Villa, p. 34, No. 327; Pérez Sánchez, *Catálogo Gijón*, 1969, p. 109.

335 MALE TORSO AND THIGHS. Formerly Gijón, Instituto Jovellanos. Destroyed in 1936 with no surviving pictorial record

250×190 mm. Pencil, ink and white chalk. Blue paper.

On the back, heads and arms in red chalk, 'far superior to everything on the front' according to Moreno Villa.

Moreno Villa, p. 34, No. 328; Pérez Sánchez, *Catálogo Gijón*, 1969, p. 215.

BARTOLOMÉ ROMAN

Madrid *c.* 1598–Madrid 1659.
A pupil of Vicente Carducho, whose little studied *œuvre* was painted in Madrid between 1616 and 1640 and is somewhat marked by Velázquez's influence, according to Palomino.

Attribution not accepted

PARABLE OF THE GUEST AT THE KING'S WEDDING Madrid, National Library
This is by Félix Castelo. See No. 261.

Barcia, No. 470.

DIEGO DE ROMULO

Born in Madrid about 1580, the son of Rómulo Cincinnato. Patronized by the Duque de Alcalá, he went to Rome when still quite young and there painted a portrait of Urban VIII, achieved great success and took the habit of the Order of Christ. He died in Rome in 1625. No paintings from his hand have been preserved.

336 THE CIRCUMCISION. Formerly Gijón, Instituto Jovellanos. Destroyed in 1936 with no surviving pictorial record

430×290 mm. Ink and wash.

Attributed by Menéndez Acebal to Diego de Rómulo, by Moreno Villa to Diego's father Rómulo. Like the other drawings, it probably had some inscription 'Rómulo'. As this drawing and Nos. 337, 338, 339 are no longer extant it is impossible to say whether they were by the father or by the son, but the name 'Romulo' is more

likely to refer to the son, since the father was generally known as Cincinnato.

Menéndez Acebal, *Catálogo . . . del Instituto Jovellanos*, 1886, no. 399. Moreno Villa, no. 399. Pérez Sánchez, *Catálogo Gijón*, 1969, p. 115.

337 ALLEGORICAL FEMALE FIGURE WITH A GLOBE
Formerly Gijón, Instituto Jovellanos. Destroyed in 1936 with no surviving pictorial record

150×110 mm. Ink, pen and wash. Paper pasted on another sheet.

Inscribed on the original paper: *Rómulo*, on the new paper: *Diego Rómulo* and *Luquetto*. Moreno Villa gave it to the father, Cincinnato.

Menéndez Acebal, *op. cit.*, no. 400; Moreno Villa, no. 400; Pérez Sánchez, *Catálogo Gijón*, 1969, p. 115.

338 ROMAN SOLDIER(S?) AND A WOMAN WITH A PHRYGIAN CAP. Formerly Gijón, Instituto Jovellanos. Destroyed in 1936 with no surviving pictorial record

210×320 mm. Sepia wash and chalk.

Inscribed: *Rómulo*. Moreno Villa attributed it to the father, Cincinnato.

Menéndez Acebal, *op. cit.*, no. 401. Moreno Villa, no. 401. Pérez Sánchez, *Catálogo Gijón*, 1969, p. 115.

339 THE ISRAELITES IN THE DESERT. Formerly Gijón, Instituto Jovellanos. Destroyed in 1936 with no surviving pictorial record

240×300 mm. Ink and sepia wash.

Moreno Villa described it as follows: 'Some are praying, others bend down to drink . . . Among the characteristics of the drawing are the thick ankles and wrists, the staring eyes and the broken outlines. The wrong reading of a name, which I read *romuli*, *romulu* or *romulo*, has given rise to an unfounded attribution'. In fact, Menéndez Acebal gave the drawing to 'Rometi', a non-existent artist. If Moreno Villa's reading was correct, the drawing can be grouped with the other drawings of Diego de Rómulo.

Menéndez Acebal, no. 580. Moreno Villa, no. 580. Pérez Sánchez, *Catálogo Gijón*, 1969, p. 116.

ANDRÉS RUIZ

A painter who lived in Madrid, whose works have yet to be identified, who made a will on the 6 September 1622. From this document one infers that he practised portrait and landscape painting.

340 THE VENERABLE DOÑA SANCHA ALFONSO
Madrid, National Library

318×193 mm. Pen and ink and sepia wash. Buff laid paper. *Plate LXXXV*

In ink in handwriting that may be the artist's own: *Regnum mundi et omnem Ornatum eius comtespsi / propter amorem Domini mei Jesu Christi* (I have contemned (?)

the realm of the world and its every ornament for the love of my Lord Jesus Christ).
Signed: *Andres Ruis ynbenit* (Andrés Ruiz invenit). Also in ink: *6 Rs, 2 R., ½ r*. In pencil in a modern hand: *La venª Dª Sancha Alfonso*.

The venerable lady depicted was the daughter of King Alfonso IX. The habit which she is wearing is that of the Comendadoras de Santiago, a Spanish order in which only noblewomen take the vow.
The style of the drawing, very close to that of Carducho or Cajés, does not corroborate Barcia's attribution to the Sevillian Andrés Ruiz de Sarabia. This is now the only work which can be attributed with certainty to the Madrilenian Andrés Ruiz, who we know from documentary evidence must have moved in the same circles as the Madrilenians Cajés, Carducho, and Nardi.

Provenance: Carderera Collection.

Barcia, No. 102.

LUIS TRISTÁN

Toledo *c*. 1580–1624.
A Toledan painter, pupil of El Greco, Luis Tristán was an important figure at the dawn of the seventeenth century because of his move towards naturalism and tenebrism, although he abandoned neither his master's exceptionally svelte norm for the human figure nor his inspiration. Major works by him are the altar-pieces at Yepes (1616) and in the church of Santa Clara de Toledo (1623), and the excellent portrait of Cardinal Sandoval in Toledo Cathedral (1624); but no authenticated drawings are known.

341 WOMAN AT PRAYER. Whereabouts unknown

240×160 mm. Black chalk and wash.

Sold at the Hôtel Drouot, 8 November 1963, lot 173.

We have not seen it.

342 FOUR LANDSCAPES. Toledo, Catalina de la Higuera (1614)

The four drawings were valued at 34 rs. They appear in the inventory of the owner's dowry, according to a document published by F. B. San Roman, and testify to Tristán's interest in landscape drawing.

San Román, 'Noticias Nuevas para la biografía de Luis Tristan', *Boletín de la Real Academia de Bellas Artes*, 1924, p. 122; Angulo–Pérez Sánchez, *Pintura Toledana*, 1973, p. 199.

Attributions not accepted

CHRIST ON THE CROSS. Madrid, Prado Museum
Probably by Pereda. See No. 302.

Lefort, *Collection*, 1869, No. 193.

CHRIST CRUCIFIED, SURROUNDED BY ANGELS, WITH THE CREATOR IN GLORY. Madrid, Prado Museum

This is a copy, with variants, of the canvas by Reni in Santa Trinitá dei Pellerini. It may have been made from an engraving, perhaps after Tristán's death.

Provenance: Paris, Lefort Collection. Fernández Durán Bequest, No. 1694.

DEATH OF THE VIRGIN. Madrid, Academia de San Fernando
See under Anonymous Drawings, No. 376.

THE PLACING OF THE CHASUBLE UPON ST. ILDEFONSUS. Madrid, National Library
See Anonymous Drawings, No. 383.
Barcia, No. 487.

PENITENT ST. JEROME. Madrid, National Library
See Anonymous Drawings, No. 385.
Barcia, No. 488.

VIEW OF TOLEDO. London, British Museum. Inventory 1846-5-9-177
The attribution to Tristán dates from the nineteenth century and was no doubt made for no other reason than that the view was of Toledo and Tristán was the best known Toledan artist. Like its companion, it was done long after Tristán's death, perhaps even in the eighteenth century.

VIEW OF TOLEDO. London, British Museum
Inventory 1846-5-9-178
Companion piece to the preceding work.

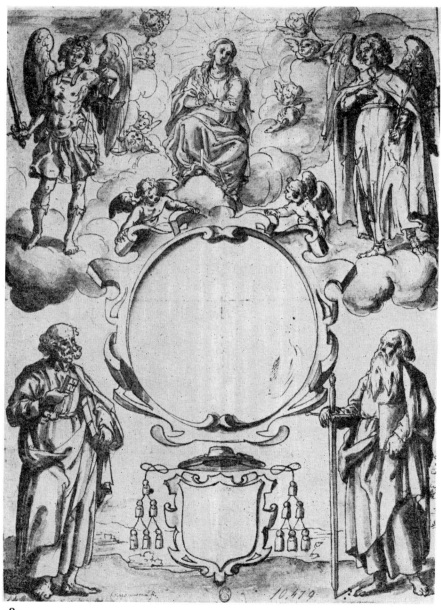

289

ANONYMOUS DRAWINGS

OLD TESTAMENT, NEW TESTAMENT AND MARIAN THEMES

343 THE TRINITY. Florence, Uffizi

292×166 mm. Pen and ink. Sepia wash. Buff laid paper.
Plate LXXXVI

The three persons are depicted with similar faces, according to the old iconography which fell into disuse in the sixteenth century but which survived in a few isolated cases in Spain and was much used until the eighteenth century in Spanish America.

This bears a certain stylistic likeness to the only known drawing by Santiago Morán the Younger (see No. 289) and to the Flight into Egypt (No. 362), without it being possible to assert that they are from the same hand.

Provenance: Santarelli Collection.

Santarelli Catalogue, p. 712, No. 69 (Inventory 10399).

344 THE TRINITY. Madrid, Private Collection

145×215 mm. Blacklead. Greyish-buff paper. Squared in pencil. *Plate LXXXVI*

345 MUSICIAN ANGELS. Madrid, National Library

175×295 mm. Pen and ink and sepia wash. Dark buff paper. *Plate LXXXVI*

The corners have been docked.

Provenance: Castellanos Collection.

Barcia, No. 563.

346 BIBLICAL FIGURE WITH A SWORD (ABRAHAM?) Florence, Uffizi

272×130 mm. Pen and ink and sepia wash. Buff laid paper. *Plate LXXXVII*

The Santarelli Catalogue, which attributes the drawing to a completely unknown Andrea Lascheta, considers that the man is Abraham.

Provenance: Santarelli Collection.

Santarelli Catalogue, p. 704, No. 4 (Inventory 10297).

347 LOT AND HIS DAUGHTERS. Madrid, National Library

189×120 mm. Pen and ink and light sepia wash. Buff paper. *Plate LXXXVII*

This could possibly be Italian.

Provenance: Madrazo Collection.

Barcia, No. 505.

348 A BANQUET, PROBABLY BIBLICAL. Hamburg, Kunsthalle. Inventory 38636

195×267 mm. Preparatory drawing in pencil. Brush and ink wash. Buff laid paper. *Plate LXXXVII*

In pen and ink, in an eighteenth-century hand: *Beláz-quez*.

On the back in ink: *162 / me dieron* (162 / they gave me).
This may not be Spanish.

349 BIBLICAL SCENE (?). Florence, Uffizi

72×86 mm. Brush and ink. Buff laid paper.
Plate LXXXVII

On the verso: fragments of a letter in Spanish.

This seems to represent a high priest next to an altar and an angel in the foreground.

Provenance: Santarelli Collection.

Santarelli Catalogue, p. 721, No. 222 (Inventory 10550).

350 AGRIPPINE SIBYL. Florence, Uffizi

340×205 mm. Pen and ink. Brown wash. Buff paper.
Plate LXXXVIII

The top is damaged.

The classical sibyls were characteristically represented, as here, revealing in paintings or cartouches the episodes of Christ's Passion, which they were supposed to have foretold. This iconography, studied by Mâle and Réau, fell into disuse from 1500 onwards apart from frequent exceptions in Spain, which are nearly always cyclic in form.

The drawing's style seems the reflection of a particular tradition from El Escorial. It appears to come from the same hand as the *Mater dolorosa* in the British Museum, No. 375.

Provenance: Santarelli Collection.

Santarelli Catalogue, p. 715, No. 134 (Inventory 10464).

351 PRUDENCE; FAITH. Madrid, Prado Museum

135×115 mm. Pen and ink and sepia wash. Buff paper.
Plate LXXXVIII

These are two different drawings on two separate, juxtaposed sheets of paper, but they are by the same artist and probably belong to a series of Virtues.

The work is very typical of the beginning of the century and of the Escorial tradition.

There is a resemblance to the stucco figures on the vaults of the Colleges of St. Sebastian at Málaga and St. Augustine at Cordova, which can be dated *c.* 1620.

Provenance: Fernández Durán Bequest, 1930, No. 652.

Pérez–Sánchez, *Catálogo Prado*, 1972, p. 162.

352 IMMACULATE VIRGIN. Madrid, Prado Museum

184×140 mm. Brush and violet ink, with touches of white lead. Dark-coloured paper. *Plate LXXXVIII*

Provenance: Fernández Durán Bequest, 1930, No. 1203.

Pérez Sánchez, *Catálogo Prado*, 1972, p. 136.

353 THE IMMACULATE VIRGIN WITH ST. ANTHONY AND ST. FRANCIS. Florence, Uffizi

215×142 mm. Pen and ink and sepia wash. Buff paper.
Plate LXXXIX

Listed as anonymous in the collection. It seems to be by a pupil of Vicente Carducho.

Provenance: Santarelli Collection.

Santarelli Catalogue, p. 709, No. 13 (Inventory 10343).

354 MARRIAGE OF THE VIRGIN. Madrid, National Library

202×191 mm. Blacklead, pen and ink and sepia wash. Dark buff paper. Squared. *Plate LXXXIX*

Barcia thought this was by Carducho, although he had his reservations. In fact, its strongly Zuccaresque character might suggest that it was by Federico Zuccaro himself.

Barcia, No. 53.

355 ADORATION OF THE ANGELS. Madrid, Academia de San Fernando

240×194 mm. Pen and ink and blue wash. Buff paper.
Plate LXXXIX

The figure types are fairly close to those of Cajés. The drawing was attributed to José Leonardo by Gómez Moreno—an attribution that Pérez Sánchez appears to accept. Velasco thought it an anonymous work of the sixteenth century.

Velasco, No. 9; Pérez Sánchez, *Catálogo San Fernando*, 1967, p. 99.

356 VIRGIN AND CHILD IN GLORY WITH ST. ANTHONY ABBOT, ST. JOHN THE EVANGELIST AND ST. CATHERINE. Florence, Uffizi

416×287 mm. Pen and ink and sepia wash. Buff paper.
Plate LXXXIX

Attributed to Blas de Prado in the Santarelli Collection, this is the work of an imitator of Cambiaso, possibly a Genoese, although the possibility that the drawing may be early seventeenth-century Spanish cannot be excluded.

Provenance: Santarelli Collection.

Santarelli Catalogue, p. 698, No. 29 (Inventory 10211).

357 VIRGIN AND CHILD WITH MONK AND NUN SAINTS. Florence, Uffizi

84×70 mm. Pen and ink and light wash. White laid paper. *Plate LXXXVIII*

The monk on the right and the nun appear to be wearing the white habit of the Bernardines. The monk on the left, in a black habit, could be St. Benedict; he is presenting the nun to the Virgin. The scene seems to be inscribed in a circle.

A Madrilenian work from a group close to Carducho's pupils.

Provenance: Santarelli Collection.

Santarelli Catalogue, p. 710, No. 46 (Inventory 10376).

358 THE VIRGIN OF THE LEATHER THONG WITH AN AUGUSTINIAN SAINT AND A DONOR. Madrid, National Library

290×185 mm. Pen and ink and wash. Buff paper.
Plate XC

The Virgin and Child are typical of the Renaissance, but the dress of the donor compels one to date the drawing to the second decade of the seventeenth century.

Provenance: Madrazo Collection.

Barcia, No. 603.

359 VIRGIN AND CHILD. Hamburg, Kunsthalle Inventory 5489

143×98 mm. Pen and brush and ink and sepia wash. Buff paper. *Plate XC*

In ink in a seventeenth-century hand: *1620*, $\overset{\circ}{I}$ or $\overset{\circ}{T}$.

Mayer attributed this to Pereda. Since then, it has been considered the work of an anonymous Andalusian because it is slightly reminiscent of Cano. The attribution to Pereda appears unacceptable in any case, and the monogram is difficult to decipher.

Mayer, 'Die Spanischen Handzeichnungen in der Kunsthalle zu Hamburg', *Zeitschrift für bildende Kunst*, 1918, p. 117; Exh. Hamburg, 1966, No. 7.

360 VIRGIN AND CHILD. Hamburg, Kunsthalle Inventory 5488

143×96 mm. Pen and brush and ink and sepia wash. Buff paper. *Plate XC*

In ink: $\overset{\circ}{T}$ *P. A. J.* intertwined.

Companion piece to the preceding drawing and from the same hand, and like it once attributed to Pereda.

361 THE VIRGIN OF THE ROSARY. Madrid, Prado Museum. Inventory No. F.A. 756

160×210 mm. Red chalk and carmine wash. Buff wire-marked paper. *Plate XCI*

This drawing is of outstanding quality and has some relationship to the work of Cajés, but may possibly be of Italian origin.

Provenance: Beroqui Collection. Bequeathed to the Museum in 1958.

Pérez Sánchez, *Catálogo Prado*, 1972, p. 146.

362 FLIGHT INTO EGYPT. Florence, Uffizi

202×246 mm. Pen and ink and sepia wash. Yellowish paper. Squared in blacklead. *Plate XCI*

Attributed to Blas de Prado in the Santarelli Collection, this is the work of a Madrilenian pupil of Carducho and

is close in style to the only known work by Santiago Morán the Younger (see No. 289) and to drawing No. 343.

Provenance: Santarelli Collection.

Santarelli Catalogue, p. 698, No. 26 (Inventory 10208).

363 BAPTISM OF CHRIST. Whereabouts unknown

Semicircular at the top. Pen and ink wash. *Plate XC*

An attribution in an eighteenth-century hand: *Vicencio Carducho fec.*

The figure types are close to Carducho's and the poses and style do not differ radically from those current in his shop, but because we do not know any authenticated drawings by him in this technique, it seems preferable to consider this anonymous, even though it may be the work of an artist from his circle.

Photo Más G. 39640.

364 THE AGONY IN THE GARDEN. Florence, Uffizi

186×145 mm. Blacklead. Buff paper. *Plate XCI*

Provenance: Santarelli Collection.

Santarelli Catalogue, p. 715, No. 13 (Inventory 10461).

365 THE AGONY IN THE GARDEN. Madrid, Academia de San Fernando

175×160 mm. Brush and sepia ink. Buff laid paper. *Plate XCI*

The style is reminiscent of some of Cajés' drawings. Velasco attributes the work, with reservations, to Alonso Cano—an impossible attribution.

Velasco, No. 23.

366 CHRIST IN THE GARDEN. Florence, Uffizi

140×90 mm. Blacklead and red chalk. Buff paper. *Plate XCI*

In ink: *6 Rls.*
Probably from Cajés' circle.

Provenance: Santarelli Collection.

Santarelli Catalogue, p. 711, No. 62 (Inventory 10392).

367 CHRIST BOUND TO THE COLUMN. Florence, Uffizi

210×130 mm. Greasy blacklead and sepia wash. Touches of white lead. Buff laid paper. Squared in black pencil. *Plate XCII*

Inscribed in ink: *4 Rs.*

In the Santarelli Collection the drawing was attributed to Blas de Prado, but it is in fact by a Madrid artist and very close to the circle of Cajés and Carducho.

Provenance: Santarelli Collection.

Santarelli Catalogue, 1870, p. 698, No. 19 (Inventory 10201).

368 CRUCIFIXION. Madrid, Prado Museum

480×387 mm. Pen and ink and sepia wash. Buff paper. *Plate XCII*

This has repeatedly been attributed to J. Martin Cabezalero (1633–73) and linked with the painting in the chapel of the Third Order in Madrid, which barely resembles it. The drawing dates from the beginning of the seventeenth century and is in the El Escorial tradition of Tibaldi, not far removed from Francisco Ribalta, although it could be by a Castilian painter with similar training.

Provenance: Lefort Collection. Fernández Durán Bequest, 1930, No. 119.

Lefort, *Collection*, Paris, 1869, No. 27; Sánchez Cantón, III, 243; Vey and de Salas, *German and Spanish Art*, 1965, p. 270; Exh. Hamburg, 1966, No. 38, Pl. 56; Pérez Sánchez, *Catálogo Prado*, 1972, p. 140.

369 ERECTION OF THE CROSS. Madrid, National Library

135×92 mm. Pen and ink and dark sepia wash. Buff paper. *Plate XCII*

Inspired by Tintoretto's composition in the Scuola di San Rocco, Venice.

Provenance: Carderera Collection.

Barcia, No. 523.

370 CALVARY WITH THE VIRGIN, ST. JOHN AND MARY MAGDALENE. Madrid, National Library

156×110 mm. Blacklead and a wash of india ink. Buff paper. *Plate XCII*

In ink: *2 Rls.*

Listed as an anonymous work of the sixteenth century by Barcia. Probably Castilian of *c.* 1600, not unrelated to Carducho.

Provenance: Castellanos Collection.

Barcia, No. 124.

371 DESCENT FROM THE CROSS. Madrid, Academia de San Fernando

135×115 mm. Pen and ink. Buff paper. *Plate XCII*

Tormo pointed out the similarities to works by Pereda, but it is doubtful whether this can be by him.

Provenance: Royal Collection at the Palace of El Pardo.

Tormo, p. 91; Velasco, No. 1; Pérez Sánchez, *Catálogo San Fernando*, 1967, p. 162.

372 VIRGIN. Florence, Uffizi

169×80 mm. Preparatory drawing in pencil. Brush and yellowish wash. Buff laid paper. *Plate XCIII*

Listed as an anonymous work in the collection. The way of gathering the mantle at the bottom suggests an artist influenced by Alonso Cano.

Provenance: Santarelli Collection.

Santarelli Catalogue, p. 716, No. 151 (Inventory 10481).

373 MATER DOLOROSA. Florence, Uffizi

377×230 mm. Red chalk. Buff laid paper.

Plate XCIII

On the same sheet, a study of the praying hands in blacklead. Several prices: *6 Rls.* half deleted and *3 R* partly cut away.

Could possibly be Italian, perhaps Tuscan.

Provenance: Santarelli Collection.

Santarelli Catalogue, p. 717, No. 167 (Inventory 10497); Pérez Sánchez, *Catálogo Prado*, 1972, p. 165.

374 MATER DOLOROSA (OR ST. ANNE?). Florence, Uffizi

165×80 mm. Preparatory drawing in pencil. Ink and light wash. Buff laid paper. *Plate XCIII*

Listed as an anonymous Spanish work in the Santarelli Collection, it must be from the beginning of the century, still in the Escorial tradition.

Provenance: Santarelli Collection.

Santarelli Catalogue, p. 717, No. 153 (Inventory 10483).

375 MATER DOLOROSA. London, British Museum Inventory 1846-5-9.182

338×217 mm. Pen and brush and ink with greyish wash. White laid paper. *Plate XCIII*

Although attributed to Pereda, it seems to be not by him but rather a work of the early seventeenth century, still very dependent on the figure types and the sensitivity of the Cinquecento tradition at El Escorial. It seems to come from the same hand as the *Agrippine Sibyl*, No. 350.

376 DEATH OF THE VIRGIN. Madrid, Academia de San Fernando

160×110 mm. Pen and ink. Buff paper. *Plate XCIV*

In ink in an eighteenth-century hand: *30 Rs.* In pencil in a modern hand: *Tristán, 28.*

The attribution to Tristán seems unwarranted.

Tormo, No. 24, p. 66; Velasco, No. 3; Pérez Sánchez, *Catálogo San Fernando*, 1967, p. 163.

377 CORONATION OF THE VIRGIN. Madrid, National Library

245×198 mm. Pen and ink. Light sepia wash. Buff laid paper. Squared in pencil. *Plate XCIV*

Barcia thought this was of the sixteenth century. It must surely come from Vicente Carducho's circle.

Provenance: Castellanos Collection.

Barcia, No. 126.

378 OUR LADY OF RANSOM. Madrid, National Library

213×166 mm. Pen and ink and light sepia wash. Buff paper. *Plate XCV*

Kneeling beneath the Virgin's mantle are two Mercedarian saints. The one on the right holding a chalice is probably St. Raymund Nonnatus, who was known for his devotion to the Holy Sacrament.

Judging by the donors' dress, this can be dated *c.* 1630.

Provenance: Madrazo Collection.

Barcia, No. 551.

SAINTS

379 recto ST. ANTHONY OF PADUA AND A BISHOP SAINT ADORING THE CROSS. Florence, Uffizi

210×176 mm. Pen and ink and green wash. Buff laid paper. *Plate XCV*

379 verso In the same media, the same composition, with two saints, a man and a woman, kneeling in front of the Cross, wearing what appear to be imperial crowns. Presumably they are Heraclius and St. Helen.

Plate XCV

Attributed to Blas de Prado in the Santarelli Collection, the drawings could belong to the beginning of the seventeenth century.

Provenance: Santarelli Collection.

Santarelli Catalogue, p. 699, No. 36 (Inventory 10218).

380 ST. CASILDA (?). Madrid, Prado Museum. Inventory No. F.D. 913

186×125 mm. Pen and ink and brown and sepia washes. Buff wire-marked paper. Squared in black chalk.

Plate XCV

Inscribed in pencil: *4* in the upper right-hand corner.

A work of the first half of the century. Iconographically it could represent either St. Casilda or St. Isabel of Portugal as both are portrayed in the same way, with the conversion into flowers of the provisions they were bringing by stealth to prisoners.

Provenance: Fernández Durán Collection. Bequeathed to the Prado in 1931.

Pérez Sánchez, *Catálogo Prado*, 1972, p. 148.

381 ST. DOMINIC AT SORIANO. Los Angeles, Los Angeles County Museum. Inventory L. 2492.64-9

280×180 mm. Blacklead and red ochre. Buff paper.

Plate XCIV

The Dominican legend of which an episode is depicted here tells how a monk in the monastery of Soriano in Italy who wanted to know the founder's true features received a canvas bearing the portrait of St. Dominic from the hands of the Virgin, in the presence of Mary Magdalene and St. Catherine (Réau, *Iconographie de l'Art Chrétien*, 1958, III, p. 394). The drawing has been regarded as Spanish, perhaps because of the similarity of its subject to that represented by Maino (Angulo–Pérez Sánchez, Pls. 264 and 265), but it may well be Italian, and possibly Lombard.

Provenance: donated by Mr. and Mrs. Henry Blanke.

382 ST. STEPHEN. Florence, Uffizi

410×305 mm. Preparatory drawing in pencil. Ink and brown wash. Buff laid paper. *Plate XCVI*

Definitely a work of the first half of the seventeenth century, this drawing is evidently related, in its figure type and in the way it presents St. Stephen, to the *St. Lawrence* by Luis Fernández (1594–*c.* 1657), a pupil of Cajés (Angulo–Pérez Sánchez, Pl. 206). But in view of the lack of authenticated drawings by this artist, it would be rash to attribute it to him definitively.

Provenance: Santarelli Collection.

Santarelli Catalogue, p. 708, No. 8 (Inventory 10338).

383 THE PLACING OF THE CHASUBLE UPON ST. ILDEFONSUS. Madrid, National Library

275×190 mm. Pen and ink and sepia wash. Buff paper. *Plate XCIV*

Judging by the subject and by the slight reminiscence of Blas de Prado's technique, this is probably Toledan. But its style is unrelated to any painting by Tristán, to whom it is attributed by Rosell, whose opinion is seconded by Barcia. As we lack any authenticated drawings by Tristán, it is more prudent to class the drawing as anonymous.

Provenance: Carderera Collection.

Barcia, No. 487.

384 ST. HYACINTH. Madrid, National Library

290×192 mm. Pen and ink and light wash. Dark buff paper. Squared in pencil. *Plate XCVI*

On the upper part of the sheet in ink in a seventeenth-century hand: *q^do maestro digo que despues de aver escrito esta carta que embio a V. e visto la edad de que murio san Jacinto, que fue de quarenta años y segun esto . . . el rostro segun esta edad y no viejo como yo decia; los otros frailes que estan repartidos quatro a cada lado; que se distingan y no esten juntos sino uno trás otro, este rostro me parece bien poniendole de la edad* (Dear Master, I must say that after having written the letter which I sent you, and having seen the age at which St. Hyacinth died, namely forty years old, and according to this . . . the face appropriate to that age and not old, as I said. And let the other friars who are grouped four on each side be differentiated, and not bunched but arranged one behind the other. This face seems to me apt for his age). At the bottom, in the same hand: *a este lado izquierdo otros quatro, a este lado derecho an de ir quatro frailes, el Santo enmedio* (on this, left-hand, side, another four; on this, right-hand, side, there should be four friars; the saint in the middle).

On the back, a composition with the woman of Samaria, copied, according to Barcia, from an engraving.

An interesting drawing, no doubt by a Madrilenian painter of *c.* 1630–40.
The comments, doubtless from the hand of the prior of the house, are most curious and testify to the rigorous control over paintings exercised by those who commissioned them. The drawing is by the same artist as the *St. Elmo*, No. 397.

Provenance: Madrazo Collection.

Barcia, No. 593.

385 PENITENT ST. JEROME. Madrid, National Library

249×167 mm. Pen and ink and blue wash. Buff paper. The side edges are damaged. *Plate XCVI*

Barcia attributed this, with reservations, to Tristán, and related it to a *St. Jerome* at the Academia de San Fernando (*Catálogo San Fernando*, 1967, No. 627, p. 83), which was then thought to be by him, but which we now know to be by Bartolomé Carducho (Angulo–Pérez Sánchez, p. 39). The style of Tristán's paintings does not support an attribution to him, but neither does the drawing's similarity to the picture in the Academia warrant an attribution to Bartolomé Carducho, whose style of draughtsmanship is becoming increasingly well known.

Provenance: Carderera Collection.

Barcia, No. 488; Exh. Madrid, 1934, No. 22.

386 PENITENT ST. JEROME. Madrid, Academia de San Fernando

103×89 mm. Pen and ink and sepia wash. Buff paper. *Plate XCVI*

Tormo and Velasco thought this was by Herrera the Elder. Pérez Sánchez confined himself to classing it anonymous seventeenth century.
The violent chiaroscuro may perhaps suggest a possible attribution to a tenebrist in the manner of Tristán.

Provenance: Royal Collection at the Palace of El Pardo.

Tormo, p. 66, No. 32; Velasco, No. 83; Pérez Sánchez, *Catálogo San Fernando*, 1967, p. 162.

387 ST. JOSEPH. Florence, Uffizi

197×105 mm. Very fine pen and ink and light wash over preparatory drawing in pencil. White laid paper. *Plate XCVII*

In ink in an early hand: *2 Rs.*

Attributed in the collection to an 'Andrea Lascheta', who is not known as a painter. See Nos. 400, 412, and 413. Probably from the beginning of the century.

Provenance: Santarelli Collection.

Santarelli Catalogue, p. 704, No. 5 (Inventory 10298).

388 ST. JOSEPH AND THE INFANT CHRIST. Madrid, Prado Museum. Inventory No. F.A. 1764

217×145 mm. Sepia wash over pencil. Buff wire-marked paper. *Plate XCVII*

On the verso, a faint sketch for the lower half of a nude figure.

A work of the beginning of the seventeenth century, close to Vicente Carducho and Eugenio Cajés in style, but not definitely attributable to either of them.

Provenance: Beroqui Collection. Bequeathed to the Prado in 1958.

Pérez Sánchez, *Catálogo Prado*, 1972, p. 152.

389 ST. JOHN THE BAPTIST. Florence, Uffizi

128×95 mm. Pen and ink and light wash. Greenish and buff laid paper. *Plate XCVII*

In the Santarelli Collection this is called *St. Francis receiving the Stigmata*, but the presence of the rush cross confirms that it is St. John.
Listed as anonymous in the collection, it appears to be a Madrilenian work from close to the circles of Carducho and Cajés.

Provenance: Santarelli Collection.

Santarelli Catalogue, p. 710, No. 42 (Inventory 10372).

390 THE INFANT ST. JOHN THE BAPTIST. Madrid, National Library

138×164 mm. Pen and ink and wash. Dark buff paper. Badly torn. *Plate XCVII*

Barcia rightly notes that this seems to have been done for a medallion or cartouche. The mixtilinear design, partially preserved, corroborates the idea.
A work from just after the turn of the century.

Provenance: Madrazo Collection.

Barcia, No. 565.

391 ST. JOHN THE BAPTIST. Madrid, National Library

320×195 mm. Blacklead. Buff, squared paper. *Plate XCVIII*

The attribution to Vicente Carducho made by Barcia seems unconvincing, and it is preferable to consider the drawing an anonymous work from the beginning of the century.

Provenance: Madrazo Collection.

Barcia, No. 19.

392 BEHEADING OF ST. JOHN. Florence, Uffizi

130×114 mm. Preparatory drawing in pencil. Ink and sepia wash. Buff paper. *Plate XCVIII*

Listed as anonymous in the Santarelli Collection, this is an early seventeenth-century work, probably from Carducho's circle.

Provenance: Santarelli Collection.

Santarelli Catalogue, p. 710, No. 33 (Inventory 10363).

393 BEHEADING OF ST. JOHN OR ST. JAMES Florence, Uffizi

205×160 mm. Preparatory drawing in pencil. Ink and red, brown and sepia watercolour. Buff paper. *Plate XCVIII*

A price: *2 Rls.*

Attributed to Blas de Prado in the Santarelli Collection, this is a Madrilenian work of the first third of the seventeenth century, by a close follower of Vicente Carducho.

Provenance: Santarelli Collection.

Santarelli Catalogue, p. 699, No. 38 (Inventory 10220).

394 ST. MICHAEL. Madrid, National Library

193×130 mm. Pen and ink and sepia wash. Buff paper. *Plate XCVIII*

Barcia thought this was in the style of, and perhaps by, Herrera the Younger (1622–85), but the attribution seems implausible, and the drawing is better regarded as a work of the first half of the seventeenth century.

Provenance: Madrazo Collection.

Barcia, No. 555.

395 ST. NICHOLAS OF TOLENTINO. London, Courtauld Institute

173×94 mm. Pen and ink and sepia wash. Buff paper. *Plate XCIX*

The saint, who is not identified in the collection, is without doubt the Austin friar St. Nicholas of Tolentino, recognizable by the live partridge on the dish.
Probably mid seventeenth century.

Provenance: Collection of Sir John Stirling-Maxwell. Witt Collection.

Witt, p. 163, No. 118.

396 THE BLESSED PETER OF CASTILNOVO (?) Florence, Uffizi

290×125 mm. Blacklead and sepia and yellow washes with touches of white lead. Dark grey paper. *Plate XCIX*

In ink: *1 Rl.*

The habit is definitely Bernardine, and the martyr depicted is probably the Blessed Peter of Castilnovo, who preached the crusade against the Albigensians and was lanced to death by order of the Duke of Aquitaine in 1202. Angelo Nardi painted him in a similar manner on a stylobate of the altar-piece of the Bernardines at Alcalá (Angulo–Pérez Sánchez, Pl. 222).
Considered anonymous in the collection, this may very well be by Nardi, although the absence of any authenticated drawings by him precludes a definitive attribution.

Provenance: Santarelli Collection.

Santarelli Catalogue, p. 718, No. 186 (Inventory 10516).

397 ST. ELMO. Madrid, National Library

275×187 mm. Pen and ink and wash. Buff paper. Squared in pencil. *Plate XCIX*

In ink in a seventeenth-century hand: *Arco iris en el cielo* (Rainbow in the sky) and *hacha* (firebrand).

Barcia notes, probably correctly, that this seems to be by the same artist as the *St. Hyacinth* catalogued above (No. 384) and considers that both were for a Dominican friary.

Provenance: Madrazo Collection.

Barcia, No. 594.

398 AN APOSTLE OR EVANGELIST. Barcelona, Private Collection

175 × 160 mm. Pen and brush and ink and sepia wash. Buff paper. *Plate XCIX*

Provenance: Félix Boix Collection.

We are indebted to D. Manuel Gómez Moreno for the photograph.

399 AN APOSTLE. Madrid, National Library

158 × 102 mm. Pen and ink. Dark buff paper. The top left-hand corner has been trimmed. *Plate XCIX*

Barcia catalogues this with anonymous works of the sixteenth century. In fact, it seems to belong to the seventeenth century.

Provenance: Madrazo Collection.

Barcia, No. 135.

400 AN ABBOT SAINT APPEARING TO CAPTIVES Florence, Uffizi

265 × 310 mm. Blacklead and light sepia wash. Buff laid paper. Squared in pencil. *Plate C*

In ink in an eighteenth-century hand: *Andᵃ Lascheta.*

The saint appears to be wearing a Benedictine habit. In the Santarelli Collection this is attributed to the above-mentioned Andrea Lascheta, on whom we have no information. The person in question was most probably a collector, Italian to judge by the name. See Nos. 387, 412, 413.

Provenance: Santarelli Collection.

Santarelli Catalogue, p. 702, No. 1 (Inventory 10294).

401 TWO BISHOPS KNEELING. Florence, Uffizi

130 × 205 mm. Pen and ink and light sepia wash. Buff paper. *Plate C*

This is attributed to Blas de Prado in the Santarelli Collection, but the attribution seems unacceptable. Perhaps the drawing belongs to the beginning of the seventeenth century, and perhaps it comes from the same hand as the *Mater dolorosa*, No. 374.

Provenance: Santarelli Collection.

Santarelli Catalogue, p. 697, No. 15 (Inventory 10197).

402 BEHEADING OF A BISHOP SAINT. Florence, Uffizi

245 × 195 mm. Blacklead and brown wash. Buff laid paper. *Plate C*

In ink: *1 rl.*

Listed as anonymous in the Santarelli Collection, this seems to be the work of a pupil or imitator of Vicente Carducho.
If the drawing were Castilian, as it appears to be, then it would be admissible to think the subject was St. Eugene, Bishop of Toledo.

Provenance: Santarelli Collection.

Santarelli Catalogue, p. 709, No. 25 (Inventory 10355).

403 A MIRACULOUS HEALING. Madrid, National Library

114 × 184 mm. Reddish wash heightened with white lead. Dark buff paper. *Plate C*

Barcia includes this among Orrente's drawings without substantiating the attribution. In fact, the technique and the figure types are more Madrilenian, and there is a recollection of Angelo Nardi, about whose drawings we are so ill-informed.
Barcia interprets the scene as a miracle of the physician saints Cosmas and Damian, who do indeed appear in a nimbus in the background, but it should probably be linked with the legend of a Bernardine saint, judging by the habit of the monk in the foreground.

Provenance: Madrazo Collection.

Barcia, No. 90.

404 A BISHOP SAINT RECEIVING THE RULE OF A MONASTIC ORDER. Formerly Gijón, Instituto Jovellanos

210 × 190 mm. Red chalk and carmine wash. Thin buff paper. *Plate CI*

This is a remarkable work, in a Madrilenian style of the early years of the century, somewhere between Carducho, of whose paintings for El Paular the composition is very reminiscent, and Cajés, to whom it is very close in the proportions and character of the figures and also in its red wash technique, which he often used.
Menéndez Acebal and Moreno Villa attributed it to Carreño, and the latter suggested that it could represent the Founding of the Order of the Trinity, a subject painted by Carreño for the Trinitarians of Pamplona in a picture long since lost. The canvas which has recently been acquired by the Louvre (*Goya*, No. 63, 1964, p. 140; *Revue du Louvre*, 1965) has nothing to do with the drawing. Pérez Sánchez was the first to point out the drawing's true date and school.

Menéndez Acebal, *Catálogo . . . del Instituto Jovellanos*, 1886, No. 352; Moreno Villa, p. 352; Pérez Sánchez, *Catálogo Gijón*, 1969, p. 143, Pl. 280.

405 AVOWAL OF A FRANCISCAN MONK. Madrid, Prado Museum. Inventory No. F.A. 103

290 × 260 mm. Thick pen and ink over pencil with light sepia wash. Buff wire-marked paper. *Plate CI*

Inscribed in pencil: *legajo 7* and *nᵒ 3.*

A work of the beginning of the century, very close in style to Vicente Carducho and also to Eugenio Cajés, but not attributable with certainty to either of them.

Provenance: Royal Collections.

Pérez Sánchez, *Catálogo Prado*, 1972, p. 159.

406 MARTYRDOM OF A WOMAN SAINT. Madrid, National Library

286 × 195 mm. Pen and ink and sepia wash. Buff paper. The edges are damaged on both sides. *Plate CII*

Without doubt from the circle of Eugenio Cajés.

Provenance: Madrazo Collection.

Barcia, No. 621.

407 A CARDINAL SAINT BEING LED BY AN ANGEL
Madrid, National Library

250×157 mm. Pen and ink and light wash. Buff paper. Stained and badly damaged on the right. *Plate CIV*

In ink in an early hand: *3 R.*

Provenance: Madrazo Collection.

Barcia, No. 579.

408 PRESENTATION OF A DEVOTIONAL PAINTING TO A PRELATE. London, British Museum. Inventory 46-4-172

260×170 mm. Pen and ink and sepia wash. Buff paper.
 Plate CI

In ink in handwriting that may be seventeenth century: *Blas de Prado.*

The proferred painting appears to depict a friar saint. It is not easy to determine whether it is his hand or the hull of a model boat that he is holding at chest-level. The latter would suggest he was the Dominican St. Elmo, or Pedro González.
The costume of the kneeling knight inclines one to date the drawing to the opening years of the seventeenth century, in which case the attribution to Blas de Prado, who died in 1599, does not seem credible.
The difference of technique from Blas de Prado's best authenticated drawings discourages any attribution to him, although the potential authority of the inscribed attribution, which seems to date from relatively soon after the artist's death, should not be forgotten.
The drawing has recently been published, with the traditional attribution, by J. M. Brown.

J. M. Brown, *Archivo*, 1968, p. 33.

409 AVOWAL OF A RELIGIOUS. Madrid, Academia de San Fernando

400×374 mm. Blacklead and red chalk. Buff paper. Squared in red chalk and blacklead. *Plate CI*

This has been attributed to Zurbarán and to Carreño. Pérez Sánchez remarks that it is unconnected with the former and must be earlier than the latter. He suspects that it could be an Italian work of the late sixteenth century. The technique is indeed that of Zuccaro's circle, such as was also current in Spain around 1600–25.

Tormo, p. 65, No. 5; Velasco, No. 6; Exh. Hamburg, 1966, No. 219; Pérez Sánchez, *Catálogo San Fernando*, 1967, p. 165.

410 FUNERAL OF A MONK. Florence, Uffizi

177×225 mm. Pen and ink and red chalk. Buff laid paper. *Plate CIV*

The composition is contained within an oval.

The work may possibly be Italian.

Provenance: Santarelli Collection.

Santarelli Catalogue, p. 710, No. 31 (Inventory 10361).

411 SCENE IN FRONT OF A CORPSE. Florence, Uffizi

90×130 mm. Pen and ink and wash. Buff laid paper.
 Plate CII

The scene, showing a figure on a couch brought before a monarch, is difficult to interpret. The work could possibly be Italian.

Provenance: Santarelli Collection.

Santarelli Catalogue, p. 721, No. 221 (Inventory 10549).

412 EREMITIC SAINT. Florence, Uffizi

196×116 mm. Pen and ink and light wash. Buff laid paper. *Plate CIV*

Attributed to an unknown Andrea Lascheta. See Nos. 387, 400, and 413.

Provenance: Santarelli Collection.

Santarelli Catalogue, p. 704, No. 2 (Inventory 10295).

413 BEHEADING OF A KNIGHT. Florence, Uffizi

243×265 mm. Pencil and light sepia wash. Buff laid paper. Squared in pencil. *Plate CIV*

In ink: *mº R* (half a *real*).

Probably from the same hand as the *Abbot saint*, No. 400, which is attributed in the Uffizi to the unknown Lascheta. See Nos. 387, 400, and 412.

Provenance: Santarelli Collection.

Santarelli Catalogue, p. 714, No. 113 (Inventory 10443).

414 A WOMAN SAINT (?). Madrid, National Library

180×95 mm. Pen and ink and sepia wash. Buff paper.
 Plate CII

Her breast appears to be pierced with an arrow.

Definitely from the beginning of the century.

Provenance: Madrazo Collection.

Barcia, No. 619.

415 THE FUNERAL OF A HOLY KING. New York, The Metropolitan Museum of Art. Inventory 805.3.507

316×213 mm. Prepared with red chalk. Pen and ink, and sepia wash. White laid paper. *Plate CII*

Inscribed in ink, in nineteenth-century handwriting: *Zurbaran.*

The attribution to Zurbarán is untenable, and in the Museum it is classified as 'Anonymous Spanish, seventeenth century'. It is the work of a Madrid artist, made about 1600, strongly reminiscent of Zuccaro and close to the Carducho brothers and Cajés. It may represent the funeral of St. Louis, King of France, or of St. Ferdinand, King of Castile, who was canonized in 1671, but had enjoyed a limited cult since the fourteenth century.

Provenance: Vanderbilt Collection. Given to the Museum by Cornelius Vanderbilt in 1880. Inventory No. 80.3.507.

416 THE HOLY CHRIST OF BALAGUER. Madrid, National Library

427×295 mm. Pen and brush and ink with brown wash. Laid paper. *Plate CIII*

The legend recorded in the drawing concerns an effigy of Christ crucified which, when hurled into the sea by the Mohammedans, climbed the waters of the Ebro and its tributary the Segre and stopped in front of the walls of Balaguer, where all attempts to remove it proved vain,

until some nuns came to the rescue and carried it effortlessly away to their convent.
Barcia notes that a picture 'painted from this drawing' was once in the church of San Bernardo and later in that of San Cayetano in Madrid. He gives no indication of the artist, nor does Tormo (*Iglesias del antiguo Madrid*, 1929) mention him.

Provenance: Castellanos Collection.

Barcia, No. 538.

PORTRAITS AND MISCELLANEOUS STUDIES

417 KING SEATED ON A THRONE. Budapest, Museum of Fine Arts

320×230 mm. Pen and ink and light wash. Coarse laid paper. *Plate CV*

Along the bottom in an eighteenth- or nineteenth-century hand: *Diego Velázquez Spagnuolo* *ñol* *1650*.

Formerly attributed to Velázquez, it was later linked with the seated figures of kings painted for the Hall of the Theatre at Buen Retiro and thought to be by Cano. This attribution seems unlikely. It may be remembered that, besides Alonso Cano, the following artists worked on the Hall of the Theatre series: Diego Polo, Francisco Fernández, Félix Castelo, Pedro Núñez, and Antonio Arias.

Provenance: Esterhazy Collection.

Propyläen Weltgeschichte, VI ('Das Zeitalter des Absolutismus, 1660–1789'), Berlin, 1931, p. 107—as being by Velázquez; K. Gerstenberg, 'Zeichnungen von Carducho, Cano, und Velázquez', *Pantheon*, 1966, pp. 191 ff.—as being by Alonso Cano.

418 KNIGHT STANDING BESIDE A RAMPART. London, Jennings-Brown

Ink and wash. Laid paper. *Plate CV*

This may perhaps be Flemish rather than Spanish.
The coat of arms on the shield, which is probably Spanish, has not been successfully identified.

Provenance: Sold on 29 July 1929 at Sotheby's (No. 38), where Mr. Corkie bought it, together with a portrait in pastels, for five shillings.

419 KNIGHT KNEELING. Madrid, National Library

198×130 mm. Pen and ink. Buff paper. *Plate CV*

The figure has been cut out and mounted on another sheet of paper, which someone has tried to blend with the original drawing by means of wash and hatching.
Underneath, in ink in Valentín Carderera's hand: *De Juan de la + Pantoja* (By Juan Pantoja de la Cruz).
Barcia catalogues this as being by Pantoja, but the fashion of dress seems later than 1609, when that artist died.
Without doubt a study for a sepulchral effigy.

Provenance: Carderera Collection.

Barcia, No. 96.

420 PORTRAIT OF A KNIGHT. Madrid, National Library

280×200 mm. Blacklead. Greenish-grey paper.
 Plate CXI

Barcia, who catalogued this under El Greco's name, already expressed doubts about this attribution. Since then, no one has accepted it.

Provenance: Madrazo Collection.

Barcia, No. 106.

421 STANDING FIGURE OF A PAINTER. Raleigh, North Carolina Museum. Inventory G. 63.3.64

180×60 mm. Pen and ink and sepia wash. Buff paper.
 Plate CVIII

In ink in a hand contemporary with the drawing: . . . *ose magno* or *mayno* (?). The stamps of the eighteenth-century collections of Thomas Hudson and Charles Rogens.

The drawing was attributed to Velázquez by its donor and published as his by Gerstenberg. The attribution seems unacceptable, though the work must certainly be Madrilenian and of the first half of the seventeenth century.

Provenance: donated in 1964 by W. R. Valentine.

K. Gerstenberg, *Pantheon*, 1966, pp. 191 ff.

422 STANDING MALE NUDE. Florence, Uffizi

342×205 mm. Red ochre and blacklead. Touches of white chalk. Buff paper. *Plate CVIII*

In ink: *15 rˢ*.

Attributed to Blas de Prado in the Santarelli Collection, this is definitely a seventeenth-century work, and it may be Italian, from Pietro da Cortona's circle. It is very similar to No. 10219 in the same collection, although in different media on different paper.

Provenance: Santarelli Collection.

Santarelli Catalogue, p. 698, No. 22 (Inventory 10204).

423 MALE NUDE. Florence, Uffizi

276×173 mm. Blacklead. Buff paper. *Plate CVIII*
In ink: *3 Rls*.

Attributed to Blas de Prado in the Santarelli Collection,

this is probably a work of the mid seventeenth century, and it is definitely Madrilenian.

Provenance: Santarelli Collection.

Santarelli Catalogue, p. 698, No. 20 (Inventory 10202).

424 MALE NUDE. Florence, Uffizi

400×256 mm. Blacklead and white chalk. Coarse greyish paper. *Plate CVIII*

Attributed to Blas de Prado in the Santarelli Collection, this is seventeenth century, definitely Madrilenian, by the same artist as the preceding drawing, and close to other drawings in the Academia de San Fernando which are attributed to Cabezalero.

Provenance: Santarelli Collection.

Santarelli Catalogue, p. 699, No. 37 (Inventory 10219).

425 A KNIGHT AND A LADY. Madrid, National Library

80×70 mm. Pen and ink. Buff paper. *Plate CVI*

On the verso: numerical jottings and sums.

Judging by the costumes, the drawing dates from the second quarter of the century.

Repeating an attribution by the scholar Rosell, Barcia catalogues this as a work by Felipe de Liaño, who died before 1603. As no authenticated work by Liaño is known, this can only be admitted as a possibility, and even then it is scarcely plausible, since Liaño is supposed to have died somewhat before the date of the fashion depicted.

Provenance: Carderera Collection.

Barcia, No. 84.

426 TWO HORSEMEN RIDING AT A WALK. Florence, Uffizi

104×95 mm. Thick-nibbed pen, ink and sepia wash. Buff paper. *Plate CVI*

Provenance: Santarelli Collection.

Santarelli Catalogue, p. 710, No. 45 (Inventory 10375).

427 THREE HORSEMEN. Formerly Gijón, Instituto Jovellanos. Destroyed in 1936

110×90 mm. Pen and ink and sepia wash. Buff paper. *Plate CVI*

In ink in an eighteenth-century hand: *Diego Velázquez.*

Moreno Villa thought the attribution to Velázquez very doubtful, but presumed that it could be accepted as being to D. Antonio González Velázquez (1729–93). Pérez Sánchez points out that the drawing is indubitably a Madrilenian work of the first half of the seventeenth century. One might think it by an artist very close to Vicente Carducho.
The head-dress of the figure on the left suggests a date at the beginning of the seventeenth century.

Moreno Villa, p. 44, No. 406; Pérez Sánchez, *Catálogo Gijón*, 1969, p. 144, Pl. 282.

428 OLD MAN SITTING WITH A BOOK. Florence, Uffiz

240×160 mm. Red chalk. Dark buff paper. Squared in blacklead and red chalk. *Plate CIX*

Possibly a study for a *Jesus arguing with the doctors.*

Provenance: Santarelli Collection.

Santarelli Catalogue, p. 718, No. 172 (Inventory 10502).

429 A RELIGIOUS IN PRAYER. Florence, Uffizi

260×192 mm. Blacklead with touches of white chalk. Dark blue-tinted paper. *Plate CIX*

The Santarelli Catalogue calls the figure St. Francis, but that does not seem possible, since he is beardless.

Provenance: Santarelli Collection.

Santarelli Catalogue, p. 714, No. 110 (Inventory 10440).

430 KNEELING FRIAR. Madrid, National Library

279×241 mm. Red chalk and touches of white lead. Dark buff paper. *Plate CIX*

Barcia attributed this, with a query, to Zurbarán. Kehrer did not think it was by him, and Lafuente thought it could be by Carducho, although he also found it reminiscent of Blas de Prado.

Provenance: Madrazo Collection.

Barcia, No. 504; Kehrer, *Francisco de Zurbarán*, 1918, p. 112; Exh. Madrid, 1934, No. 15.

431 TWO HALF-NAKED FIGURES SEEN FROM THE BACK. Madrid, Prado Museum. Inventory F.A. 109

210×190 mm. Red chalk. Buff laid paper *Plate CVIII*

In pencil, a nineteenth-century inscription: *Legajo 43* (Bundle 43), *n⁰ 22.*

Close to Cajés in style.

Provenance: Royal Collection.

Pérez Sánchez, *Catálogo Prado*, 1972, p. 109.

432 A YOUNG MAN PRAYING. Madrid, Prado Museum Inventory No. F.D. 1471

152×98 mm. Red chalk. Buff wire-marked paper. *Plate CX*

On the same sheet, a faint sketch for the upper part of a face.

Fairly close in style to Cajés.

Provenance: Fernández Durán Collection. Bequeathed to the Prado in 1931.

Pérez Sánchez, *Catálogo Prado*, 1972, p. 168.

433 A BOY WITH A STICK IN HIS HAND. Madrid, Prado Museum. Inventory No. F.A. 729

152×104 mm. Black chalk. Buff wire-marked paper. *Plate CIX*

With a cut inscription: *Con . . .* in ink. Very stained.

A work of the Madrid School of the first half of the century, which recalls in style the drawings of Eugenio Cajés.

Provenance: Allende–Salazar Collection. Bequeathed to the Prado Museum in 1939.

Pérez Sánchez, *Catalogo Prado*, 1972, p. 166.

434 STANDING FIGURE. Madrid, Prado Museum Inventory No. F.D. 1952

145×82 mm. Heavy pen and ink and brush. Buff wire-marked paper. *Plate CVI*

By the same hand as the following item.
Madrid School of the beginning of the century.

Provenance: Fernández Durán Collection. Bequeathed to the Prado Museum in 1931.

Pérez Sánchez, *Catálogo Prado*, 1972, p. 167.

435 TWO STANDING FIGURES. Madrid, Prado Museum Inventory No. F.D. 872

144×133 mm. Heavy pen and ink and brush. Buff wire-marked paper. *Plate CVII*

On two different pieces of paper, stuck together.

By the same hand, and certainly the pendant to the preceding drawing.

Provenance: Fernández Durán Collection. Bequeathed to the Prado Museum in 1931.

Pérez Sánchez, *Catálogo Prado*, 1972, p. 168.

436 SEATED BOY. Madrid, Prado Museum

246×135 mm. Blacklead. Buff laid paper. *Plate CX*

In ink, an early inscription: *4 Rs.*

While to some extent related to certain of the drawings by Cajés catalogued here, this nevertheless appears to be by an artist of the next generation—*c.* 1640–50.

Provenance: Allende–Salazar Bequest (1939).

Pérez Sánchez, *Catálogo Prado*, 1972, p. 165.

437 HEAD OF A MAN. Hamburg, Kunsthalle. Inventory 38634

275×185 mm. Blacklead. Buff paper. *Plate CXI*

In ink in handwriting that may be eighteenth century: *Belazquez*. The right side is damaged.

The attribution to Velázquez cannot be accepted. The work seems to be from the first half of the century, and Madrilenian, from Carducho's circle. It appears to be a study for the head of a saint in ecstasy.

Exh. Hamburg, 1966, No. 10. Pl. 23.

438 HEAD OF A MAN. London, Courtauld Institute

285×185 mm. Stumped blacklead. Buff paper. *Plate CXI*

In ink in an eighteenth-century hand, partly hidden by the frame: *. . . jas fecit.*

This seems to be taken from a classical sculpture, and there is no particular reason for thinking it by Eugenio Cajés, to whom it is attributed in the collection.

Provenance: Collection of Sir John Stirling-Maxwell. Witt Collection.

Witt, p. 159, No. 180.

439 FORESHORTENED BUST OF A BOY. Madrid, Prado Museum. Inventory No. F.D. 1472

150×95 mm. Red chalk. Untreated buff wire-marked paper. *Plate CX*

Very close in style to Cajés.

Provenance: Fernández Durán Collection. Bequeathed to the Prado Museum in 1931.

Pérez Sánchez, *Catálogo Prado*, 1972, p. 168.

440 HEAD OF A WOMAN. Madrid, Prado Museum Inventory No. F.D. 433

190×145 mm. Mixed black and red chalk. Dark paper. *Plate CXI*

Very early in the century, in the monumental style of the sixteenth century.

Provenance: Férnandez Durán Collection. Bequeathed to the Prado Museum in 1931.

Pérez Sánchez, *Catálogo Prado*, 1972, p. 170.

441 VARIOUS STUDIES. Madrid, Prado Museum Inventory No. F.A. 817

210×272 mm. Black and red chalk. Grey paper. *Plate CX*

Inscribed in pencil in a modern hand: *Carducci*.

On the verso, a faint sketch of the figure of a monk in black chalk, with the head and hands in red chalk.

Madrid School of the first half of the seventeenth century. The attribution to *Carducci*, doubtless meaning Vicente Carducho, should not be entirely rejected, though not absolutely convincing.
The attitudes of prayer and the figure, suggest that this may be a preparatory drawing for a painting of St. Carlos Borromeo visiting the plague-stricken.

Entered the Museum in 1971.

Pérez Sánchez, *Catálogo Prado*, 1972, p. 172.

442 FOOT. London, Courtauld Institute

248×178 mm. Blacklead, red chalk and white chalk. Buff paper. *Plate CX*

Possibly drawn from a statue.
There is no particular reason for accepting the drawing's attribution, in the collection, to Eugenio Cajés.

Witt, p. 159, No. 181.

443 TABERNACLE. Madrid, National Library

248 × 203 mm. Pen and ink and sepia wash. Buff paper.

Plate CXII

Very typical of the early years of the seventeenth century, still imbued with the tradition of El Escorial.

Provenance: Madrazo Collection.

Barcia, No. 715.

444 DECORATION FOR A VAULT. New York, The Metropolitan Museum of Art. Inventory 80.3.657

130 × 192 mm. Prepared with red chalk. Pen and ink, and sepia wash. Yellowish laid paper. *Below*

This is clearly a project for a ceiling or vault with a decoration of stucco and painted compartments in the mannerist style, which lasted in Madrid well into the seventeenth century. The influence of the Zuccari in the figures of Cupid recalls the decorations of the Pardo Palace, which was, as we know, carried out by Carducho and Cajés together with other artists (Juan de Soto, Francisco Carvajal, Julio Cesar Semini, Pedro de Guzmán, J. de Mora), of whose style little or nothing is known.

Provenance: Vanderbilt Collection. Given to the Museum by Vanderbilt in 1880.

444

ILLUSTRATIONS

PLATE I

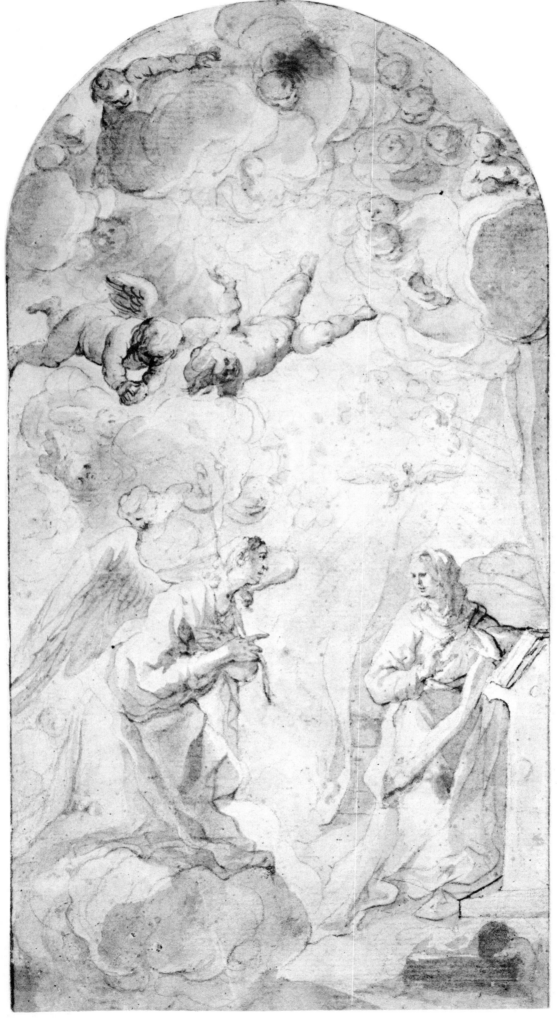

6

PLATE II

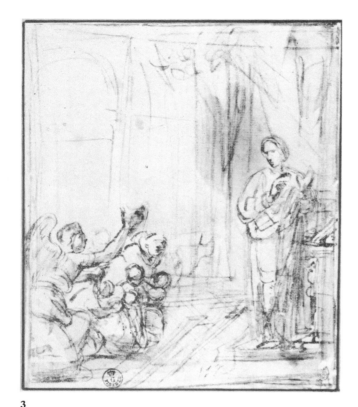

3

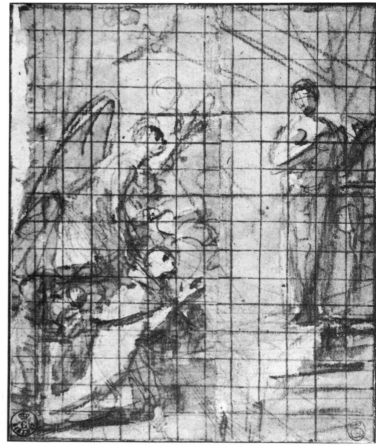

2

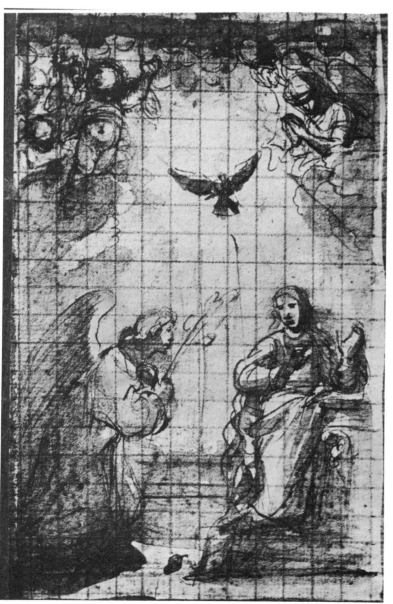

4

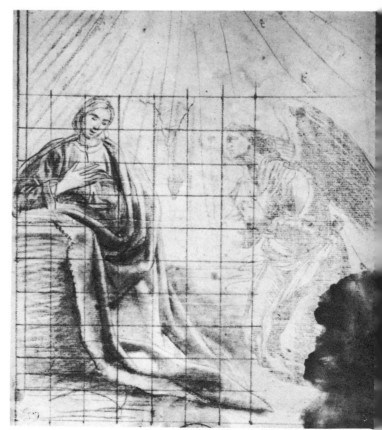

5

PLATE III

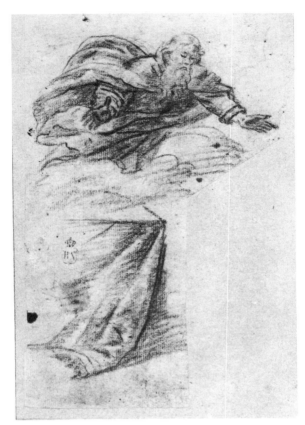 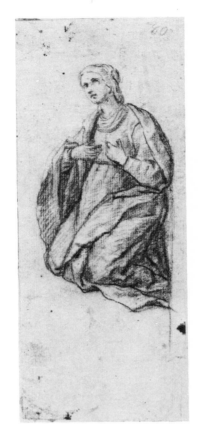

1

7

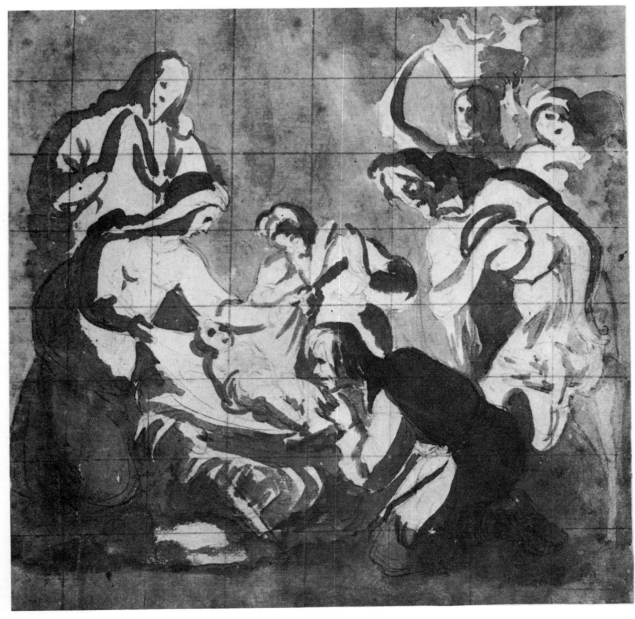

8

PLATE IV

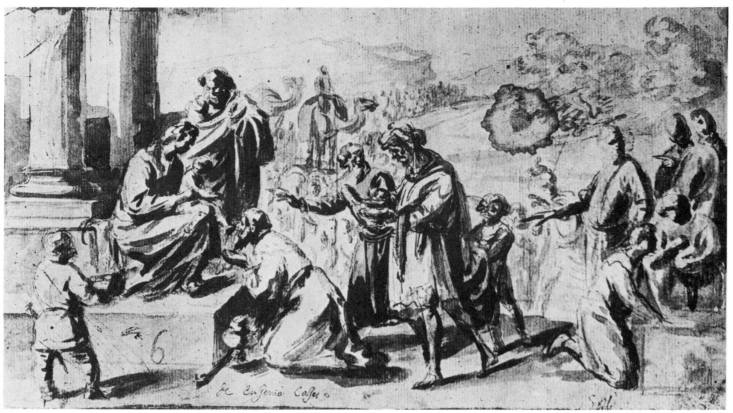

9

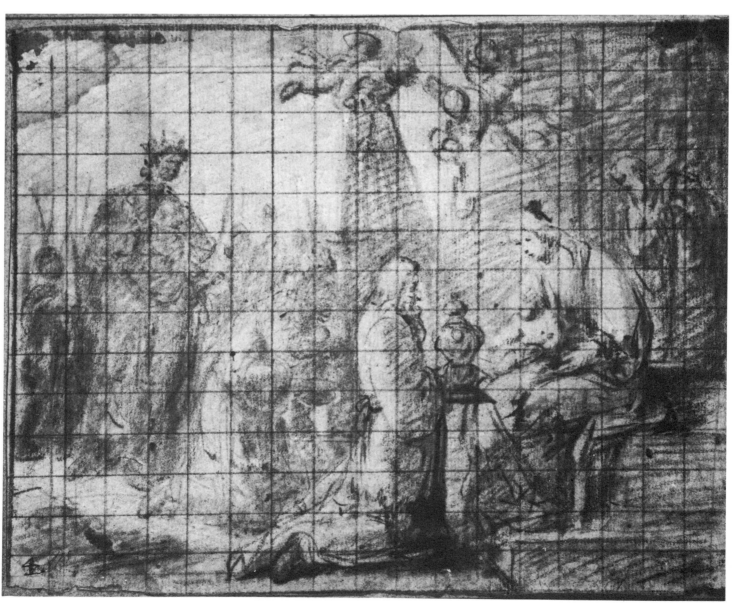

11

PLATE V

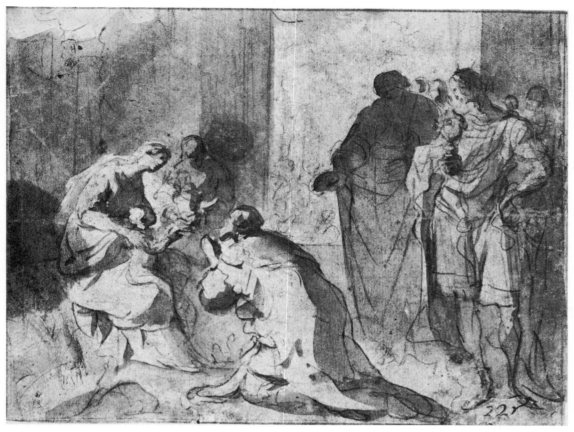

13

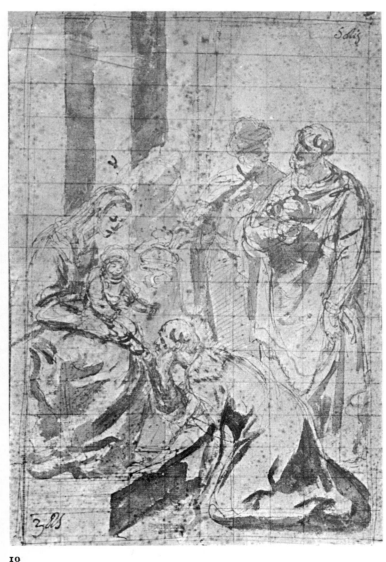

10

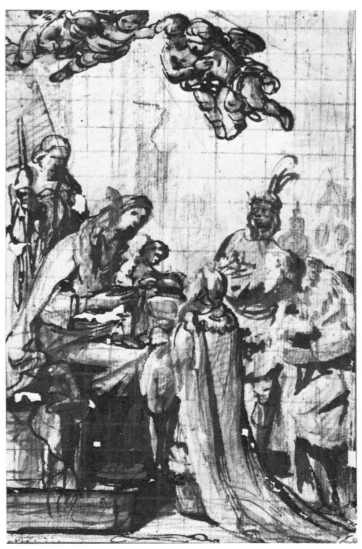

12

PLATE VI

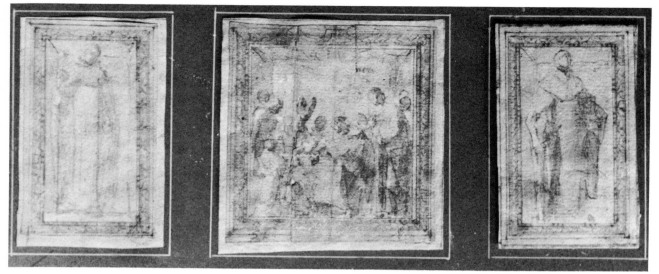

14

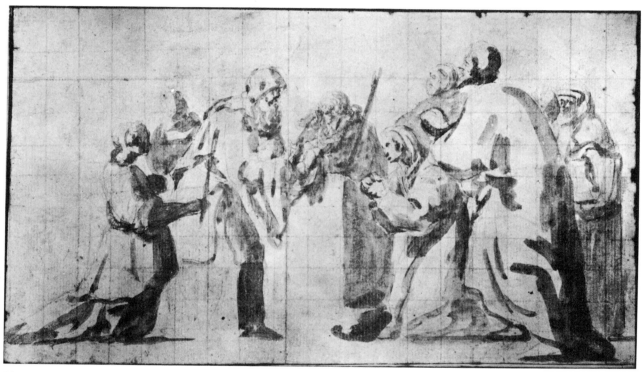

15

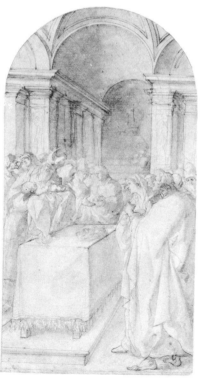

17

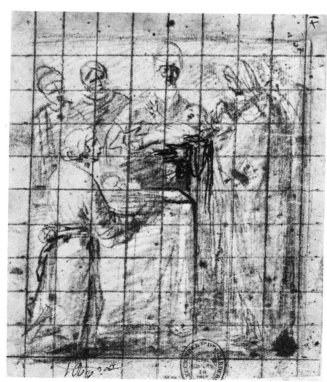

16

PLATE VII

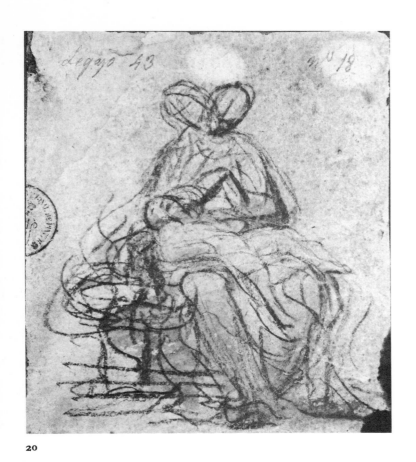

20

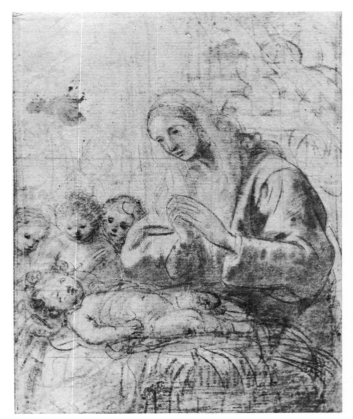

19

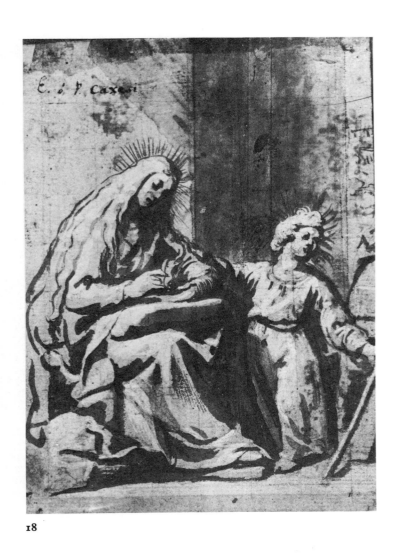

18

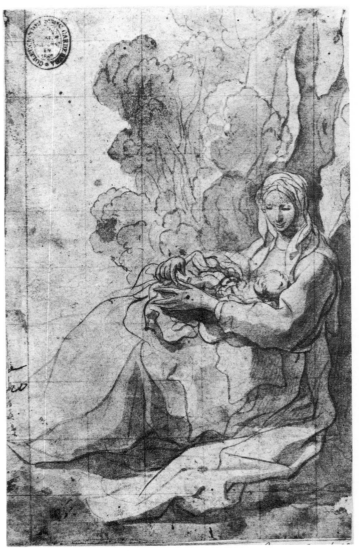

21

PLATE VIII

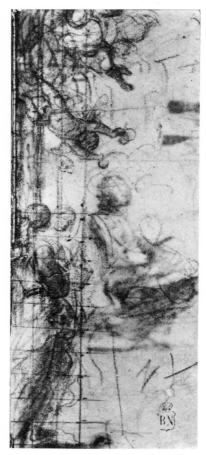
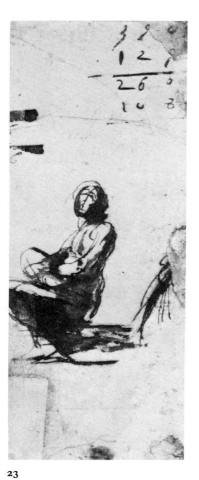

22

23

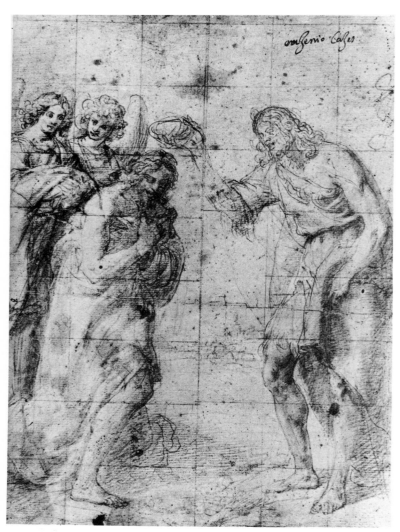

28

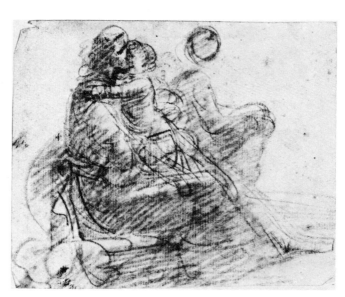

24

PLATE IX

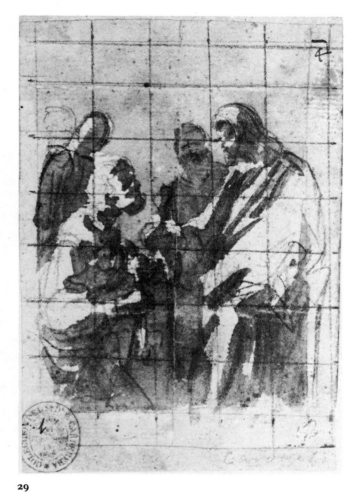

29

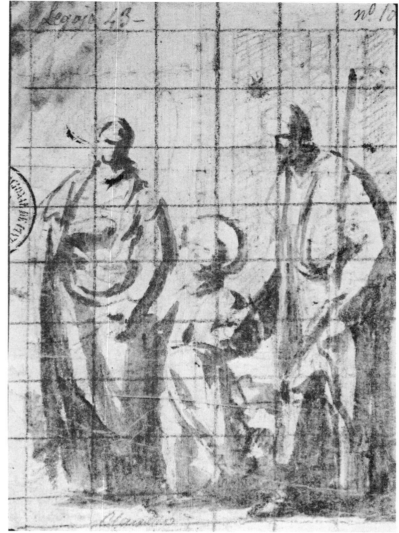

25

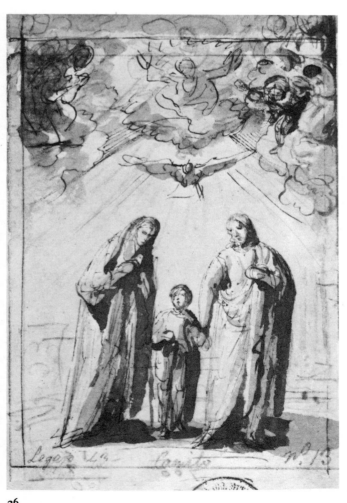

26

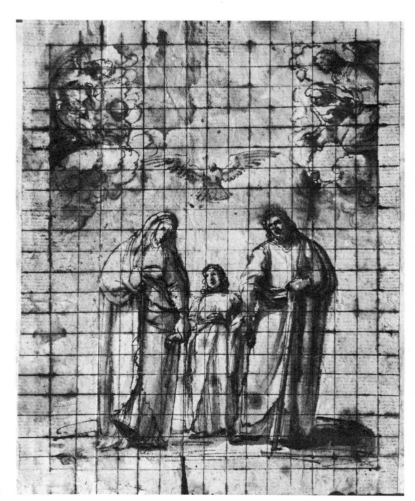

27

PLATE X

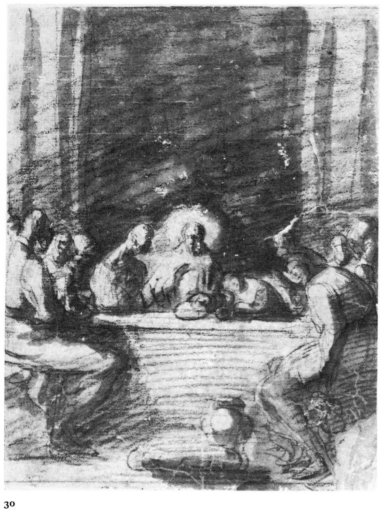

30

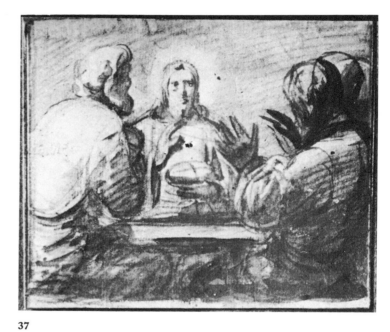

37

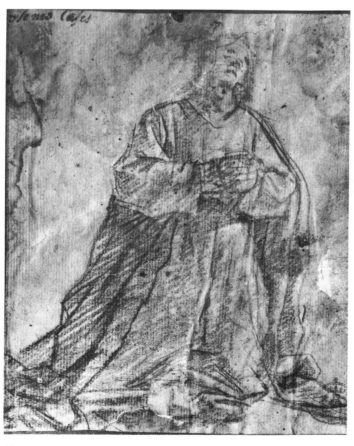

31

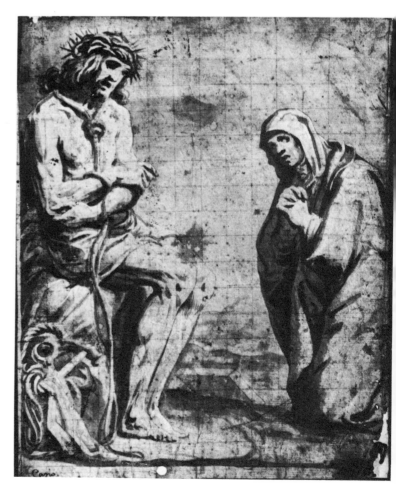

35

PLATE XI

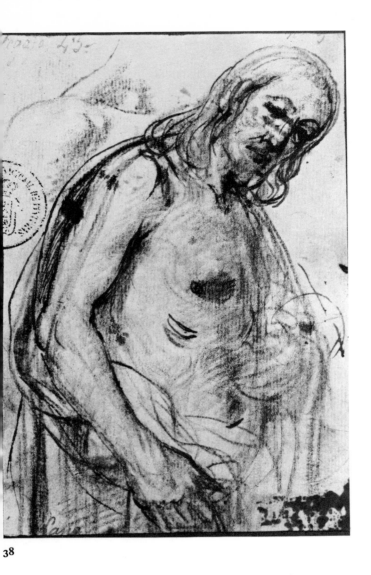

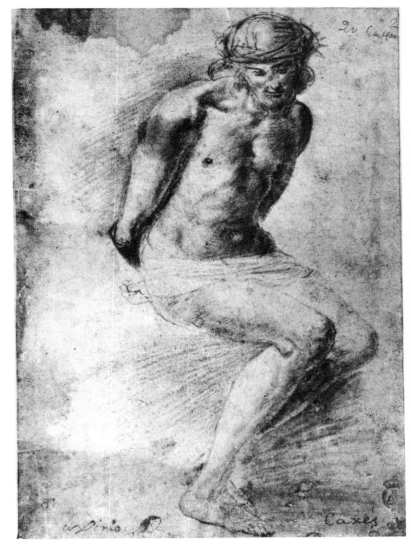

38

36

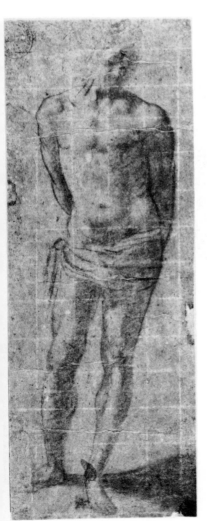

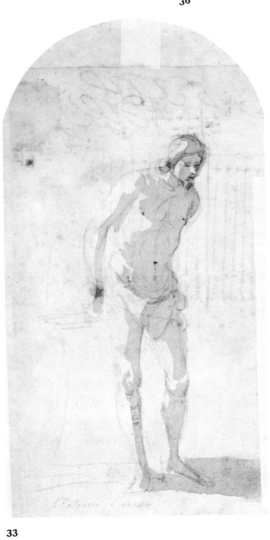

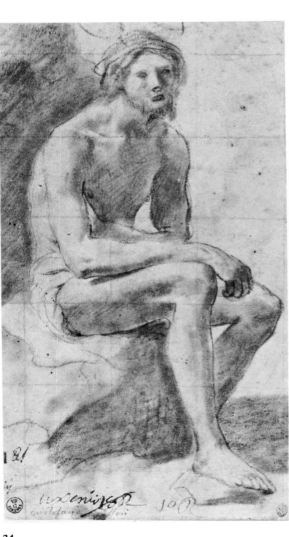

32

33

34

PLATE XII

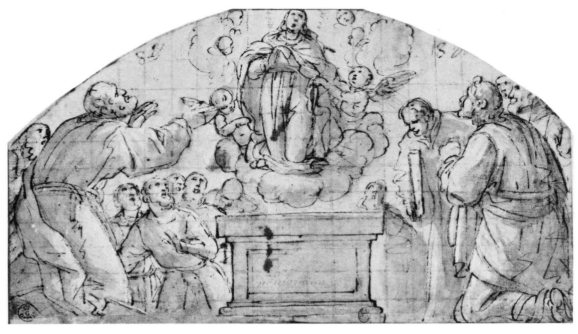

42

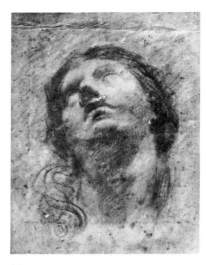

44

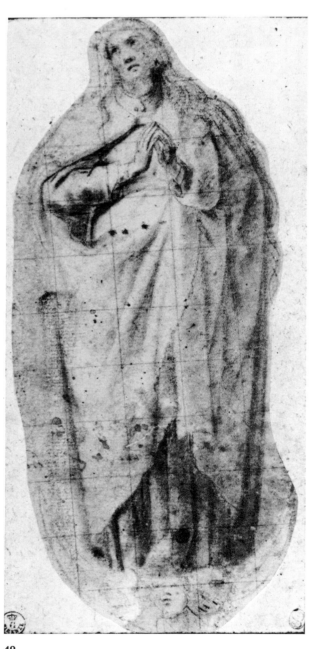

40

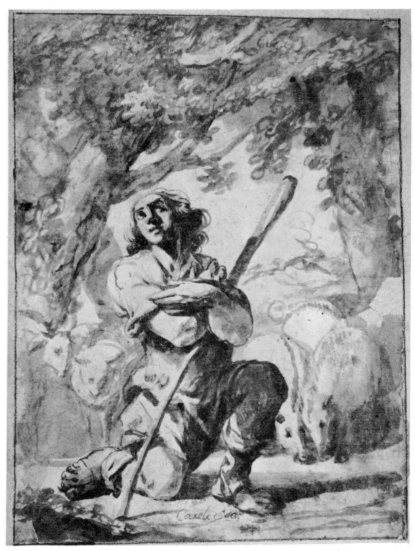

39

PLATE XIII

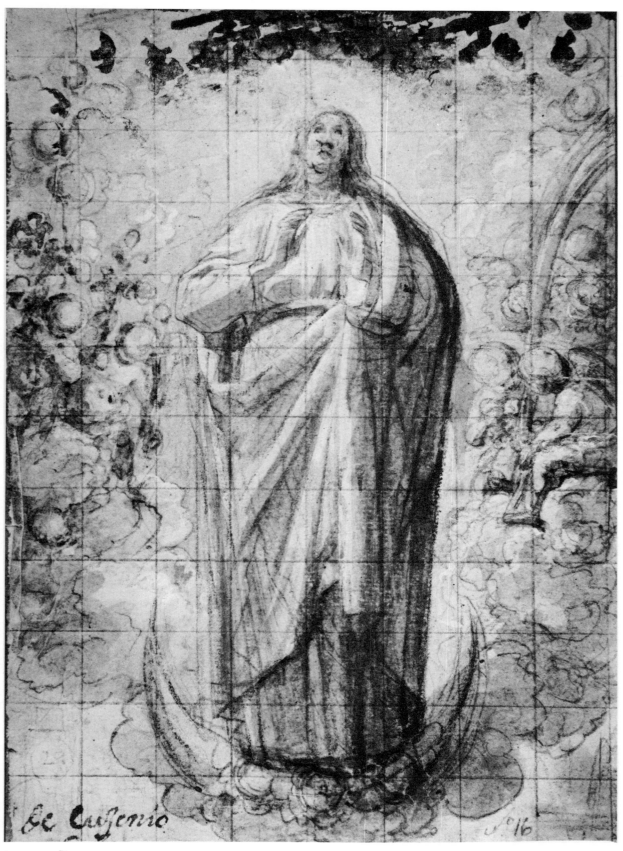

de Eugenio Nᵒ 16

PLATE XIV

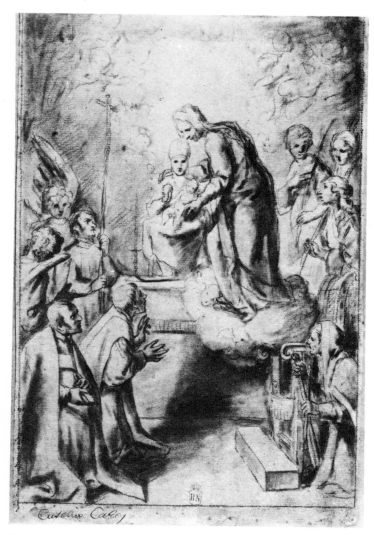

43

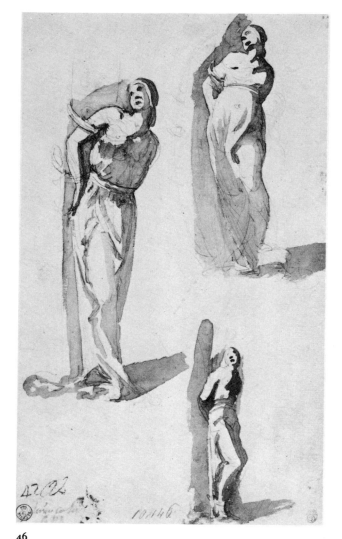

46

45

47

PLATE XV

51

53

48

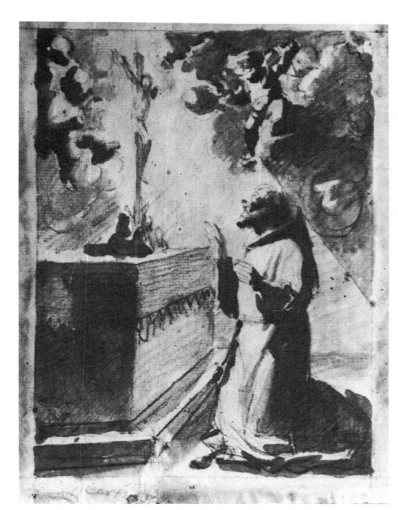

49

PLATE XVI

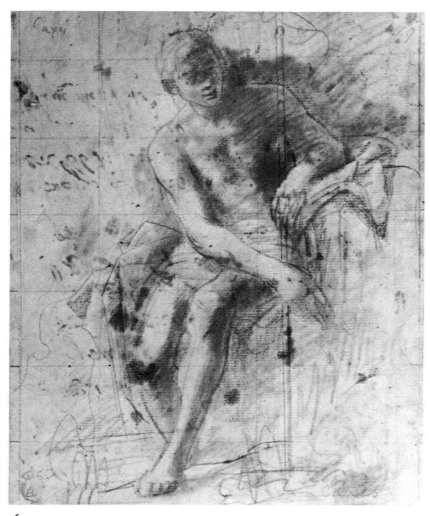

56

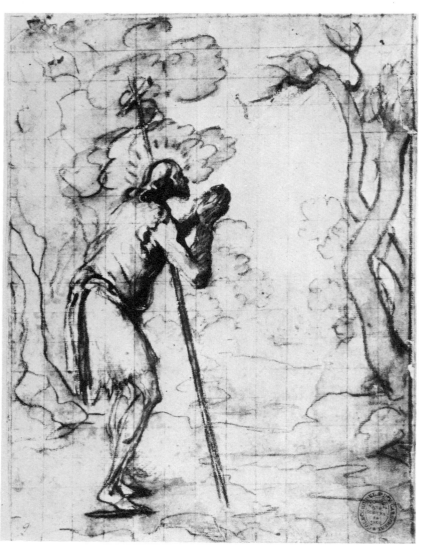

57

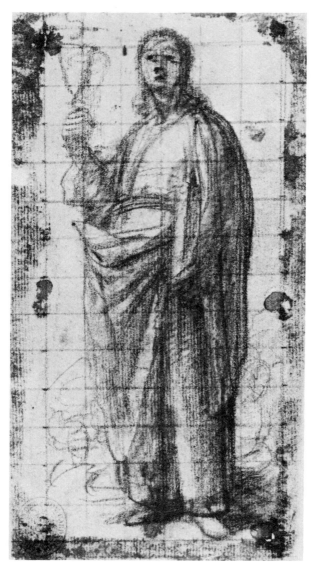

58

PLATE XVII

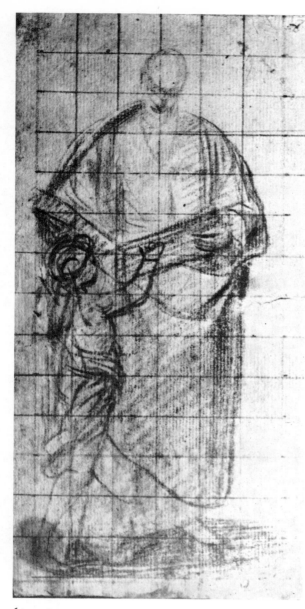

64 recto

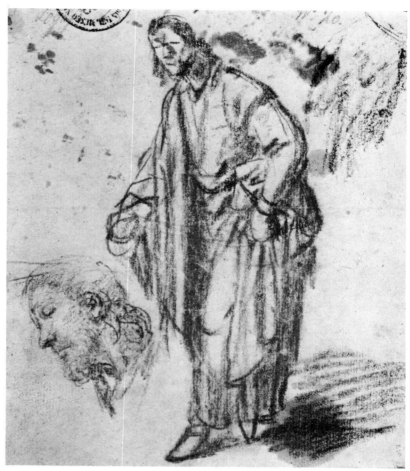

65 recto

64 verso

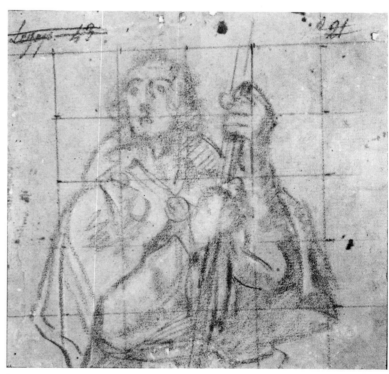

65 verso

PLATE XVIII

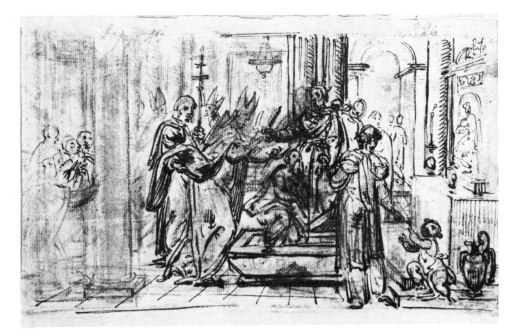

52

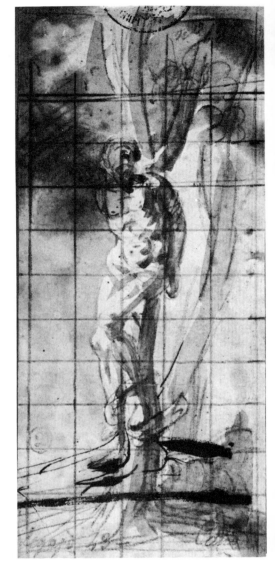

66

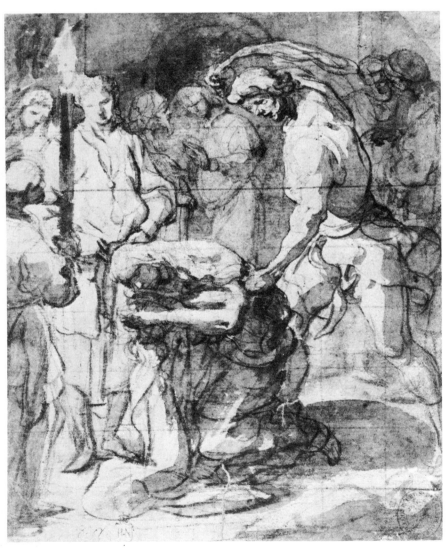

60

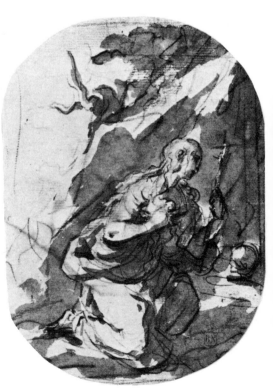

61

PLATE XIX

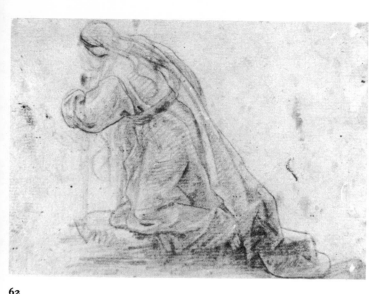

62

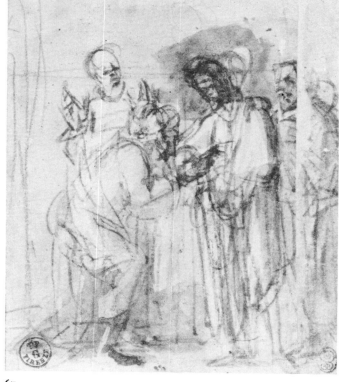

67

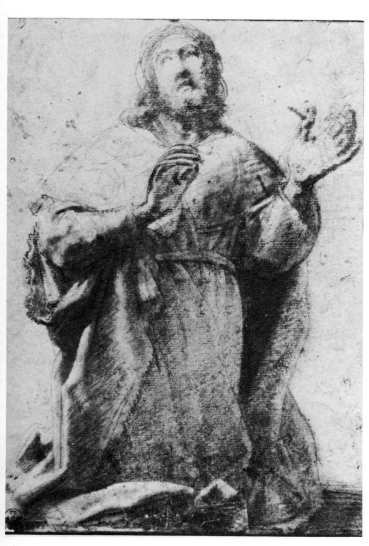

68

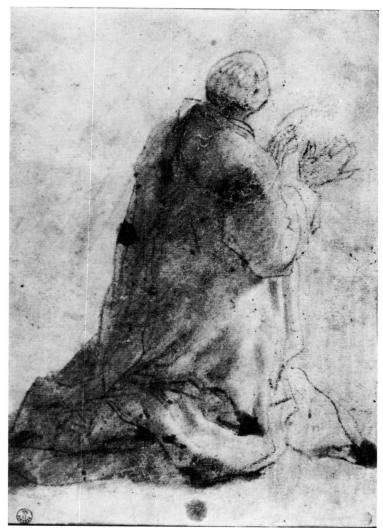

69

PLATE XX

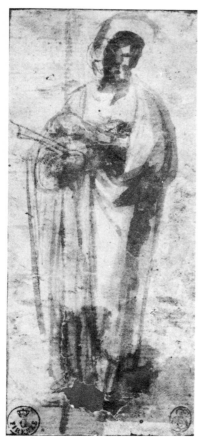

71

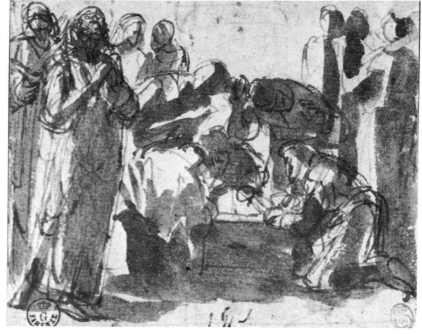

70

79

72

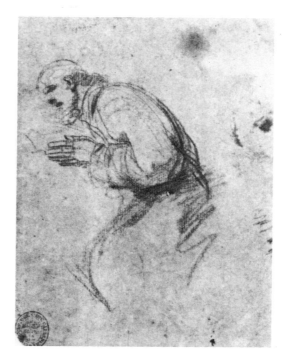

73

PLATE XXI

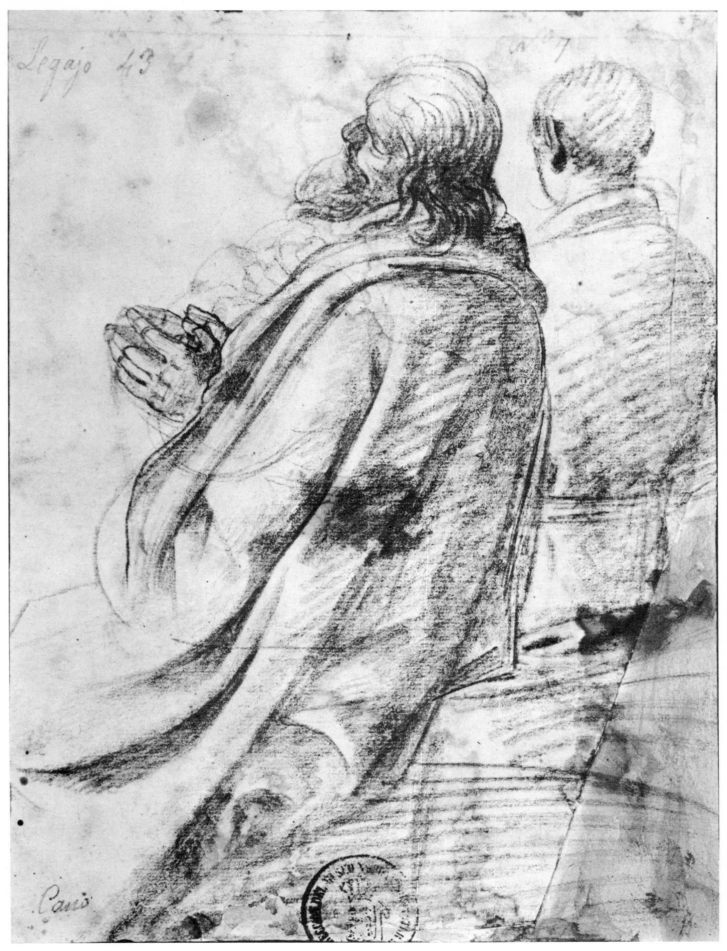

Legajo 43

Cano

PLATE XXII

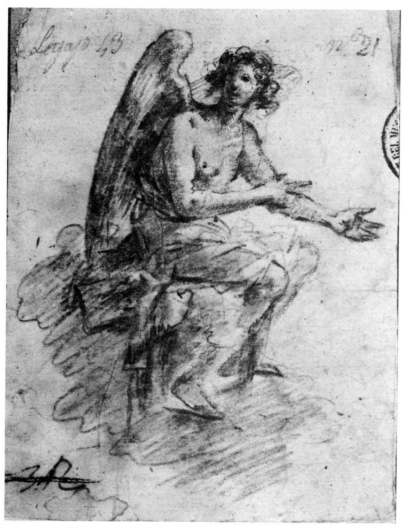

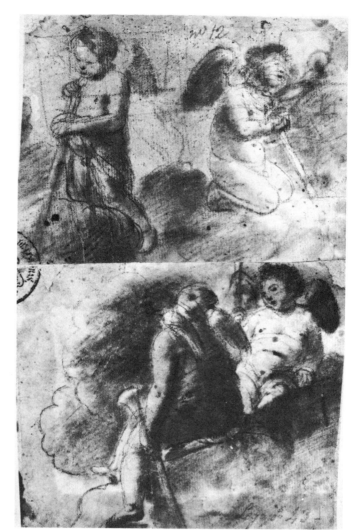

80

81

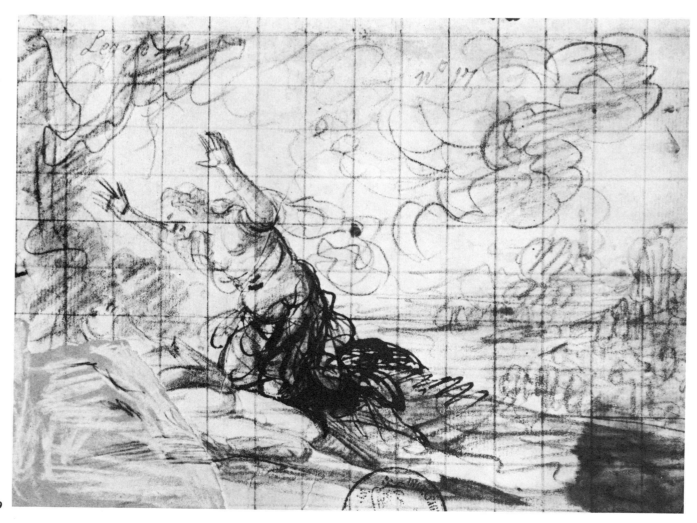

89

PLATE XXIII

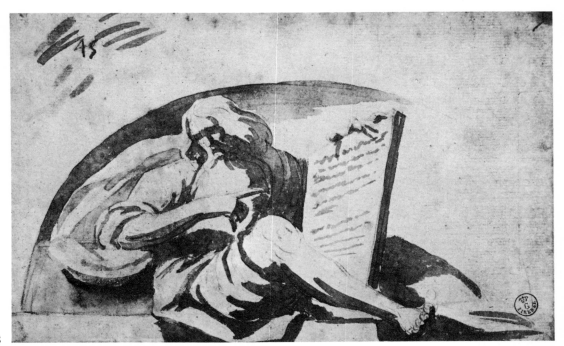

88

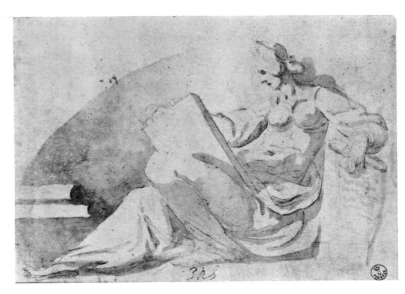

87

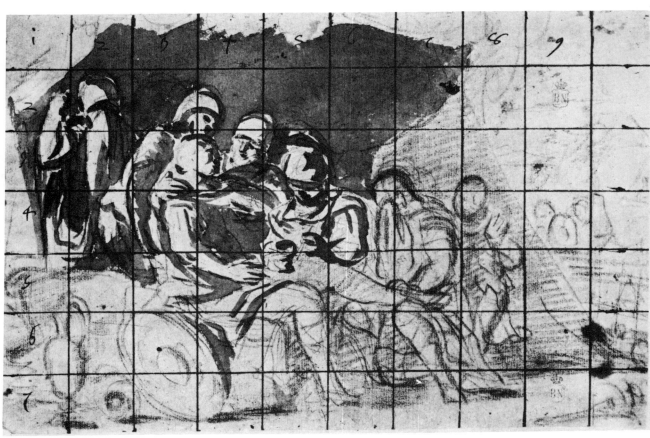

90

PLATE XXIV

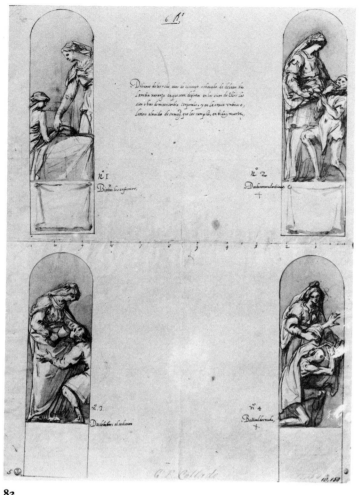

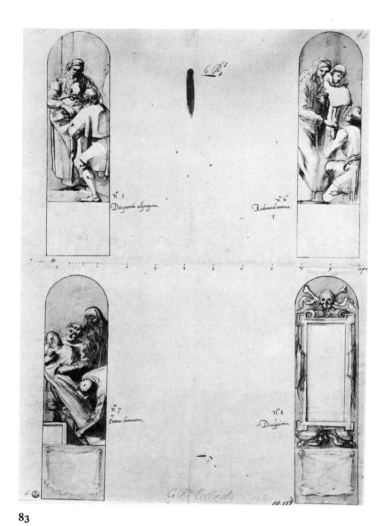

82

83

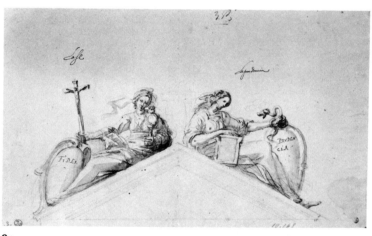

84

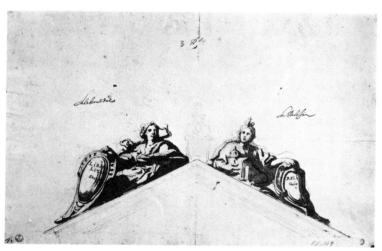

85

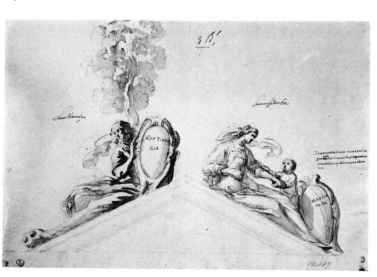

86

PLATE XXV

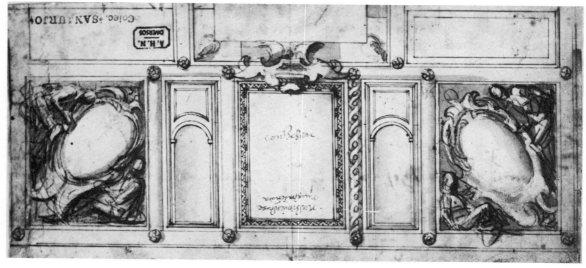

107

95

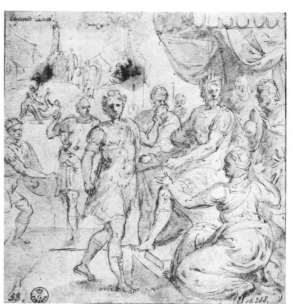

91

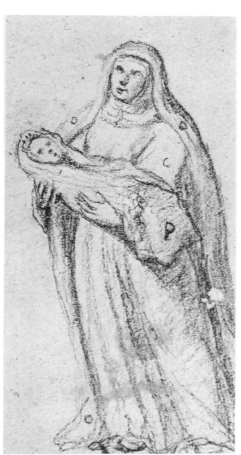

93 verso

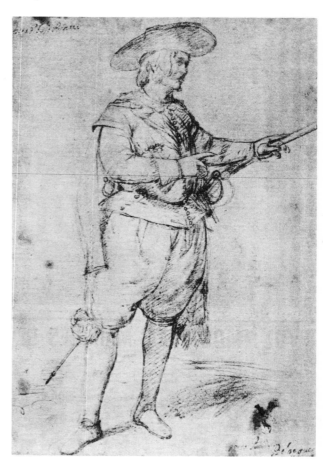

94

PLATE XXVI

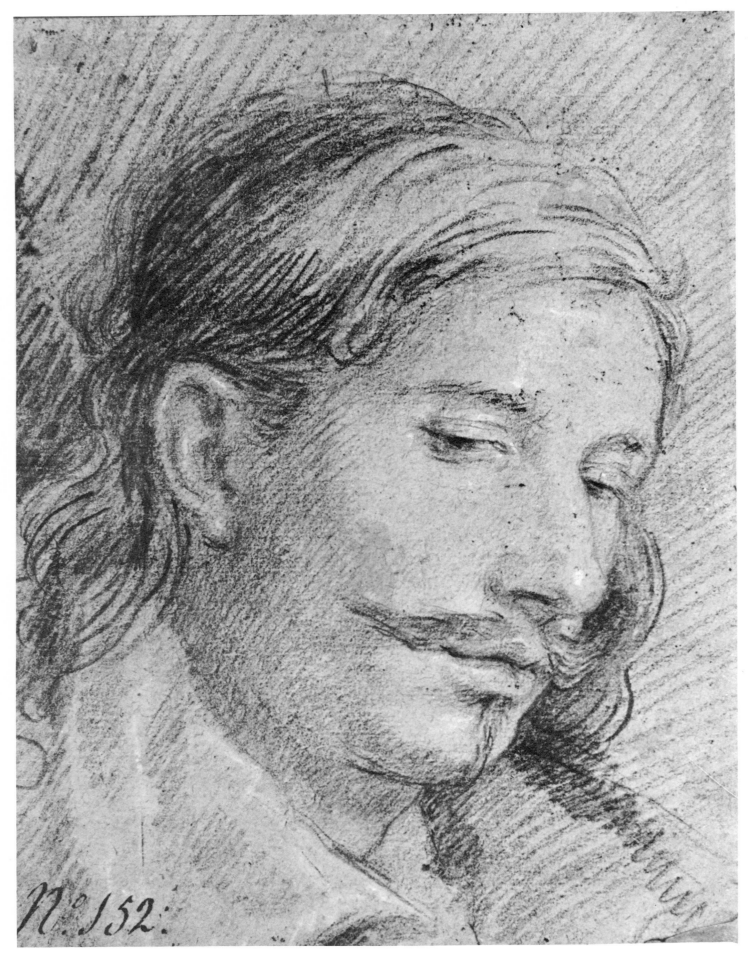

N.º 152:

PLATE XXVII

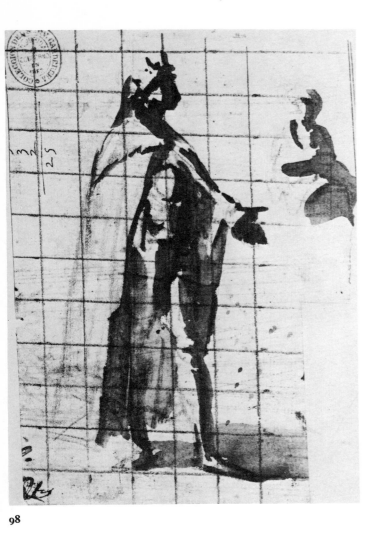

98

101

99

96

PLATE XXVIII

104

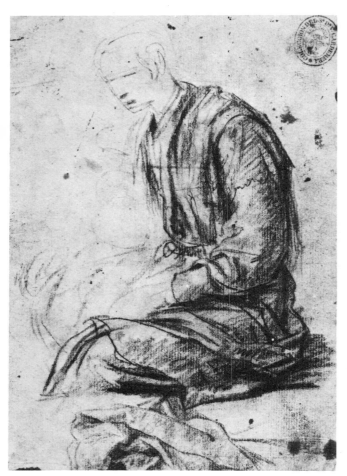

100

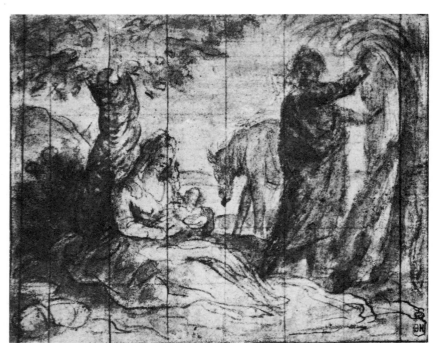

108

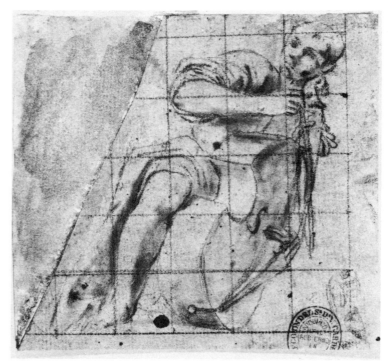

97

PLATE XXIX

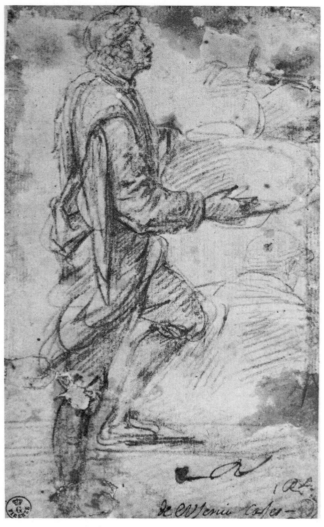

105

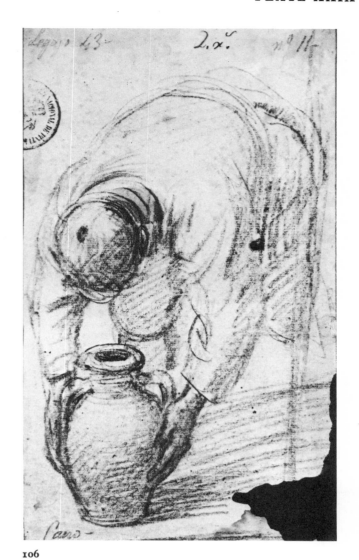

106

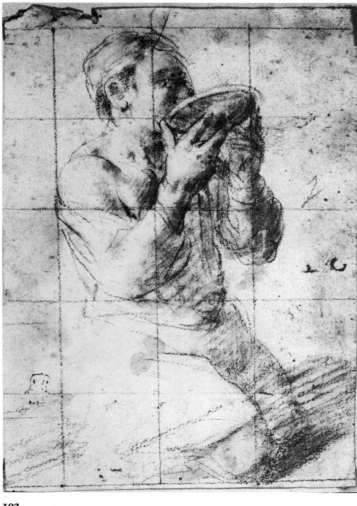

102

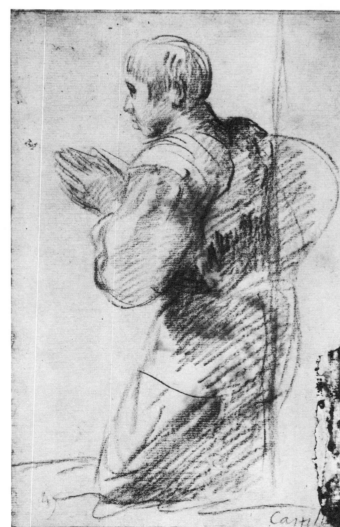

103

PLATE XXX

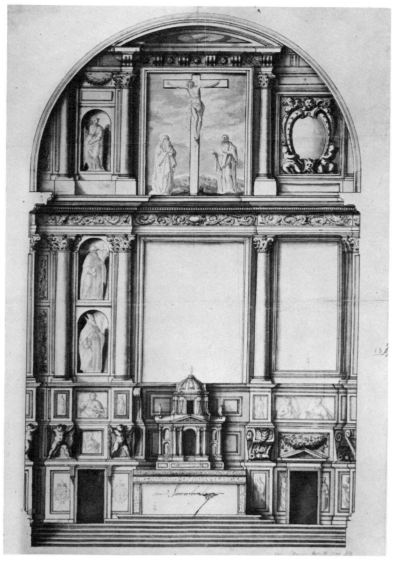

110

109

111

PLATE XXXI

112

113

PLATE XXXII

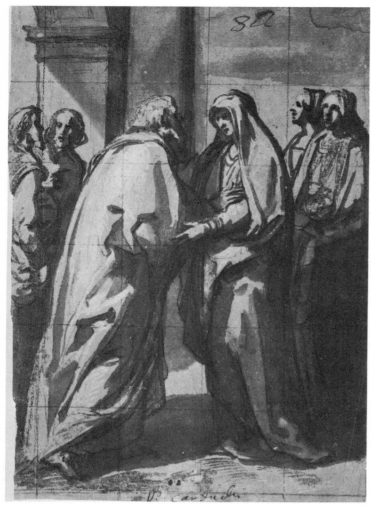

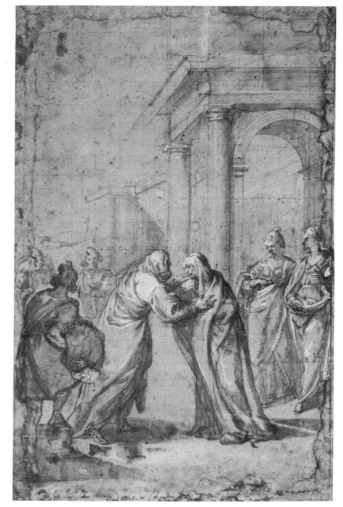

115 recto

114

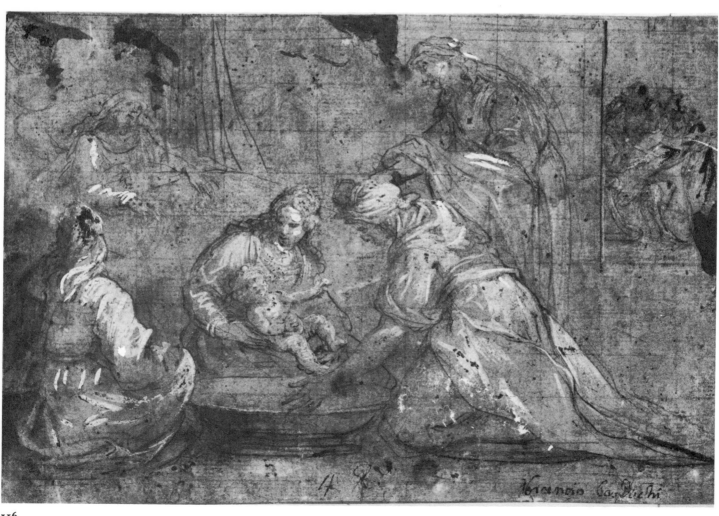

116

PLATE XXXIII

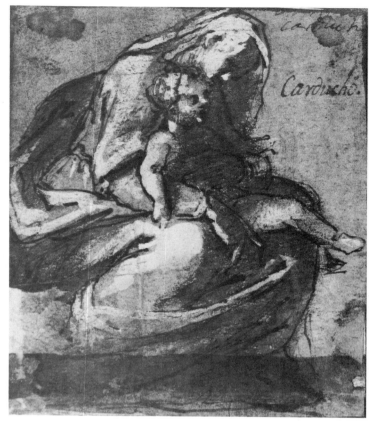

123

117

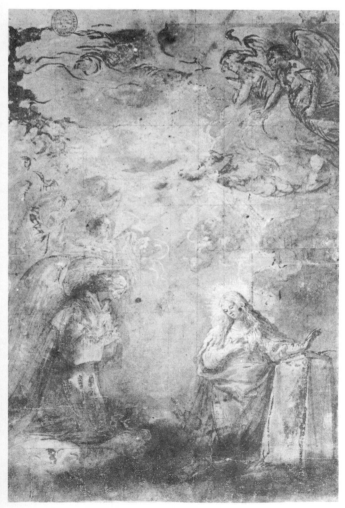

118

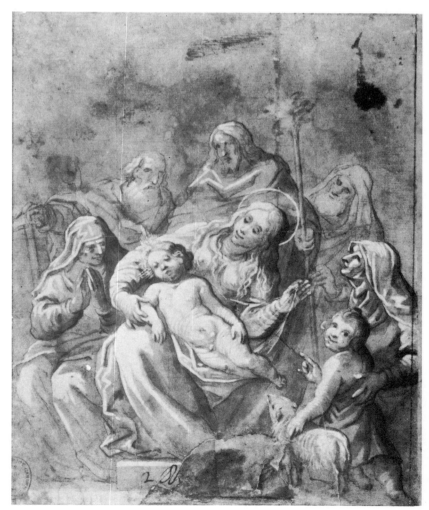

122

PLATE XXXIV

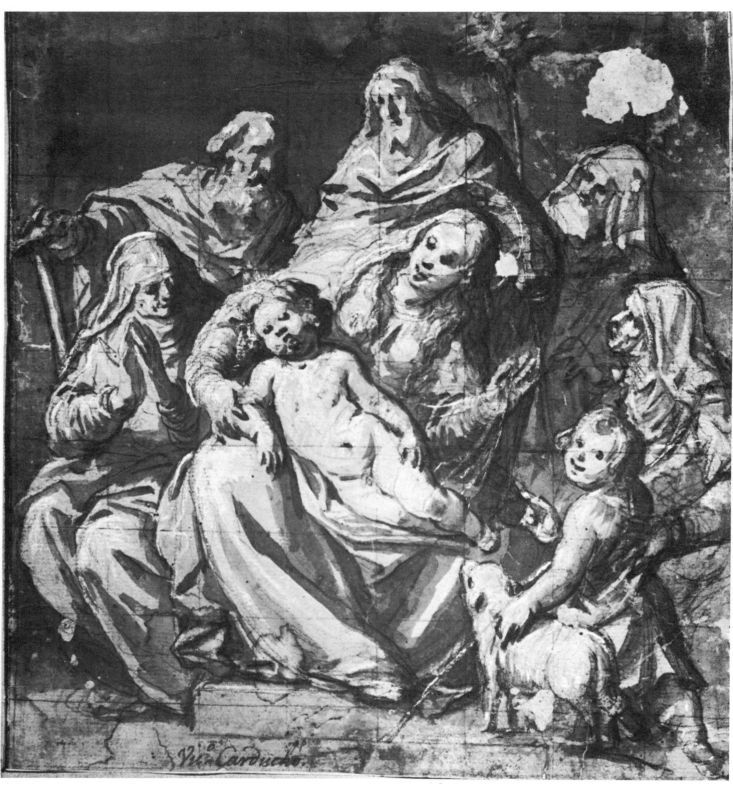

PLATE XXXV

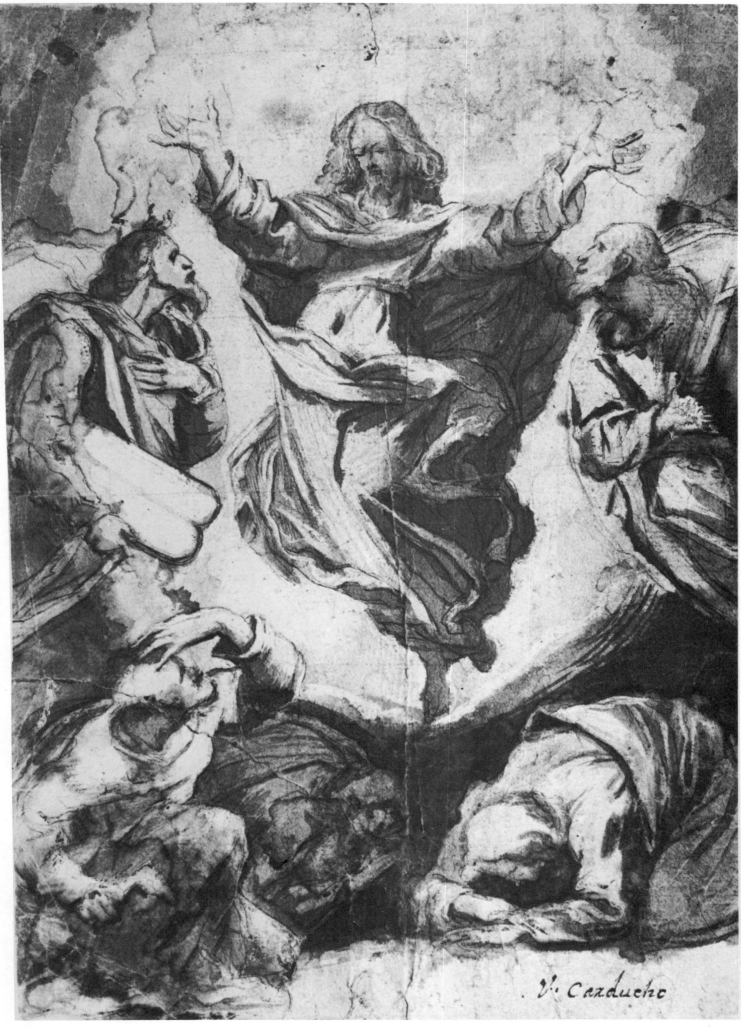

V. Carducho

PLATE XXXVI

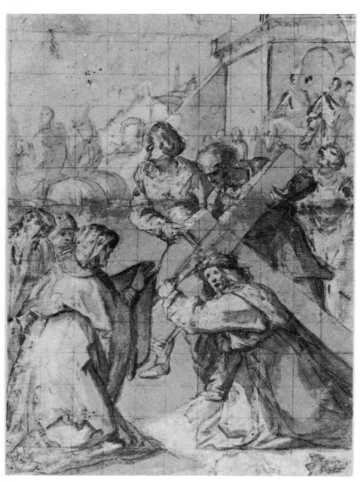

126

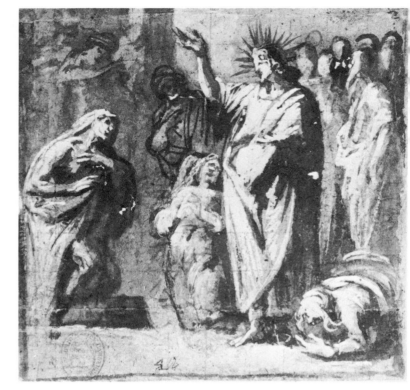

124

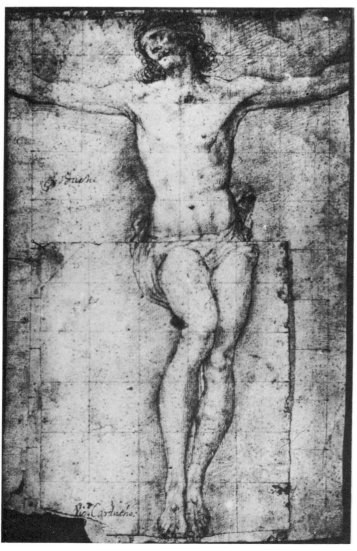

127

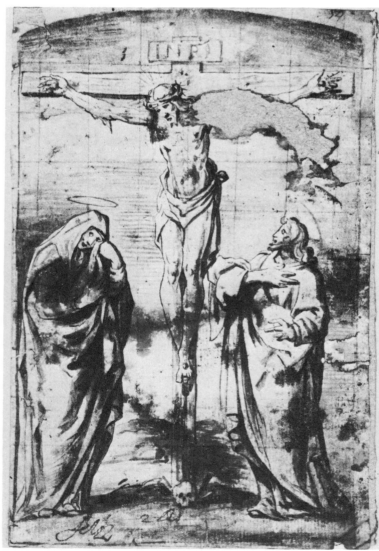

128

PLATE XXXVII

129

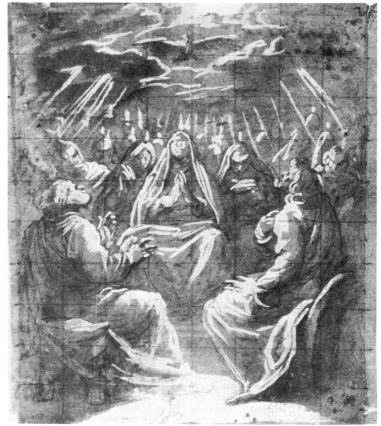

130

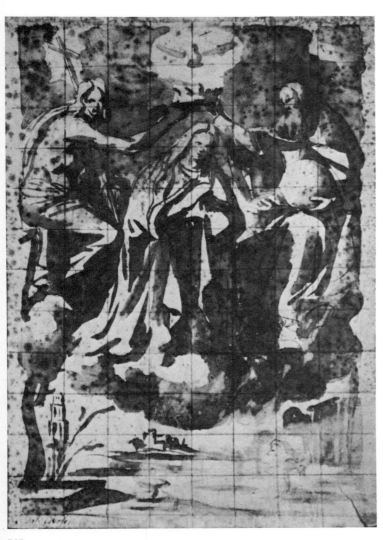

131

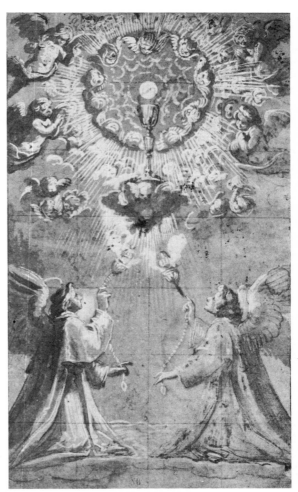

133

PLATE XXXVIII

134

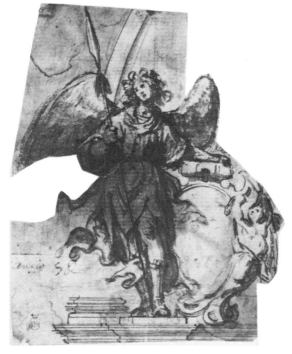

137

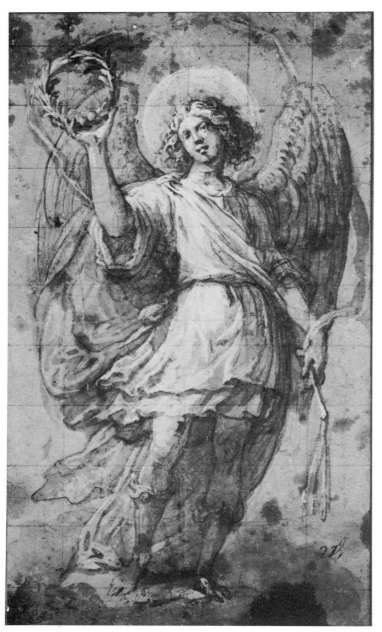

135

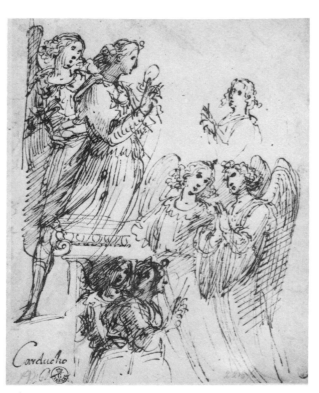

136

PLATE XXXIX

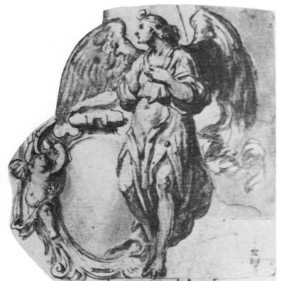

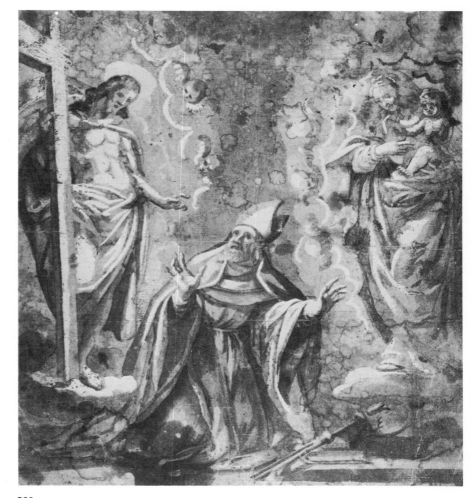

138

139

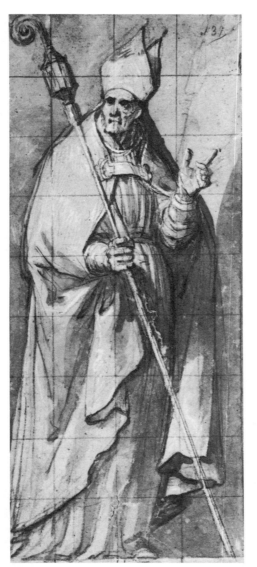

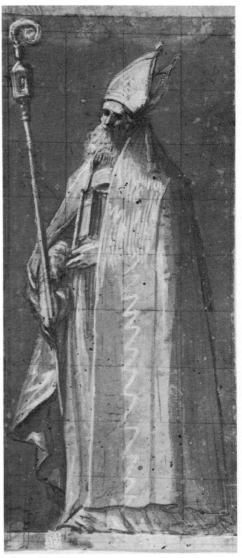

140

141

PLATE XL

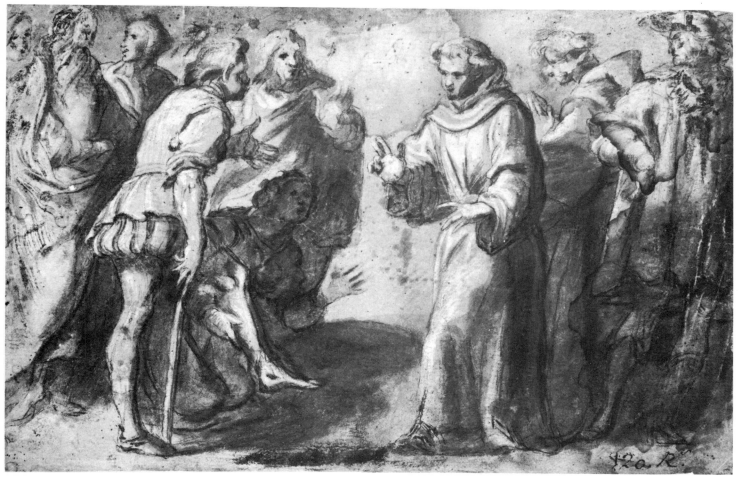

143

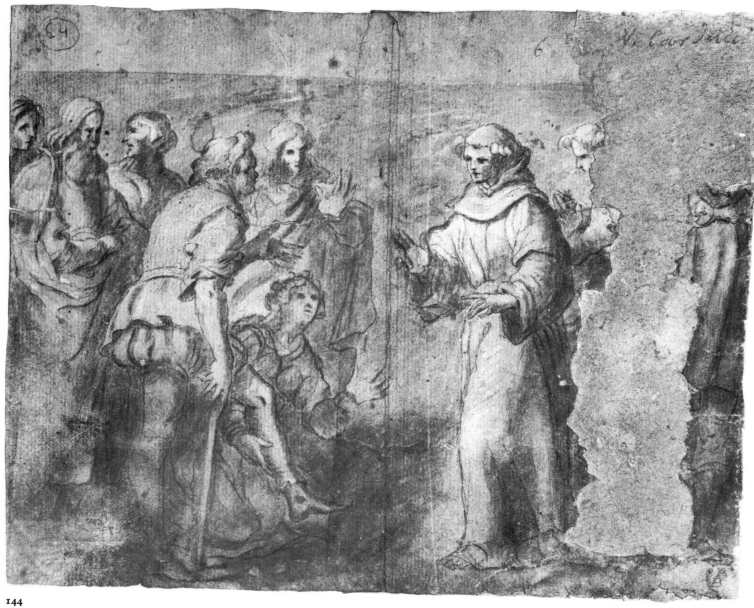

144

PLATE XLI

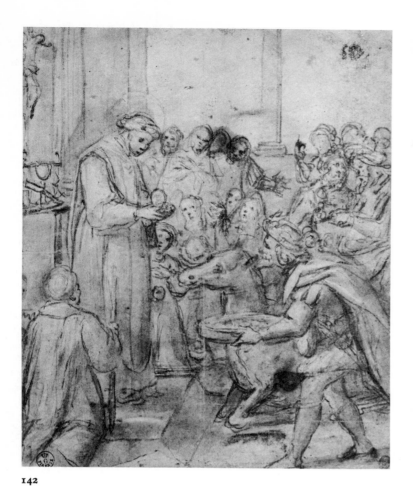

142

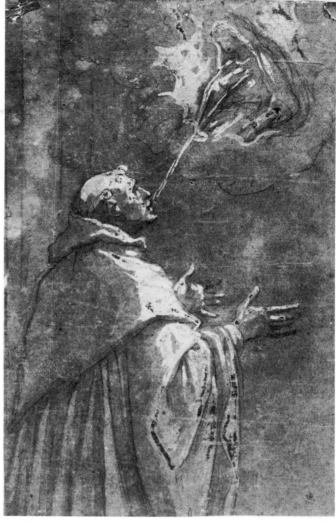

145

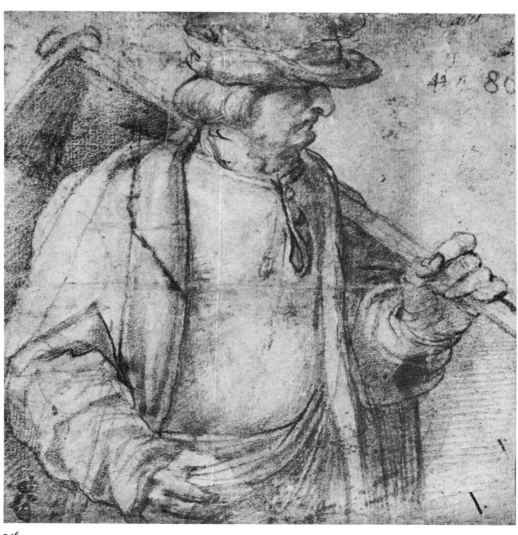

146

PLATE XLII

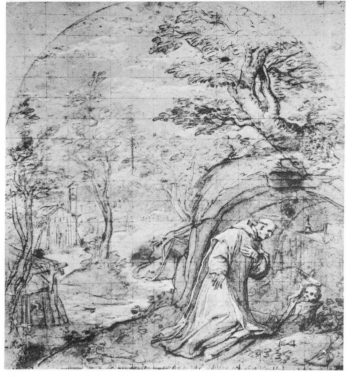

147

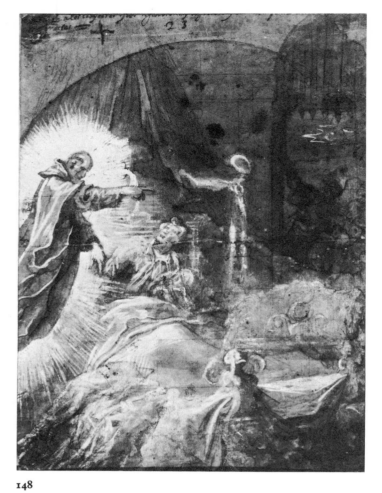

148

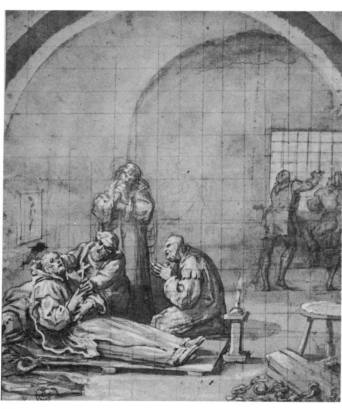

149

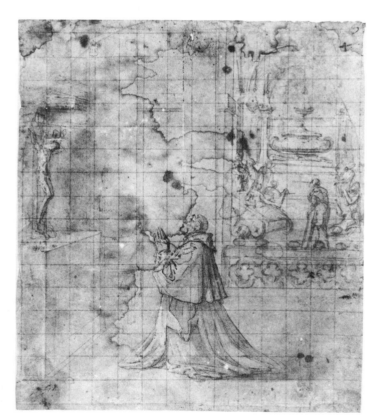

152

PLATE XLIII

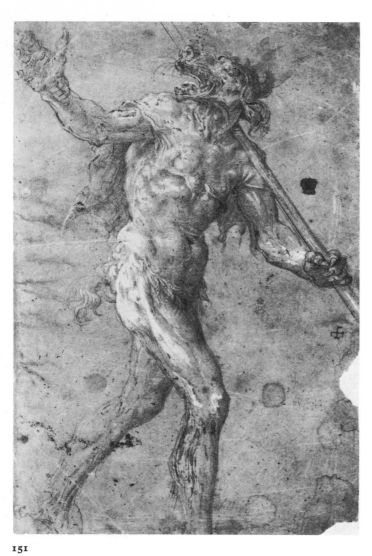

151

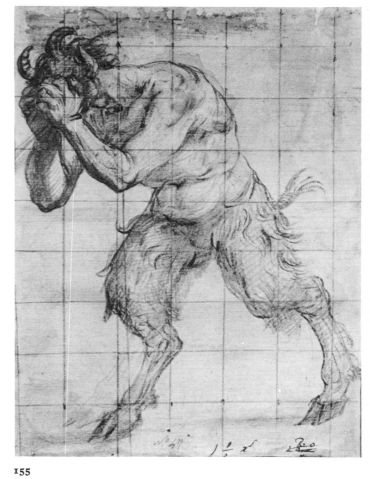

155

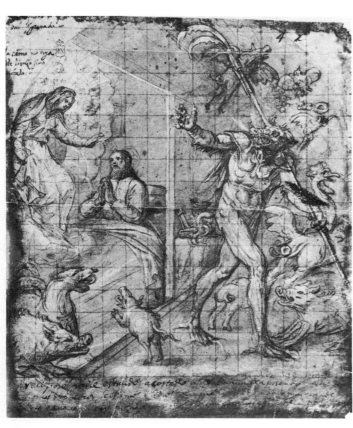

150

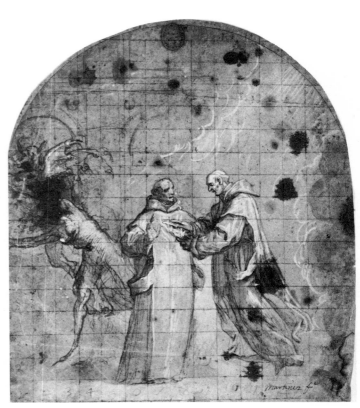

154

PLATE XLIV

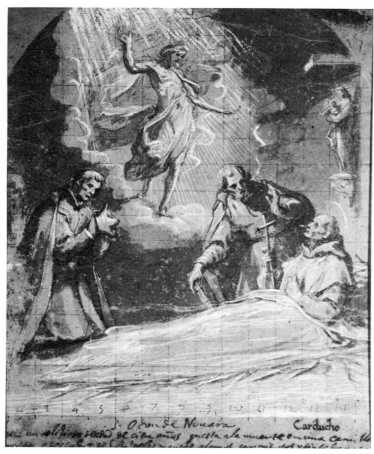

156

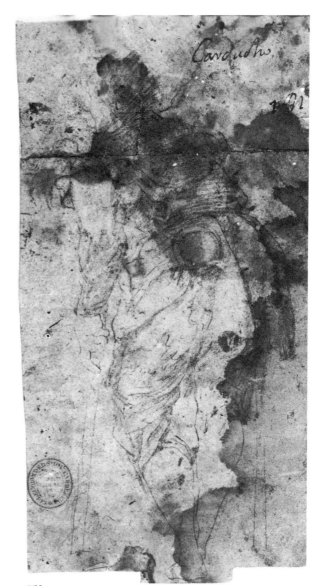

153

157

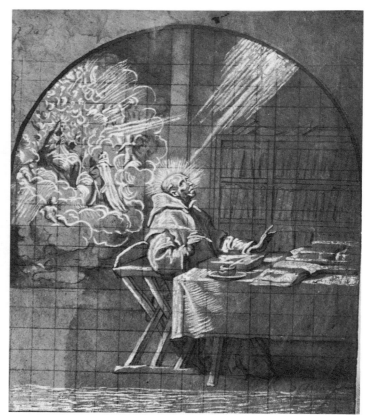

158

PLATE XLV

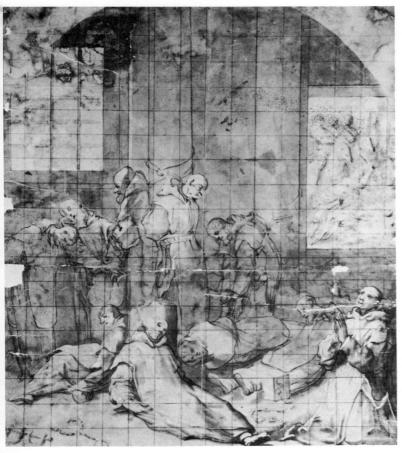

159

160

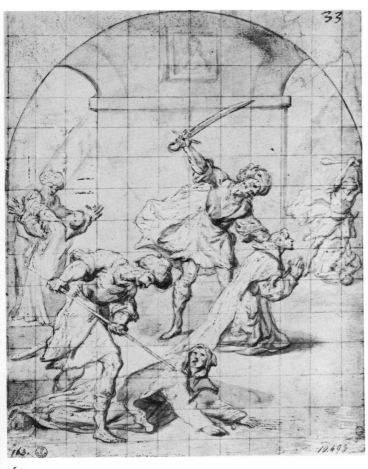

162

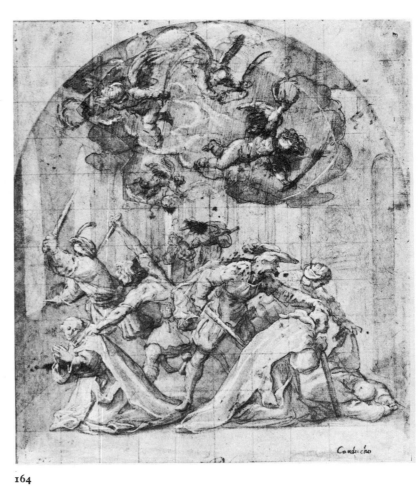

164

PLATE XLVI

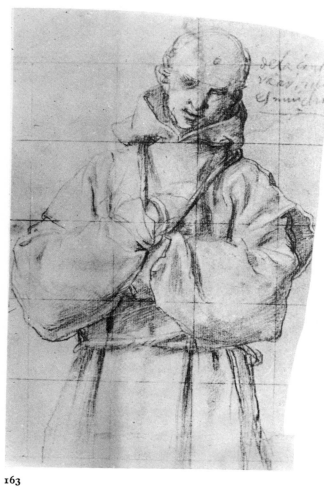

163

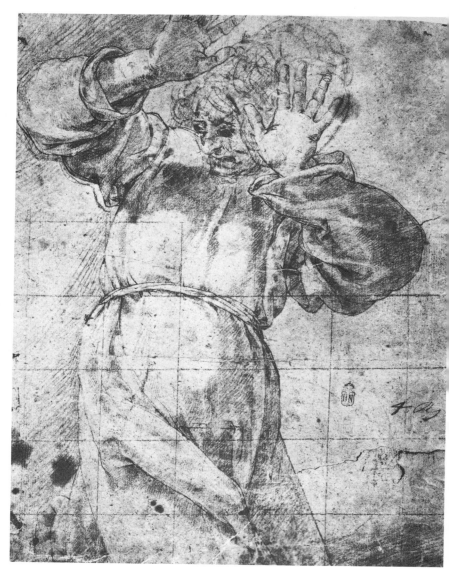

166

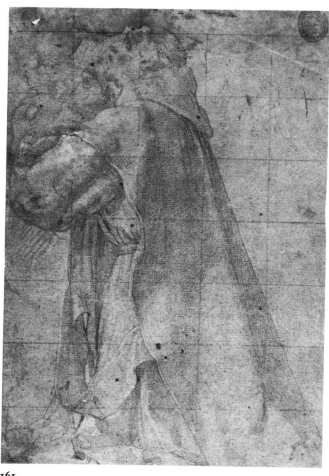

161

PLATE XLVII

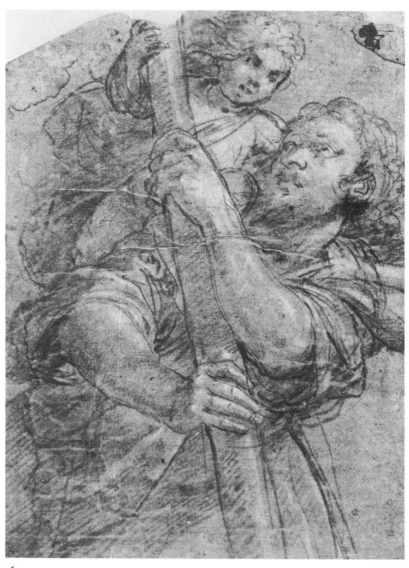

169

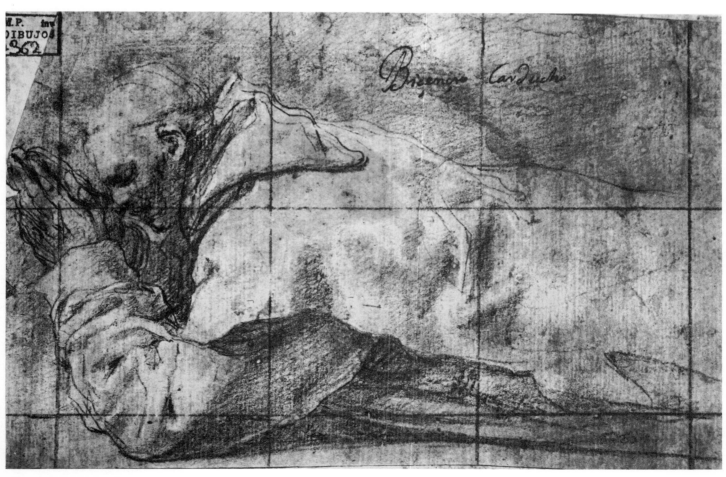

165

PLATE XLVIII

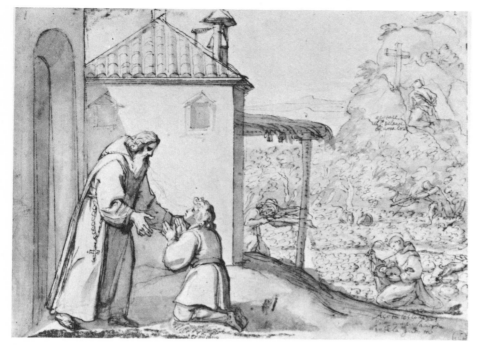

171

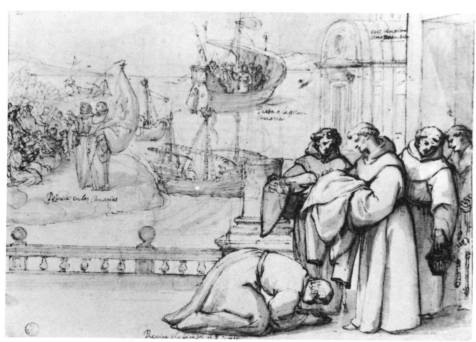

172

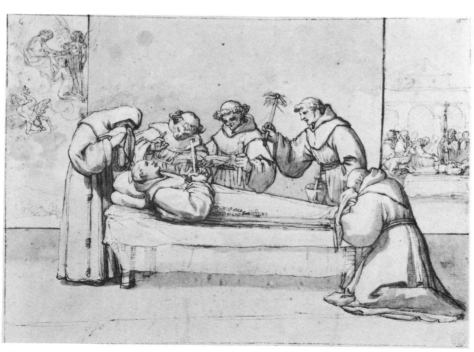

173

PLATE XLIX

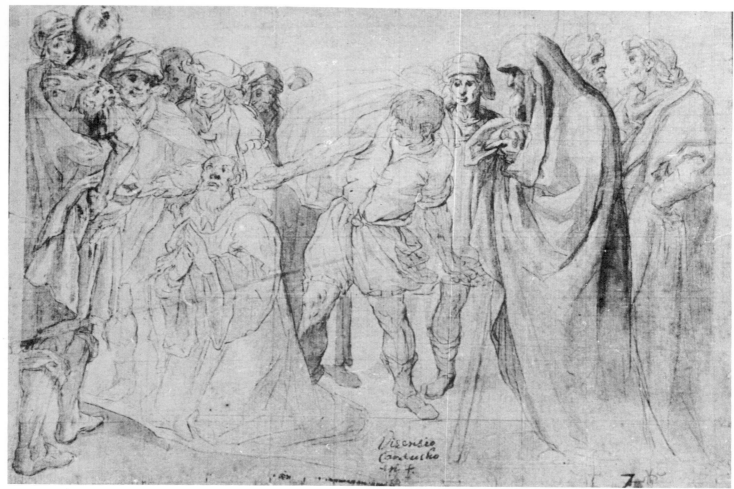

175

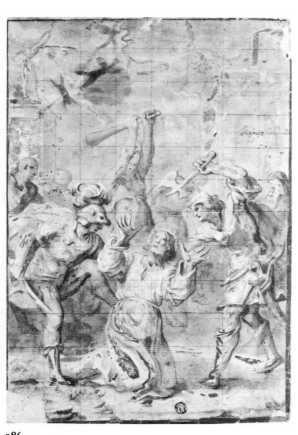

186

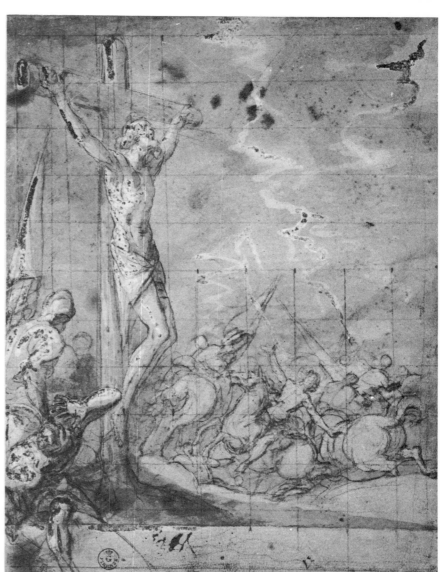

176

PLATE L

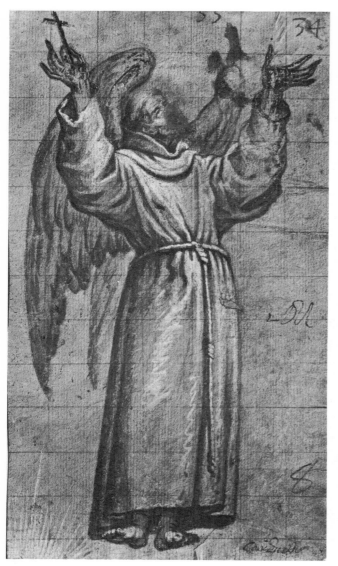

177

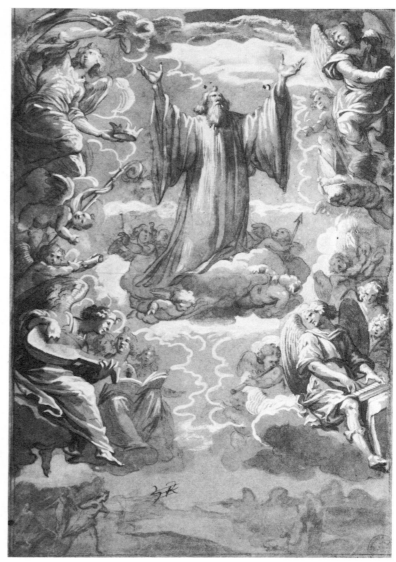

179

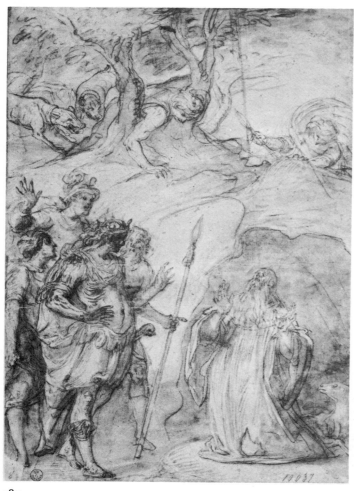

180

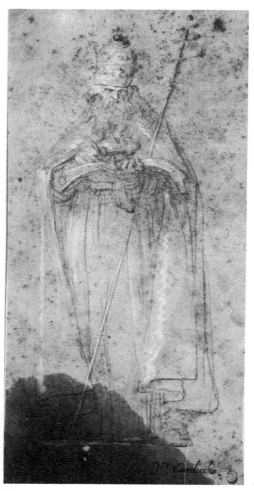

181

PLATE LI

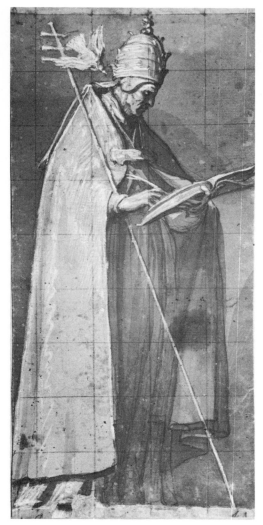

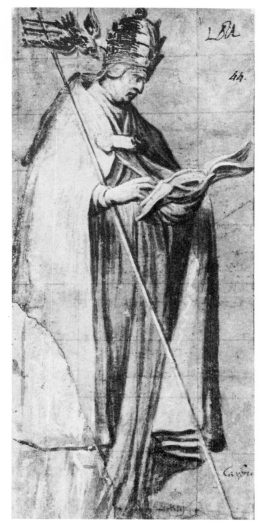

182

183

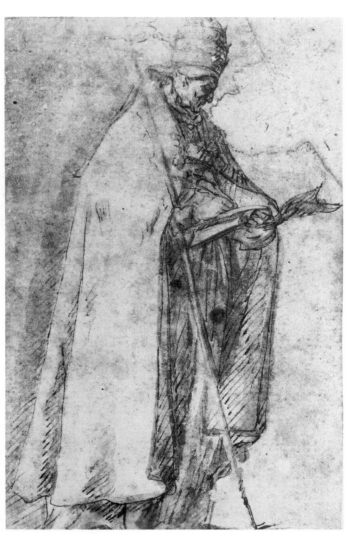

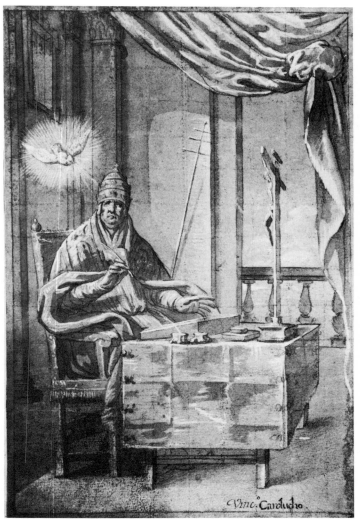

184

185

PLATE LII

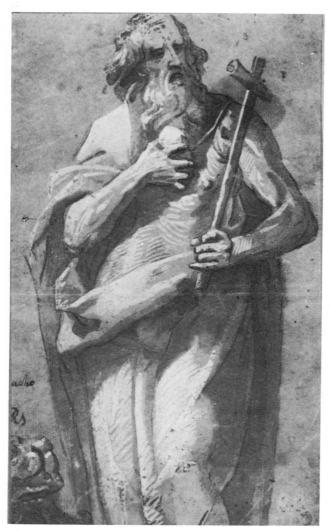

187

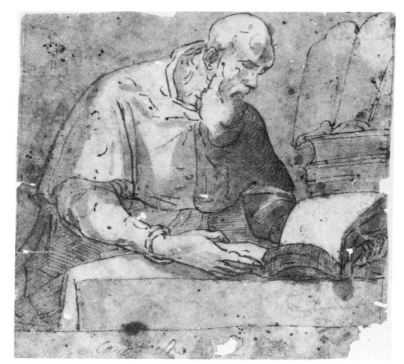

189

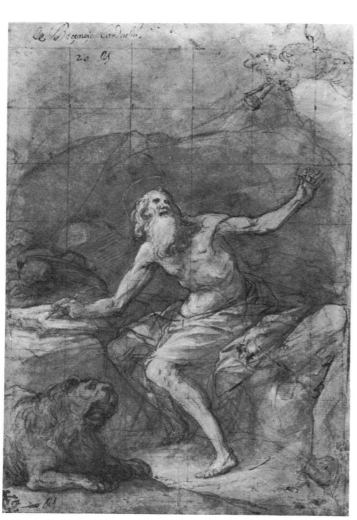

190

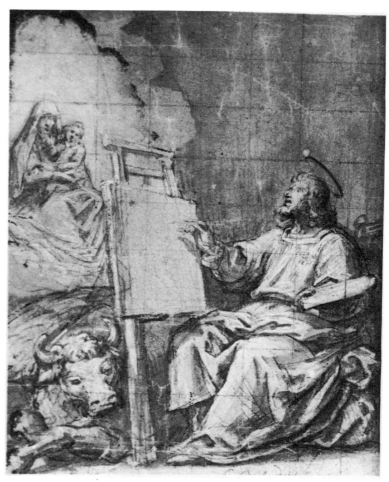

194

PLATE LIII

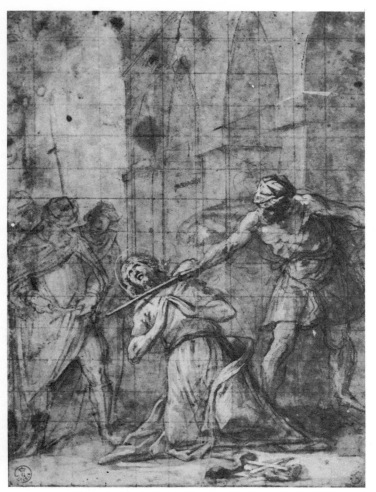

191

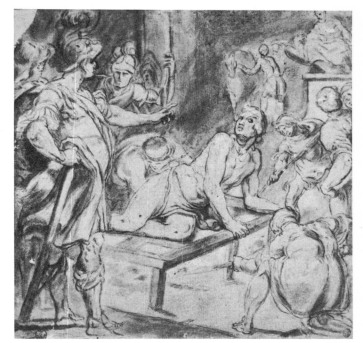

192

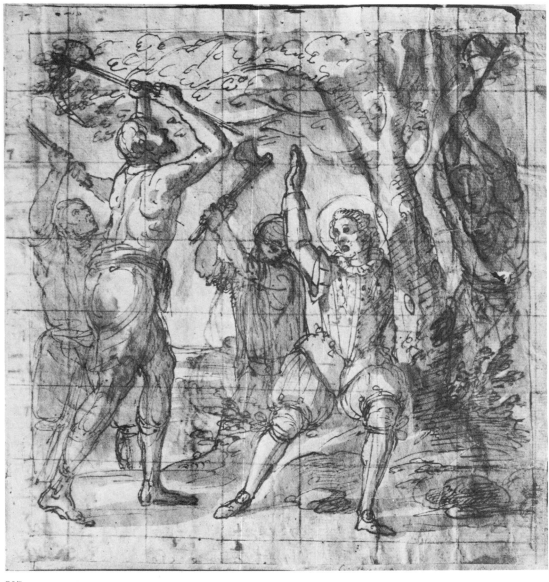

197

PLATE LIV

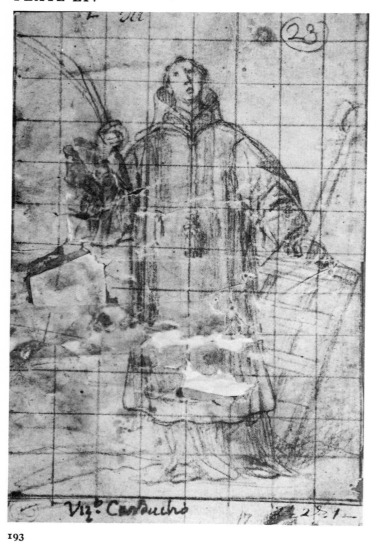

193

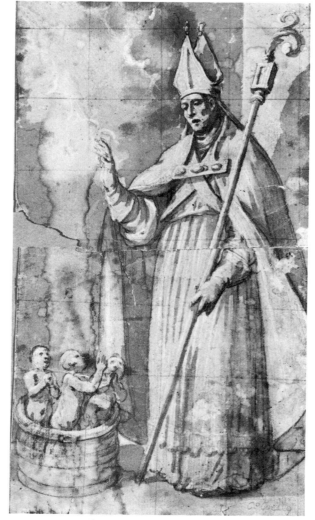

196

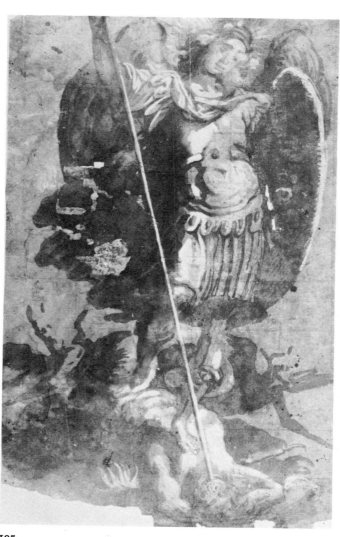

195

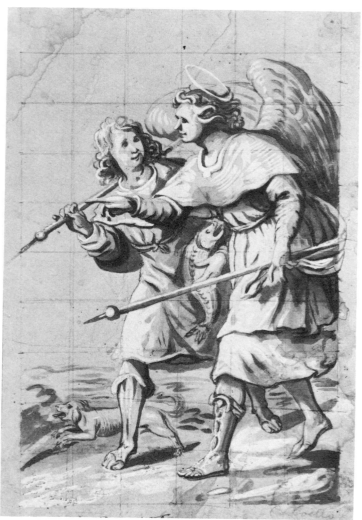

198

PLATE LV

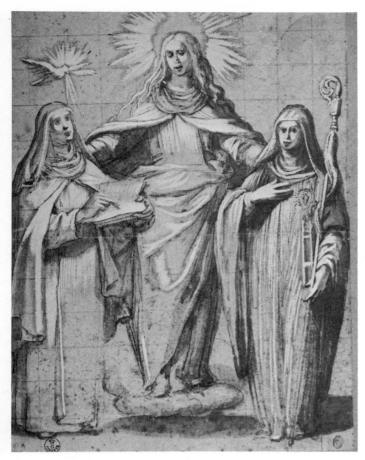

199

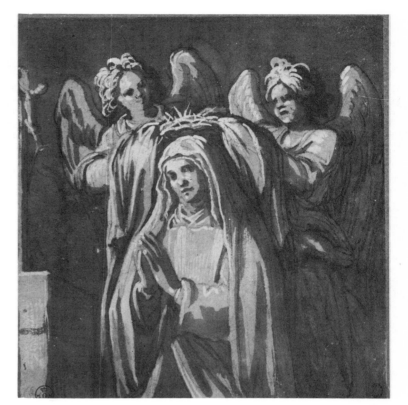

205

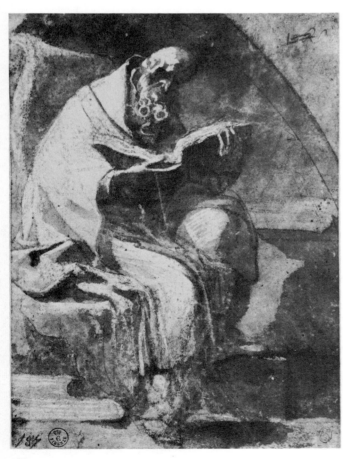

202

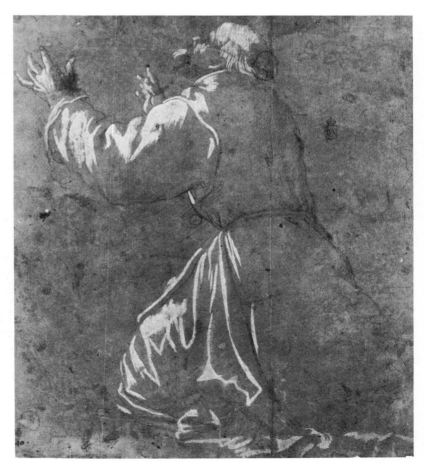

204

PLATE LVI

200

206

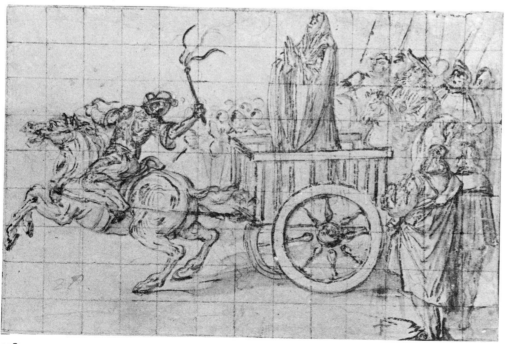

208

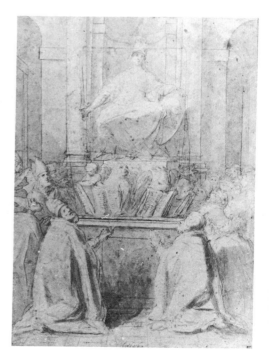

210

PLATE LVII

207

203

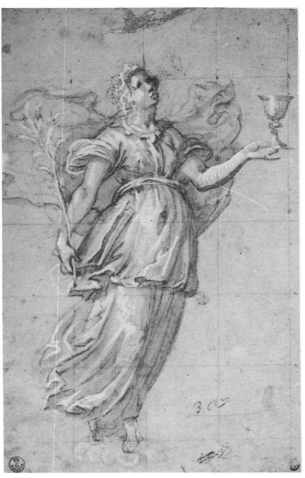

211

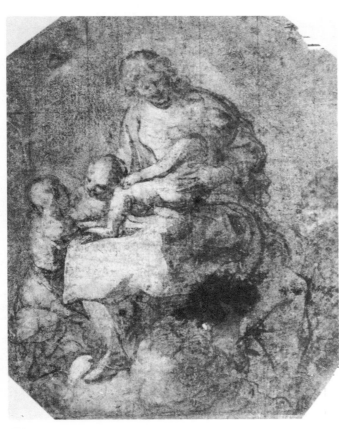

209

PLATE LVIII

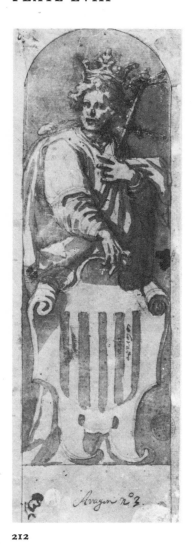

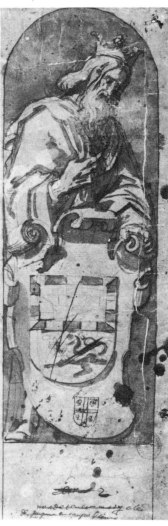

212

213

214

215

216

217

PLATE LIX

218

219

220

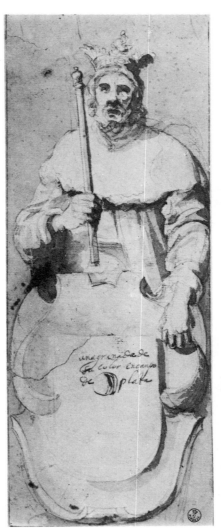

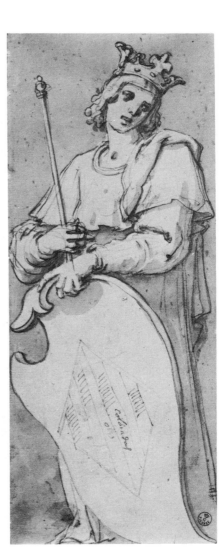

221

222

223

PLATE LX

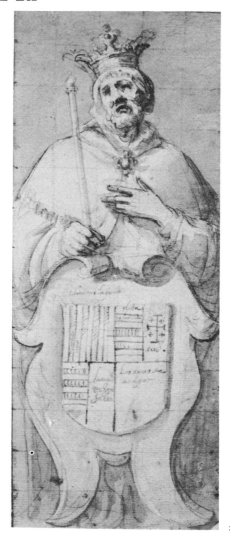

224

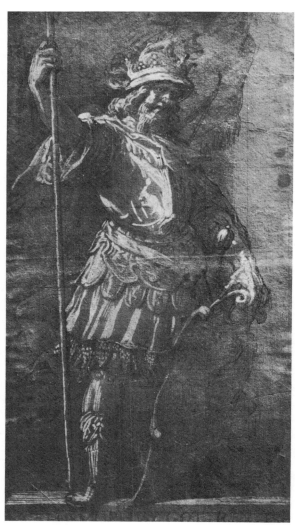

225

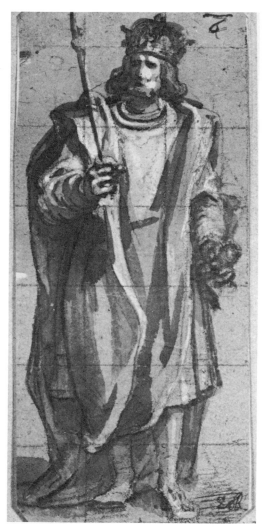

235

PLATE LXI

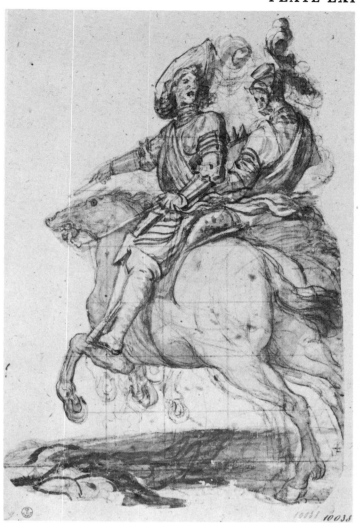

227

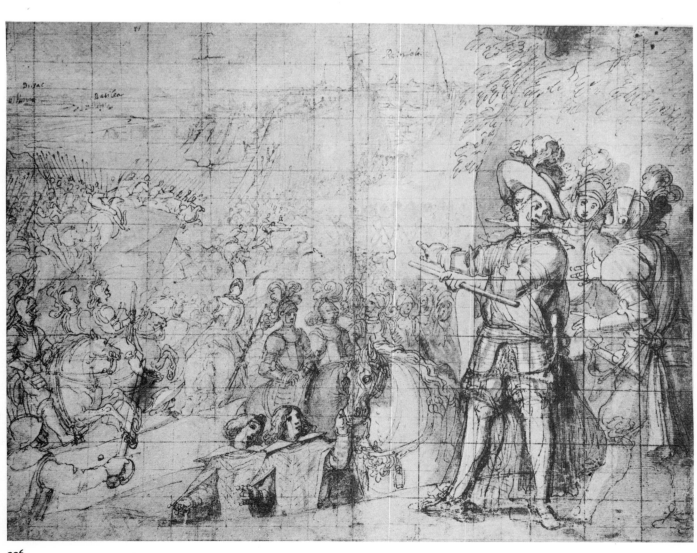

226

PLATE LXII

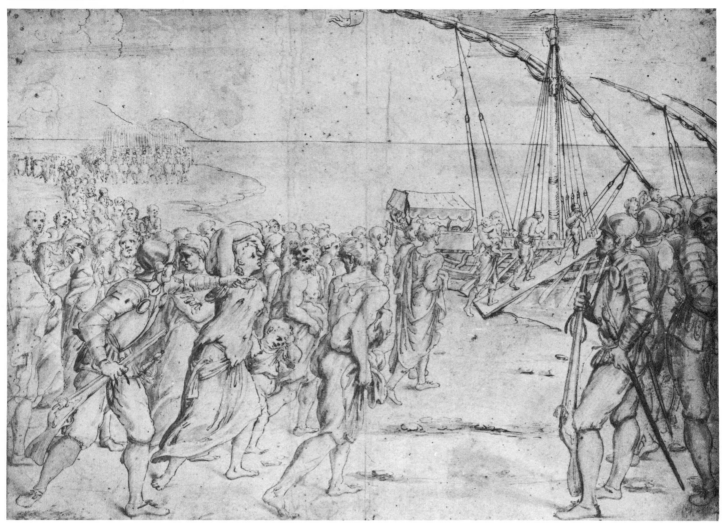

229

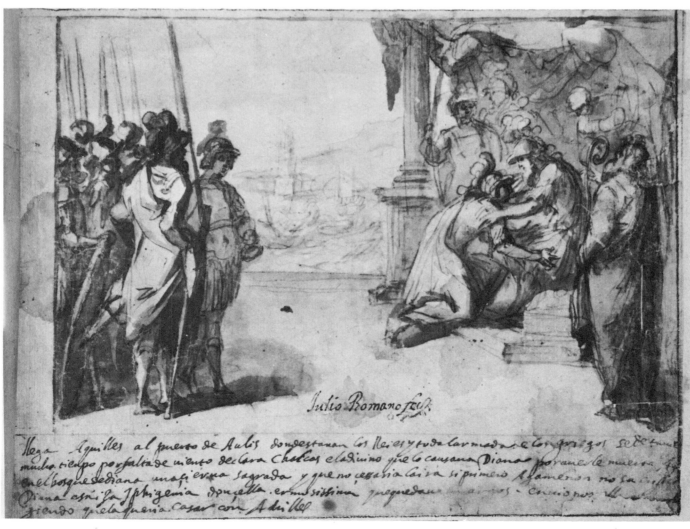

Iulio Romano fecit

Llega Aquilles al puerto de Aulis dondestaban los Reies y toda larmada de los griegos se deten
mucho tiempo porfalta de viento declara Chalcas eladivino que lo causaba Diana porque le muera
en el bosque de diana una siervra sagrada y que no cessaria la ira si primero no la muera
Diana asu hija Iphigenia donzella comsisima quequedan_____
siendo q̃ la queria casar con Achilles

231

PLATE LXIII

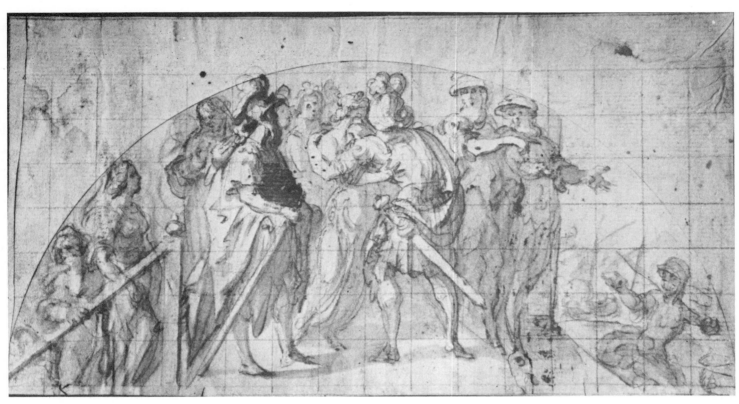

232

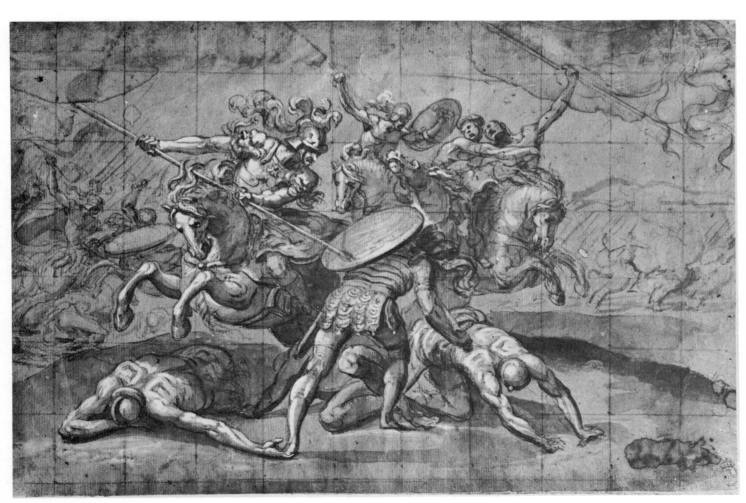

234

PLATE LXIV

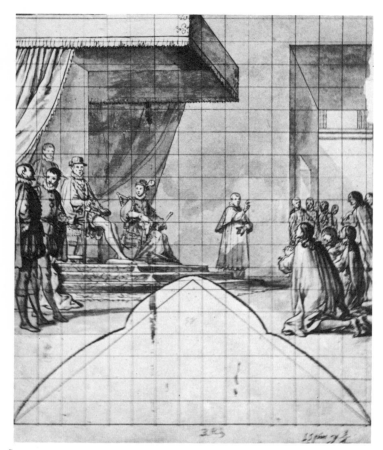

228

241

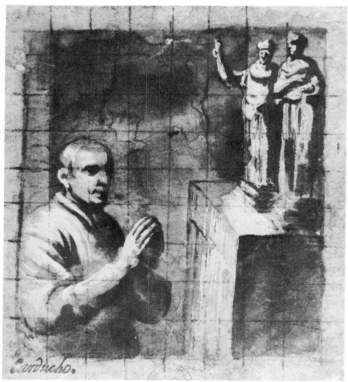

236

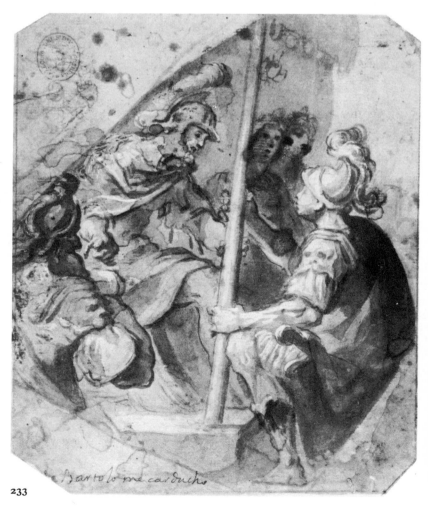

233

PLATE LXV

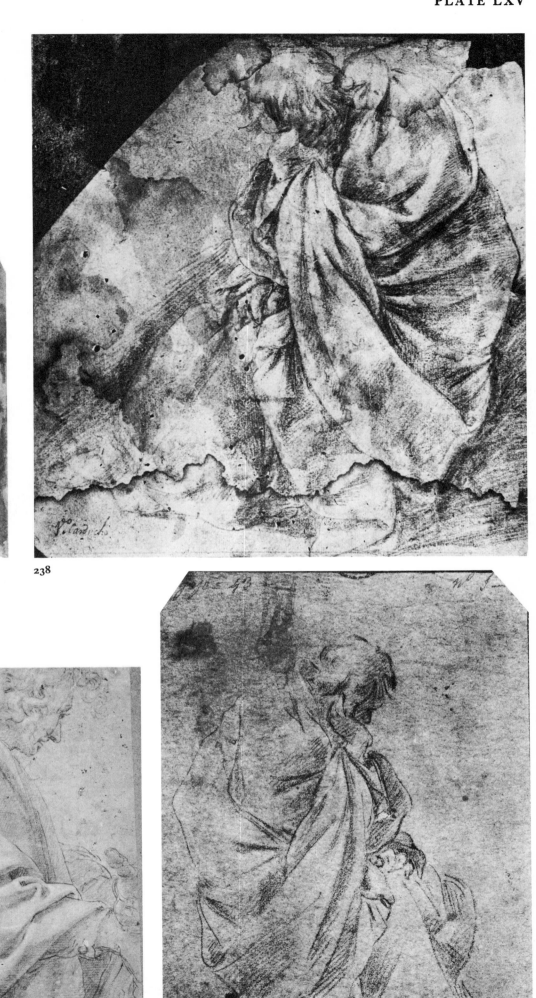

242 238

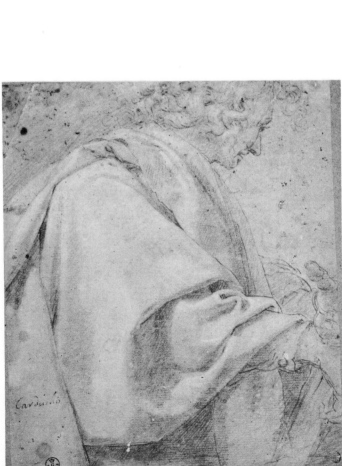

240 239

PLATE LXVI

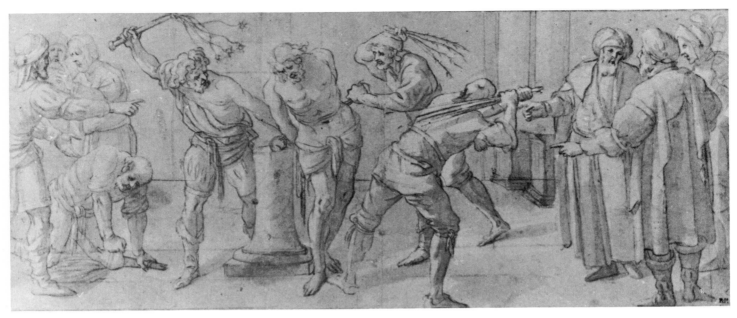

246

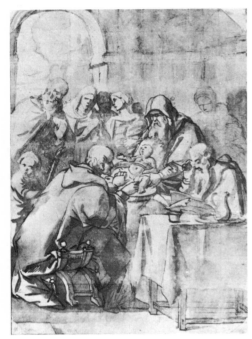

245

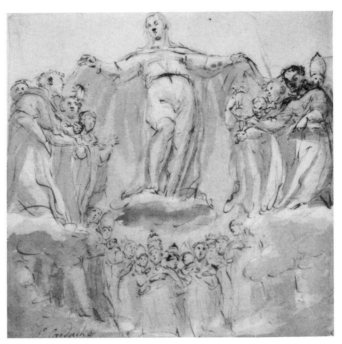

248

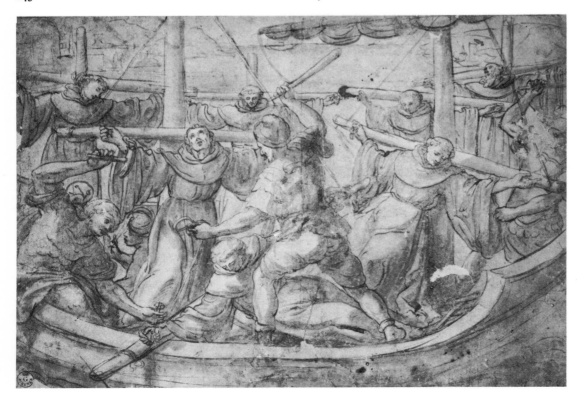

256

PLATE LXVII

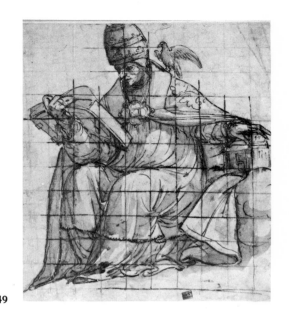

249

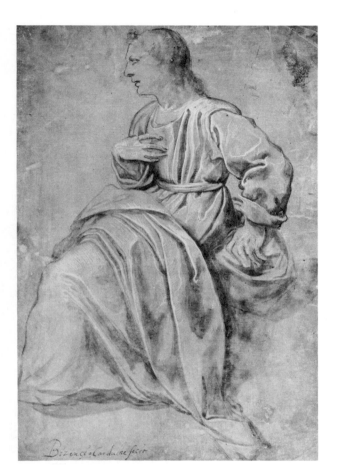

255

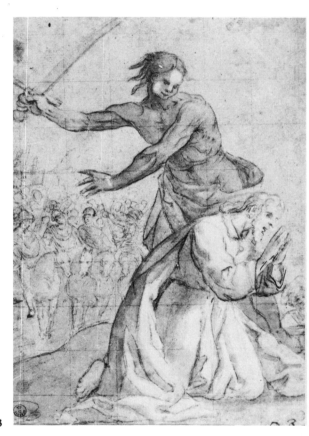

253

251

PLATE LXVIII

247

250

257

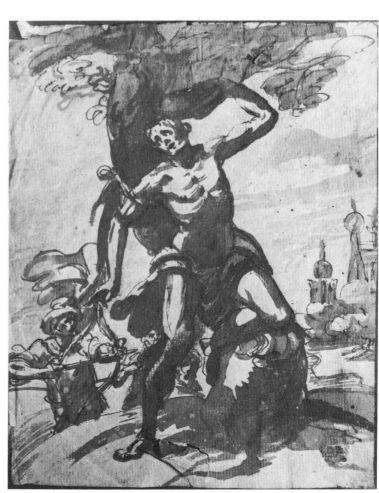

254

PLATE LXIX

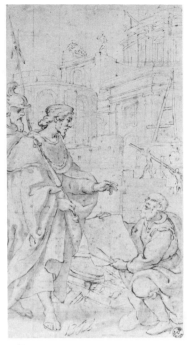

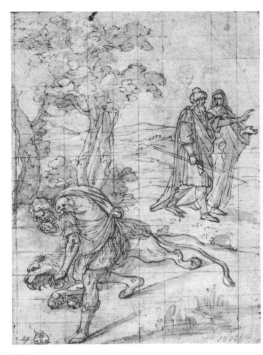

258

259

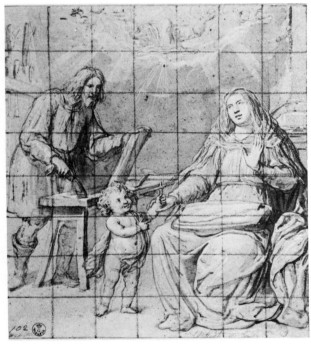

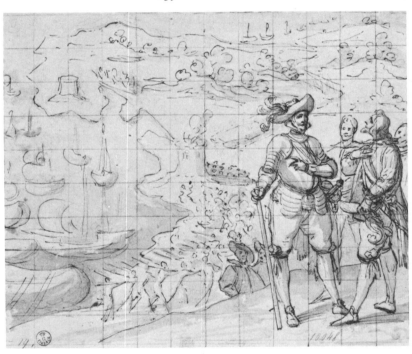

260

262

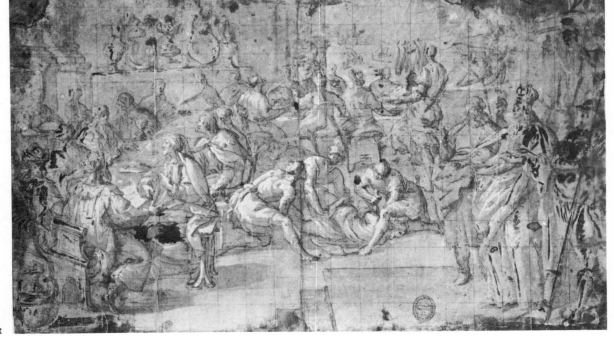

261

PLATE LXX

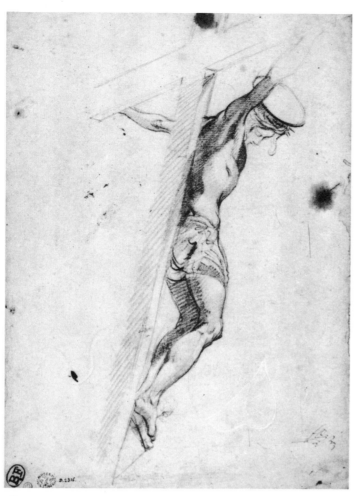

267

271

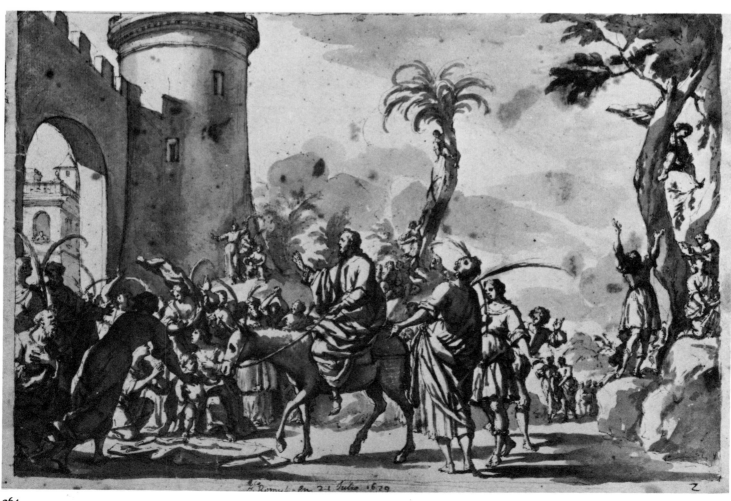

264

PLATE LXXI

277

268

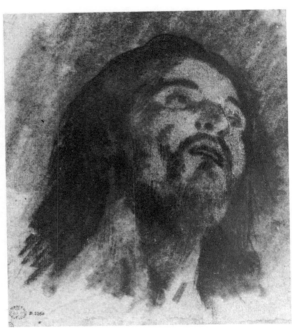

270

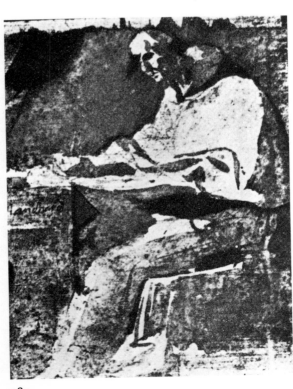

280

265

PLATE LXXII

272

273

274

PLATE LXXIII

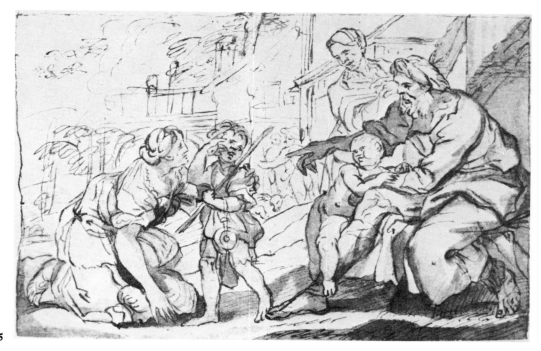

275

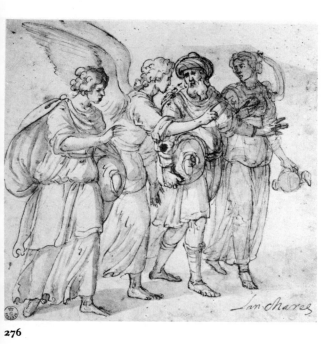

276

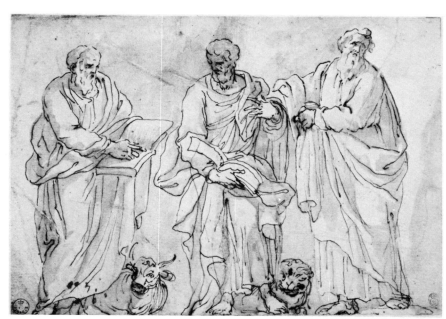

278

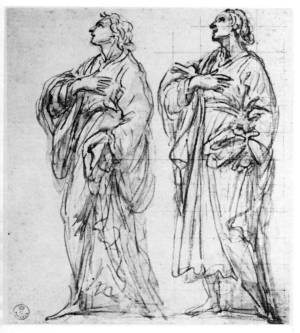

279

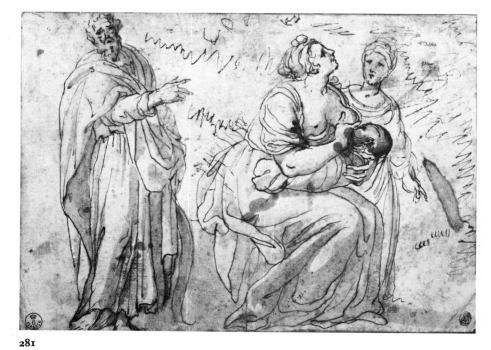

281

PLATE LXXIV

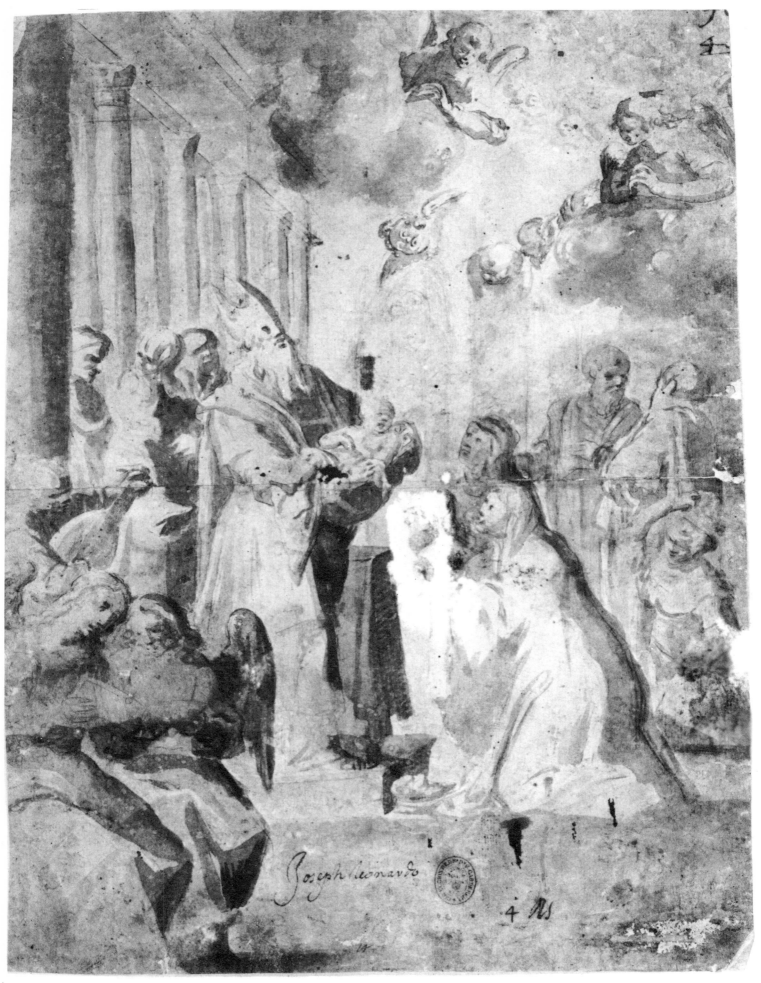

Joseph leonardo

PLATE LXXV

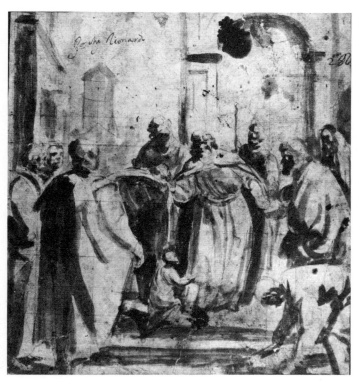

283

284

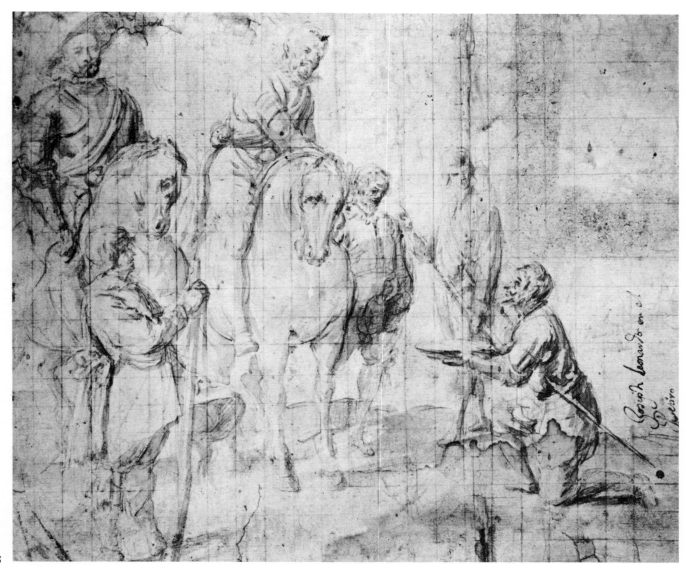

285

PLATE LXXVI

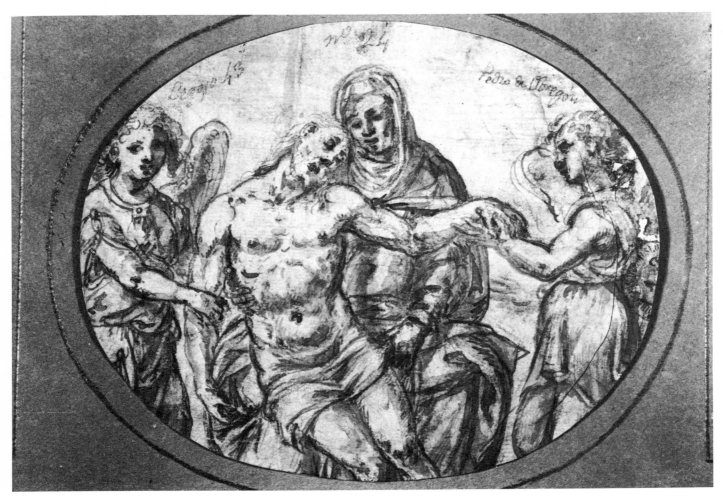

294

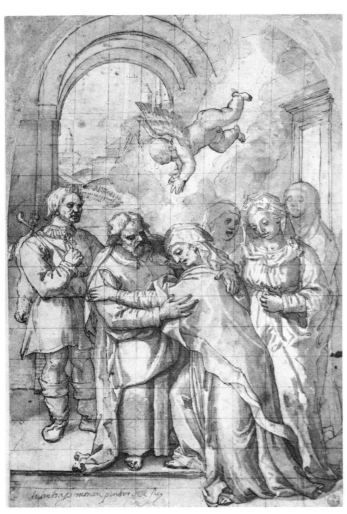

287

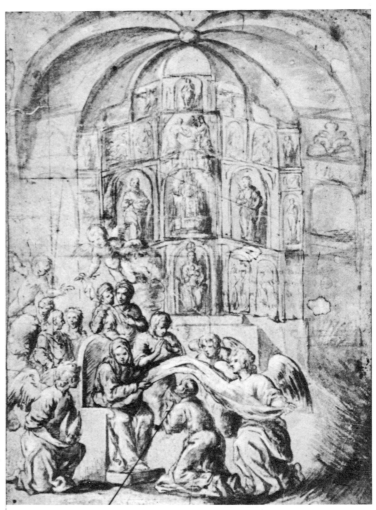

290

PLATE LXXVII

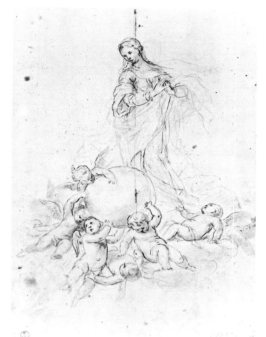

298

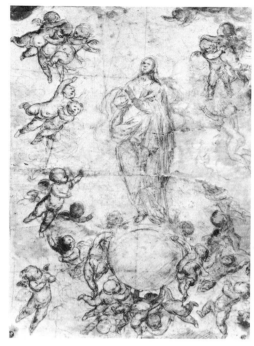

299

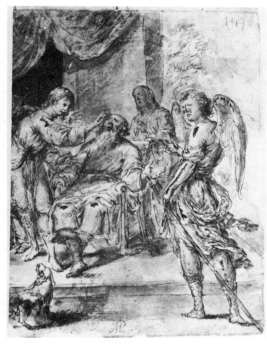

296

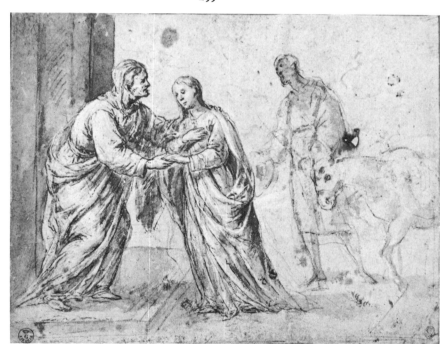

300

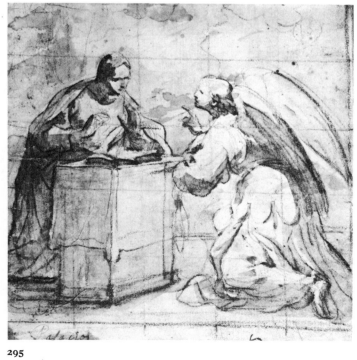

295

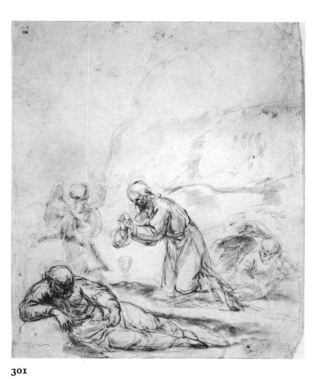

301

PLATE LXXVIII

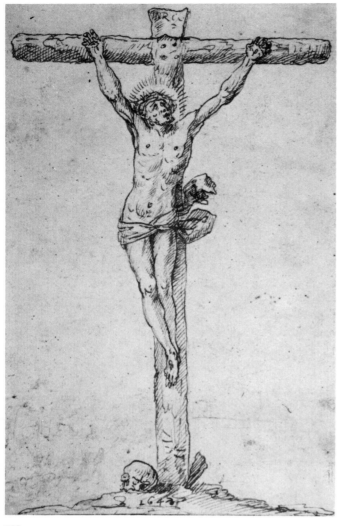

302

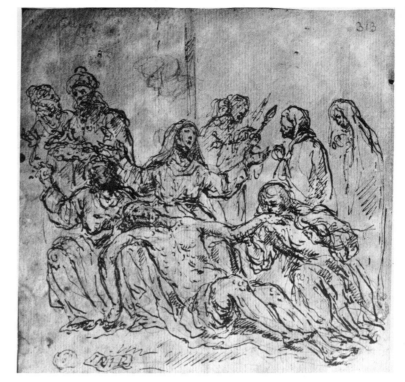

303

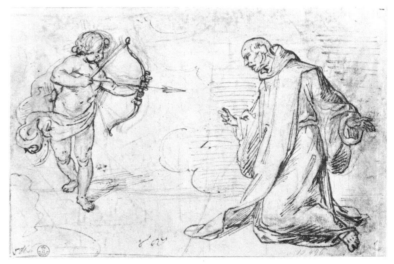

311

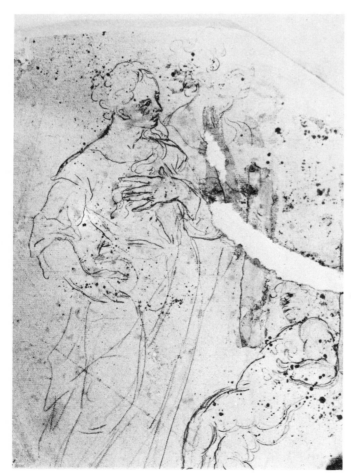

305 verso

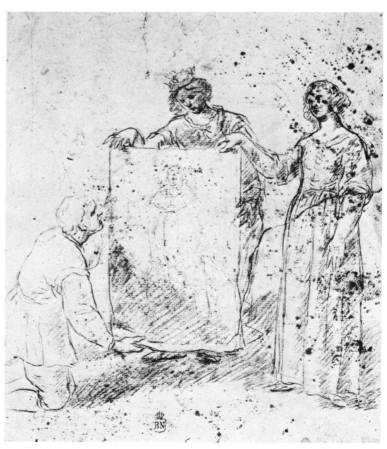

305 recto

PLATE LXXIX

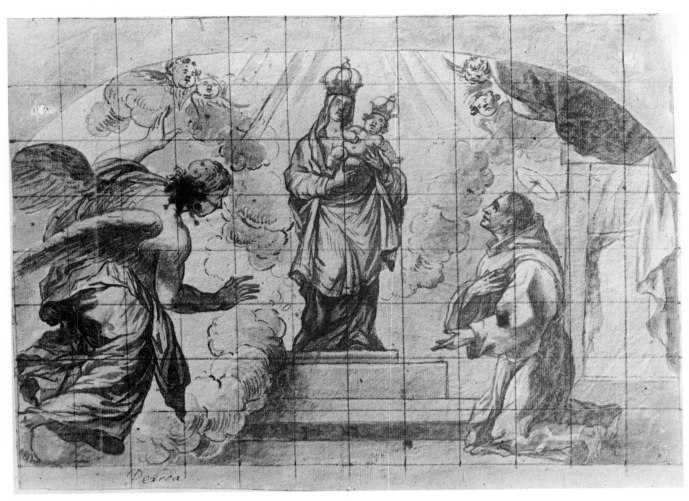

312

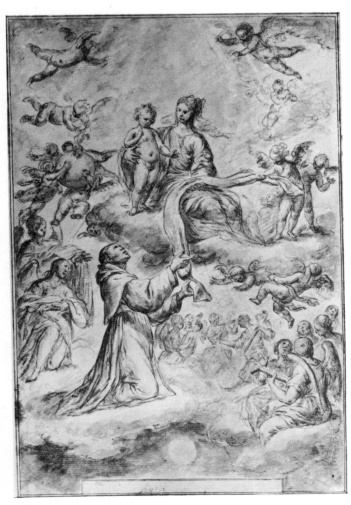

306

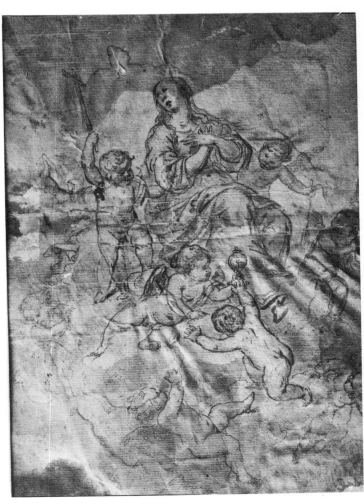

309

PLATE LXXX

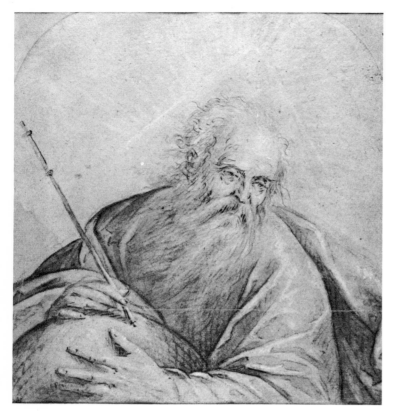

297

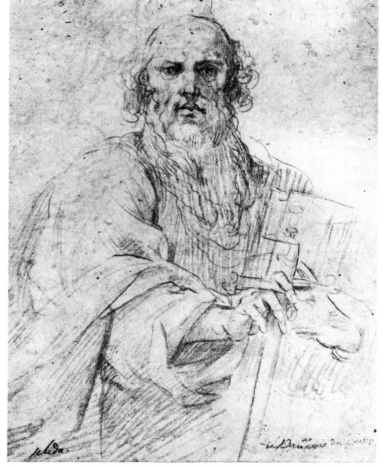

310

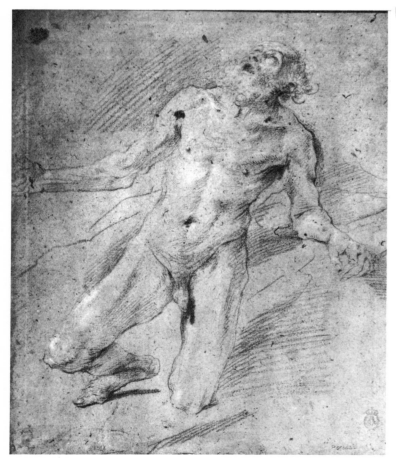

308

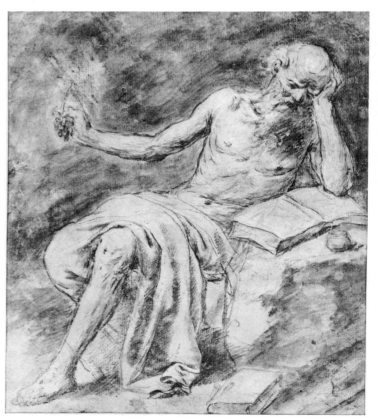

307 recto

PLATE LXXXI

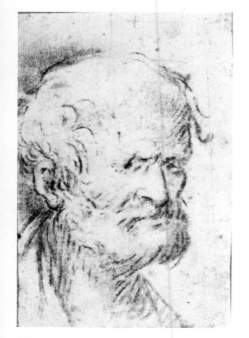

315

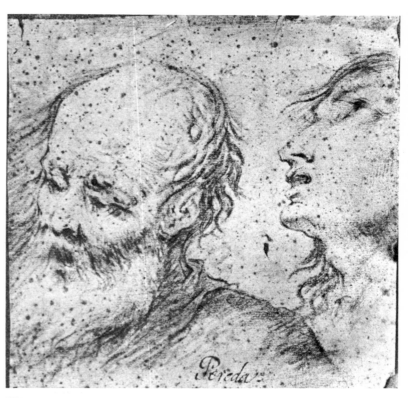

314

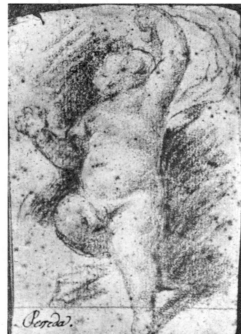
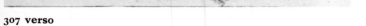

313

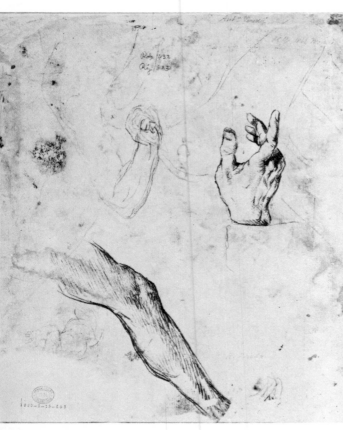

307 verso

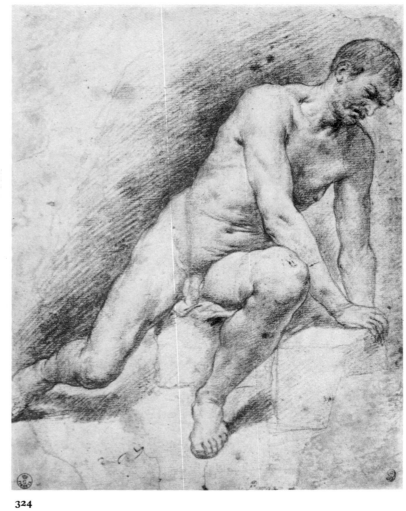

324

PLATE LXXXII

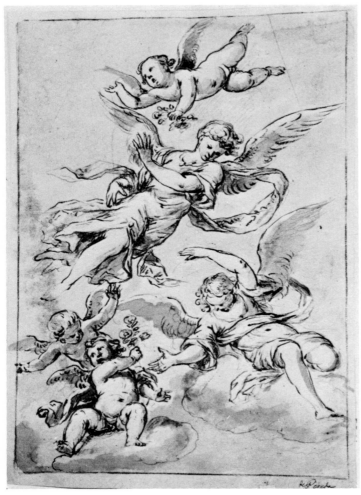

316

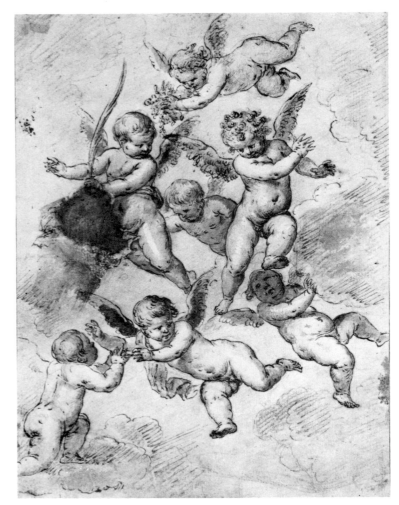

317

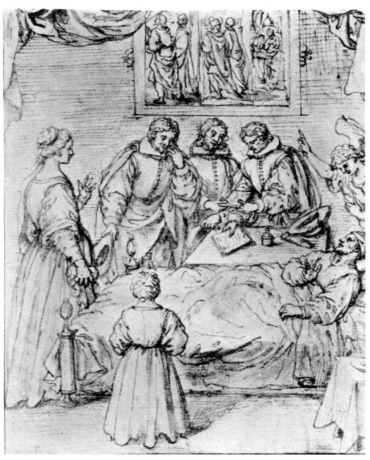

318

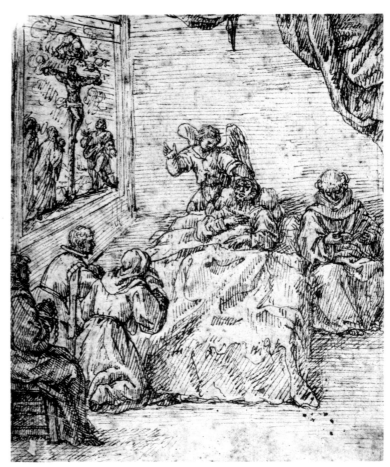

319

PLATE LXXXIII

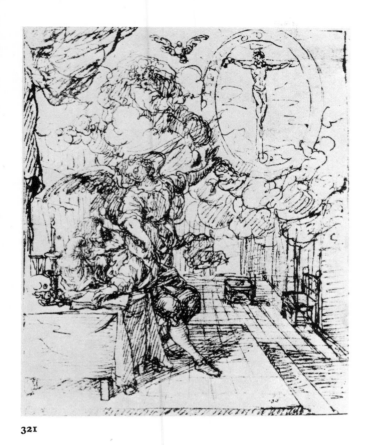

321

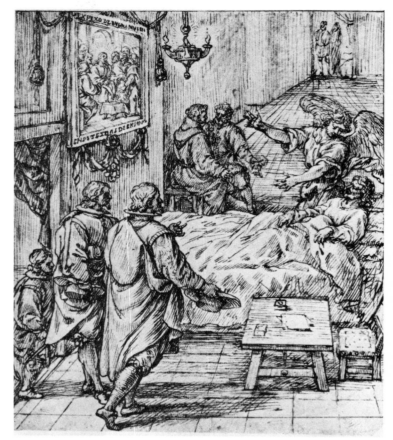

320

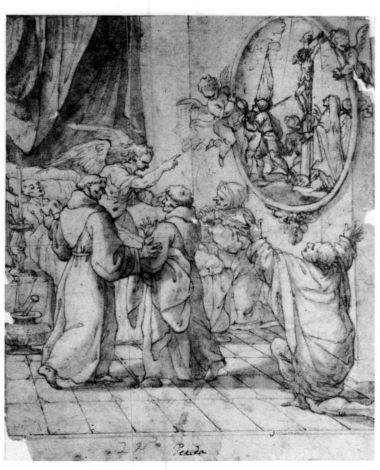

322

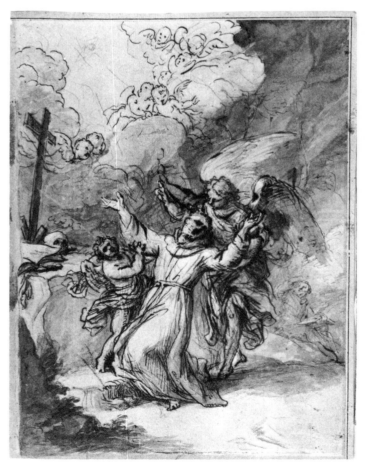

323

PLATE LXXXIV

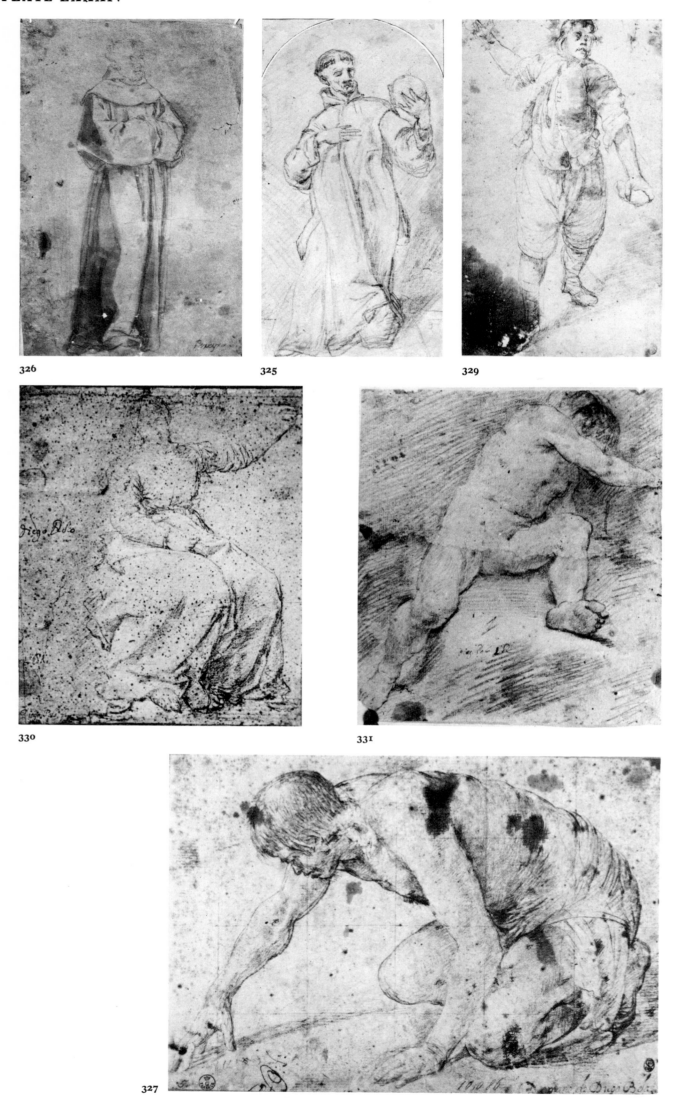

326

325

329

330

331

327

PLATE LXXXV

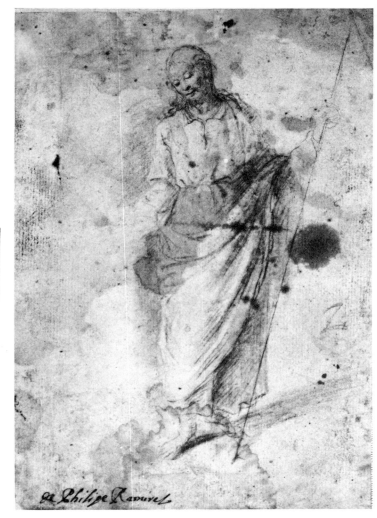

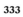

333

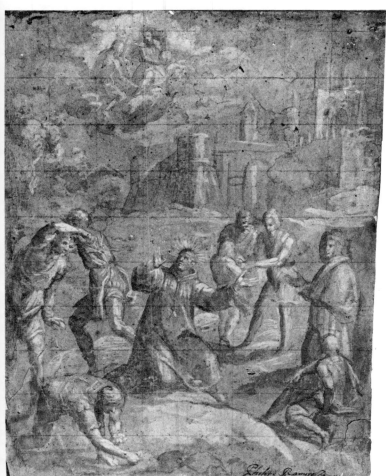

332

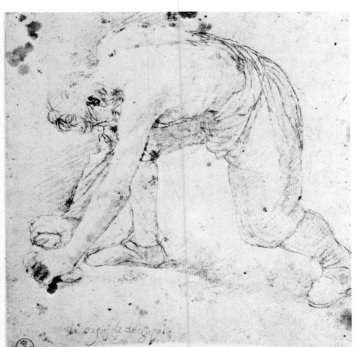

328

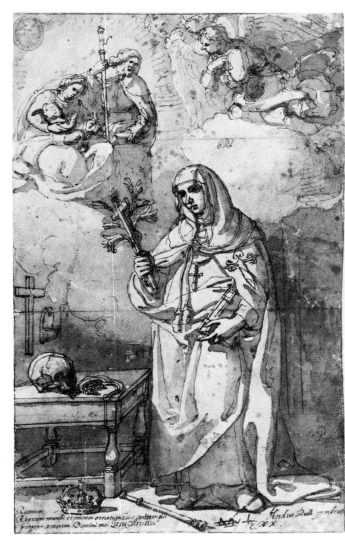

340

PLATE LXXXVI

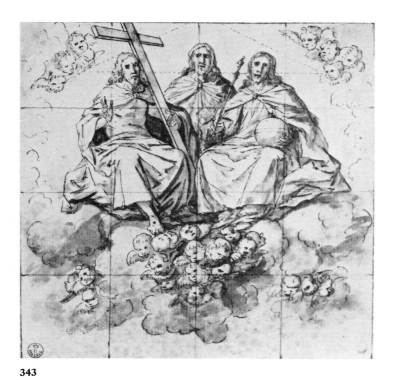

343

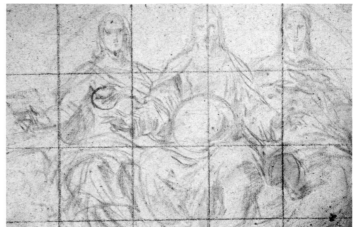

344

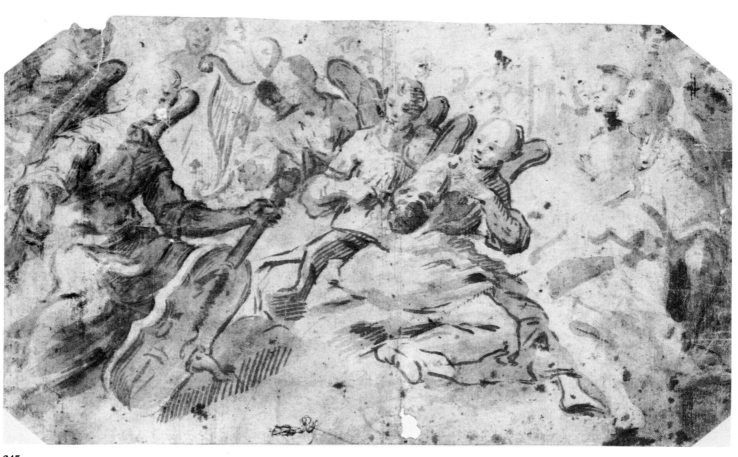

345

PLATE LXXXVII

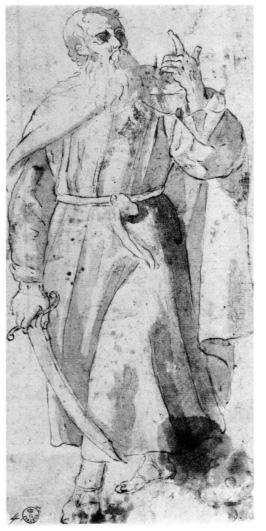

346

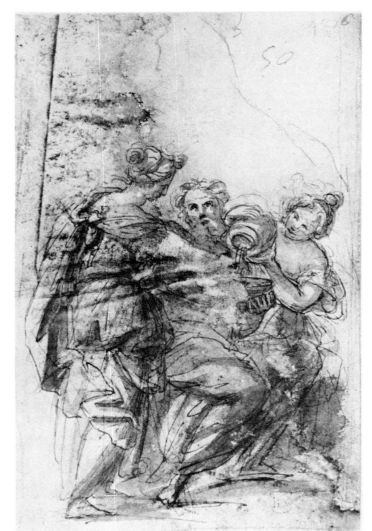

347

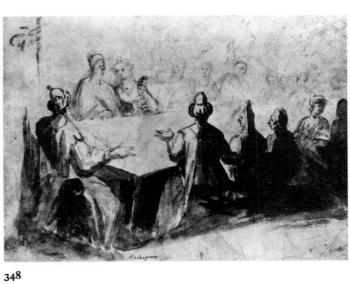

348

349

PLATE LXXXVIII

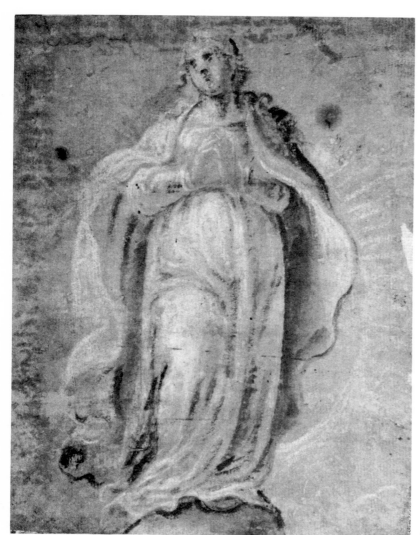

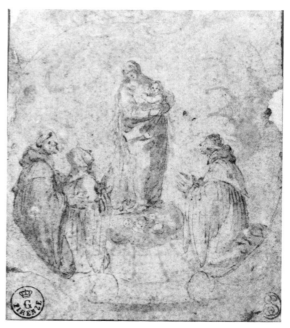

357

352

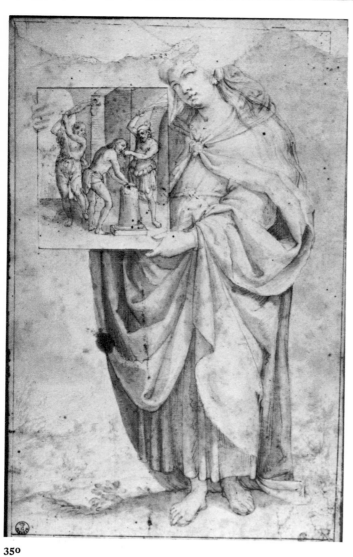

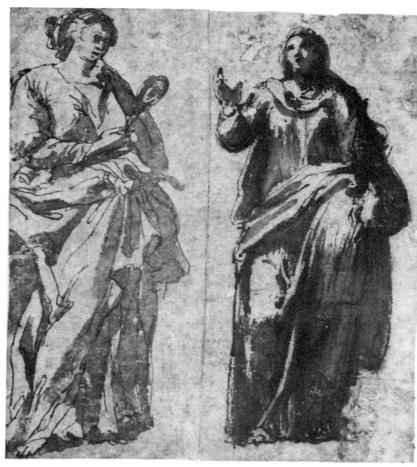

350

351

PLATE LXXXIX

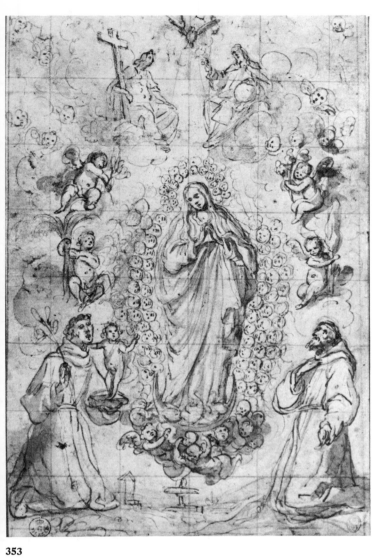

353

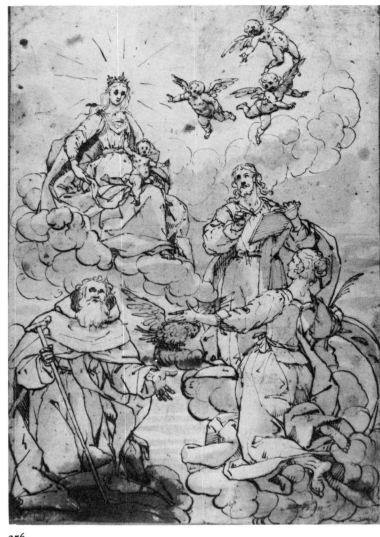

356

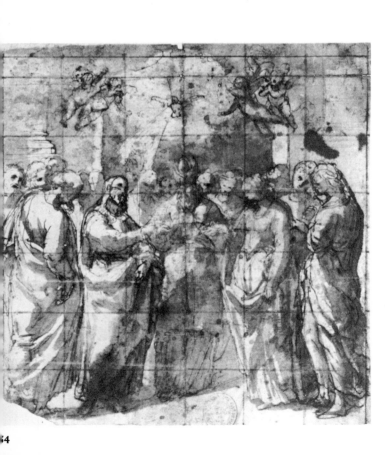

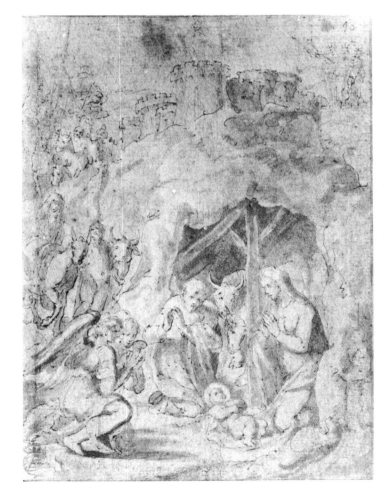

355

PLATE XC

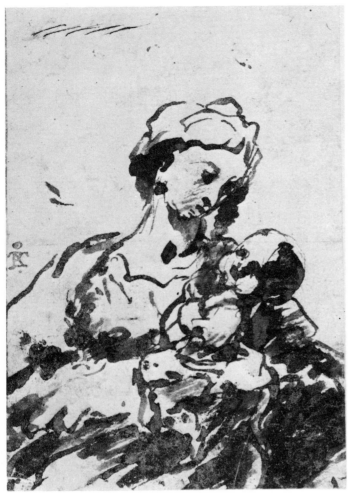

360

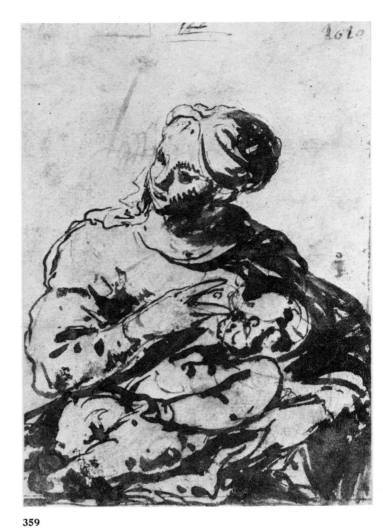

359

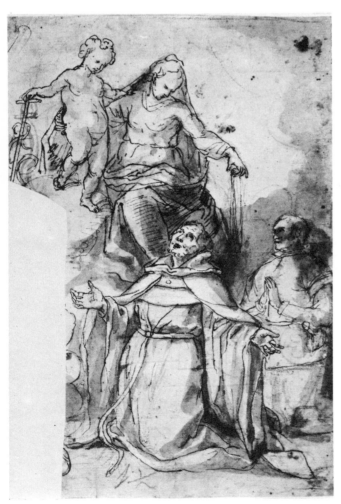

358

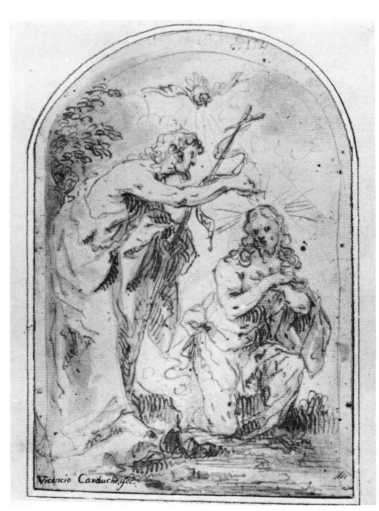

363

PLATE XCI

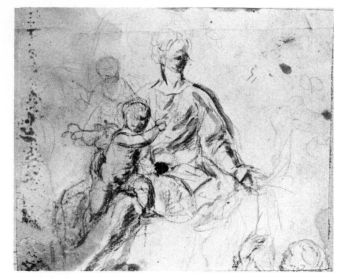

361

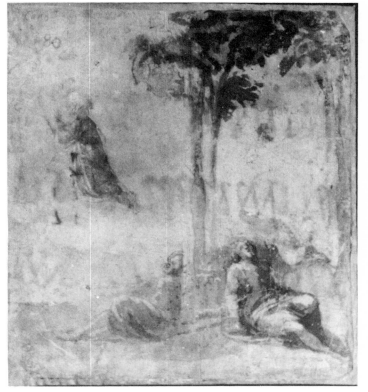

365

362

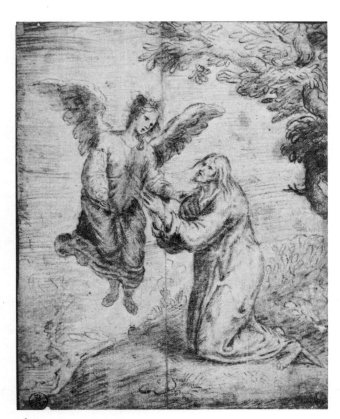

364

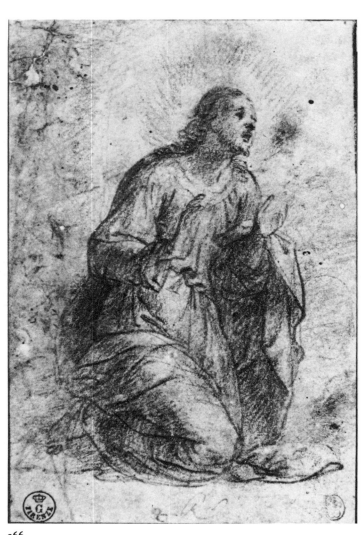

366

PLATE XCII

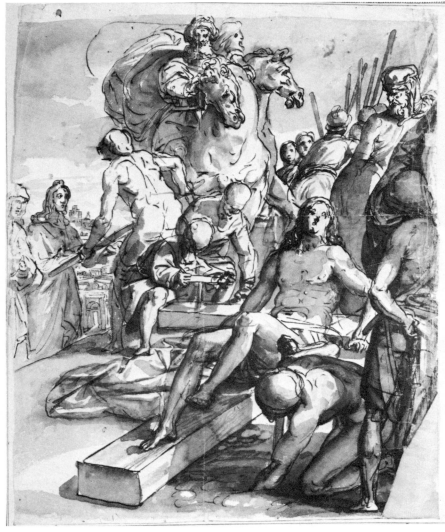

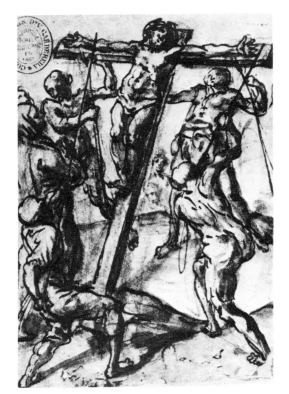

369

368

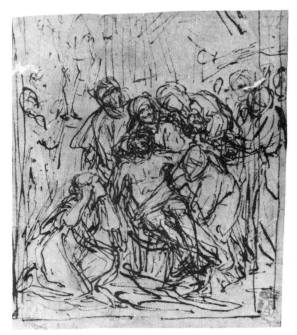

371

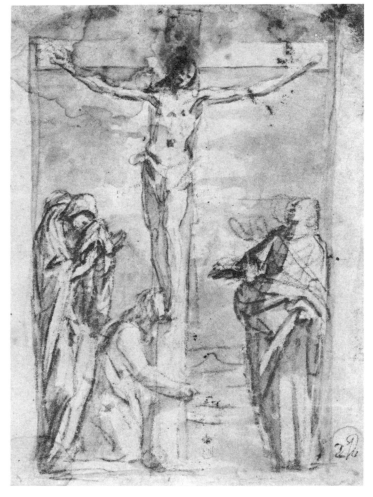

370

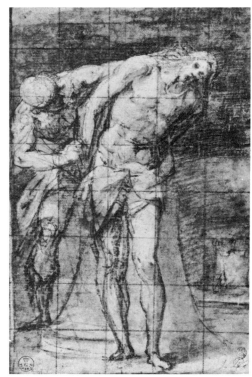

367

PLATE XCIII

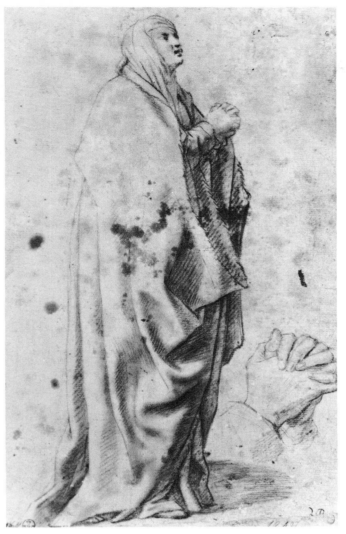

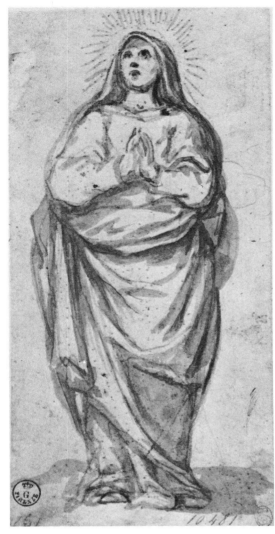

373

372

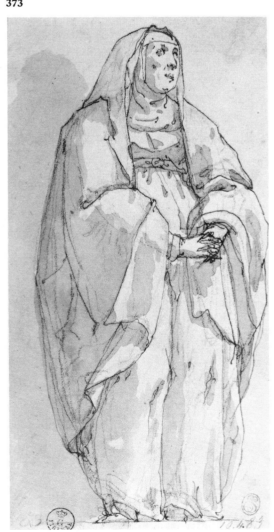

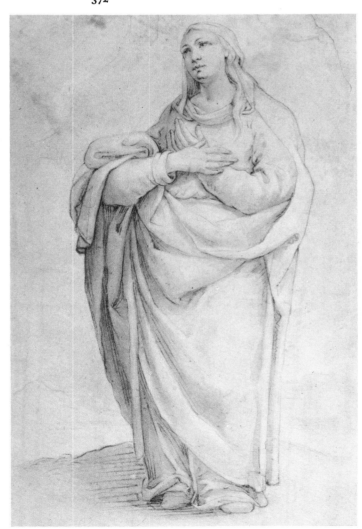

374

375

PLATE XCIV

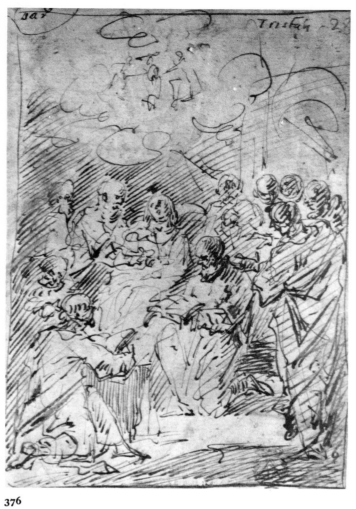

376

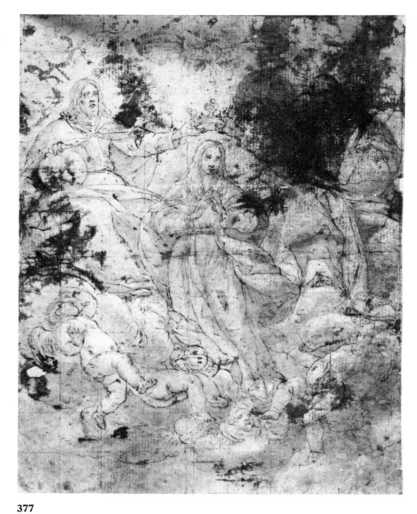

377

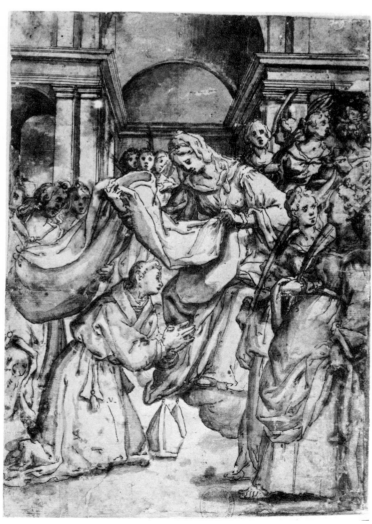

383

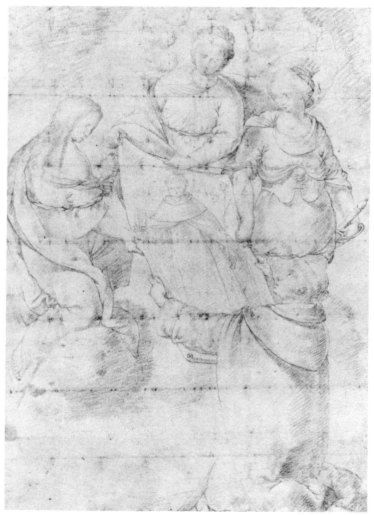

381

PLATE XCV

379 recto

379 verso

378

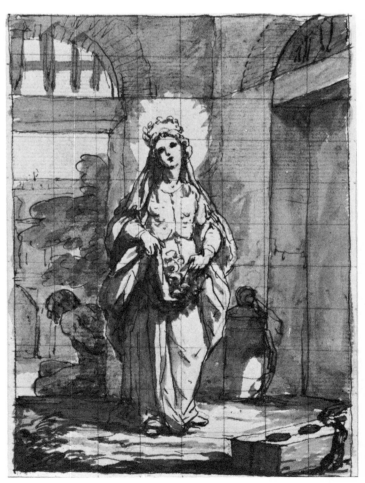

380

PLATE XCVI

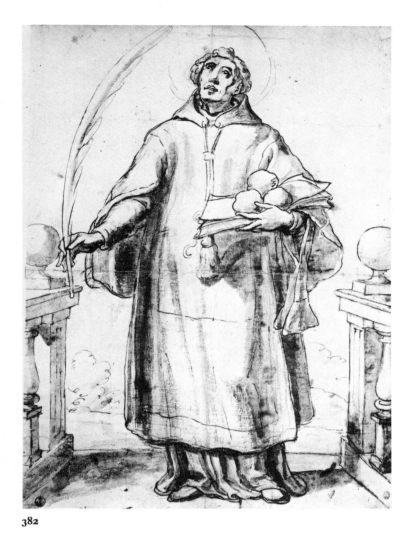

382

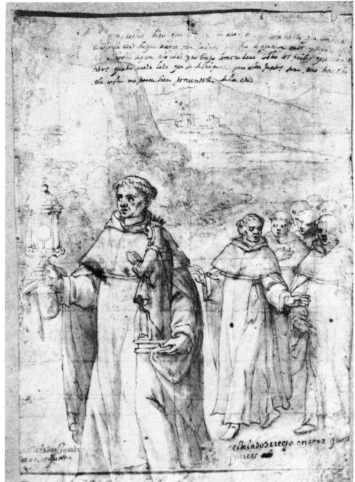

384

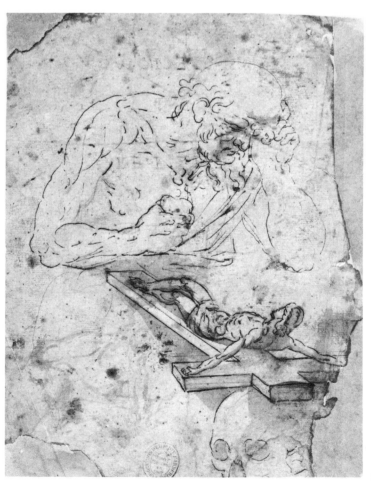

385

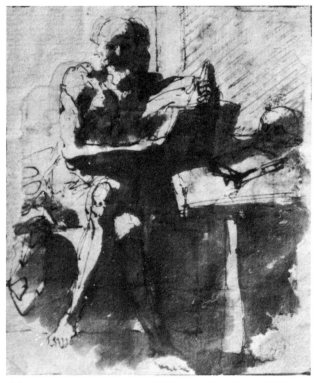

386

PLATE XCVII

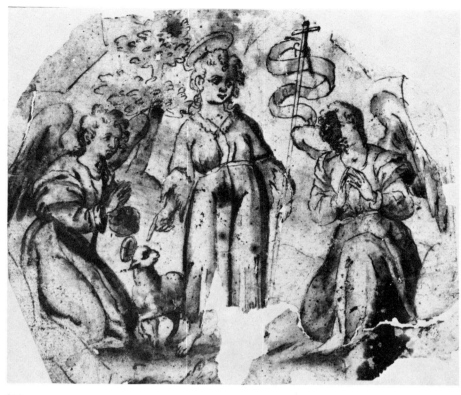

390

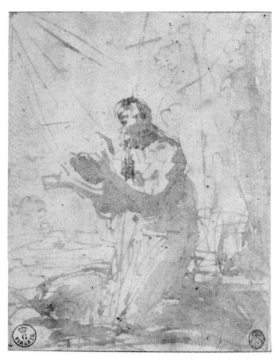

389

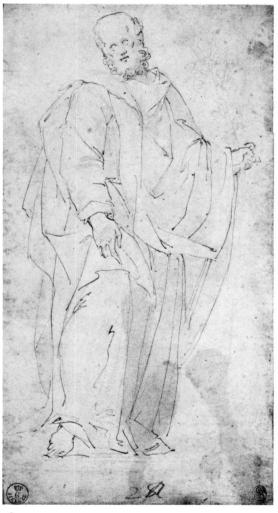

387

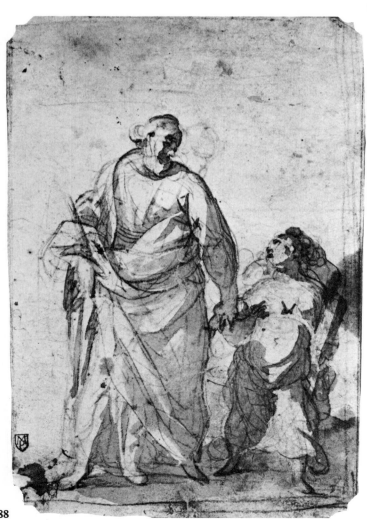

388

PLATE XCVIII

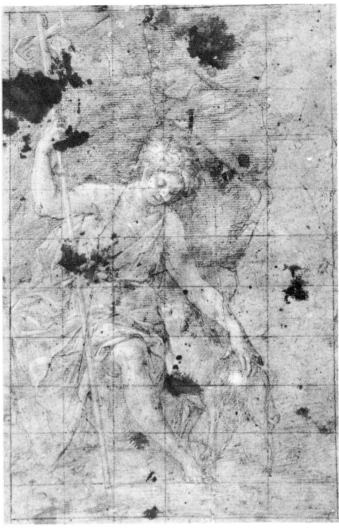

391

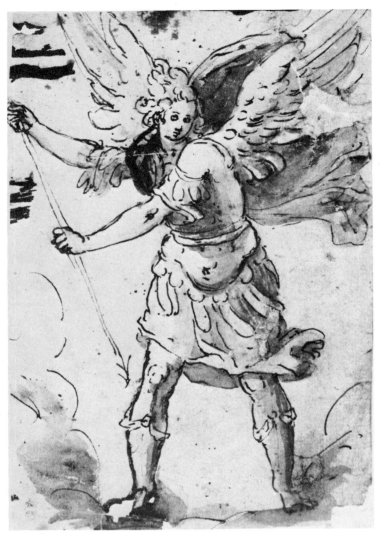

394

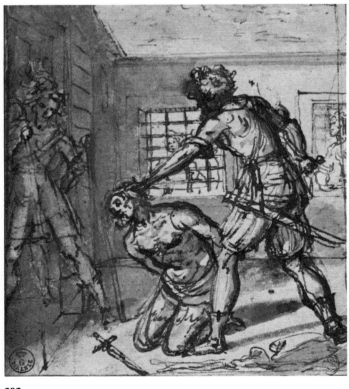

392

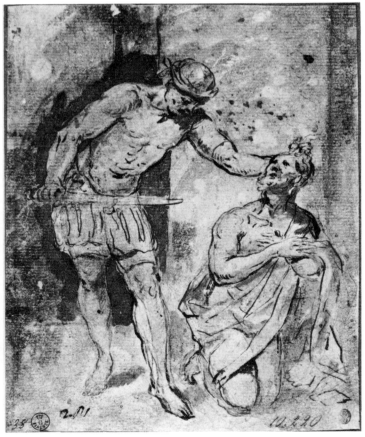

393

PLATE XCIX

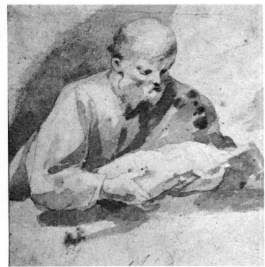

398

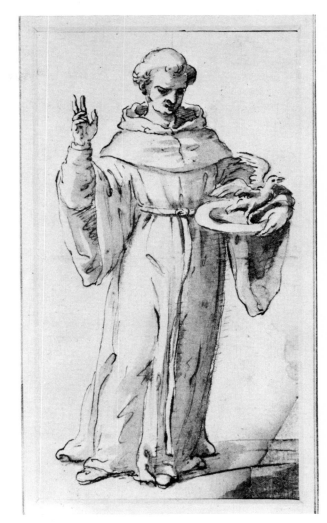

395

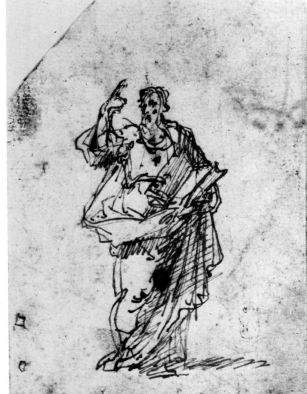

399

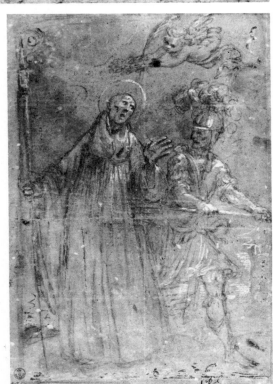

396

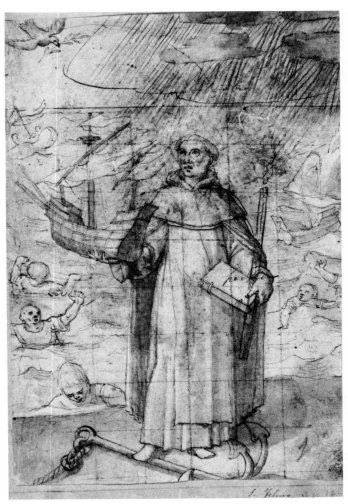

397

PLATE C

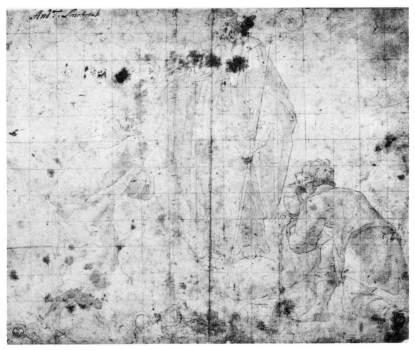

400

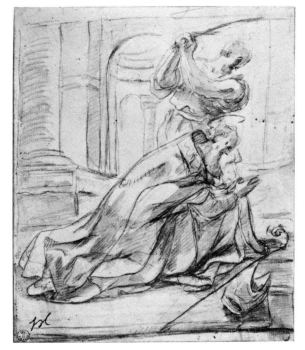

402

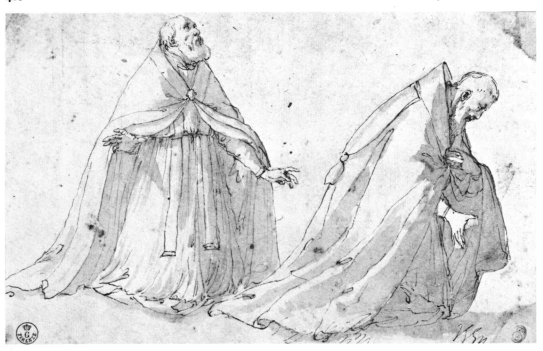

401

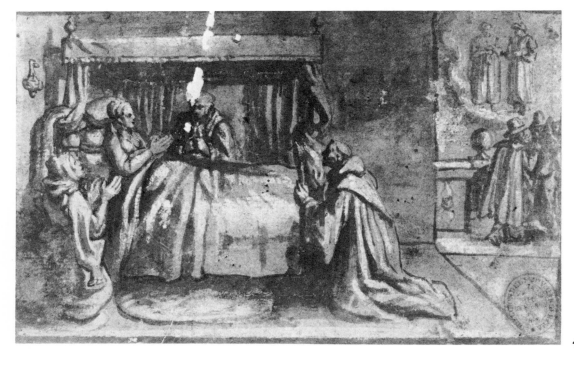

403

PLATE CI

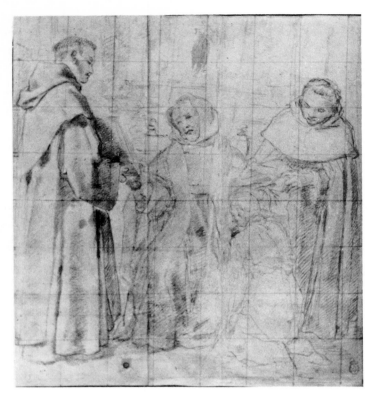

409

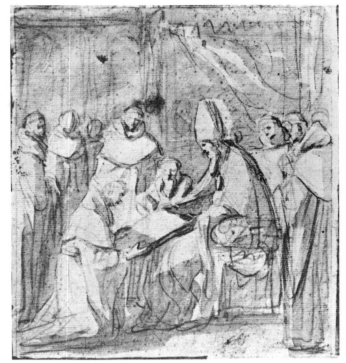

404

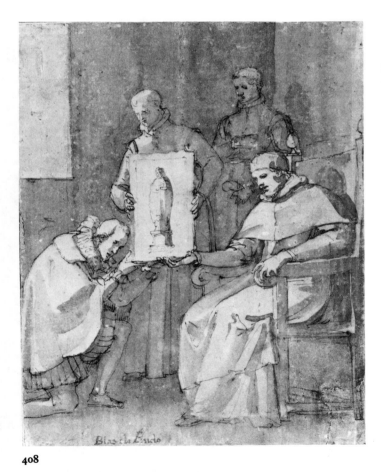

408

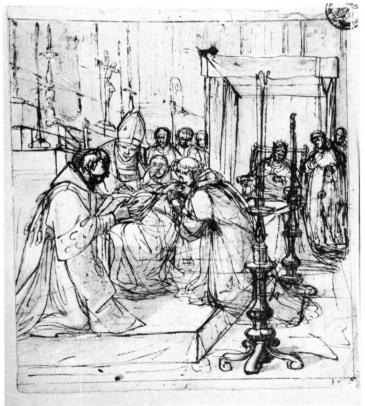

405

PLATE CII

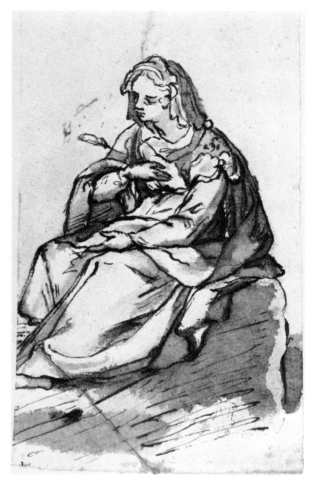

414

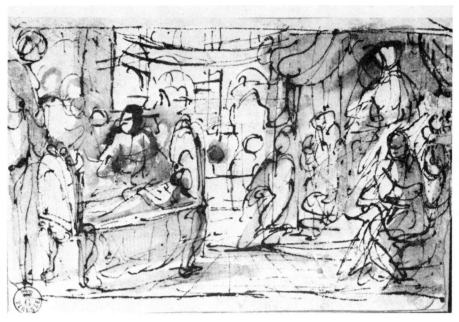

411

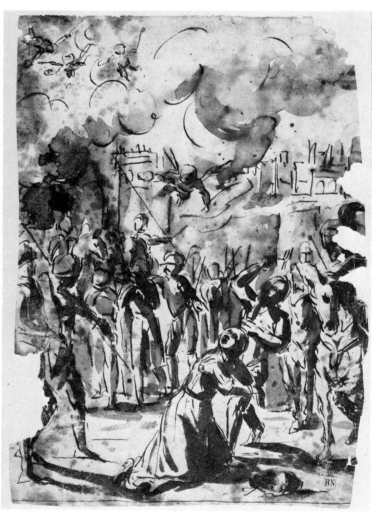

406

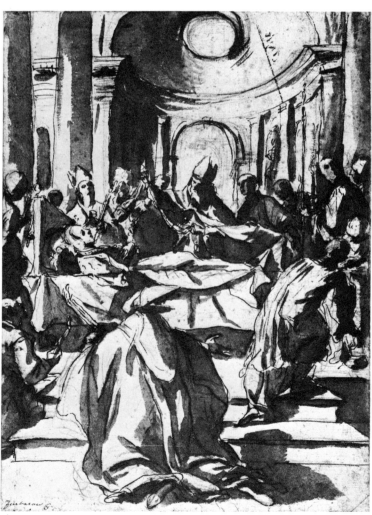

415

PLATE CIII

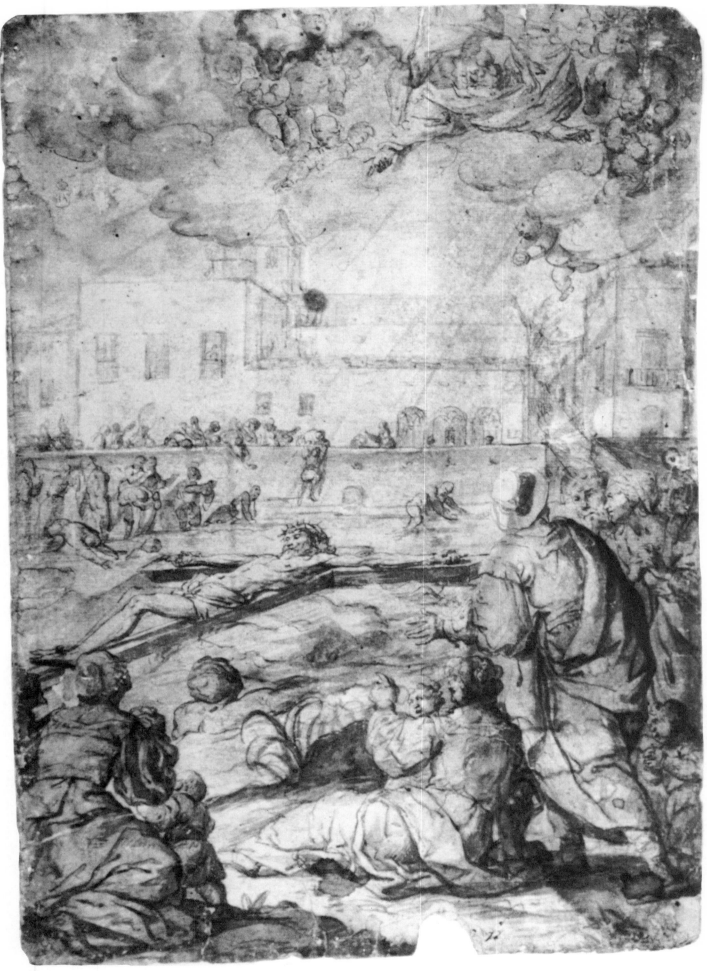

PLATE CIV

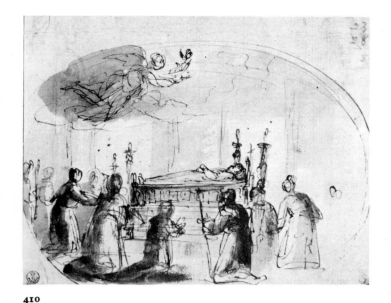

410

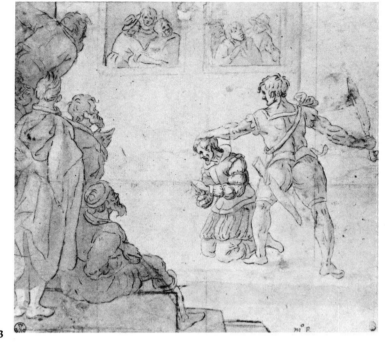

413

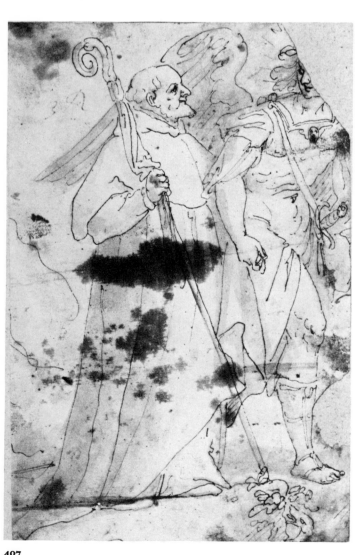

407

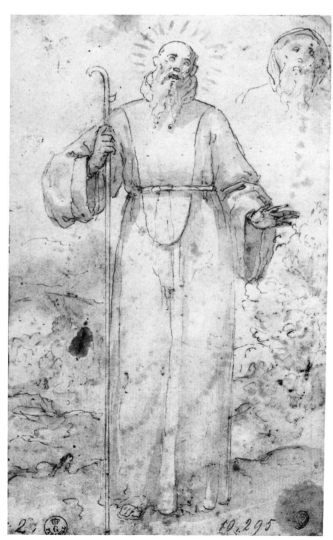

412

PLATE CV

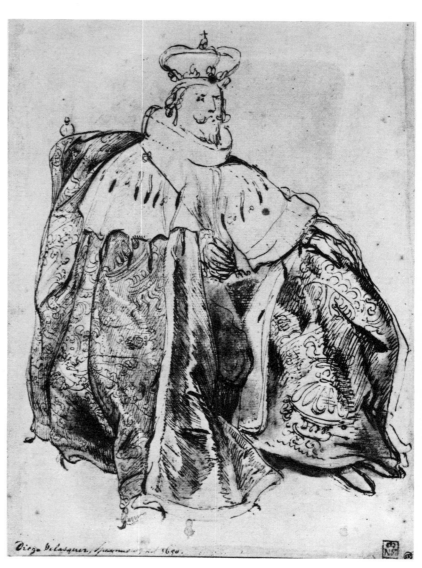

417

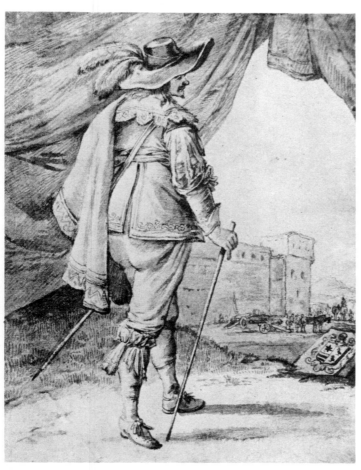

418

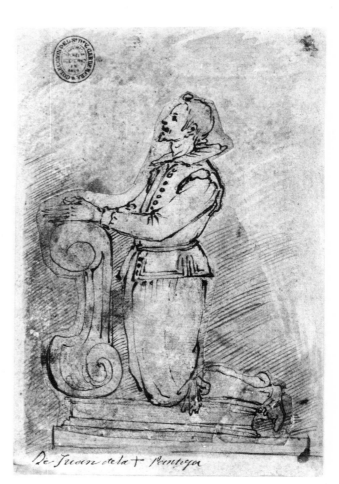

419

PLATE CVI

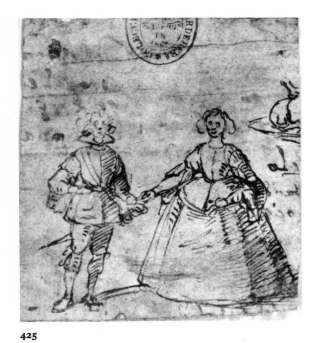

425

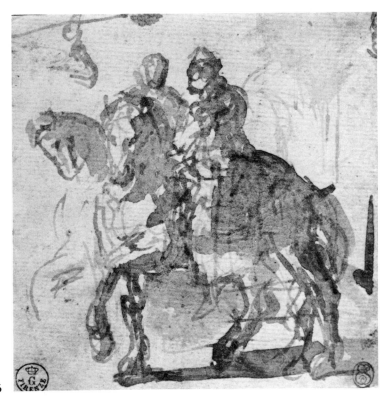

426

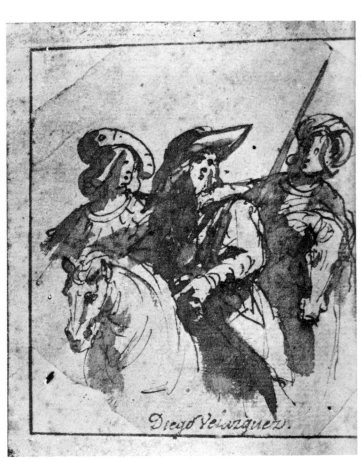

427

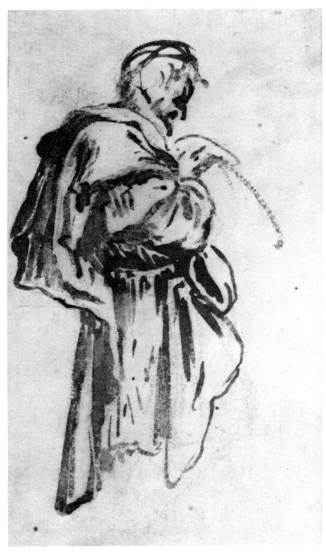

434

PLATE CVII

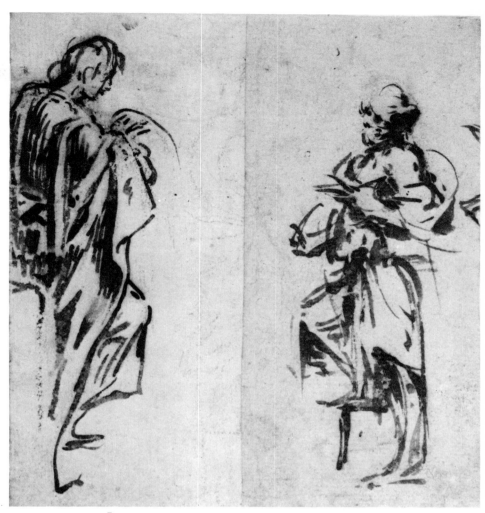

435

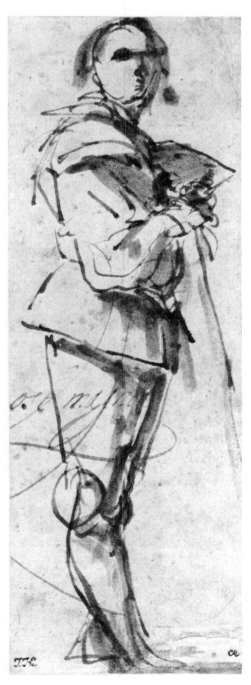

421

PLATE CVIII

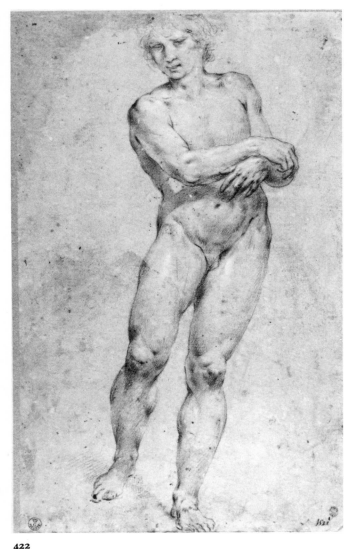

422

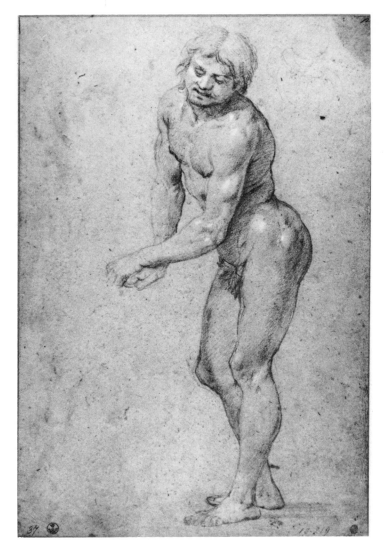

424

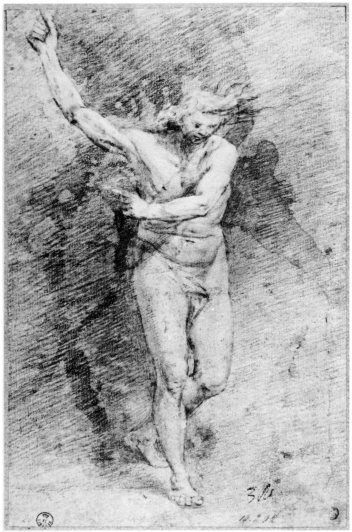

423

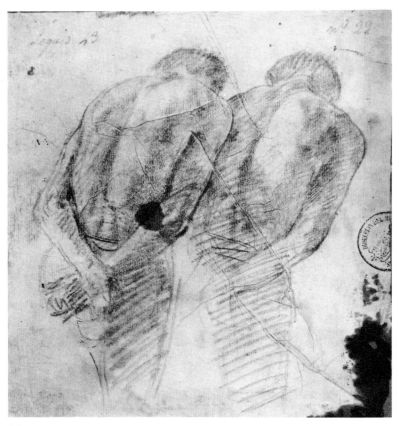

431

PLATE CIX

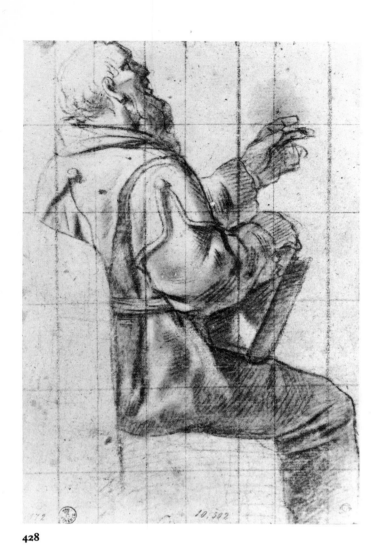

428

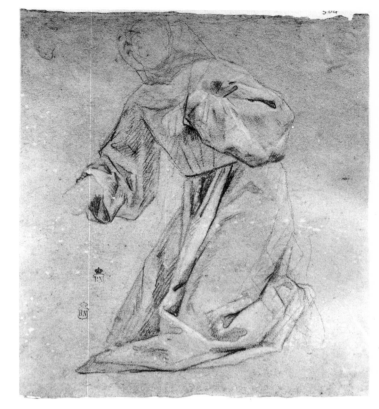

430

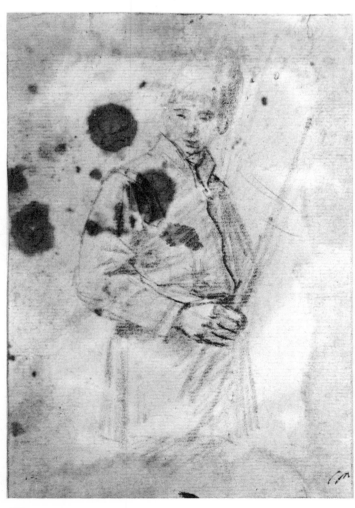

433

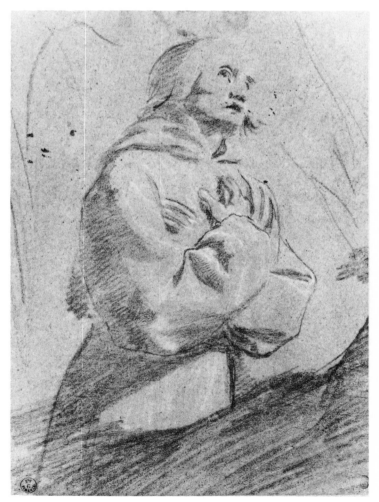

429

PLATE CX

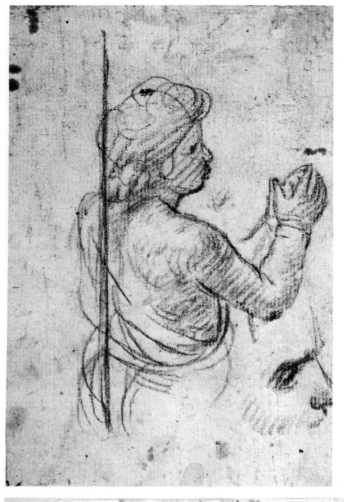

432

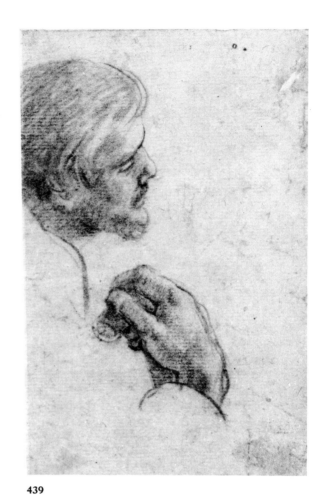

439

441

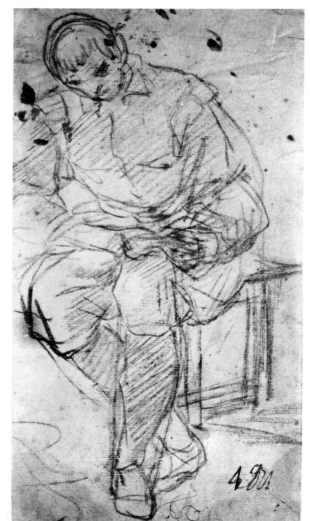

442

436

PLATE CXI

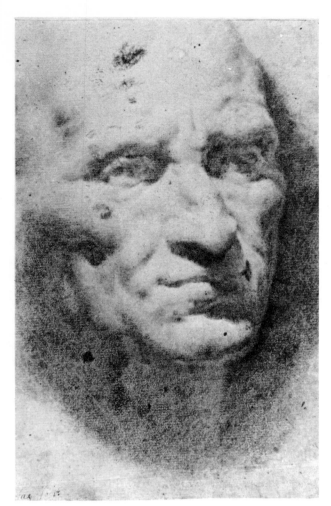

438

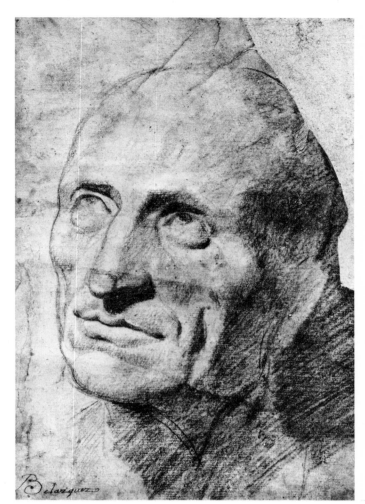

437

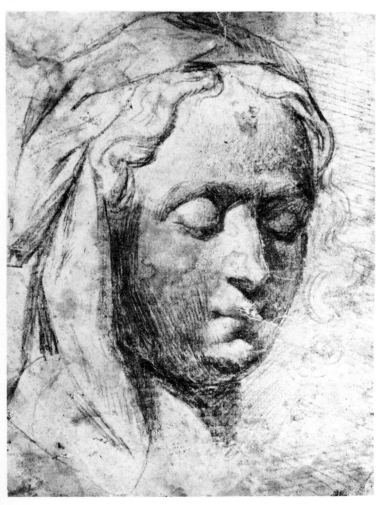

440

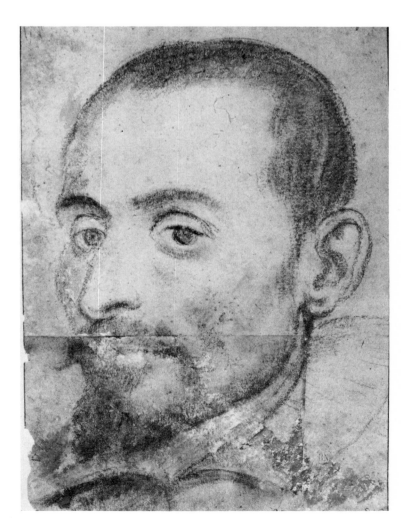

420

PLATE CXII

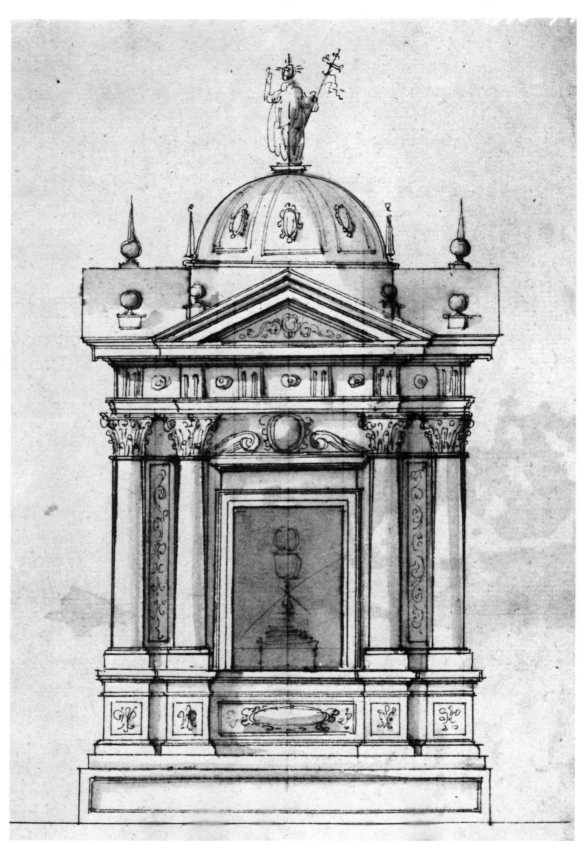

443

INDEX

This Index consists of four parts. The first is the *INDEX OF NAMES*, which includes the names of all artists whose drawings are catalogued and of those referred to in the text, as well as the names of all historic personages mentioned. Entries in heavy type indicate the named artists catalogued and the catalogue numbers of their drawings.

The second part is the *INDEX OF LOCATIONS*, which gives present locations of all drawings listed in the catalogue in alphabetical order of towns. The *INDEX OF OTHER WORKS OF ART REFERRED TO IN THE CATALOGUE*, which is part three, also lists all works by location.

The fourth and final part is the *INDEX OF THEMES*. Here the drawings have been arranged thematically as far as possible. Anatomical drawings, including figure studies, are classified. Religious subjects are grouped under five main headings: Old Testament, New Testament, Apostles, Saints, and The Virgin. Within these headings the subjects are arranged alphabetically, with the exception of the New Testament which follows a chronological pattern.

INDEX OF NAMES

All artists whose drawings are catalogued and who are referred to have been included, as well as all historic personages mentioned. Entries in **heavy type** *indicate named artists catalogued and the catalogue numbers of their drawings*

INDEX OF LOCATIONS

This shows present locations of all drawings listed in the catalogue in alphabetical order of towns. Where page-reference only is given, this refers to drawings which have no definite attribution

PRIVATE COLLECTIONS: (Barcelona), Diego Polo, cat. 331; Anon., cat. 398; (Madrid), Vicente Carducho, cat. 200, 248; Anon., cat. 344; (Switzerland), Eugenio Cajés, cat. 94

WHEREABOUTS UNKNOWN: Eugenio Cajés, cat. 50, 54, 59, 63, 75, 92; Vicente Carducho, cat. 119, 120; cat. 132, 168, 170, 178, 201, 243–4; Félix Castelo, cat. 263; Santiago Morán, cat. 288; Angelo Nardi, cat. 291–3; Antonio de Pereda, cat. 304, 309, 321; Manuel Pereira, cat. 326; Luis Tristán, cat. 341; Anon., cat. 363

INDEX OF OTHER WORKS OF ART
REFERRED TO IN THE CATALOGUE

This lists under location all works of art, apart from those catalogued

ALCALÁ
Altar-piece of the Bernardines: Nardi, *The Blessed Peter of Castilnovo*, cat. 396

BARNARD CASTLE
Bowes Museum: Pereda, *The Healing of Tobias*, cat. 296
BARCELONA
University: Cajés, *Christ seated on Calvary*, cat. 34, 35
BUDAPEST
Museum: Cajés, *Adoration of the Magi*, cat. 9, 11, 13
BURGOS
Charterhouse of Miraflores: V. Carducho, *Apparition of the Virgin to a Carthusian Brother*, cat. 150

CÁCERES
Museum of Fine Arts: V. Carducho, *Beheading of St. John the Baptist*, cat. 191
CASTELLÓN
Museum: Anon. copy of V. Carducho's *Apparition of the Virgin to the Venerable Juan Fort*, cat. 161
Anon. copy of V. Carducho's *Martyrdom of Monks and Lay Brothers of the London Charterhouse*, cat. 159
CASTROGERIZ (Burgos)
Church of St. John: Cajés copy, *Immaculate Virgin*, cat. 40
CEBREROS (Ávila)
J. Leonardo, Altar-piece, *Adoration of the Magi*, cat. 10
Last Supper, cat. 30
COPENHAGEN
Museum: Cajés, *The Devil vanquished by St. Michael*, cat. 104
CORDOVA
Cathedral: V. Carducho, *Apparition of the Virgin to the Venerable Juan Fort*, cat. 161; *St. Eulogius*, cat. 175, 191; *St. Anthelm consecrated Bishop of Belley by Alexander III*, cat. 157; *St. Bruno praying in Retreat at La Torre*, cat. 147
College of St. Augustine: Anon., stucco figures on vaults, cat. 351
CORUNNA
School of Fine Arts: V. Carducho, *The Venerable Denys van Rijkel (Dionysius the Carthusian) writing*, cat. 158; *The Martyrdom of Nothingham and Auxialme, the Carthusian Priors of London*, cat. 163
COVADONGA
V. Carducho, *Annunciation*, cat. 118
CUENCA
Cathedral: V. Carducho, *Crucifixion*, cat. 128

EL ESCORIAL
Navarrete el Mudo, *Beheading of St. James*, cat. 191
EL PAULAR (Madrid Province)
Charterhouse: V. Carducho, series of paintings depicting *Stories of St. Bruno and Venerable Carthusians*, p. 32

FLORENCE
Contini Bonacossi Collection: V. Carducho, *Martyrdom of Four Carthusians*, cat. 162

GRANADA
Charterhouse: Anon. Copy of V. Carducho's *Apparition of the Virgin to the Venerable Juan Fort*, cat. 161
GUADALUPE
Monastery: Cajés, Altar-piece, *Assumption of the Virgin*, cat. 74; Cajés and Carducho, Altar-piece, cat. 274; p. 13; de Guevara, funeral monuments of Henry IV of Castile and Doña Maria, cat. 272, 273

LISBON
Santo Domingo de Benficá: V. Carducho, *Attendant Saints*, cat. 169
LONDON
National Gallery: Nardi, *Adoration of the Shepherds*, cat. 291–2
Private Collection: V. Carducho, *Holy Family with Saints*, cat. 121
LOS ANGELES
County Museum of Art: J. Leonardo, *St. John the Baptist*, cat. 95

MADRID
Academia de San Fernando, B. Carducho; *St. Jerome*, cat. 385; Pereda, *The Dream of Life*, cat. 321; Pereira, Statue of St. Bruno, cat. 325; Rubens, *St. Augustine between Christ and the Virgin Mary*, cat. 139
Alcázar: Cajés, *Agamemnon*, cat. 90; Salón de Comedias, V. Carducho, Series of Kings, p. 47; Royal Chapel, Antechamber of Sacrarium, Castelo, Painted vault, cat. 259
Army Museum: V. Carducho, *Ataulf*, cat. 224
Capilla del Cristo de San Ginés: Cano, *Christ and the Virgin Mary on Calvary prior to the Crucifixion*, cat. 35
Ceballos Collection: Castelo, *Parable of the Guest at the King's Wedding*, cat. 261
Cerralbo Museum: Cajés, Assumption of the Virgin, cat. 44; Pereda, St. Dominic in Soriano, cat. 305 recto and verso, 306
Chapel of the Third Order: Cabezalero, *Crucifixion*, cat. 368
Church of the Algete: Cajés, Altar-piece, cat. 16, retable, *The Circumcision*, cat. 17
Church of the Buen Suceso: Cajés, Baptism of Christ, cat. 28
Church of Santo Domingo El Real: Cajés, *The Holy Family as the Holy Trinity on Earth*, cat. 26, 27
Church of the Villa del Prado: copy of V. Carducho, *Annunciation*, cat. 117
Convent of Descalzas Reales: V. Carducho, *Annunciation*, cat. 117
Convent of the Encarnación: V. Carducho, *Annunciation*, cat. 117, Altar-piece of St. Philip, cat. 192
Convent of St. Giles: V. Carducho, Retable dedicated to St. Giles, cat. 179, 180
Convento de la Merced Calzada: Cajés, Vault decoration, cat. 107
Hospital of the Tertiary Order: Pereda, *The Immaculate Conception*, cat. 298
Lázaro Galdiano Museum: Pereda, *The Visitation*, cat. 300

INDEX OF THEMES

Anatomical drawings, including figure studies, are classified. Religious subjects are grouped under five main headings: Old Testament, New Testament, Apostles, Saints, *and* The Virgin. *Within these headings the subjects are arranged alphabetically with the exception of the New Testament which follows a chronological pattern*